LIVING IN STYLE
LONDON

Photography by *Andreas von Einsiedel*
Texts by *Karin Gråbæk Helledie*

teNeues

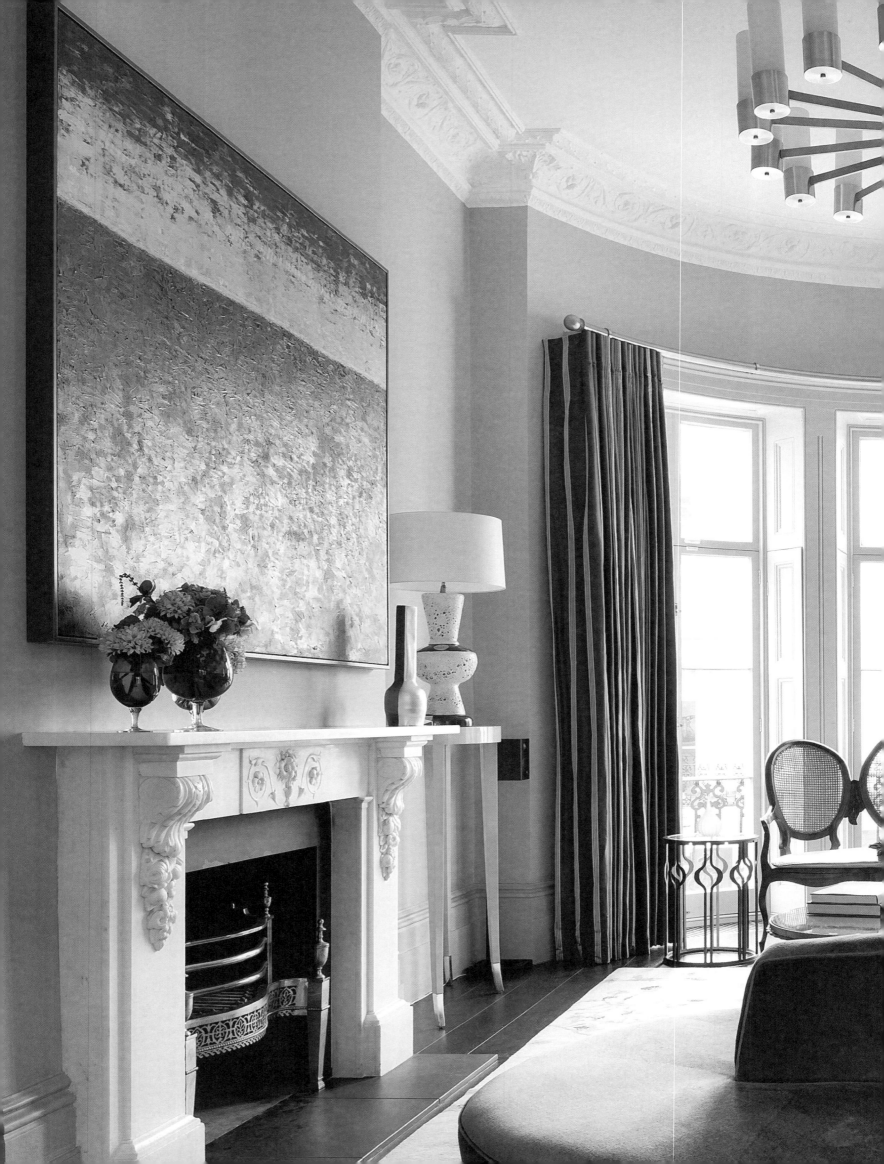

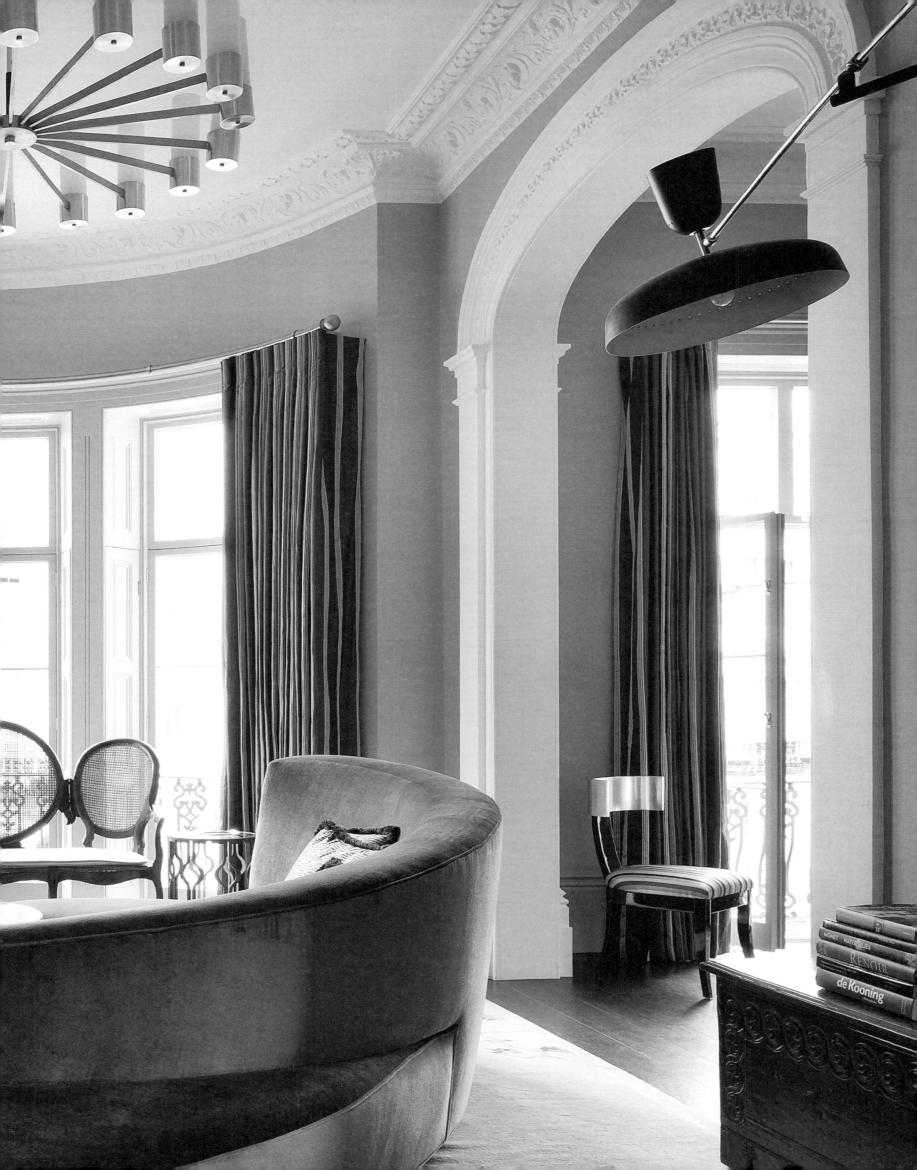

CONTENTS

INTRODUCTION

The essence of London's interior style is about as difficult to capture as London itself. This vibrant, ever changing, world-leading city is a bit of a maverick, always on to the next new thing, and at the same time it's old and charming with a strong sense of heritage and traditions. A fascinating symbiosis of "stiff upper lip" and keeping up appearances, on one side, and on the other side there is this celebration of anything slightly rebellious, witty and quirky. London seems to have a lot of everything – from tall, dazzling skyscrapers with super-expensive penthouses wrapped in glass and overlooking the booming skyline, to cosy cottages with rainbow coloured facades, tucked away in mews. Being one of the greenest big cities, blessed with lots of lush parks and quaint streets with old Victorian architectural pride, the unique village feel in the many different neighbourhoods makes London unlike most other cities of this scale. The easiest way to pin down the interior style is probably to compare it with any other styles sported by Londoners. In the world of fashion, London has always ranked as the wild, anything-goes rebel, on a par with New York and trying to keep up with chic, cosmopolitan Paris and the forever leading, classic style guru Milan. "London has its own completely individual style and has been known to be more of a trendsetter than following trends. It's part of the British DNA to celebrate eccentricity," says interior designer extraordinaire David Carter, who has worked on the theatrical décor in the first glamorous warehouse apartment in this book. Living in Style in London, according to him, is about self-expression, allowing yourself to live your dream, to live your life to the fullest. Why decorate your home like everyone else, just to fit in? The homeowners in this book all seem to agree – whether they have a life-size elephant sculpture in the hallway, silk padded walls, or three storey basements with pool, gym and cinema. Whether they have gone for chic elegant or weird and wonderful, they have all invested lots of time, thought, money, passion, craftsmanship and patience in creating the most amazing homes. These house tours are all perfect examples of how London with its global alchemy does grand, glamour, classic, eclectic, modern, quirky, vintage, luxury, playful, old, new, chic etc. like no one else. The featured town houses, mansion block flats, an old warehouse apartment, mansions, mews houses, and a former water tower all remind us that it takes money to live in style in London. But even the most grand, glamorous house in this book has that unmistakable characteristic: the strong individualistic touch. Nobody tells a Londoner what he or she can and can't do, and that is quintessentially British style.

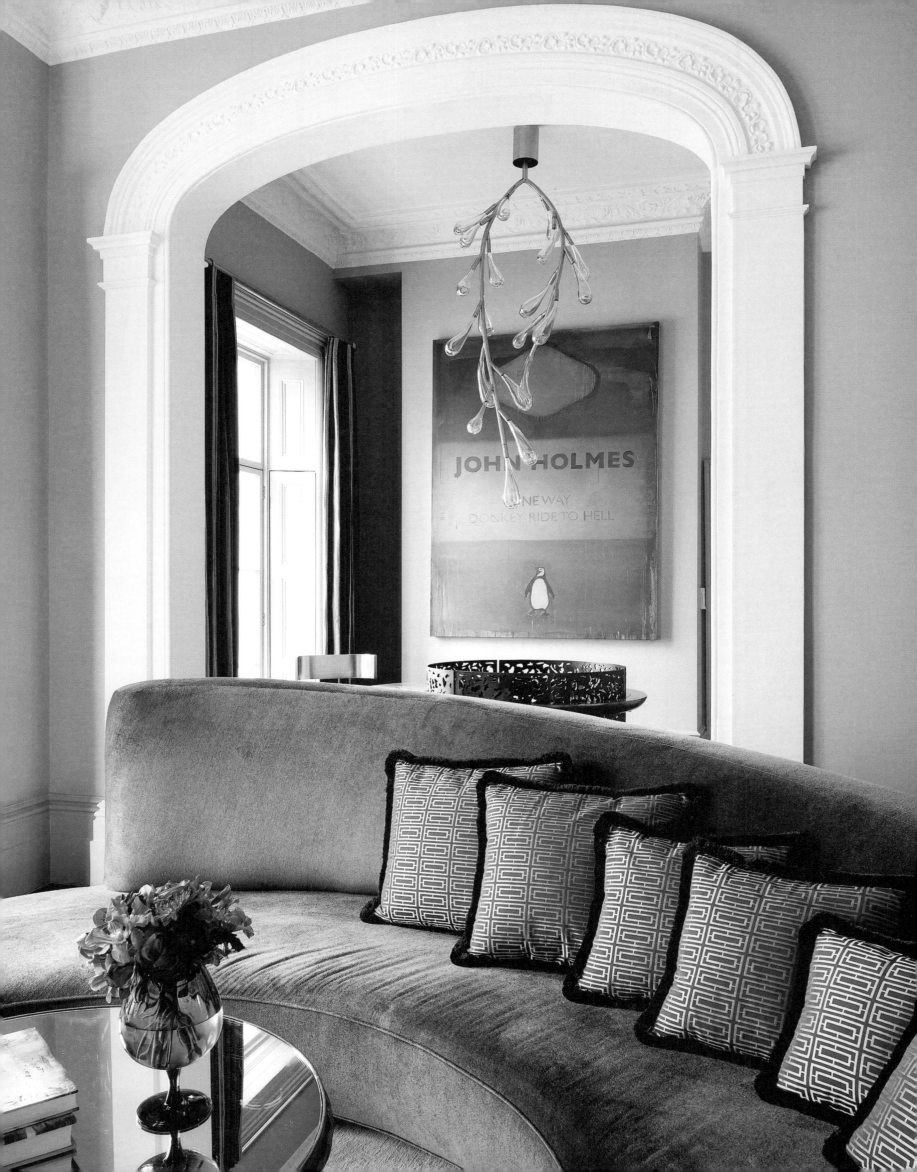

EINLEITUNG

Den Kern des innenarchitektonischen Stils von London einzufangen, ist genauso schwierig, wie die Stadt selbst einzufangen. Diese lebendige, sich stets ändernde, weltweit führende Metropole ähnelt einem Einzelgänger. Immer auf der Spur nach dem Neuen, ist sie gleichzeitig alt und charmant und fühlt sich ihrem Erbe und den Traditionen verbunden. In einer faszinierenden Symbiose bewahrt sie einerseits „Haltung" und feiert andererseits das leicht Rebellische, Originelle und Skurrile. London scheint von dem, was es alles gibt, viel zu haben – von großen, umwerfenden Hochhäusern mit superteuren, gläsernen Penthäusern, die auf die blühende Skyline der Stadt blicken, bis hin zu gemütlichen Cottages mit regenbogenfarbenen Fassaden in stillen Gassen, in denen sich früher die Stallungen der Herrenhäuser befanden. Als eine der grünsten Großstädte der Welt ist London mit vielen, üppigen Parks und idyllischen Straßen gesegnet, die im alten, stolzen, viktorianischen Baustil erstrahlen. Die vielen unterschiedlichen Viertel zeichnen sich durch jene einzigartige, dörfliche Atmosphäre aus, die London zu etwas anderem werden lässt als die meisten Städte ähnlicher Größe. Wahrscheinlich ist es am einfachsten, den innenarchitektonischen Stil mit all den anderen Stilen zu vergleichen, die die Londoner voller Stolz tragen. In der Welt der Mode hat die Stadt schon immer den Platz der Wilden eingenommen, in der alles erlaubt ist. Auf Augenhöhe mit New York versucht sie, mit dem schicken, kosmopolitischen Paris und dem klassischen Stil des ewig führenden Gurus, Mailand, mitzuhalten. „London hat seinen eigenen, völlig individuellen Stil und ist dafür bekannt, eher Trends zu setzen, als ihnen zu folgen. Exzentrik zu feiern, ist fester Bestandteil der britischen DNA", erklärt David Carter, Innenarchitekt der

Extraklasse und verantwortlich für die außergewöhnliche Ausstattung des ersten in diesem Buch vorgestellten Objekts. Seiner Meinung nach bedeutet „Living in Style in London", sich selbst zu entfalten, seinen Traum zu verwirklichen und das Leben in vollen Zügen zu genießen. Warum sein Zuhause einrichten wie jeder andere, nur um sich der Gesellschaft anzupassen? Die Hauseigentümer in diesem Buch scheinen ihm zuzustimmen – sei es, dass sie einen lebensgroßen Elefanten in ihre Diele stellen, die Wände mit Seide bespannen oder dreistöckige Keller mit Schwimmbad, Fitnessraum und Kino haben. Für welchen Stil sie sich auch entschieden haben, ob schick-elegant oder wunderbar-eigenwillig, sie alle haben viel Zeit, Geld, Gedanken, Leidenschaft, Kunstfertigkeit und Geduld investiert, um die erstaunlichsten Heime zu schaffen. Diese Hausrundgänge sind Musterbeispiele für Londons Fähigkeit, Prachtvolles, Glamouröses, Klassisches, Vielseitiges, Modernes, Skurriles, Verspieltes, Altes, Neues, Schickes, Vintage und Luxus hervorzubringen, und das vor dem Hintergrund des globalen Charakters der Stadt. Die vorgestellten Objekte, darunter Stadthäuser, Herrenhäuser, umgebaute Stallungen, stattliche Wohnungen sowie ein alter Wasserturm und ein Apartment in einem alten Lagerhaus, führen uns allesamt eine Sache vor Auge: dass es Geld kostet, um in London stilvoll zu leben. Doch selbst das prachtvollste, glamouröseste Haus in diesem Buch besitzt jene unverwechselbare Eigenschaft: die ausgeprägte, individualistische Note. Niemand schreibt einem Londoner vor, was er darf oder was nicht, und das ist der Inbegriff britischen Stils.

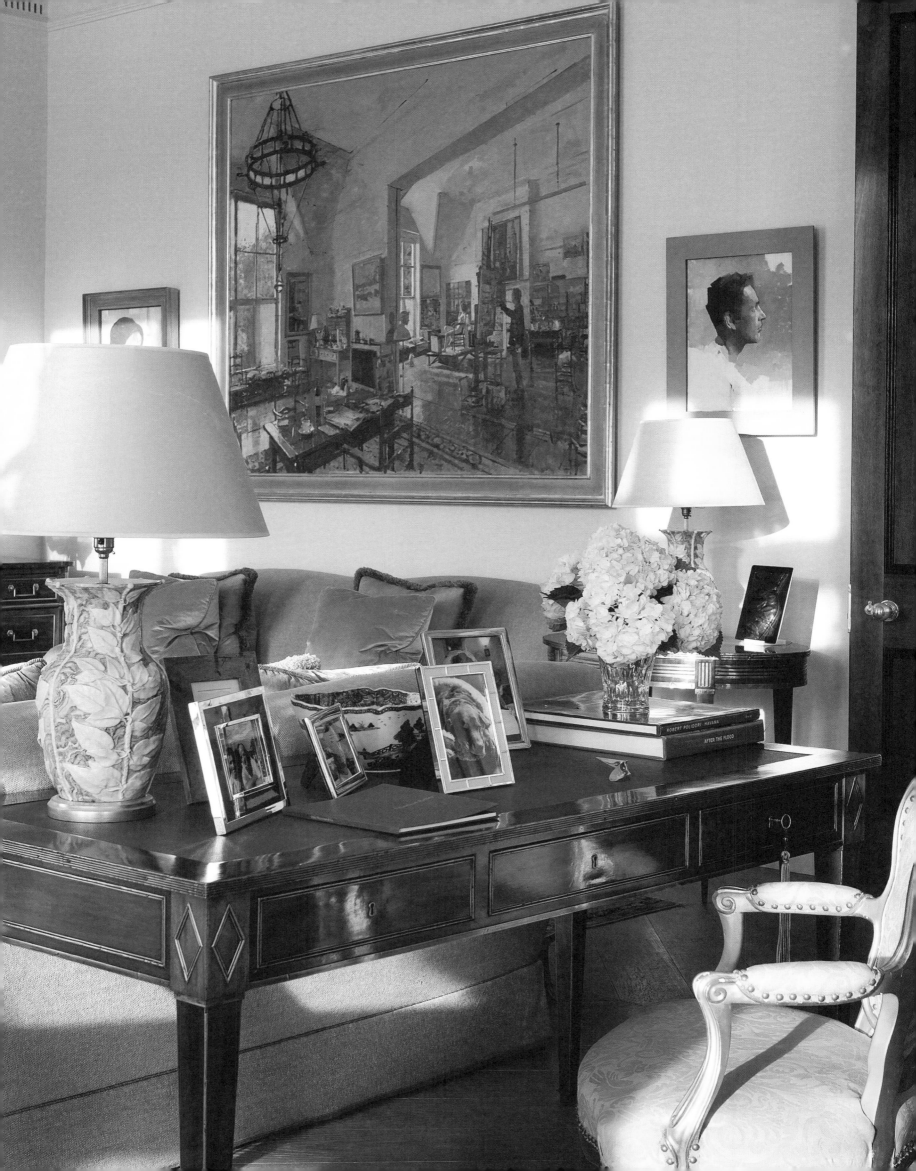

INTRODUCTION

Capter l'essence du style décoratif londonien est aussi difficile que de saisir Londres elle-même. Dynamique, changeante, internationalement reconnue, la capitale anglaise affiche un non-conformisme toujours tourné vers la nouveauté. Mais elle est aussi délicieusement ancienne, préservant fermement son héritage et ses traditions. D'un côté, une fascinante symbiose du flegme et du respect des apparences, de l'autre, le culte de ce qui, de près ou de loin, s'affirme comme rebelle, spirituel ou excentrique. Londres semble pourvue de tout en abondance – des immenses et éblouissants gratte-ciels qui accueillent des penthouses hors-de-prix, ceints de verre découvrant un admirable horizon, jusqu'aux cottages cosy, aux façades couleur arc-en-ciel, abrités dans les anciens « mews ». Avec ses nombreux parcs luxuriants qui la placent parmi les plus vertes des grandes villes, et ses rues pittoresques à l'architecture victorienne empreinte de dignité surannée, Londres diffère de la plupart des autres mégapoles par cette vie de village singulière qui caractérise nombre de ses quartiers. Sans doute, le meilleur moyen de définir l'architecture intérieure londonienne est-il de la comparer aux autres styles pratiqués par les habitants de la capitale. Dans le domaine de la mode, Londres a toujours affiché une dissidence débridée, à l'égal de New York, tout en s'efforçant de suivre le cosmopolitisme chic de Paris et le classicisme que Milan continue à imposer en éternel gourou. « Possédant un style éminemment personnel, Londres est surtout connue pour imposer les tendances et non les suivre. Célébrer l'excentricité fait partie de l'ADN anglais » affirme David Carter, remarquable architecte d'intérieur qui signe la glamour et théâtrale décoration intérieure du tout premier appartement installé dans un entrepôt mentionné dans cet ouvrage. Selon lui, l'expression de soi qui permet de vivre son rêve, de vivre pleinement sa vie, est au coeur même de « Living In Style London ». Pourquoi décorer sa maison comme tout le monde afin d'éviter de se faire remarquer ? Qu'ils possèdent un éléphant grandeur nature dans l'entrée, des murs tapissés de soie ou un triple sous-sol avec piscine, salle de gymnastique et cinéma, les propriétaires rencontrés pour cet ouvrage semblent tous d'accord. Et qu'ils aient opté pour l'élégance, le chic, l'étrange ou encore, le merveilleux, tous ont consacré beaucoup de temps, de réflexion, d'argent, de passion, de savoir-faire et de patience à la création de ces exceptionnelles demeures. Chacune des visites proposées ici illustre à la perfection l'approche à nulle autre pareille que Londres, avec cette alchimie internationale qui la caractérise, propose du grandiose, du glamour, du classique, de l'éclectique, du moderne, de l'excentrique, du rétro, du luxueux, du ludique, de l'ancien, du nouveau, du chic … Maison de ville, résidence de standing, appartement situé dans un vieil entrepôt, demeure de maître, « mews » ou encore, ancien château d'eau, chacun de ces lieux nous rappellent combien l'argent est nécessaire à l'art de vivre avec grand style à Londres. Cependant, il n'est pas jusqu'à la plus majestueuse et la plus chic des demeures présentée dans cet ouvrage qui ne possède cette indéniable caractéristique : une originalité affirmée. Nul ne saurait dire à un Londonien ou une Londonienne ce qu'il ou elle peut ou ne peut pas faire – telle est la quintessence du style anglais.

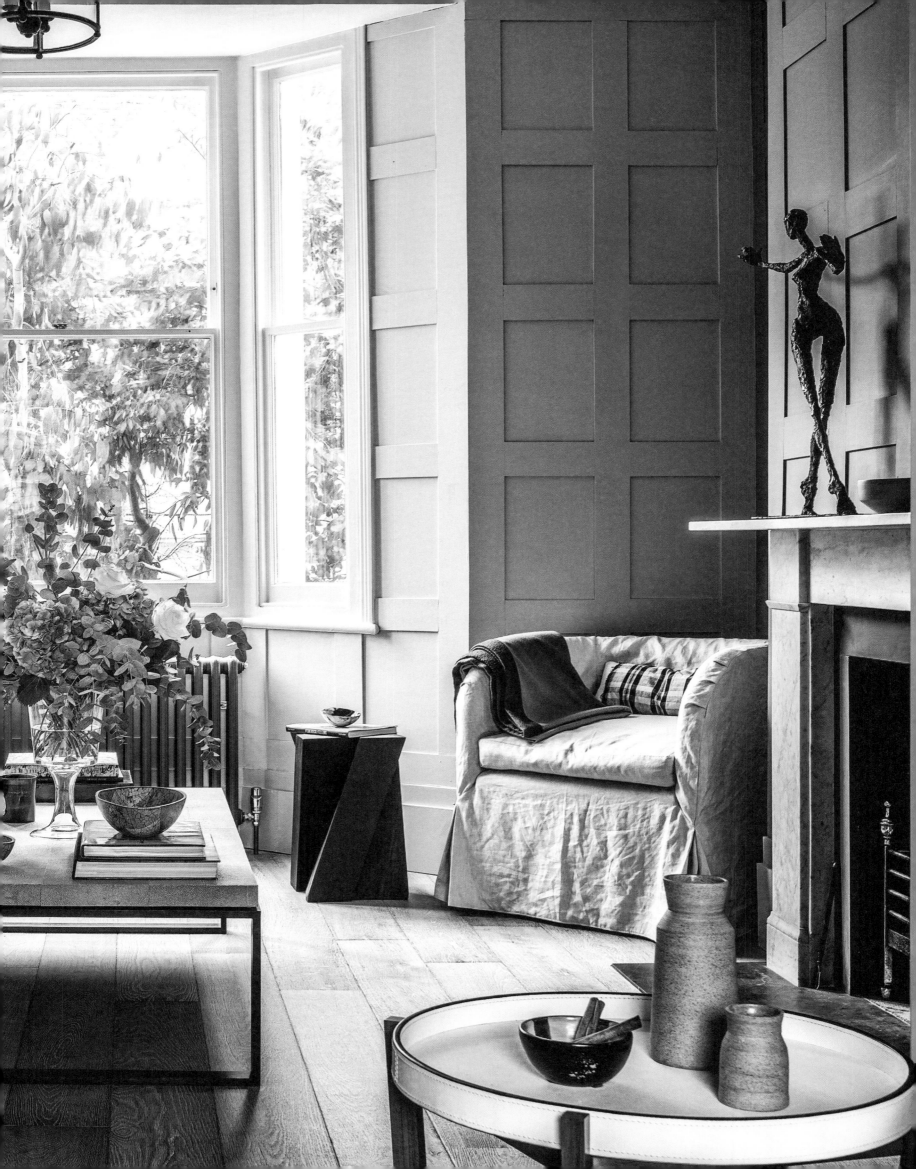

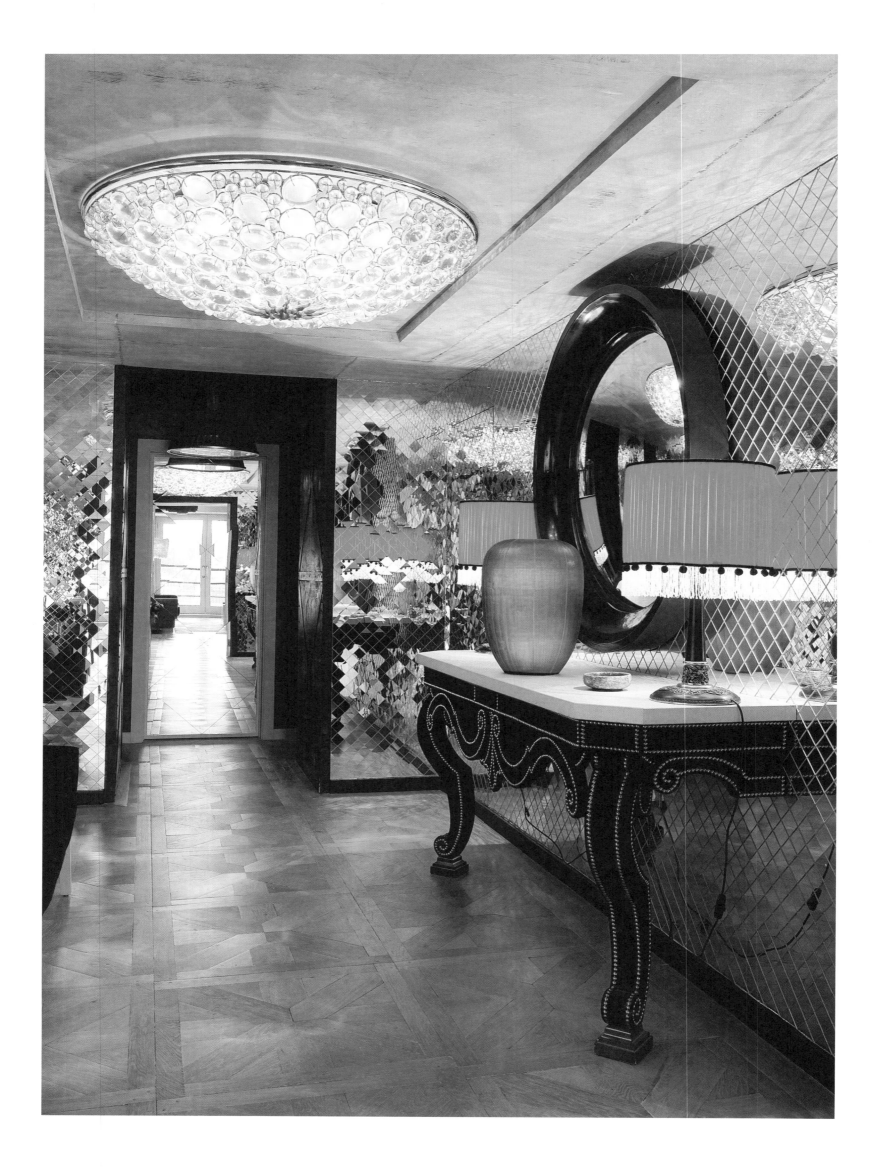

THE ART OF SEDUCTION

Southwark

The walls of the entry hall are lined with small, slightly imperfect, angled mirrors reflecting the light and making it all feel glitzy and shimmering. It's intentional, like everything else that David Carter has pulled off with this exceptionally imaginative décor. Known for his theatrical style and his work on his decadent 40 Winks hotel, the interior designer received a dream brief for the transformation of this warehouse apartment overlooking the River Thames. The well-heeled owner fancied a seductive, James Bond bachelor pad, with an atmospheric environment and a sort of quiet eroticism. The dockside apartment had great potential but the layout was wrong and the style was bland, with suspended ceilings and a long corridor with doors. Everything was re-planned and changed into a glamorous yet comfortable open-spaced home. The high concrete ceilings were exposed and fitted with galvanised metal cables and Victorian looking boxes to acknowledge the warehouse's architectural heritage. The industrial look has been paired with playful elements like a glass kitchen table top with a disco colour wheel, commissioned furniture, and cleverly concealed storage and technology. Warm, muted colours and glittering splashes have been chosen throughout the alluring, slightly mad and very masculine home. The interior designer himself describes it as "quiet luxury" and his version of minimalism.

Die Wände des Eingangsbereichs sind mit kleinen, leicht fehlerhaften, schrägen Spiegeln verkleidet, die das Licht reflektieren, wodurch das Entree glitzernd und schillernd erscheint. Das ist beabsichtigt, wie alles, was David Carter mit dieser außergewöhnlich erfinderischen Ausstattung herbeigeführt hat. Der für seinen aufwendigen Stil und die Arbeit an seinem dekadenten Hotel „40 Winks" bekannte Innenarchitekt erhielt traumhafte Anweisungen, um dieses Apartment, das sich in einer Lagerhalle mit Blick zur Themse befindet, zu verwandeln. Dem gut betuchten Besitzer schwebte eine verführerische Junggesellenbude à la James Bond vor, die ein stimmungsvolles Ambiente und eine Art stille Erotik ausstrahlen sollte. Das am Wasser gelegene Apartment besaß großes Potenzial, doch der Grundriss war unzulänglich und der Baustil uninteressant. Die Decken waren abgehängt, und ein langer Flur mit vielen Türen durchzog die Wohnung. Alles wurde neu geplant und in ein glamouröses, aber dennoch behagliches, offenes Heim verwandelt. Die

1

hohen Betondecken wurden freigelegt. Verzinkte Kabel und viktorianisch aussehende Gehäuse wurden installiert, um das bauliche Erbe des Lagerhauses zu würdigen. Der Industrie-Look ist gepaart mit verspielten Elementen wie einer gläsernen, beleuchteten Küchenarbeitsplatte, maßgefertigten Möbeln, klug verborgenen Aufbewahrungsmöglichkeiten und raffiniert versteckter technischer Ausrüstung. Warme, gedeckte Farben und glitzernde Sprenkel durchziehen dieses verführerische, leicht verrückte und sehr maskuline Heim. Der Innenarchitekt selbst bezeichnet es als „leisen Luxus" und seine Version von Minimalismus.

Grâce aux petits miroirs en forme de losange, légèrement imparfaits, qui recouvrent les murs et réfléchissent la lumière, le hall d'entrée tout entier baigne dans un brillant chatoiement. Effet voulu par David Carter qui signe ici une décoration extraordinairement imaginative. Connu pour la théâtralité de son style et l'agencement baroque de l'hôtel 40 Winks, l'architecte d'intérieur a reçu, pour la transformation de cet appartement sis dans un entrepôt donnant sur la Tamise, une commande de rêve. Une séduisante garçonnière à la James Bond, empreinte d'une véritable atmosphère et d'un paisible érotisme, tel est ce qu'imaginait le fortuné propriétaire des lieux. Situé sur les quais, l'appartement offre un grand potentiel, en dépit de son absence de style et d'un agencement déplorable que caractérisent un long couloir bordé de portes et des faux-plafonds. L'ensemble a été repensé de sorte à créer un espace ouvert, aussi glamour que confortable. Témoignant du passé architectural de l'entrepôt, les hauts plafonds en béton ont été mis à nu et équipés de câbles en métal galvanisé, ainsi que de boîtiers rappelant l'époque victorienne. Des touches ludiques, à l'exemple du plan de travail éclairé par des Leds dans la cuisine, mais aussi des meubles et des éléments de rangements réalisés sur mesure, ou un équipement technologique habilement dissimulé, complètent le caractère industriel du lieu. Des couleurs chaleureuses et discrètes, avec, çà et là, de lumineux éclats, rythment cette attrayante demeure, un peu folle et extrêmement masculine. Expression d'un « luxe paisible » pour reprendre les mots du décorateur, l'appartement correspond aussi à sa vision du minimalisme.

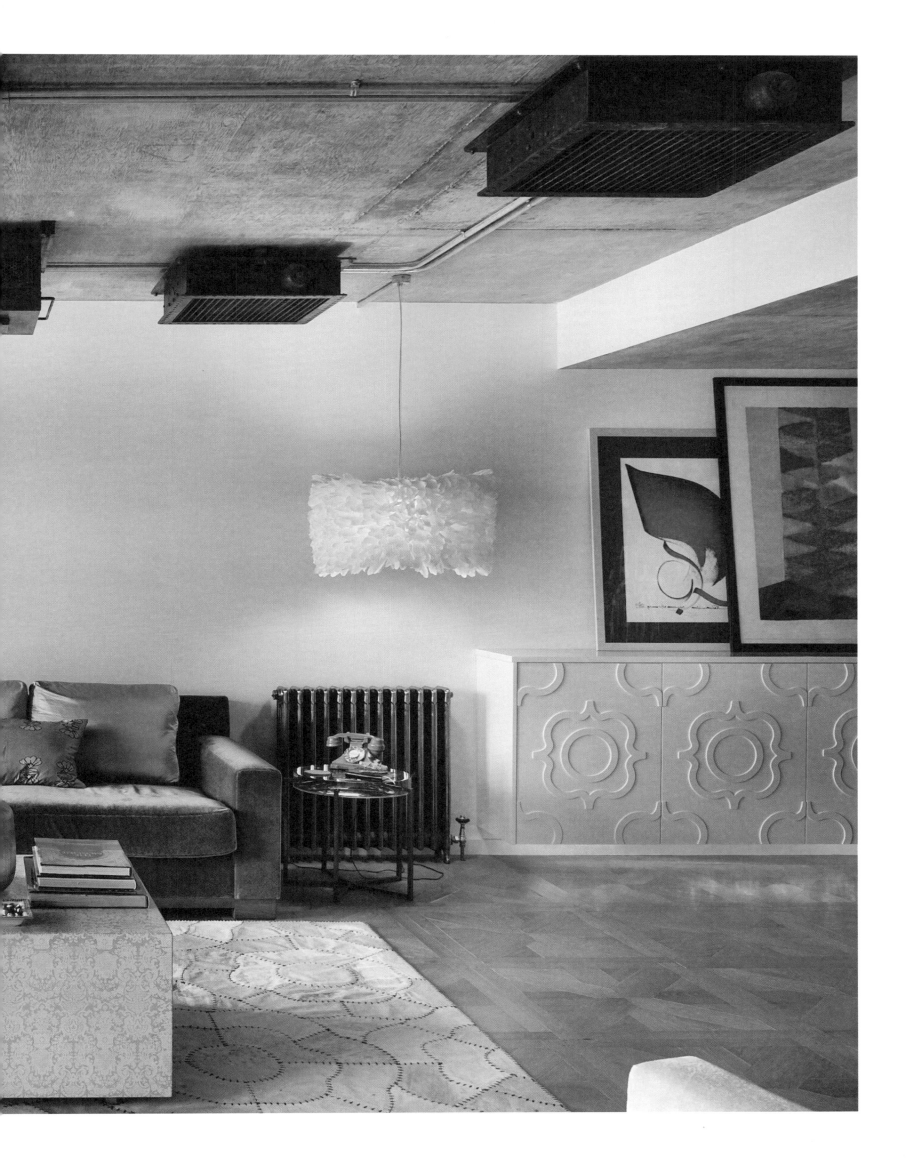

UNUSUAL MATERIALS LIKE the panelled steel walls in the guest bedroom, the Arabesque laser-cut design on the kitchen units, and other elegant wall panellings are key components of the décor. To suit the more masculine style, quirky art and objects have been carefully selected.

UNGEWÖHNLICHE MATERIALIEN WIE die stahlverkleideten Wände im Gästezimmer, das lasergeschnittene, arabisch anmutende Design der Kücheneinbauten und andere, elegante Wandverkleidungen sind Schlüsselelemente der Innenausstattung. Eigenwillige Kunst und Objekte wurden sorgfältig ausgewählt, um dem eher maskulinen Stil zu entsprechen.

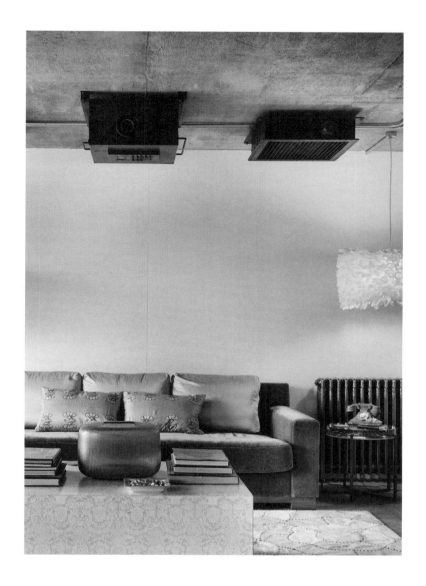

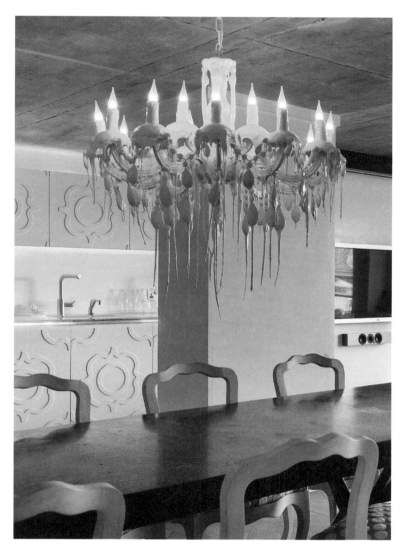

MATÉRIAUX INHABITUELS, À l'exemple des panneaux d'acier qui tapissent la chambre d'invité, des arabesques découpées au laser sur les rangements de cuisine, ou encore, élégants murs lambrissés, tels sont les éléments-clés de la décoration. Objets et oeuvres d'art ont été soigneusement sélectionnés pour s'accorder à cette ambiance particulièrement masculine.

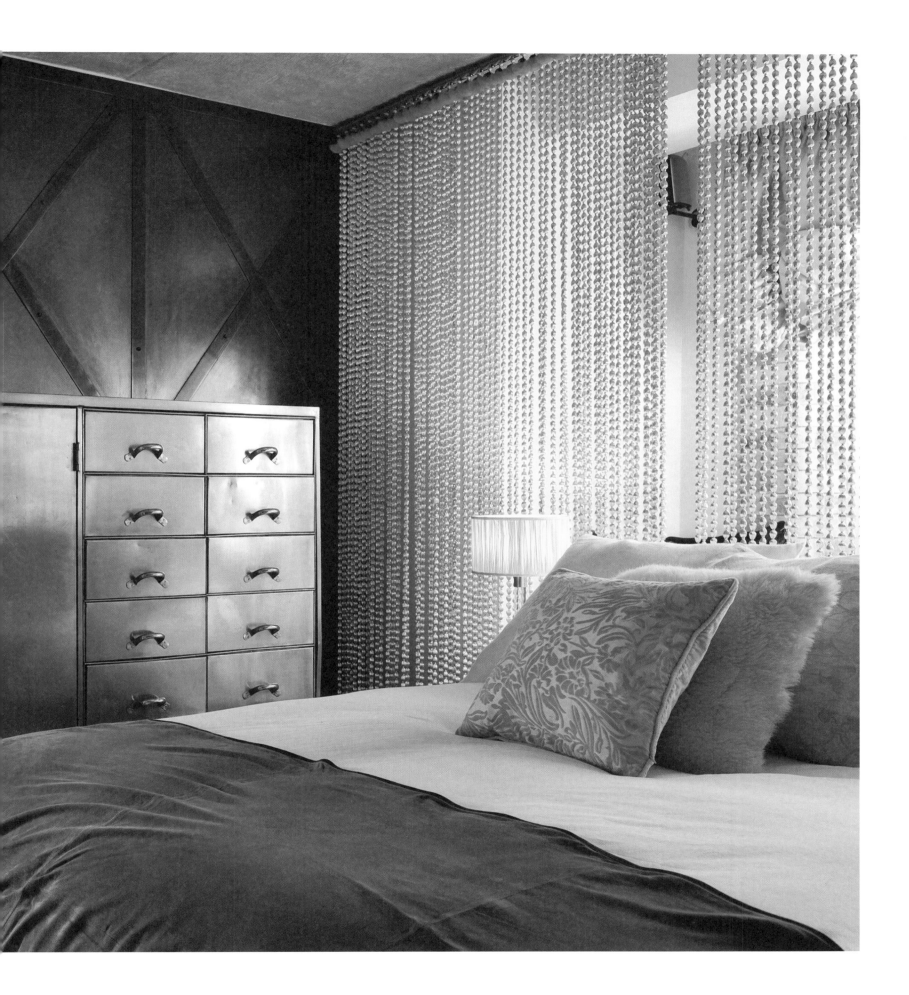

GRAND DREAM MANOR

West London

Looks can be deceptive. Despite it resembling the neighbouring houses dating from the 1840s, the West London home of Studio Indigo's architect and designer Mike Fisher is only a few years old. The big, beautiful, gutsy traditional house has all the latest technology and amenities such as an indoor swimming pool, sauna, cinema and an integral double garage. He originally fell for the 19th century style and west-facing garden, but demolished the entire building, except for the 'doll's house' façade. Instead, he created his dream house and most ambitious project ever, inspired by Sir John Soane (1753–1837) and his Pitzhanger Manor in Ealing. The design based on a central axis provides an unobstructed view extending from the front door to the tall bay windows overlooking the garden at the rear. The five-storied, eleven-thousand-square-foot house is unashamedly grand, kept in calm, relaxing shades and furnished with a stunning collection of art and antiques. However, the monumental scale is balanced by the pervading sense of comfort and warmth and an understated way of using high quality materials. "This is a house made for entertaining," says Mike. Outside, the romantic pavilion in the garden provides a perfect setting for big parties, dinners for eight or ten or an informal lunch for friends and family.

Optik kann täuschen. Trotz seiner Ähnlichkeit mit den benachbarten, aus den 1840er-Jahren stammenden Häusern ist das im Westen von London gelegene Heim des Architekten Mike Fisher (Studio Indigo) erst wenige Jahre alt. Das große, wunderschöne, charaktervolle, traditionelle Haus verfügt über modernste Technik und Annehmlichkeiten wie ein Hallenbad, eine Sauna, ein Kino und eine eingebaute Doppelgarage. Fisher war zuerst hingerissen von dem Haus im Stil des 19. Jahrhunderts und dem nach Westen gerichteten Garten, riss dann aber doch das gesamte Gebäude ab, außer der „Puppenhaus"-Fassade. Stattdessen schuf er sein Traumhaus und sein ehrgeizigstes Projekt überhaupt, inspiriert von Sir John Soane (1753–1837) und seinem Pitzhanger Manor in Ealing. Der von einer Mittelachse ausgehende Entwurf bietet einen freien Blick von der Eingangstür bis hin zu den hohen, zum rückwärtigen Garten gerichteten Erkerfenstern. Das sich über fünf Stockwerke erstreckende, tausend Quadratmeter große Haus wirkt herrschaftlich. Die Farbgebung ist ruhig und entspannt, und die Räume sind mit einer beeindruckenden Kunst- und Antiquitätensammlung ausgestattet. Die gewaltige Größe des Objekts wird dabei aber sowohl durch die Behaglichkeit und Wärme ausgeglichen, die es ausstrahlt, als auch durch den unaufdringlichen Einsatz hochwertiger Materialien. „Dies ist ein Haus, um darin zu feiern", sagt Mike. Der romantische Pavillon draußen im Garten bildet einen perfekten Rahmen für große Feste, für Abendessen mit acht oder zehn Gästen oder ungezwungene Mittagessen mit Freunden und Familie.

Les apparences sont parfois trompeuses. Si elle ressemble à ses voisines construites aux alentours des années 1840 dans le West London, la maison de l'architecte Mike Fisher (Studio Indigo) date d'il y a quelques années seulement. Audacieusement traditionnelle, cette vaste et belle demeure offre une technologie et des équipements dernier cri – piscine intérieure, sauna, salle de projection, ou encore, garage double intégré. Séduit au départ par le style XIXème siècle et le jardin, orienté à l'ouest, Mike Fisher a cependant démoli l'ensemble du bâtiment, à l'exception de la façade de type « maison de poupée ». Inspiré par Sir John Soane (1753–1837) et son Pitzhanger Manor, dans le quartier d'Ealing, il s'est lancé dans un projet particulièrement ambitieux pour recréer la maison de ses rêves. Organisé autour d'un axe central, l'agencement offre, depuis la porte d'entrée, une vue dégagée qui s'étend jusqu'aux hautes baies vitrées donnant sur le jardin, à l'arrière. Avec ses cinq étages et ses mille mètres carrés, la demeure affiche une somptuosité assumée que pondèrent des teintes paisibles et relaxantes. Une saisissante collection d'oeuvres d'art et de meubles anciens viennent l'agrémenter. Sa dimension monumentale est toutefois équilibrée par un sens du confort aussi chaleureux qu'omniprésent, ainsi que par un usage discret de matériaux de grande qualité. « C'est une maison faite pour recevoir » affirme son propriétaire. Romantique, le pavillon du jardin constitue un cadre parfait pour organiser de grandes fêtes, des dîners de huit à dix personnes, ou encore, un déjeuner informel avec la famille ou des amis.

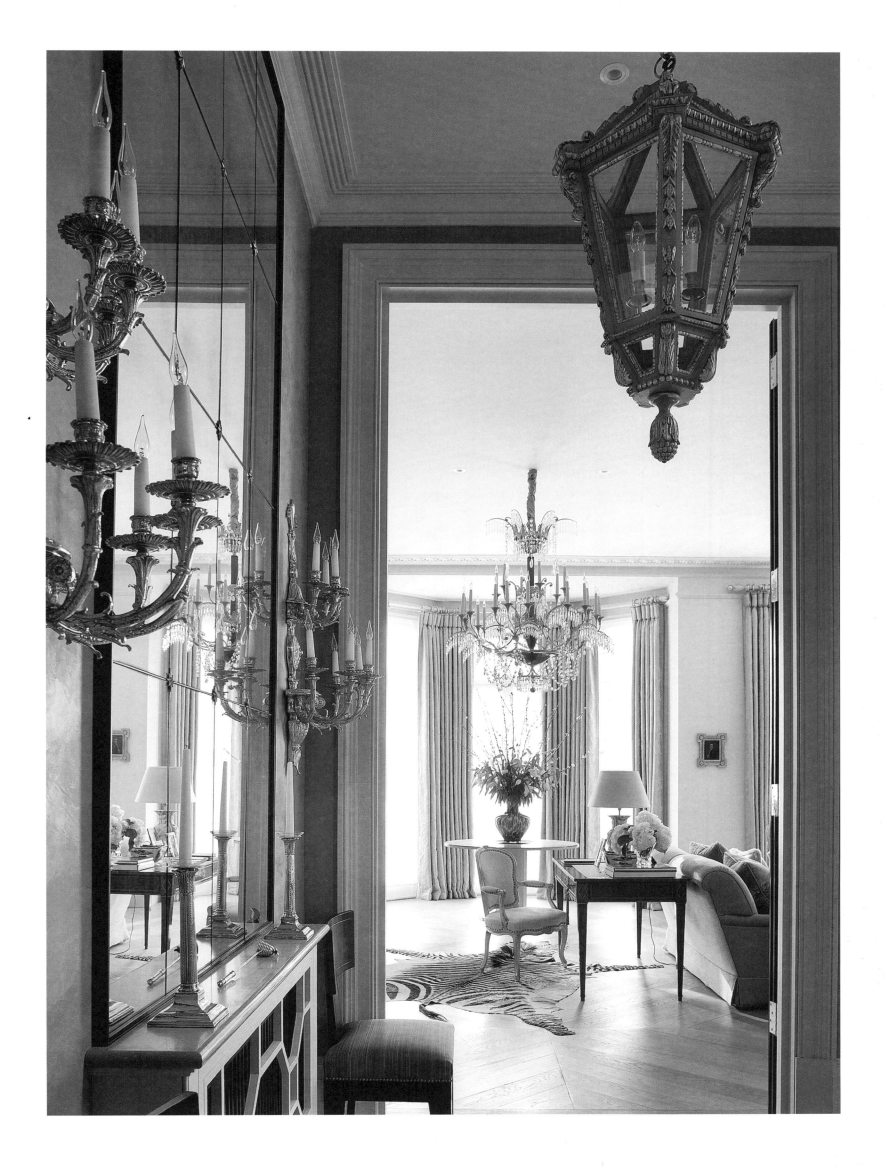

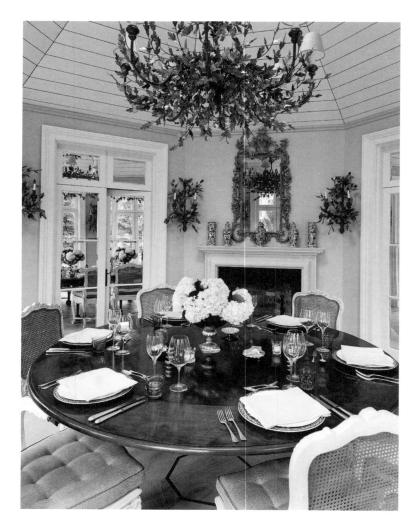

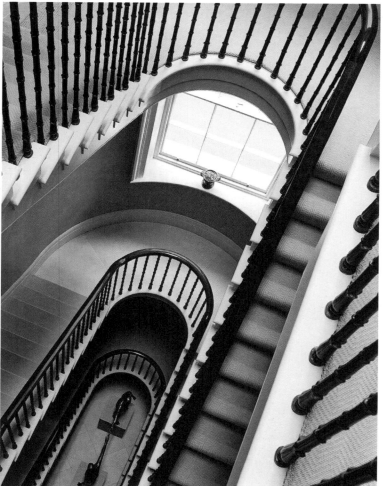

CELEBRATING THE STAIRCASE is a trademark of the architect's style. This splendid elliptical staircase rises gracefully through five floors and is situated to one side of the inner hall.

DAS ZELEBRIEREN DES Treppenhauses ist ein Markenzeichen des Baustils dieses Architekten. Die prächtige, elliptisch geformte Treppe erhebt sich anmutig über fünf Stockwerke und liegt seitlich der Eingangshalle.

METTRE EN VALEUR l'escalier est une marque de fabrique de l'architecte. Situé à l'intérieur, sur le côté de l'entrée, ce splendide specimen à noyau elliptique s'élève gracieusement sur cinq étages.

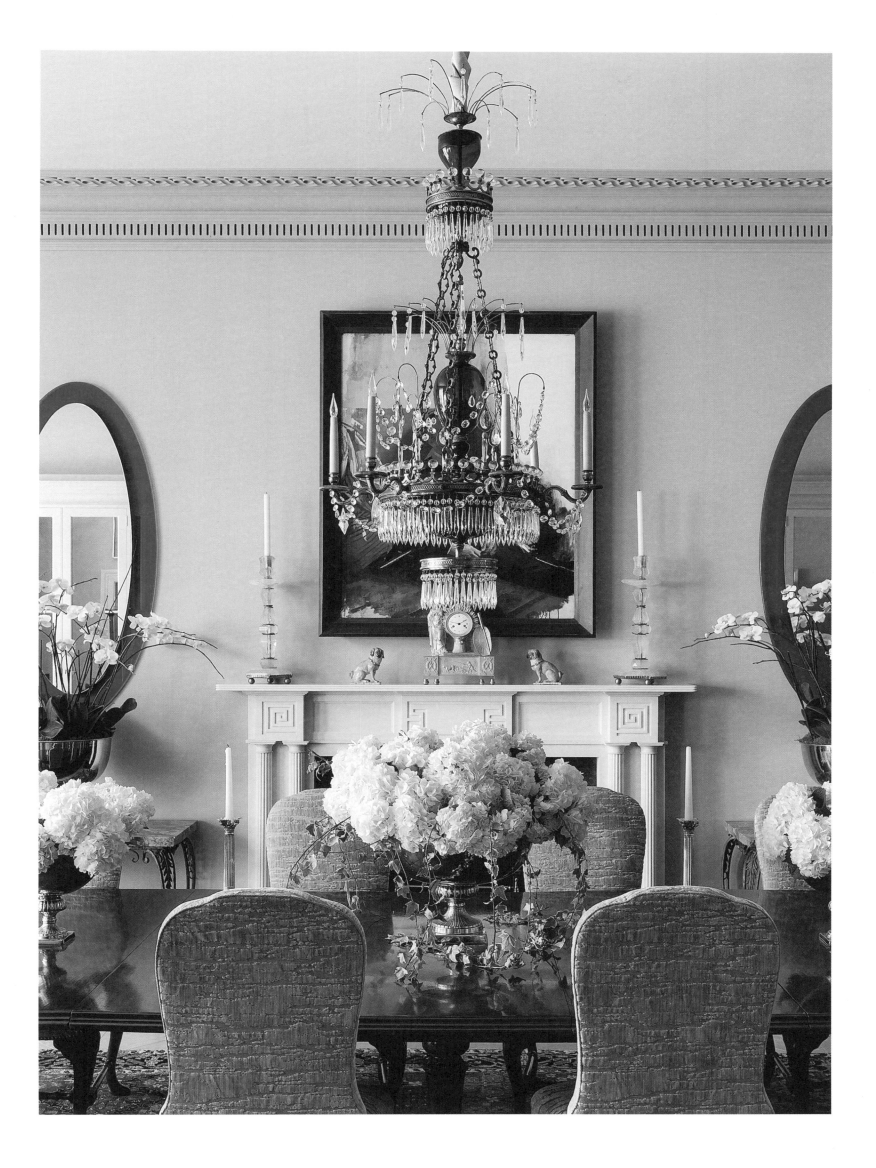

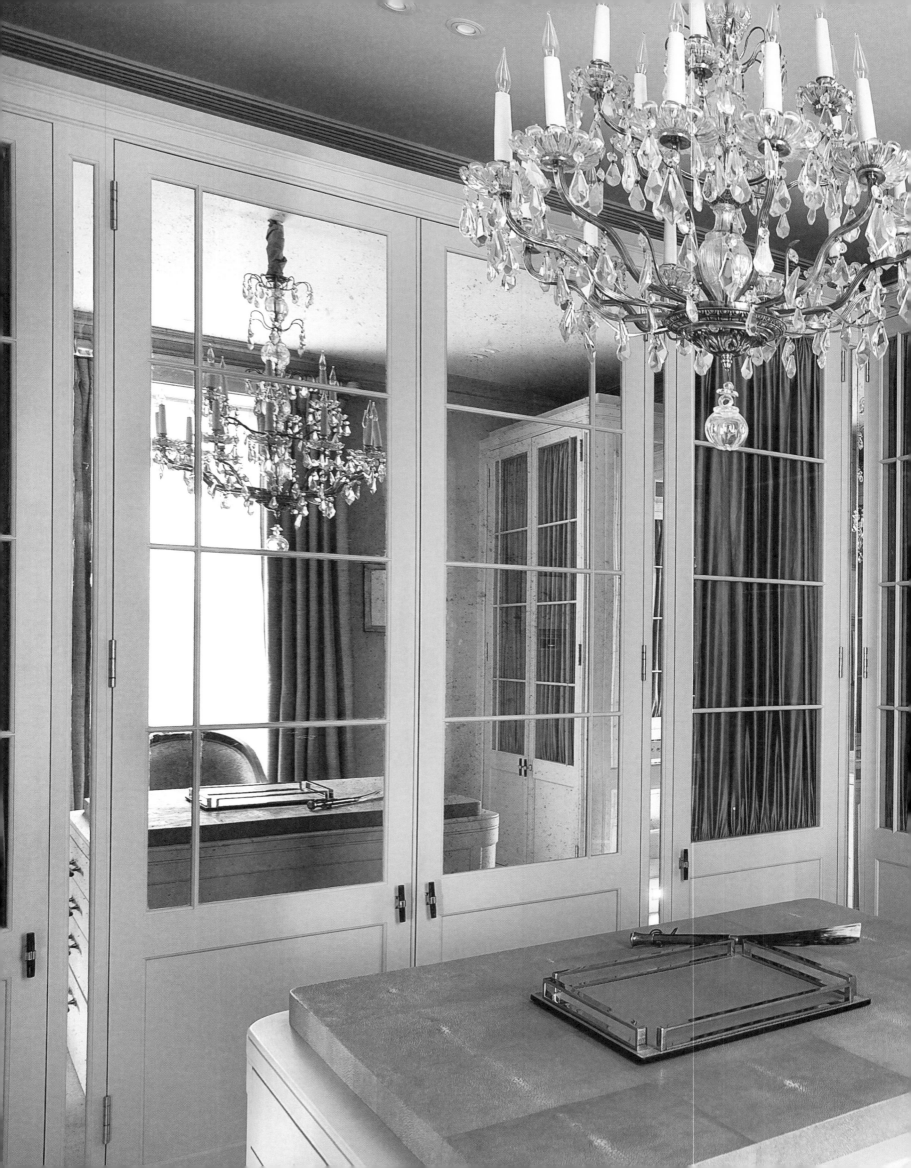

BY CHOOSING DINING chairs with backs that are only just that little bit high-er than the dining table and the rest of the furniture, the architect has taken the stiff formality out of the family room. A pair of tall custom-made cupboards are designed to stand on either side of the Sir John Soane inspired fireplace.

INDEM ER ESSZIMMERSTÜHLE wählte, deren Rückenlehnen nur etwas höher sind als der Tisch selbst und die übrigen Möbel im Wohnzimmer, ist es dem Architekten gelungen, dem Raum die steife Förmlichkeit zu nehmen. Zwei große, maßgefertigte Schränke flankieren den Kamin, der sich im Stil von Sir John Soane präsentiert.

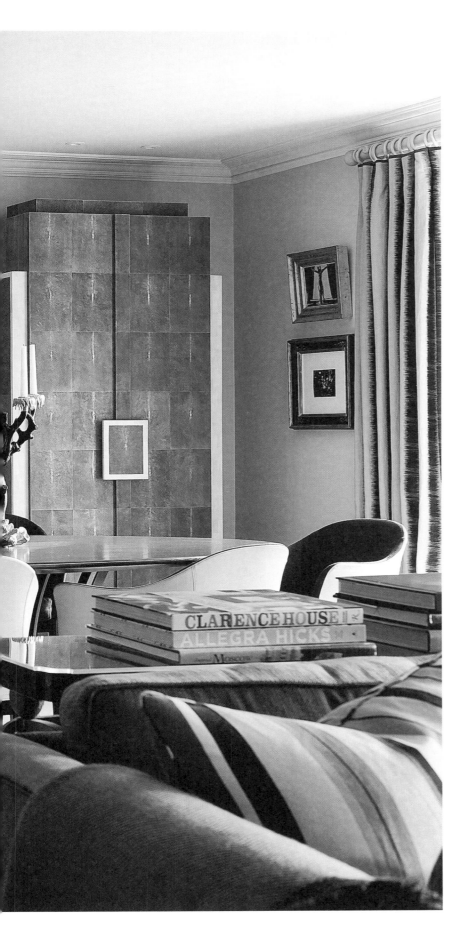

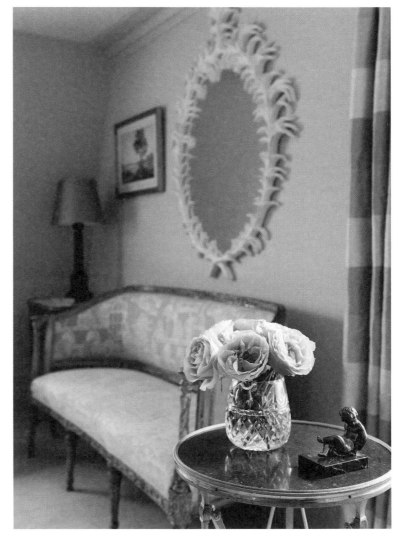

EN OPTANT POUR des chaises dont le dossier est à peine plus haut que la table ou les meubles, l'architecte d'intérieur a éliminé tout formalisme rigide de la pièce de vie familiale. De part et d'autre de la cheminée inspirée par Sir John Soane se dressent deux placards réalisés sur-mesure.

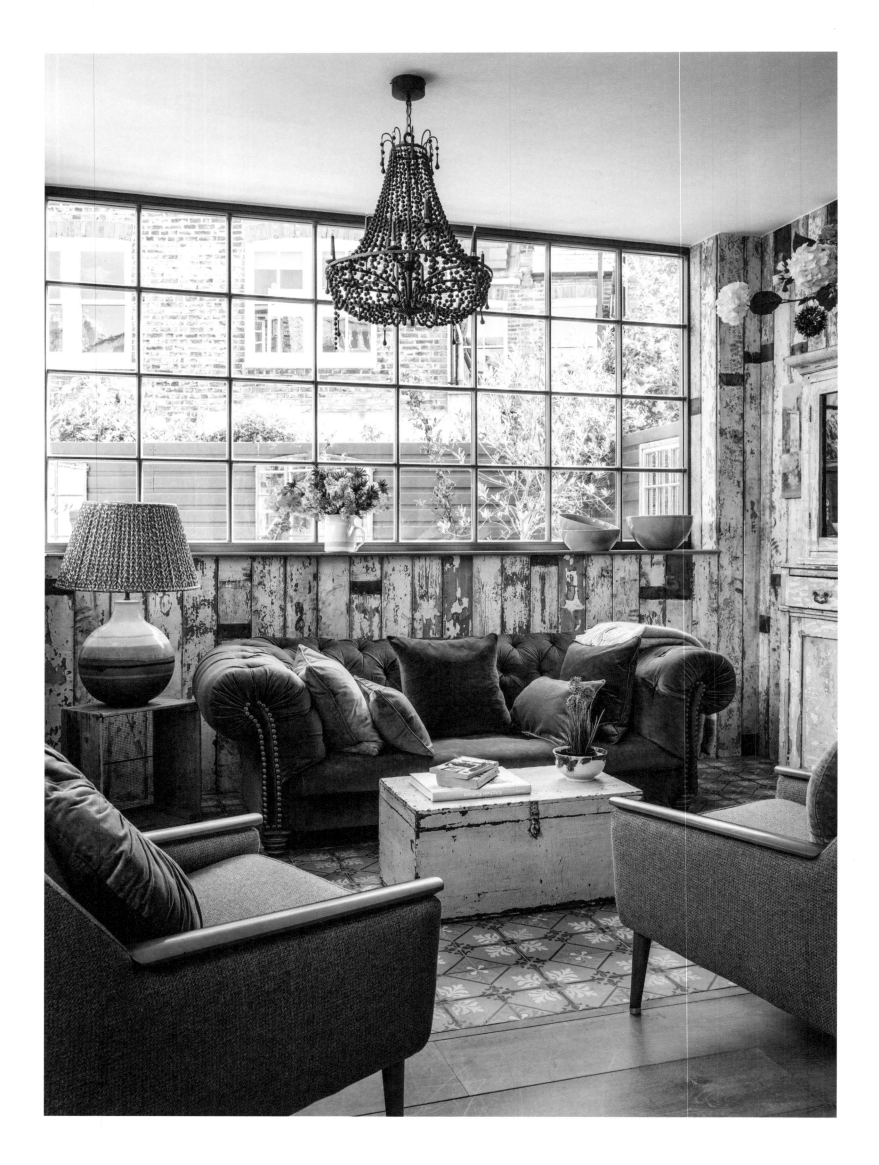

VINTAGE REVIVAL

Chiswick

With a passion for vintage items and design coupled with a healthy disregard for conventions, Bella Marshall has transformed a traditional London townhouse into a spacious, convivial family house imbued with a unique blend of beautiful pattern and style. When personal circumstances forced her to leave her job as a law lecturer, she turned her lifelong passion for interior design into a professional career. Whether working for clients or on her own home, she has a good nose for finding great pieces and loves a challenge. In this case, she solved the lack of space by adding an extra floor for bedrooms and installing beautiful French metal windows between the kitchen and the living room. With a family of four kids she needed to create a feel of light and openness without losing the quiet spaces and walls for her collection of art. Understated greys, soft shades and dark hues work as a well-curated colour backdrop giving her plenty of freedom to mix styles and splashes of teal, pink and mustard. Despite being furnished with a mismatch of mid-century vintage pieces, industrial lamps, wallpaper, tiles and textiles in many different patterns, French pieces and quirky objects like a turquoise beaded chandelier, it all comes together in a unified look.

Bella Marshall, deren Leidenschaft für den Vintage-Stil und Vintage-Objekte sich mit einer gesunden Gleichgültigkeit gegenüber Konventionen paart, hat dieses traditionelle Londoner Stadthaus in ein geräumiges, fröhliches Familienheim verwandelt, in dem Stil und Dekor auf wunderschöne Weise einzigartig miteinander verschmelzen. Als Marshall aufgrund persönlicher Umstände gezwungen war, ihre Stelle als Rechtsdozentin aufzugeben, machte sie ihre lebenslange Leidenschaft für Innenarchitektur zum Beruf. Ob für ihre Kunden oder für sich selbst, sie verfügt über eine gute Spürnase für das Auffinden großartiger Einrichtungsgegenstände und liebt die Herausforderung. Das Problem fehlenden Raums in ihrem eigenen Heim löste sie, indem sie eine zusätzliche Etage für die Schlafzimmer hinzufügte und ein prächtiges Atelierfenster zwischen Küche und Wohnzimmer einbauen ließ. Sie musste für ihre Familie, zu der vier Kinder zählen, einen hellen, offenen Raum schaffen, ohne dabei Wände und stille Ecken für ihre Kunstsammlung

einzubüßen. Unaufdringliche Grautöne, sanfte Farbschattierungen und dunkle Nuancen bilden einen durchdachten Farbhintergrund, der ihr viel Freiraum lässt, um Stile zu vermischen und Akzente in Blaugrün, Rosa und Senfgelb zu setzen. Obwohl sich die Einrichtung aus einem Mix aus Vintage-Objekten der Mitte des letzten Jahrhunderts, Industrielampen, Tapeten, Fliesen und Stoffen in vielen verschiedenen Mustern, französischen Möbelstücken und eigentümlichen Gegenständen wie einem Kronleuchter aus türkisfarbenen Perlen zusammensetzt, wirkt alles in sich harmonisch.

Passionnée par les objets vintage ou design, et dédaignant sainement les conventions, Bella Marshall a su transformer une traditionnelle maison de ville londonienne en un foyer familial spacieux et convivial, que caractérise un mélange unique de styles et de motifs superbes. Lorsque des raisons personnelles la contraignent à quitter son poste de maître de conférence en droit, elle entame une carrière dans l'architecture d'intérieur, sa passion de toujours. Qu'elle travaille pour des clients ou pour elle-même, Bella Marshall a du flair pour dénicher d'étonnants objets. Elle aime aussi relever les défis : ici, le manque de place qu'elle résoud en ajoutant un espace supplémentaire où sont disposées les chambres, ainsi qu'en installant de magnifiques portes-fenêtres métalliques entre la cuisine et le séjour. Afin d'accueillir sa famille, qui compte quatre enfants, il lui fallait créer une sensation de lumière et d'ouverture sans pour autant renoncer à préserver la tranquillité de certains espaces ou à consacrer les murs à sa collection d'oeuvres d'art. Les gris discrets, les ombres douces, les teintes sombres constituent un arrière-plan soigneusement pensé qui donne à Bella la possibilité de mélanger en toute liberté les styles, les pointes ici ou là de bleu sarcelle, de rose ou de jaune moutarde. S'il est hétéroclite, associant pièces vintage du milieu du XXème siècle ou lampes industrielles, papier peint, carrelage ou tissus aux motifs extrêmement variés, objets français ou bibelots étranges, à l'exemple de ce chandelier en perles bleu turquoise, l'agencement n'en forme pas moins un ensemble harmonieux.

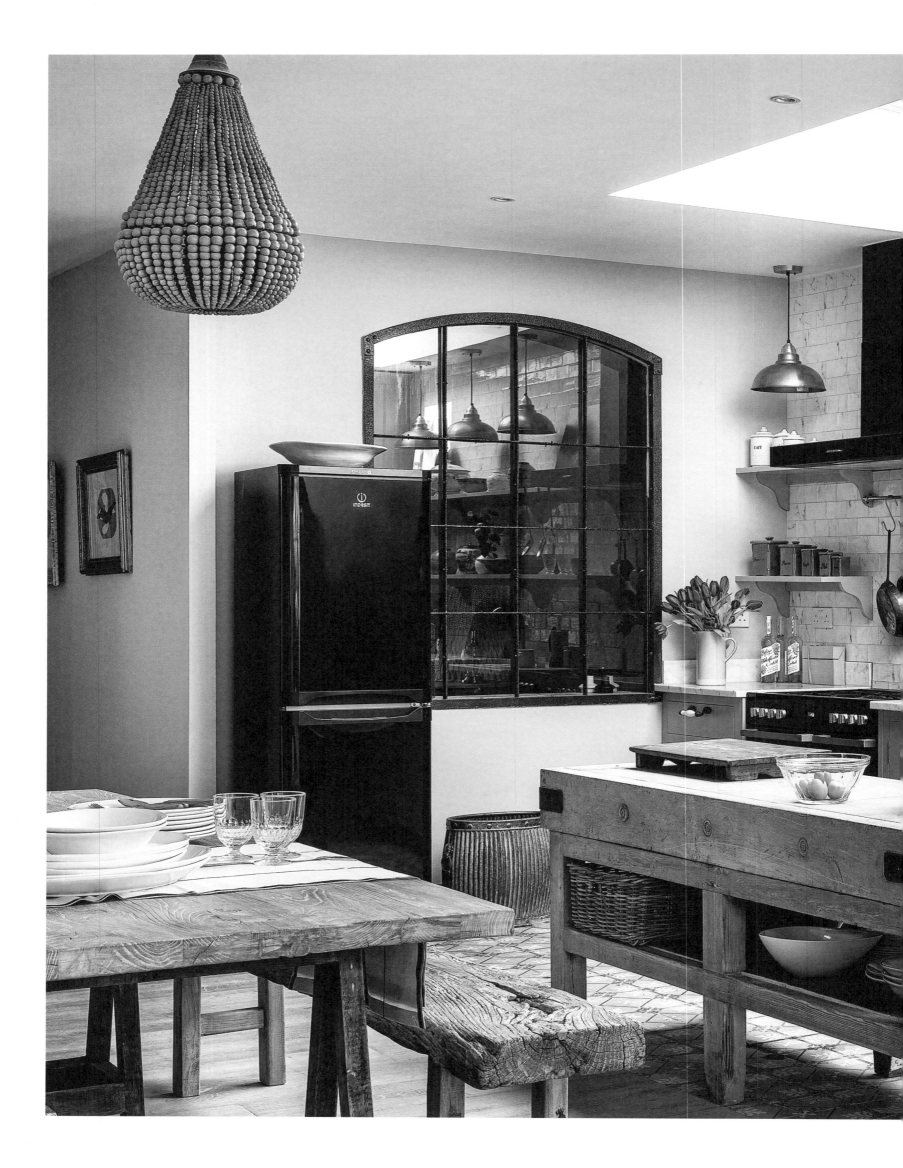

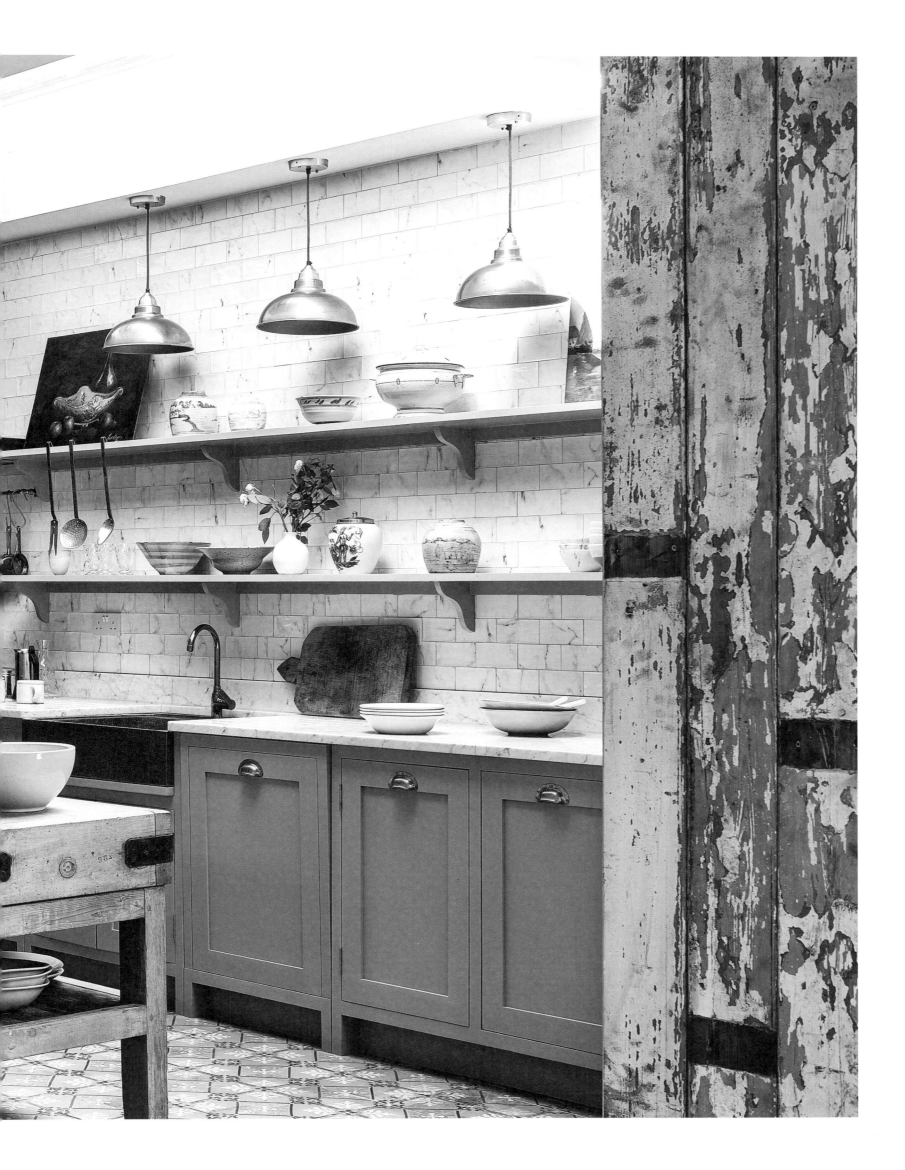

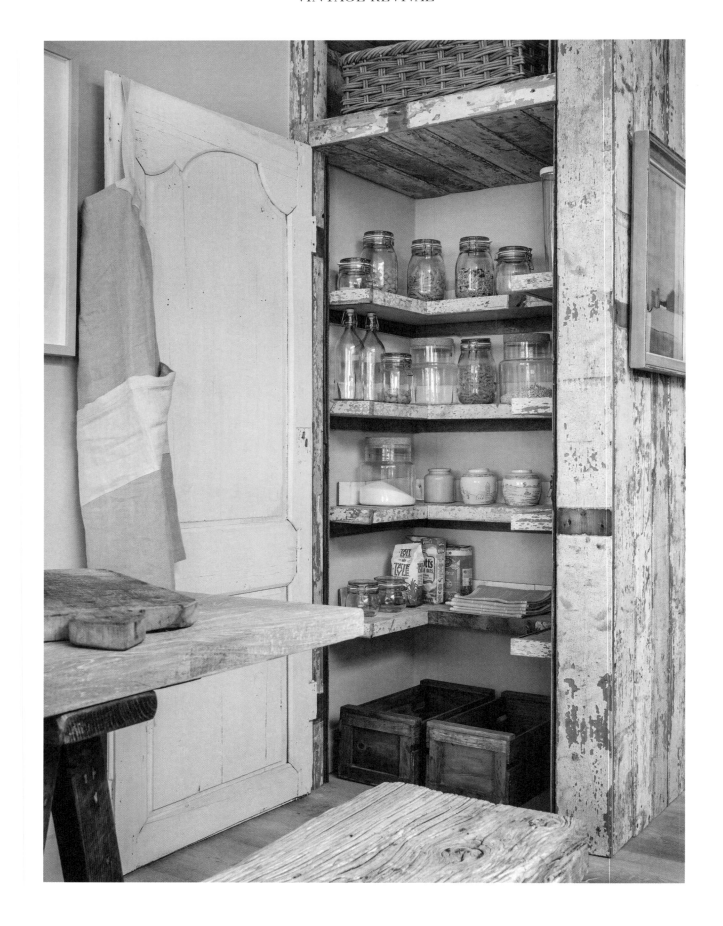

FRENCH FARM KITCHEN meets industrial chic in the kitchen. Behind an old door and the whitewashed wooden wall is a charming food pantry stocked with Mason jars.

IN DER KÜCHE trifft französischer Landhausstil auf Industrie-Chic. Hinter einer alten Tür und einer geweißten Holzwand befindet sich eine bezaubernde, mit Einmachgläsern gefüllte Vorratskammer.

RENCONTRE DU STYLE rustique et du chic industriel dans la cuisine. Derrière
une porte ancienne et un mur en bois chaulé se trouve un charmant cellier où
sont rangés des bocaux de conserve.

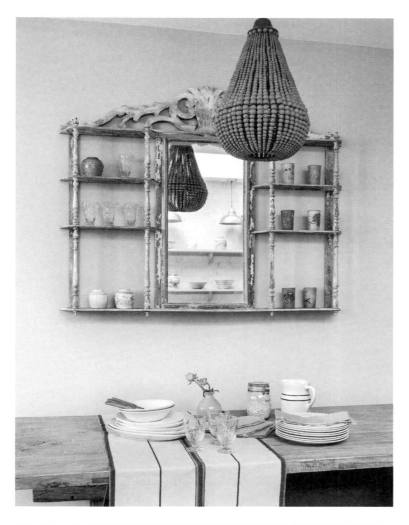

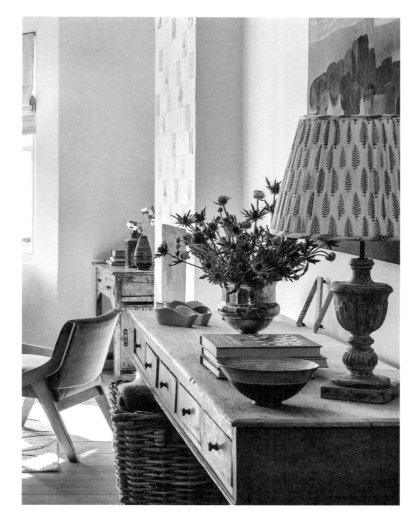

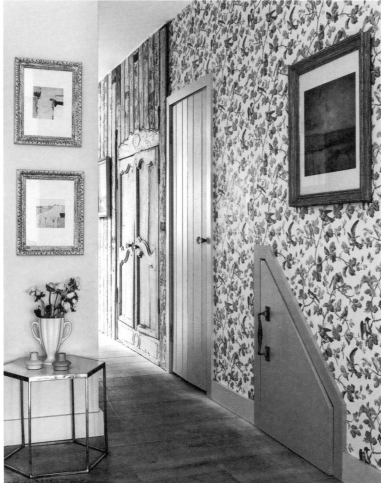

THE HALLWAY IS the perfect mix of romantic and practical space. Every inch is used, with clever solutions. The pair of French armoire painted doors conceals the washer and dryer, and the cloakroom is hidden behind the slatted doors with Cole & Son wallpaper.

DER FLUR STELLT eine perfekte Mischung aus romantischem und zweck-mäßigem Raum dar, in dem jeder einzelne Zentimeter durch clevere Lösungen optimal genutzt wird. Hinter den lackierten Flügeltüren eines fran-zösischen Schranks verbergen sich Waschmaschine und Trockner, und die Garderobe hat ihren Platz hinter der in Tapeten von Cole & Son eingefassten Lamellentür gefunden.

ASSOCIANT À LA perfection romantisme et pragmatisme, le couloir a été habi-lement exploité dans ses moindres recoins. Les portes d'armoire dissimulent un lave-linge et un sèche-linge, cependant que la porte à claire-voie entourée de papier peint Cole & Son donne sur les toilettes.

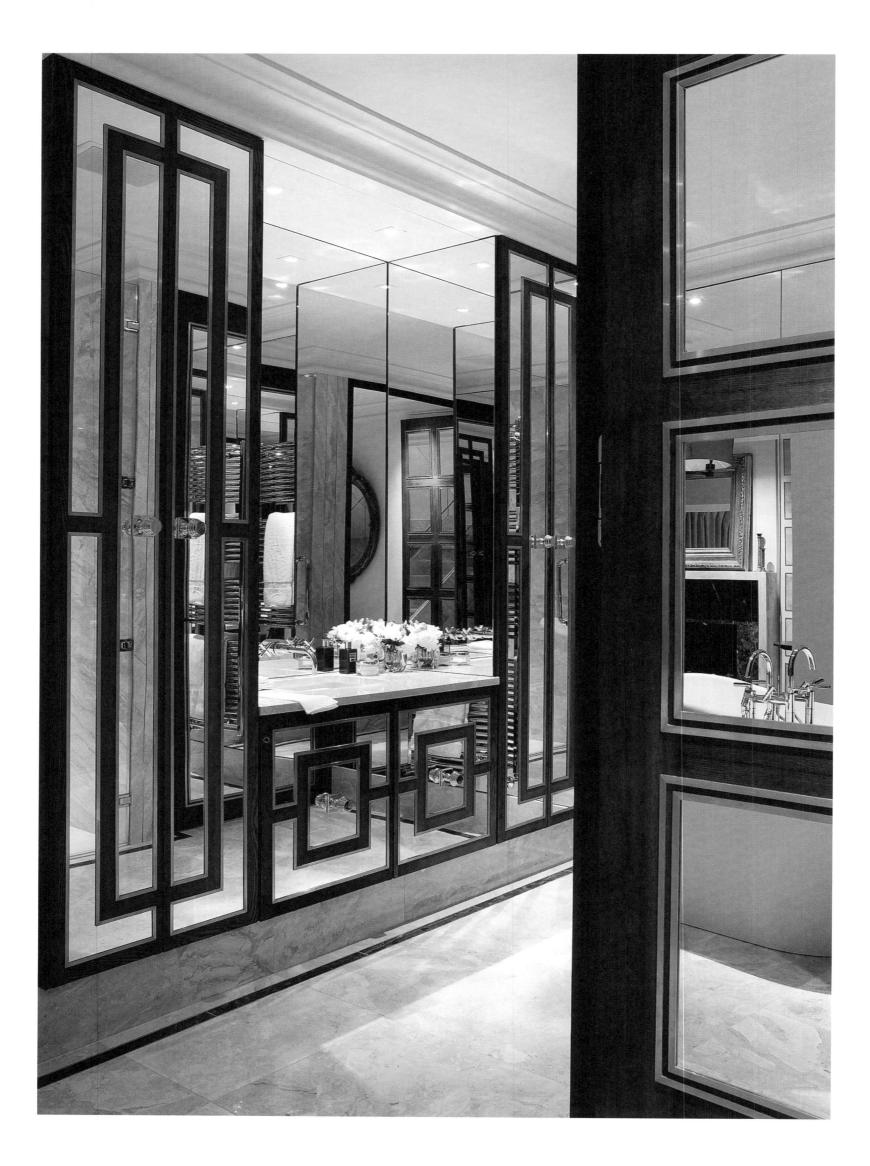

HOLLYWOOD GLAMOUR
Chelsea

Some homes have that perfect touch of glitz and glamour that makes people want to look good, wear a bespoke suit and sip a chilled cocktail. Interior designer Birgit Israel created exactly that ambience when she was given free rein to renovate and style two separate apartments, joined together into one 2,475-square foot space in London's affluent Chelsea district. Taking inspiration from the heyday of 1930s Hollywood Regency, she emphasizes this style by using elegant glossy surfaces, mirrors, velvet, marble and bespoke solutions and outstanding materials to convey luxury down to the last detail. Many of the furnishing pieces are true collector's items, sourced in and shipped from Miami. The extensive renovation took about one year, resulting in a home that is decidedly unique. Apart from adding a few carefully selected objects and antiques, Birgit Israel's studio handcrafted the entire kitchen, and created built-in units in both bedrooms and bathrooms to fit the spaces perfectly. The bedroom and en suite bathroom are reminiscent of a luxury hotel suite with soft-hued marble floors, shiny brass details and glossy lacquer finishes. This kind of opulent and elegant design can be found everywhere in the apartment and is complemented by muted colours for an overall masculine look. Like a contemporary movie about Hollywood's Golden Age, this timeless home combines both old and new.

Einige Häuser strahlen einen so perfekten Glanz und Glamour aus, dass die Menschen gut aussehen, einen maßgeschneiderten Anzug tragen und einen kühlen Cocktail trinken wollen. Als man der Innenarchitektin Birgit Israel freie Hand ließ, zwei getrennte und zu einem 230 Quadratmeter großen Wohnraum zusammengefügte Apartments in Londons wohlhabendem Stadtteil Chelsea zu renovieren und zu gestalten, schuf sie genau jenes Ambiente. Inspiriert von Hollywoods Glanzzeit der 1930er-Jahre, unterstreicht sie diesen Stil, indem sie elegante, glatte Oberflächen, Spiegel, Samt, Marmor, maßgeschneiderte Lösungen und herausragende Materialien einsetzt, um bis ins letzte Detail Luxus zu vermitteln. Viele der Einrichtungsgegenstände sind echte Sammlerstücke, die aus Miami stammen und von dort verschifft wurden. Die umfangreiche Renovierung dauerte ungefähr ein Jahr und fand ihre Vollendung in einem Haus, das durch seine Einzigartigkeit besticht. Neben einigen, von Birgit Israel sorgfältig ausgesuchten Objekten und Antiquitäten, hat ihr eigenes

Designstudio die gesamte Küche gefertigt und Schränke in beiden Schlaf- und Badezimmern eingebaut, sodass die Räume perfekt genutzt sind. Das Schlafzimmer und anschließende Bad erinnern mit ihren sanften Marmorböden, schimmernden Messingelementen und glänzenden, lackierten Oberflächen an ein Luxushotel. Dieses opulente und elegante Design durchzieht die gesamte Wohnung und wird durch gedeckte Farben ergänzt, die den Räumen eine maskuline Note verleihen. Ein zeitloses Heim, das wie ein heutiger Film über Hollywoods goldene Ära Alt und Neu verbindet.

Certaines demeures présentent cette extravagance et ce glamour parfaitement dosés qui donnent envie de revêtir une splendide tenue faite sur mesure et de siroter un cocktail glacé. Telle est l'atmosphère que l'architecte d'intérieur, Birgit Israel, a su très exactement reconstituer lorsqu'elle a reçu carte blanche pour rénover avec style, dans le quartier chic de Chelsea, deux appartements réunis pour former un espace de 230 mètres carrés. La décoratrice s'est inspirée de la grande époque du style « Hollywood Regency », dans les années 1930, auquel renvoient avec élégance les surfaces brillantes, les miroirs, les velours ou le marbre, cependant que les solutions adaptées ou les matériaux d'exception utilisés distillent une sensation de luxe jusque dans les moindres détails. Véritables pièces de collection, nombre de meubles ont été dénichés à Miami d'où ils ont été envoyés. S'étalant sur une année, la longue rénovation a abouti à une demeure résolument unique. L'équipe de Birgit Israel a non seulement choisi avec soin certains objets ou meubles anciens, mais encore, entièrement conçu la cuisine et dessiné les éléments encastrés des deux chambres et salles de bain, de sorte à ce qu'ils s'insèrent parfaitement dans l'espace. Avec leur sol en marbre doux, leurs détails en laiton étincelant et leur finition en laque brillante, la chambre et sa salle de bain ne sont pas sans évoquer la suite d'un hôtel de luxe. Présente dans tout l'appartement, cette opulente élégance s'accompagne de teintes sourdes évoquant une atmosphère masculine. A l'image d'un film contemporain sur l'Age d'Or hollywoodien, cette demeure intemporelle associe l'ancien au nouveau.

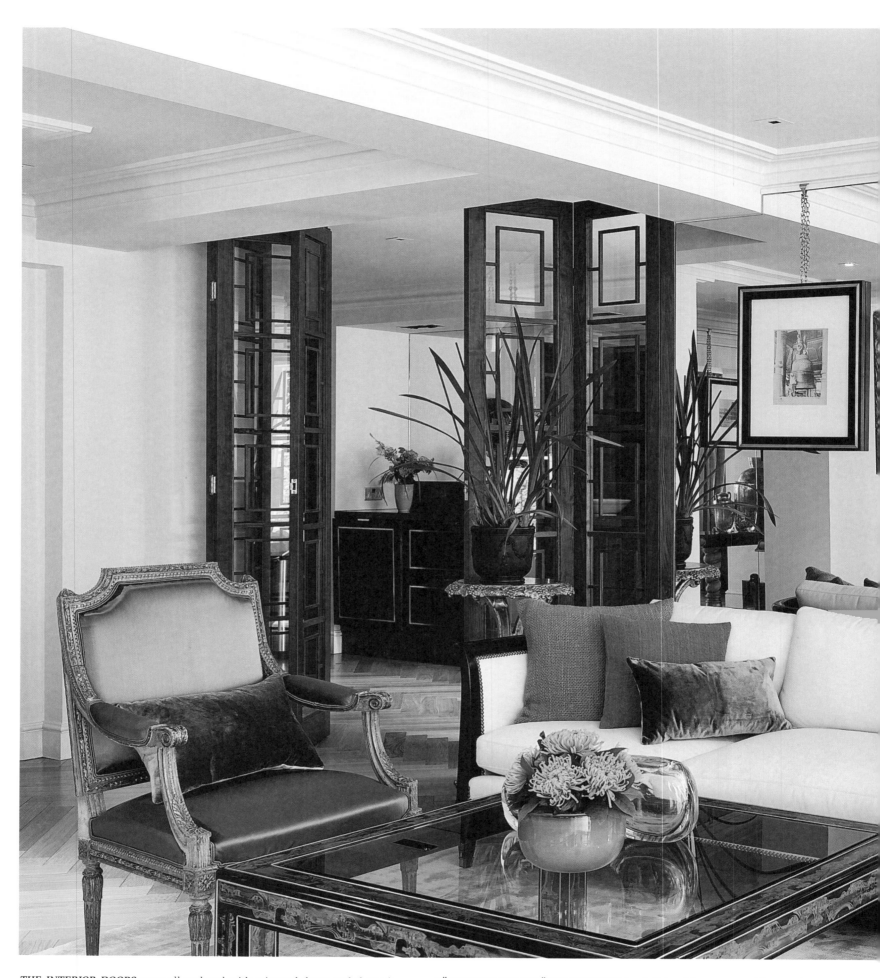

THE INTERIOR DOORS were all replaced with mirrored doors and through-out the mirrors reflect the light and create the illusion of more space. In the living room, the mirrored wall is decorated with early travel photographs. The neo-classical sofa and the Masterworks table were sourced in the USA.

SÄMTLICHE INNENTÜREN WURDEN durch Spiegeltüren ersetzt. Die verspiegelten Flächen reflektieren das Licht und schaffen so die Illusion eines größeren Raums. Frühe Reisefotografien zieren die Spiegelwand im Wohnzimmer. Das neoklassizistische Sofa und der Masterworks-Tisch stammen aus den USA.

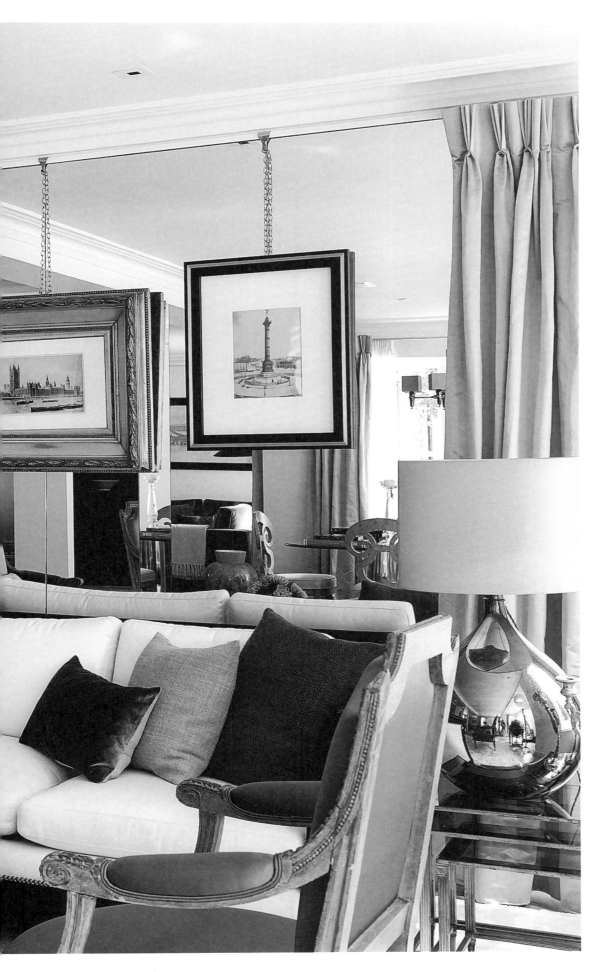

LES PORTES INTÉRIEURES ont été remplacées et pourvues de glaces, cependant que les miroirs installés un peu partout renvoient la lumière et créent l'illusion d'un espace plus vaste. Dans le salon, le mur formé d'une glace est orné d'anciennes photographies de voyage. Le canapé de style néo-classique et la table de chez Masterworks ont été dénichés aux Etats-Unis.

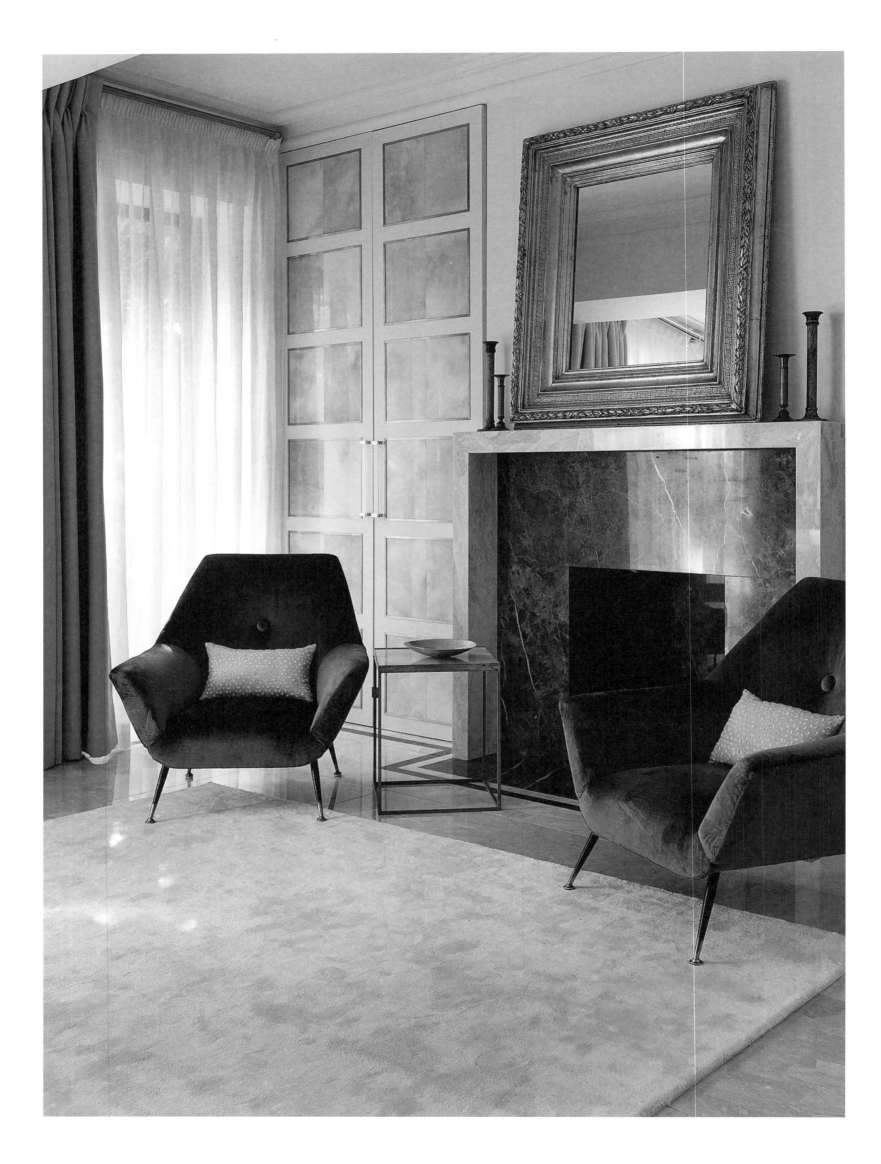

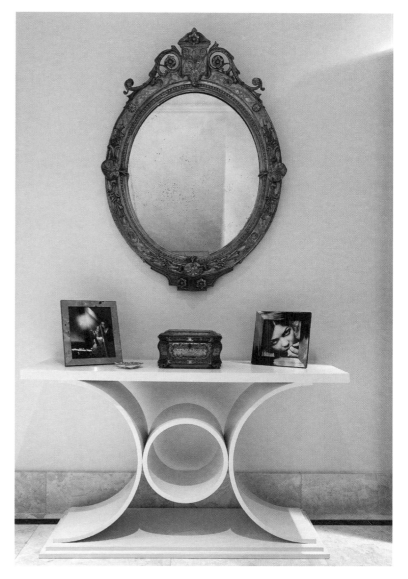

MATERIALS AND CONCEPTS are exquisite in this house – from the stained ash kitchen units with brass trims to the master bedroom with 1950s Italian chairs, silk curtains and cabinet doors with lacquered brass inlay. Designer Birgit Israel infused the rooms with a rich blend of muted colours and textures such as herringbone textiles, oak floors, velvets and silks.

MATERIALIEN UND KONZEPTE sind in diesem Haus auserlesen – von den Küchenschränken aus gebeizter Esche mit Messingbesatz bis hin zum Schlafzimmer mit italienischen Sesseln aus den 1950er-Jahren, Seidenvorhängen und Schranktüren, versiegelt mit Klavierlack und veredelt mit messingumrandeten Intarsien. Die von Designerin Birgit Israel ausgestatteten Räume erstrahlen in einer prächtigen Mischung aus gedeckten Farben und Strukturen, wie zum Beispiel Stoffen in Fischgrätmuster, Samt, Seide und Eichenböden.

DES MATÉRIAUX À la conception, tout évoque le raffinement dans cette demeure – depuis les éléments de cuisine en frêne teinté, avec leur encadrement en laiton, jusqu'à la chambre principale, avec ses chaises italiennes des années 1950, ses rideaux en soie et ses portes d'armoire avec incrustations de laiton recouvertes de laque pour piano. Dans chaque pièce, la décoratrice, Birgit Israel, a choisi de recourir à un opulent mélange de couleurs discrètes et de textures associant les tissus à chevrons aux parquets en chêne, aux velours et à la soie.

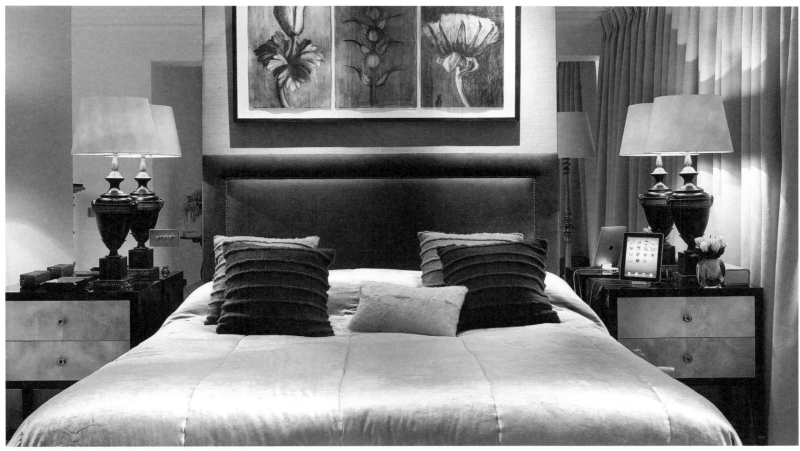

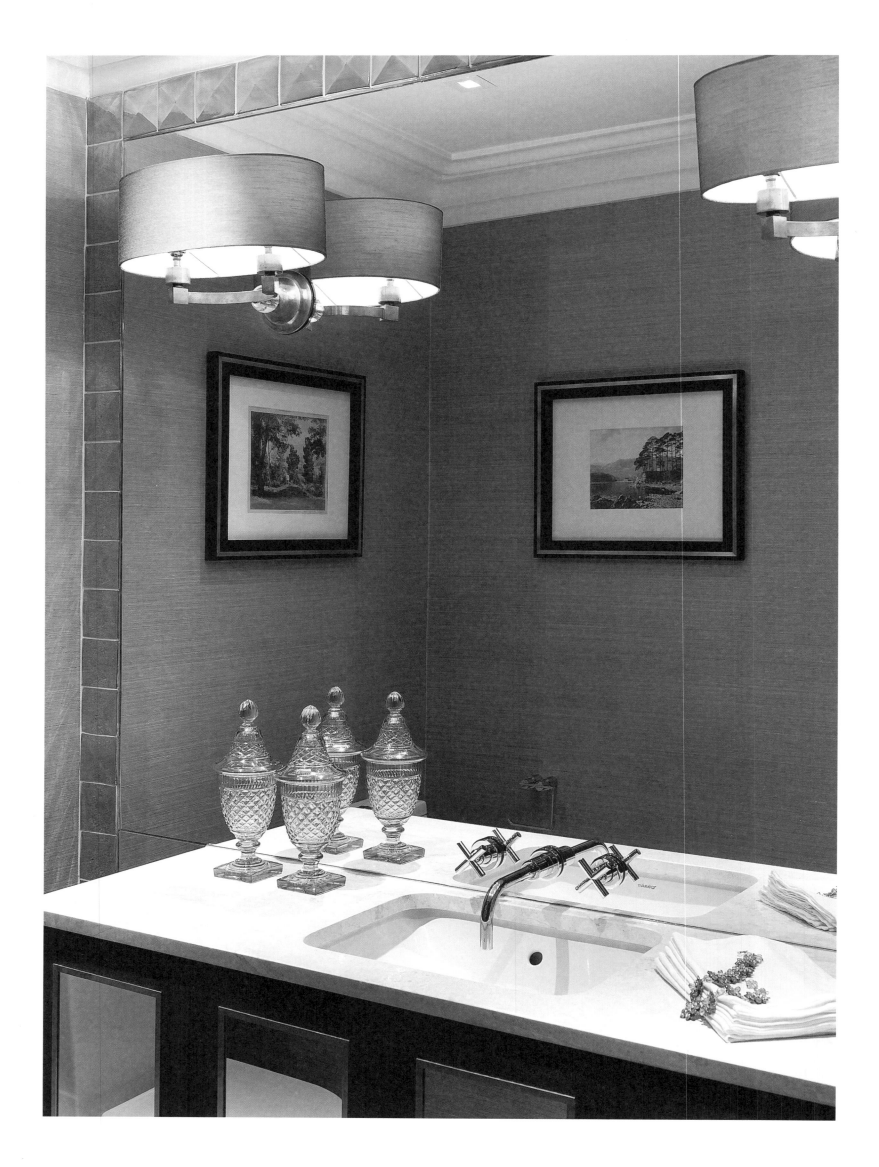

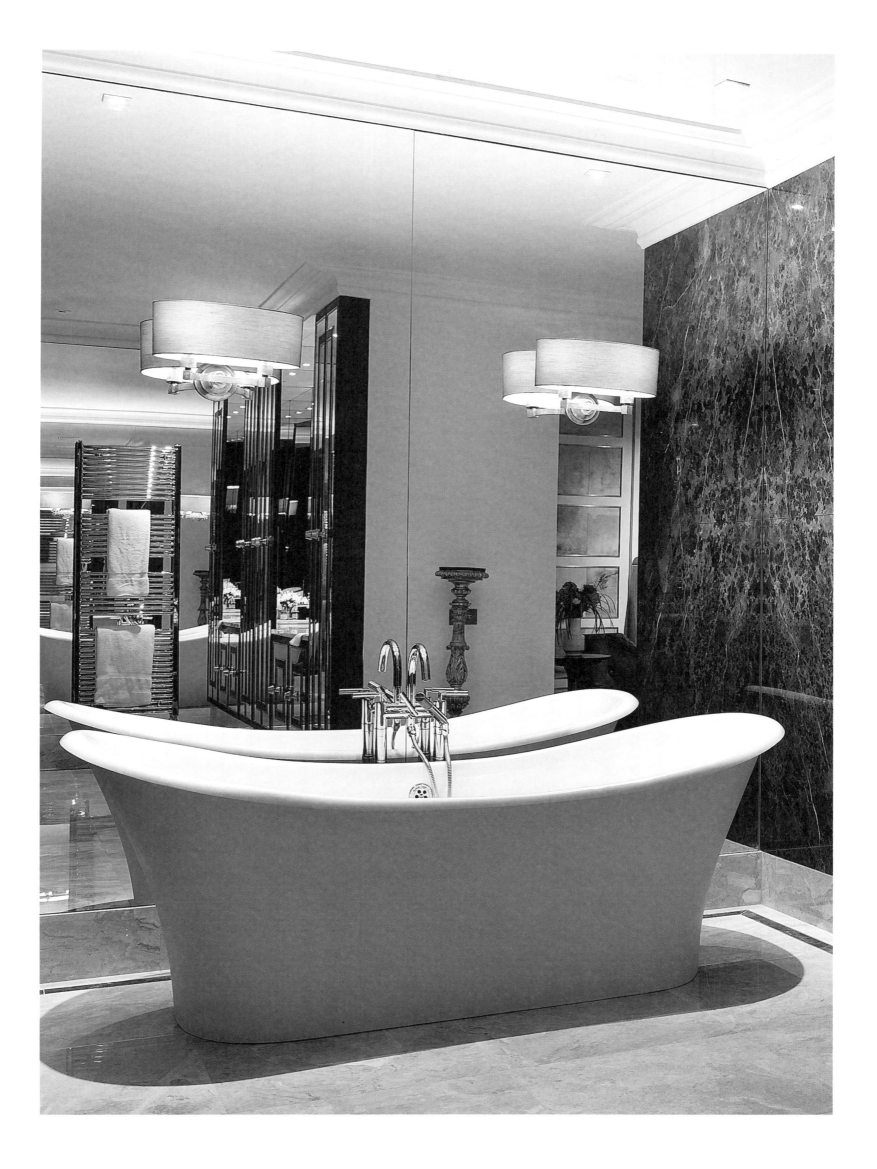

ARTY VIBE

Notting Hill

Fun, colour and art were key elements in the total renovation of this mid-nineteenth century family home in London's picturesque Notting Hill. Whilst the location, backing on to one of London's most beautiful private garden squares, was highly desirable, the condition of the Grade II listed house – converted into several apartments – made it necessary to almost completely rebuild the property. The owner teamed up with interior designer Scott Maddux, who worked closely with Make Architects and completely transformed this corner building into a gorgeous home. The unusual layout with bay windows and curves at every turn, and an original elliptical staircase, which rises gracefully from the ground floor, were emphasised. These period features were balanced with strong contemporary elements such as the bronze spiral staircase, which provides access to the basement. The interior designer brought to life a very individual style with colourful art, highly unusual vintage pieces and bespoke solutions. To complement the soft London light, all walls are painted in a subtle dove grey with the woodwork in a slightly darker shade created by expert colourist Patrick Baty. The neutral background gives the place a sense of continuity. Each room has a statement piece of furniture or art. In the living room, a large, curved sofa, custom designed by Vladimir Kagan, swirls like a gigantic comma as a cheerful and stylish statement.

Vergnügen, Farbe und Kunst stellten die Schlüsselelemente dar, als dieses aus der Mitte des 19. Jahrhunderts stammende, im malerischen Stadtteil Notting Hill gelegene Familienhaus komplett renoviert wurde. Während die Lage der Immobilie äußerst erstrebenswert war, denn sie grenzt an eine der schönsten privaten Gartenanlagen Londons, befand sich das denkmalgeschützte Haus – aufgeteilt in mehrere Wohneinheiten – in einem Zustand, der eine fast vollständige Erneuerung notwendig machte. Der Eigentümer beauftragte den Innenarchitekten Scott Maddux (Maddux Creative), der eng mit Make Architects zusammenarbeitete. Er baute das Eckhaus völlig um und verwandelte es in ein prachtvolles Heim. Der ungewöhnliche Grundriss mit Erkerfenstern und Bögen an jeder Ecke und einer elliptisch geformten, eleganten, originalen Treppe, die vom Erdgeschoss nach oben führt, wurde hervorgehoben. Jene aus der ursprünglichen Epoche stammenden besonderen Elemente wurden durch starke, zeitgenössische Komponenten ausgeglichen, wie der bronzenen

Wendeltreppe, über die man in das Untergeschoss gelangt. Der Innenarchitekt verwirklichte einen sehr individuellen Stil mit farbenprächtiger Kunst, äußerst ungewöhnlichen Vintage-Objekten und maßgeschneiderten Lösungen. Um das sanfte Londoner Licht abzurunden, wurden sämtliche Wände in einem dezenten Taubengrau gestrichen, während die Holzarbeiten einen leicht dunkleren Ton erhielten. Die farbliche Gestaltung übernahm der Farbexperte Patrick Baty. Der neutrale Hintergrund verleiht dem Ort Kontinuität. Jeder Raum hebt sich durch ein Möbelstück oder ein Kunstwerk ab. Im Wohnzimmer ist es ein großes, geschwungenes, maßgeschneidertes Sofa von Vladimir Kagan, das sich wie ein gigantisches Komma stilvoll in den Raum schmiegt.

Le jeu, la couleur et l'art sont les éléments-clés de la rénovation totale de cette demeure familiale du milieu du XIXème siècle, dans le pittoresque quartier de Notting Hill à Londres. Si l'emplacement, adossé à l'un des plus beaux squares privés londoniens, se révèle attractif, l'état de la maison, classée monument d'intérêt spécial (Grade II) et convertie en appartements, nécessite en revanche une reconstruction quasi-complète. Le propriétaire fait alors équipe avec l'architecte d'intérieur Scott Maddux, lequel travaille en étroite collaboration avec Make Architects pour transformer radicalement cette maison d'angle en une demeure superbe. Peu commun, avec ses fenêtres en saillie et ses courbes omniprésentes, l'agencement, ainsi que l'escalier elliptique d'origine qui s'élève gracieusement depuis le rez-de-chaussée, sont mis en valeur. De forts éléments contemporains, à l'exemple de l'escalier de bronze en spirale qui permet d'accéder au sous-sol, viennent équilibrer ces particularités historiques. Oeuvres d'art colorées, pièces rétro très singulières et solutions sur mesure caractérisent le style extrêmement personnel mis en oeuvre par l'architecte d'intérieur. S'harmonisant avec la lumière douce de Londres, un subtil gris tourterelle recouvre l'ensemble des murs, cependant qu'une teinte légèrement plus sombre créée par l'expert coloriste Patrick Baty a été choisie pour les menuiseries. La neutralité du fond imprime aux lieux une sensation de continuité. Chaque pièce possède son meuble ou son objet d'exception, à l'exemple du vaste canapé sur mesure du salon, conçu par Vladimir Kagan, et qui s'incurve à la manière d'une immense virgule, à l'élégance joyeuse.

5

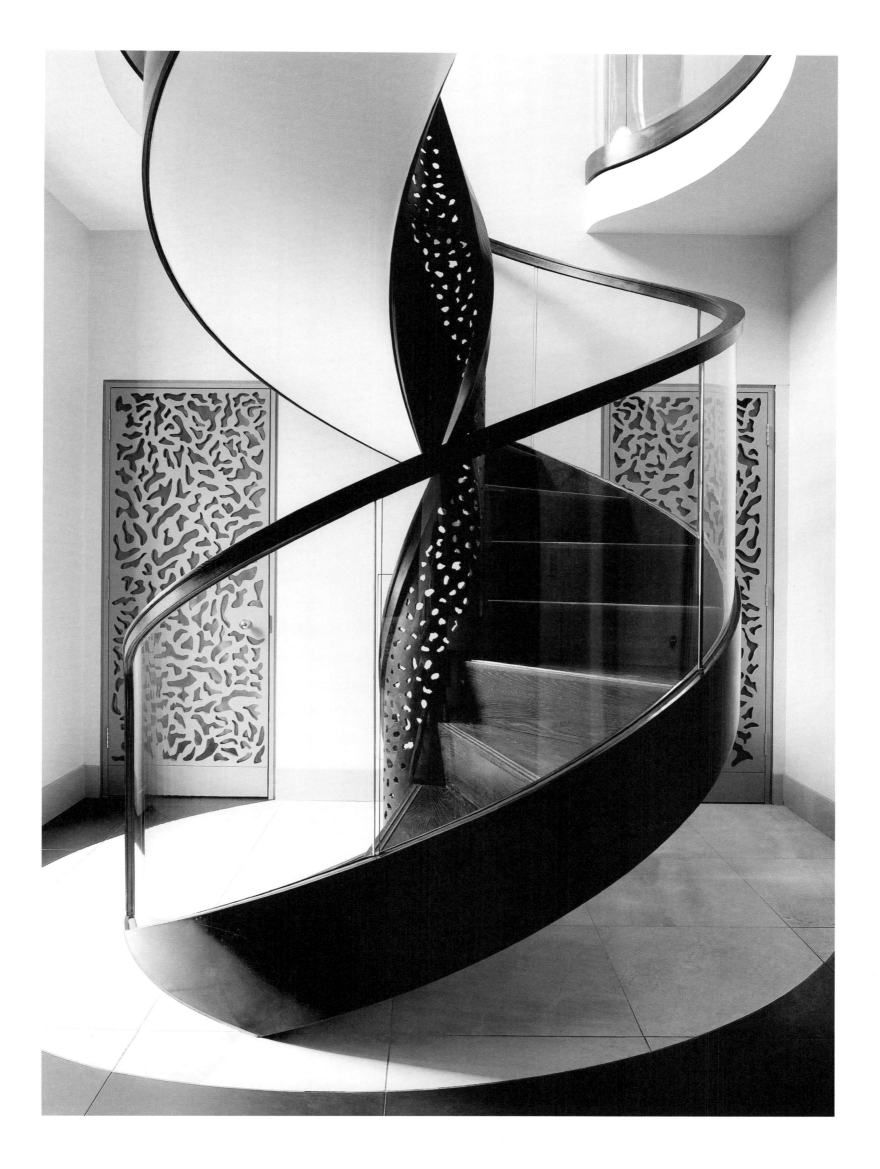

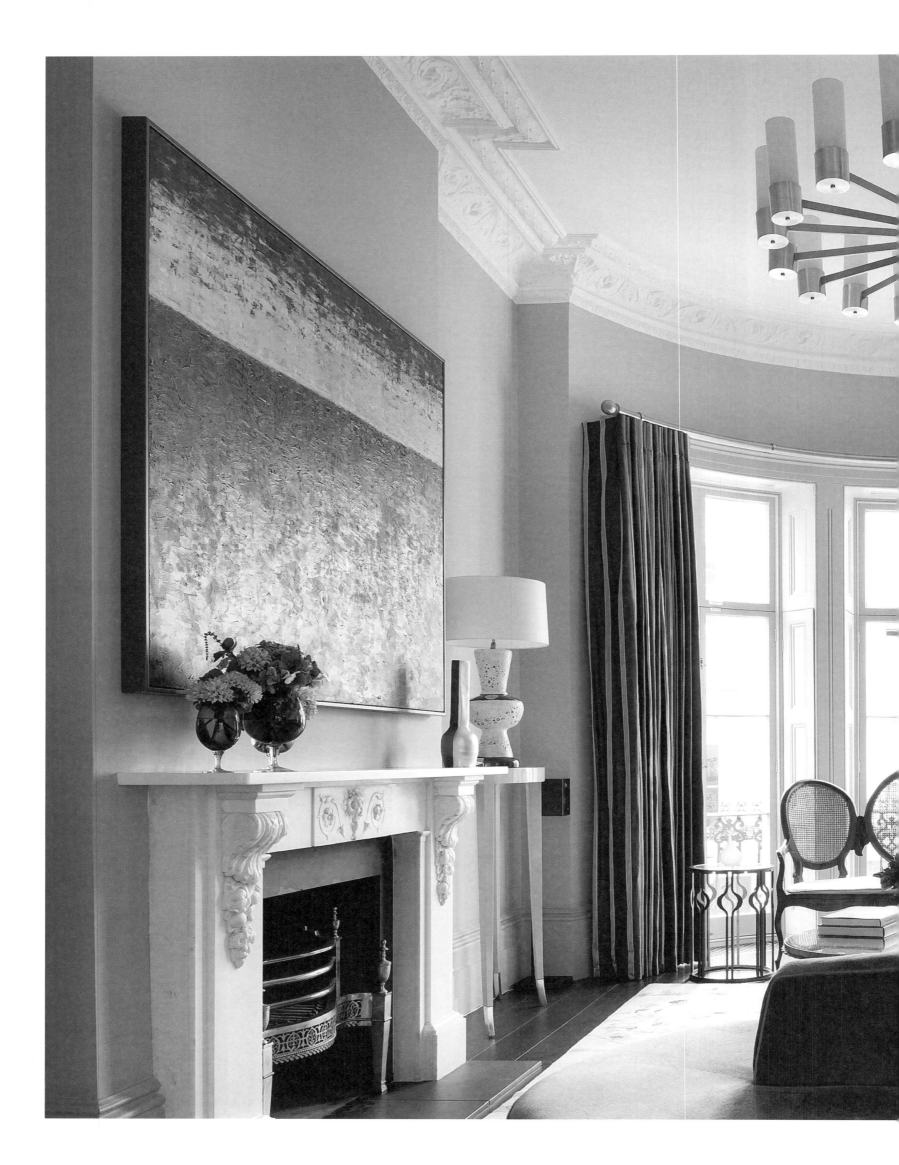

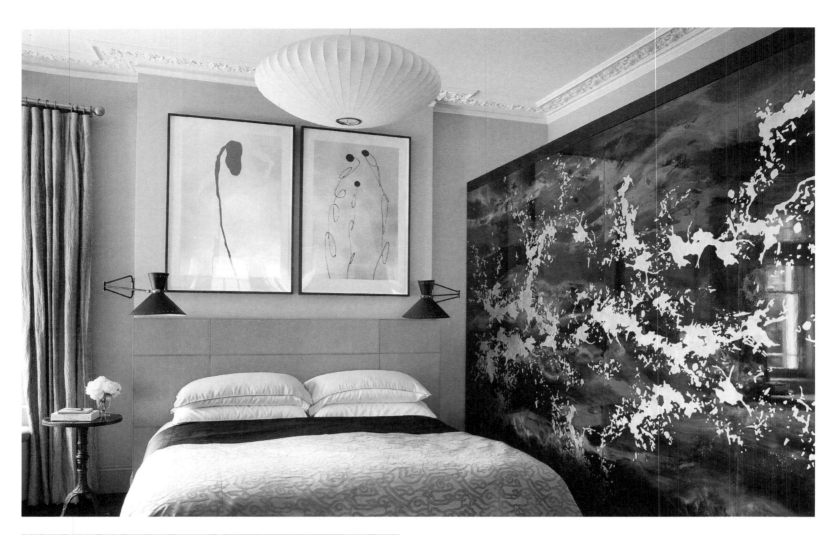

THE PERIOD PROPORTIONS of the room were left intact in the bedroom facing the lush garden. A bank of flat-fronted wardrobes runs the length of one wall, providing storage as well as the 'wow' factor. The surface is an abstract vision of purple, silver and copper, with a lacquered gloss finish. The curved forms on the original staircase have inspired the elegant lines in the living room.

DIE URSPRÜNGLICHEN MASSE des als Schlafzimmer dienenden Raums, der auf den üppigen Garten blickt, blieben unverändert. Ein Kleiderschrank mit glatter Front erstreckt sich über eine Wand und liefert sowohl Stauraum als auch einen „Wow"-Faktor. Die Oberfläche, eine abstrakte Darstellung aus Lila, Silber und Gold, ist mit einem glänzenden Lack überzogen. Die geschwungene Form der ursprünglichen Treppe diente als Inspiration für die eleganten Linien im Wohnzimmer.

LES PROPORTIONS ORIGINELLES de la chambre donnant sur le luxuriant jardin, ont été conservées. La penderie qui court le long de l'un des murs, non seulement, offre un espace de rangement, mais encore, suscite l'admiration avec ses panneaux plats, ornés d'un décor abstrait violet, argent et cuivre recouvert d'une laque brillante. La forme incurvée de l'escalier original a inspiré les élégantes lignes du salon.

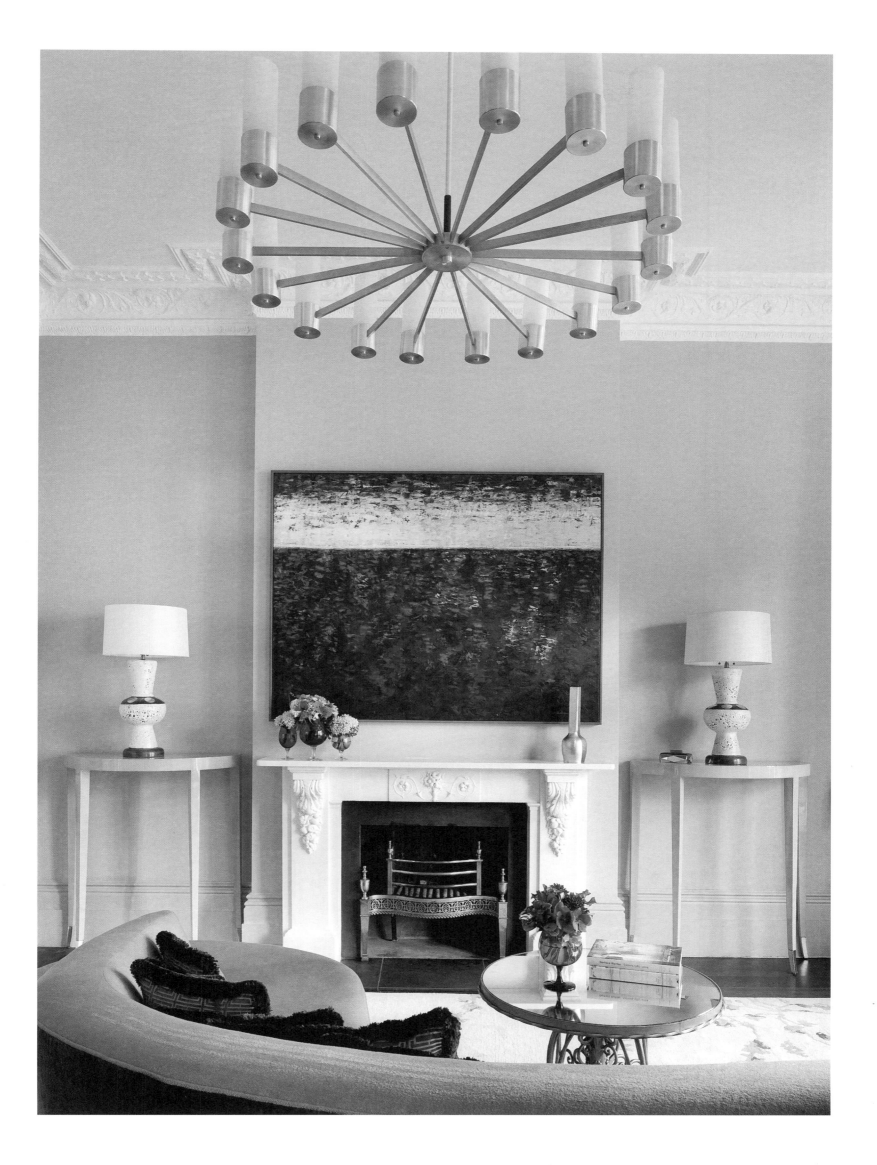

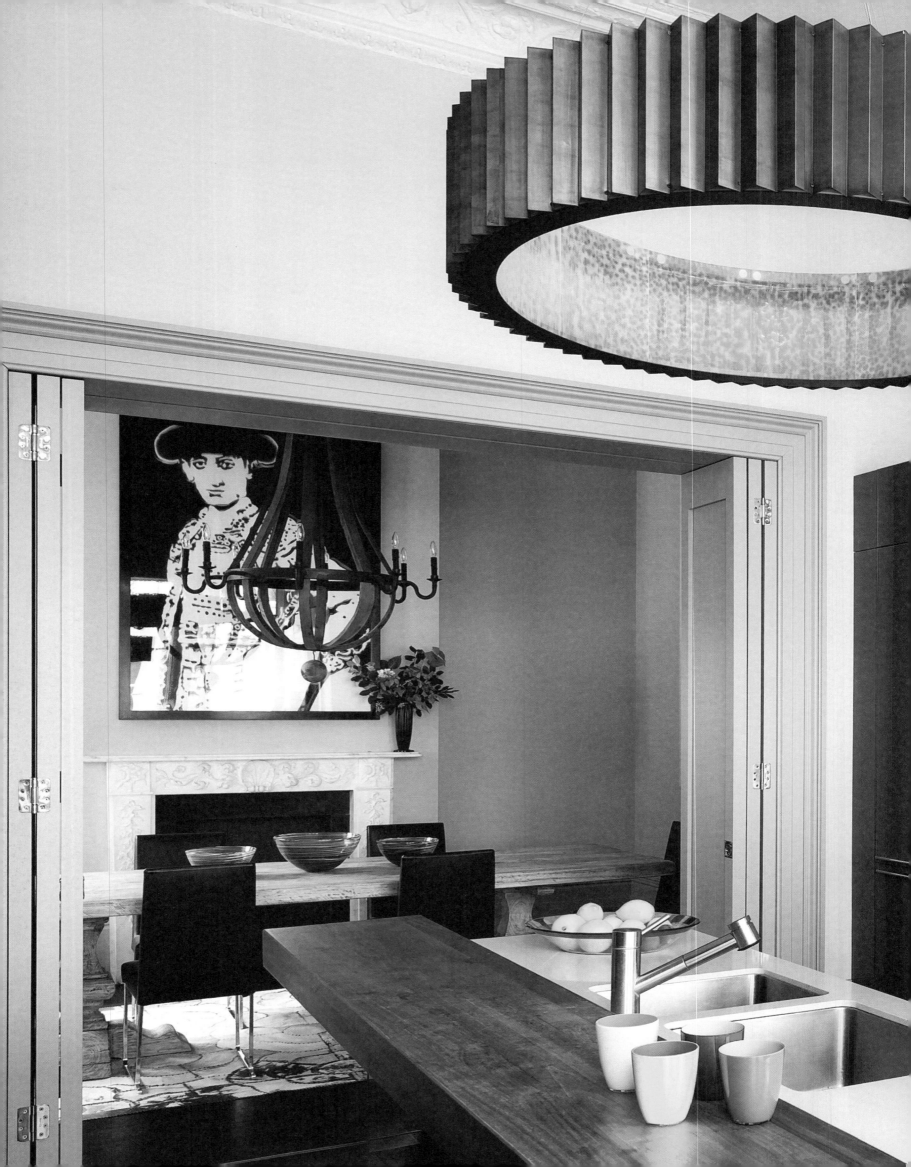

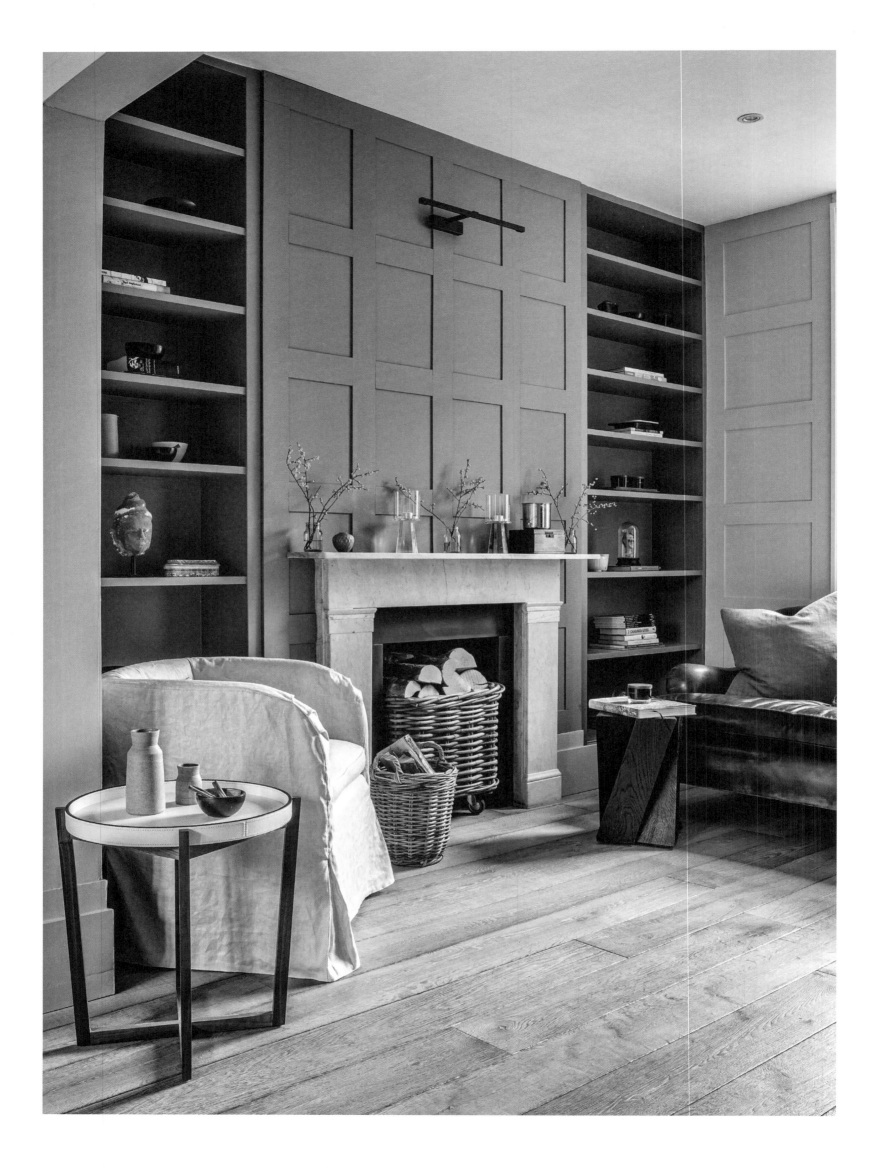

TOWNHOUSE GLORY

Clapham

Located in a neighbourhood with a small-town ambience, this sophisticated Clapham townhouse is a perfectly proportioned, peaceful and creative place to live. The 1860s Victorian terrace has been refurbished extensively. The original layout with smaller rooms has been changed to form more open spaces. The ground floor laundry room, cloak room, a small study on the first floor and a second bathroom above are all later additions. Every detail in the 2,000-square-foot house has been replaced with exceptional quality infrastructure and fittings – the kitchen is a bespoke Martin Moore with the Rolls-Royce of stoves, a Lacanche cooker. The most striking part about this home is the light and effortlessly personal, yet elegant style with beautiful wooden panels painted in neutral greys, glazed interior doors and huge original windows. The wooden floors have a subtle raised grain as if washed for decades with soap and water and the stone floors, once covered by carpets, have just the right colour and patina. This house feels clean and crisp, almost soothing, especially in the bedroom and bathroom, where painted Gustavian chairs and chests add a hint of Scandinavian cosiness. Creating a serene space is the signature style of interior stylist, author and homeware designer Cassandra Ellis, who has consulted here.

Dieses perfekt proportionierte Stadthaus in Clapham, in einer Gegend mit Kleinstadtcharakter gelegen, ist ein ruhiger und kreativer Wohnort. Das aus den 1860er-Jahren stammende Reihenhaus wurde umfangreich renoviert. Der ursprüngliche Grundriss mit kleineren Zimmern wurde geändert, um offenere Räume zu schaffen. Der Hauswirtschaftsraum und die Garderobe im Erdgeschoss, ein kleines Arbeitszimmer im ersten Stock und ein zweites Bad in dem darüber gelegenen Stockwerk wurden allesamt später hinzugefügt. Jedes einzelne Detail in diesem 185 Quadratmeter großen Haus wurde durch qualitativ hochwertige Einbauten ersetzt – die Küche, ausgestattet mit dem Rolls-Royce der Herde, einem Lacanche, ist maßgefertigt und stammt von Martin Moore. Das hervorstechende Merkmal dieses Hauses ist der leichte, ungezwungene, persönliche, aber dennoch elegante Stil, der sich in einer wunderschönen Holzverkleidung, gestrichen in neutralem Grau, verglasten Innentüren und

6

riesigen Originalfenstern offenbart. Die Maserung der Holzböden ist erhaben, als wären sie schon jahrzehntelang mit Seife und Wasser geschrubbt worden, während Farbe und Patina der früher mit Teppichen ausgelegten Steinböden genau den richtigen Ton haben. Das Haus fühlt sich frisch und rein an, fast beruhigend – besonders im Schlaf- und Badezimmer, wo gestrichene gustavianische Stühle und Kommoden einen Hauch skandinavischer Gemütlichkeit vermitteln. Das Schaffen ruhiger Räume ist typisch für den Stil von Cassandra Ellis, Innenarchitektin, Autorin und Designerin für Haushaltswaren, die hier beratend zur Seite stand.

Située dans un quartier à l'atmosphère provinciale, cette résidence raffinée de Clapham offre un espace de vie aux proportions parfaites, aussi serein qu'imaginatif. Datant des années 1860, cette maison mitoyenne de style victorien a été en grande partie rénovée. Les petites pièces qui caractérisaient l'agencement initial ont été transformées de sorte à constituer des zones plus ouvertes. La buanderie et la garde-robe du rez-de-chaussée, le petit bureau du premier étage et la seconde salle de bain, au-dessus, sont des ajouts ultérieurs. Une infrastructure et des équipements de haute qualité ont remplacé les installations de cette demeure de 180 mètres carrés – ainsi de la cuisine, une Martin Moore réalisée sur mesure et pourvue de la Rolls-Royce des cuisinières, de la marque Lacanche. Avec ses splendides panneaux de bois peint dans des gris neutres, ses portes intérieures vernies ou ses immenses fenêtres d'origine, le style lumineux, naturellement personnel et cependant élégant, est la caractéristique la plus frappante de cette propriété. Les parquets présentent une subtile texture rugueuse, comme s'ils avaient été lavés, des décennies durant, à l'eau et au savon, tandis que les sols carrelés, couverts par des tapis, affichent une teinte et une patine parfaites. Une sensation de netteté et de fraîcheur, presque apaisante, prédomine dans cet intérieur, particulièrement dans la chambre et la salle de bain où chaises et coffres peints de style gustavien introduisent une touche de confort à la scandinave. Les espaces sereins sont la marque de fabrique de la décoratrice, auteure et créatrice d'accessoires de maison, Cassandra Ellis, qui a exercé ici sa magie.

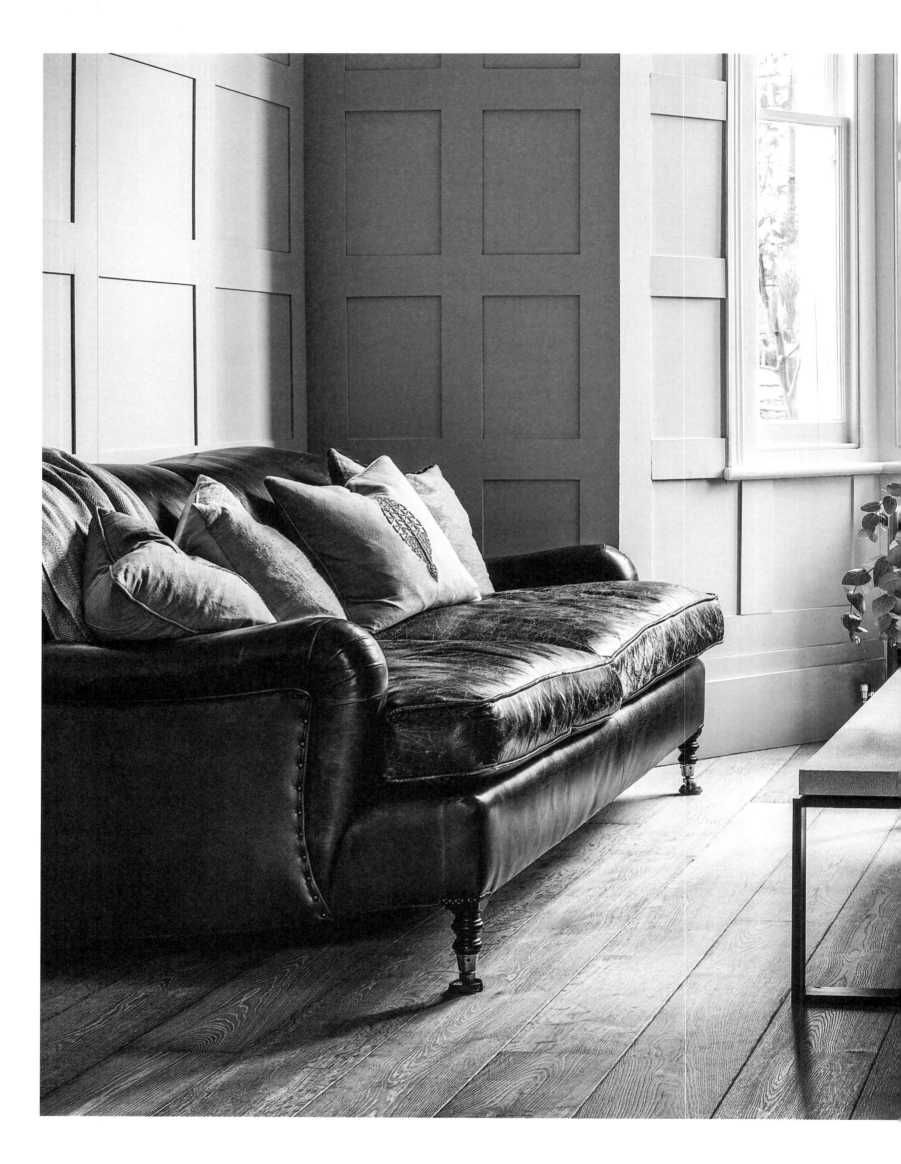

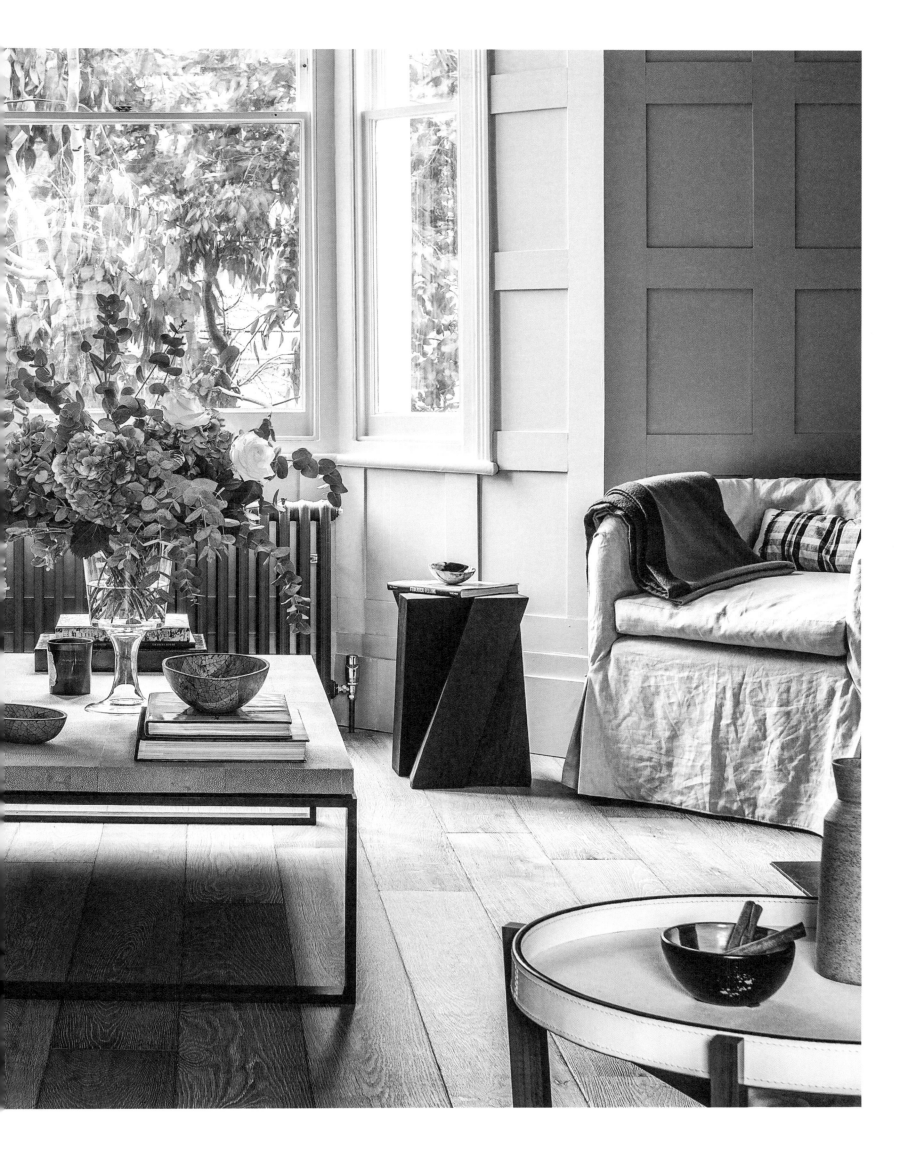

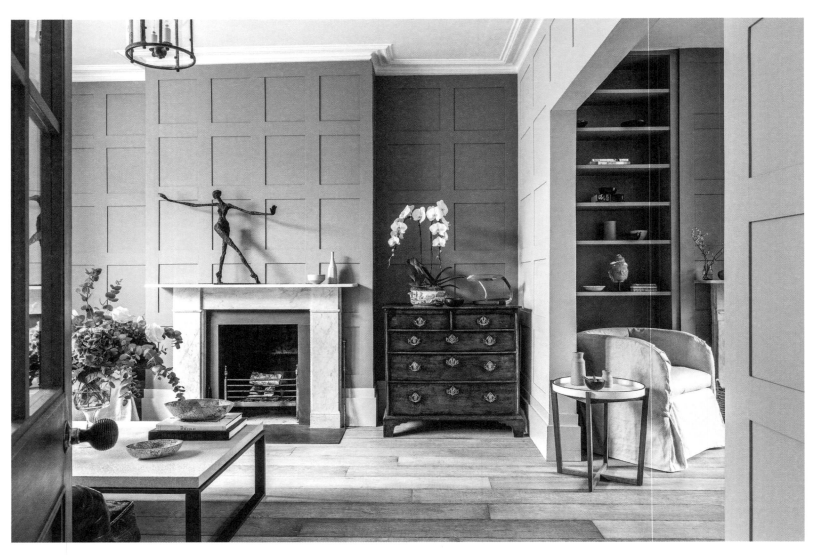

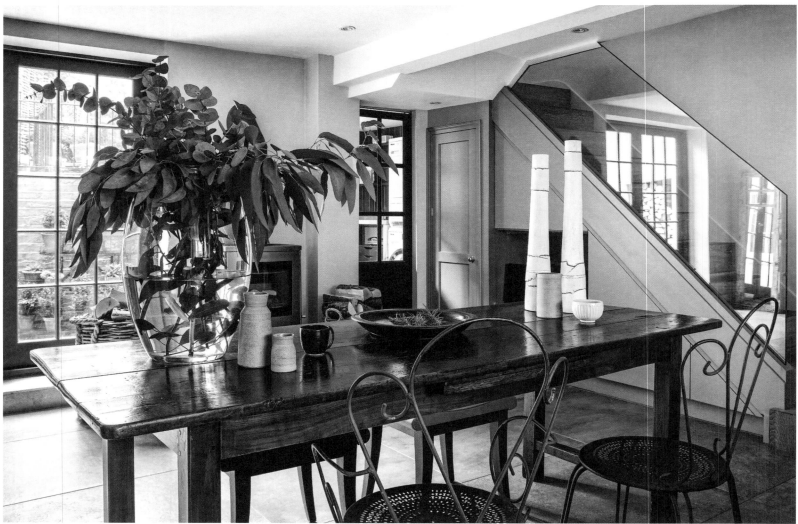

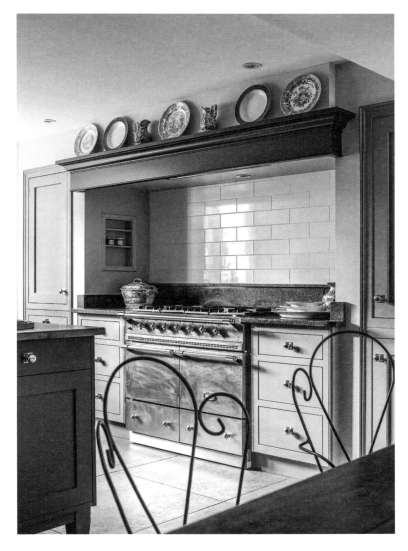

THE PANELLED WALLS and wooden floors provide a warm and simple backdrop for a hand-picked selection of antique and vintage furniture. The ground-floor rooms are cosy and uncluttered, while the personal touch shines through with carefully selected pieces including the old dining table, an heirloom, and a few ceramic candle holders from South Africa.

DIE MIT HOLZ verkleideten Wände und auf alt getrimmten, gescheuerten Holzböden bilden einen warmen und schlichten Hintergrund für eine handverlesene Auswahl antiker Möbel und Vintage-Stücke. Die Zimmer im Erdgeschoss sind gemütlich und ordentlich, trotzdem wirken sie durch sorgfältig ausgewählte Gegenstände wie den alten Esstisch, einem Familienerbstück, und ein paar Keramikkerzenständern aus Südafrika persönlich.

LES MURS LAMBRISSÉS, les parquets en bois frotté à l'ancienne, fournissent un décor simple et chaleureux aux meubles anciens ou rétro triés sur le volet. Confortables et épurées, les pièces du rez-de-chaussée se caractérisent par des touches personnelles et soigneusement sélectionnées, à l'exemple de la table ancienne de la salle à manger, d'un meuble de famille ou encore, de bougeoirs en céramique provenant d'Afrique du Sud.

ROOFTOP SANCTUARY

Bayswater

A dream house doesn't necessarily need to be a grand mansion. This modern mews house in Bayswater is everything a bachelor could ask for. Each room reflects a comfortable and sociable lifestyle: from the cosy yet glamorous living rooms to an impressive 'hidden gem' of a wine-tasting room. Colour has been used throughout the house to define the floors, with the journey beginning on the lower floors in earthy tones, gradually introducing greens and blues on the upper floors, and culminating in a 'sanctuary in the sky' on the top floor, which opens out onto a secluded terrace among the London rooftops. The key features of this home are meticulous attention to detail and an unconventional mix of Alpine architecture and Palm Springs modernism. The walls of the wine-tasting room are lined with old wine boxes, and the tiled floor incorporates motifs of grapes and vine leaves. This beautifully proportioned and uniquely configured open-plan space is full of warmth and natural textures such as the split faced slate tiling on the kitchen and sitting room walls, visually tying the two ends of the floor together. Mixing mid-century modern furniture with industrial antiques as well as contemporary pieces, the environment was kept decidedly masculine and very natural. The master bedroom with a fireplace is an intimate sleeping area with textured wallpaper and vintage furniture defining the dressing area.

Ein Traumhaus muss nicht unbedingt ein großes Herrenhaus sein. Dieses moderne, in Bayswater gelegene „Mews House", eine umgebaute Stallung, verfügt über alles, was ein Junggeselle sich wünschen kann. Sämtliche Räume spiegeln einen behaglichen und geselligen Lebensstil wider: von den gemütlichen, aber dennoch prächtigen Wohnzimmern bis hin zu dem beeindruckenden „verborgenen Juwel", eine Weinbar. Die Böden im Haus heben sich durch unterschiedliche Farbgebung voneinander ab. In den unteren Etagen dominieren Erdtöne, die in den oberen Geschossen Grau- und Blauschattierungen annehmen und im obersten Stockwerk in einem „Zufluchtsort am Himmel" gipfeln, der zu einer abgeschiedenen Terrasse über den Dächern Londons führt. Die Hauptmerkmale dieses Hauses stellen sorgfältige Liebe zum Detail und eine unkonventionelle Kombination aus alpiner Architektur und Palm-Springs-Modernismus dar. Die Wände der Bar säumen alte Weinkisten, den Fliesenboden zieren Muster von Weintrauben- und blättern. Dieser

7

wunderschön proportionierte und einzigartig gestaltete, offene Raum versprüht Wärme, und die natürlichen Strukturen, wie die Schieferwände in Küche und Wohnzimmer, verbinden beide Enden der Etage optisch miteinander. Durch den Mix aus modernen Mid-Century-Möbeln, Antiquitäten des Industriedesigns und zeitgenössischen Gegenständen bewahrt die Einrichtung ein ausgesprochen maskulines und sehr natürliches Bild. Das Schlafzimmer mit Kamin präsentiert sich als intimer Schlafbereich mit Strukturtapete, Vintage-Möbel grenzen den Ankleidebereich ab.

Nul besoin qu'une maison de rêve soit majestueuse. Située dans le quartier de Bayswater, cette « mews house » (demeure londonienne typique, installée dans d'anciennes écuries) de style moderne offre tout ce que peut souhaiter un célibataire. Chaque pièce témoigne d'un mode de vie à la fois confortable et convivial : depuis les salons cosy mais glamour, jusqu'à cet impressionnant « joyau caché » que constitue le bar à vin. La couleur sert à définir chaque étage : le voyage débute par des tons de terre, se poursuit avec une palette de verts et de bleus à mesure que l'on monte, avant d'atteindre son point culminant avec ce « sanctuaire dans le ciel » installé au dernier étage et donnant sur une terrasse isolée, parmi les toits de Londres. L'attention méticuleuse portée aux détails, le mélange peu conventionnel entre une architecture alpine et un modernisme à la Palm Springs, sont les traits marquants de cette demeure. Des casiers remplis de bouteilles anciennes couvrent les murs du bar à vin, cependant que le sol carrelé présente des motifs en forme de raisin et de feuilles de vigne. Offrant une configuration unique, cet espace ouvert magnifiquement proportionné abonde en textures chaleureuses et naturelles, à l'exemple de l'ardoise qui recouvre les murs de la cuisine et des salons, reliant visuellement les deux extrémités de l'étage. Associant un mobilier moderne du milieu du siècle à des objets industriels anciens ou des pièces contemporaines, la décoration s'affirme aussi résolument masculine que parfaitement naturelle. Pourvue d'une cheminée, la chambre principale constitue, avec son papier peint texturé et ses meubles vintages qui délimitent le dressing, un espace de repos intime.

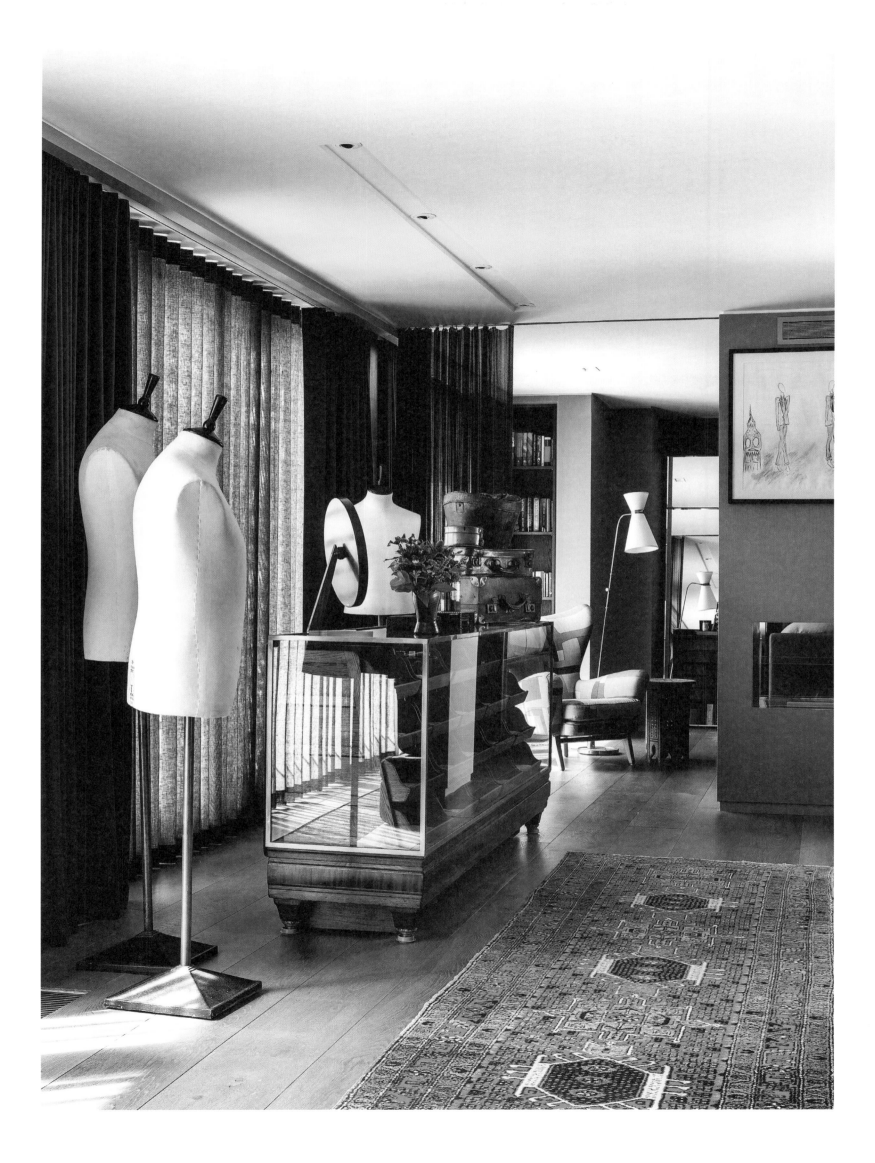

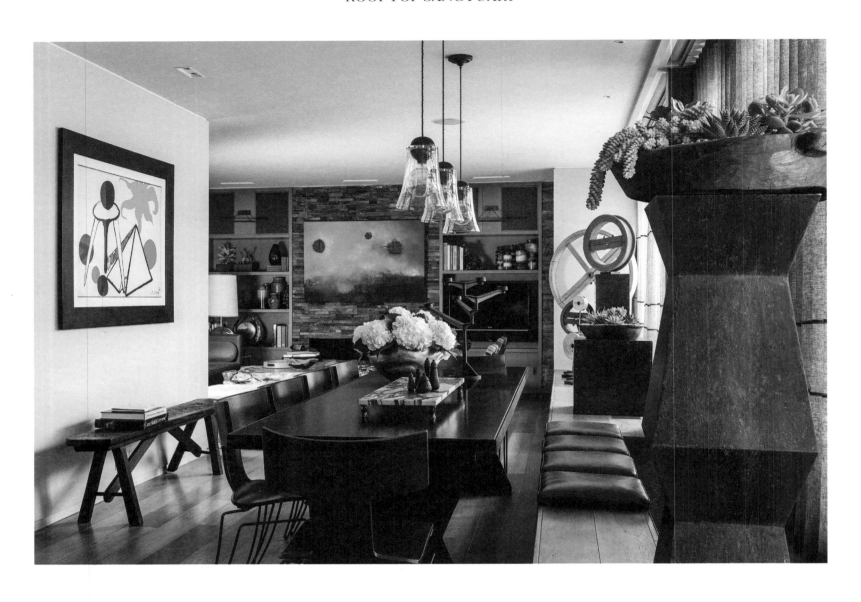

DARK WOOD, LEATHER and grand scales give the dining area the distinct masculine touch, which continues throughout the home. Splashes of orange, interesting art pieces and a cosy vintage reading corner add some funky elements and personality.

DUNKLES HOLZ, LEDER und beeindruckende Ausmaße verleihen dem Essbereich jene ausgeprägte maskuline Note, die sich im gesamten Haus fortsetzt. Orange Farbtupfen, interessante Kunstwerke und eine gemütliche Retro-Leseecke fügen dem Raum unkonventionelle Elemente beziehungsweise Persönlichkeit hinzu.

LE BOIS SOMBRE, le cuir, les vastes proportions impriment à la salle à manger une indéniable dimension masculine que l'on retrouve dans chaque pièce. Les touches de couleur orange, les oeuvres d'art singulières ou le confortable coin-lecture de style rétro installé en retrait sont autant d'éléments excentriques qui donnent de la personnalité aux lieux.

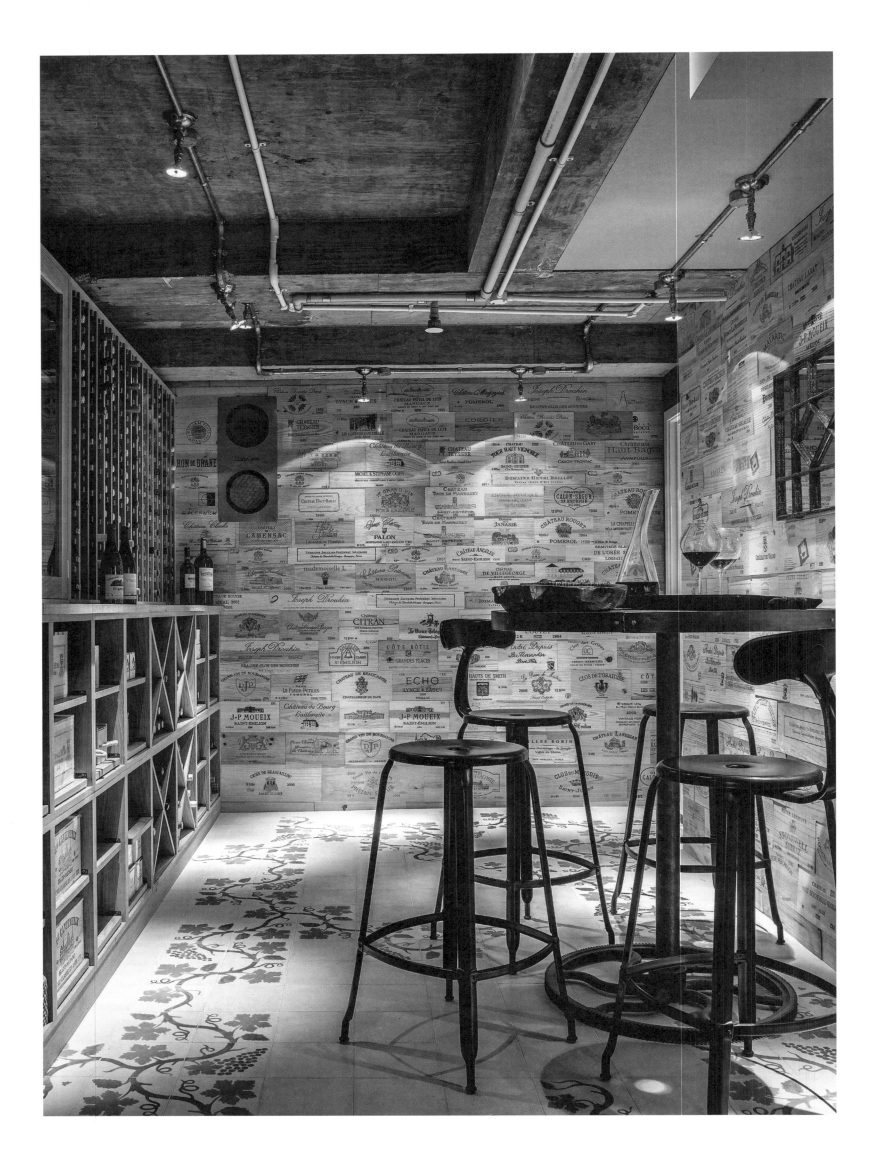

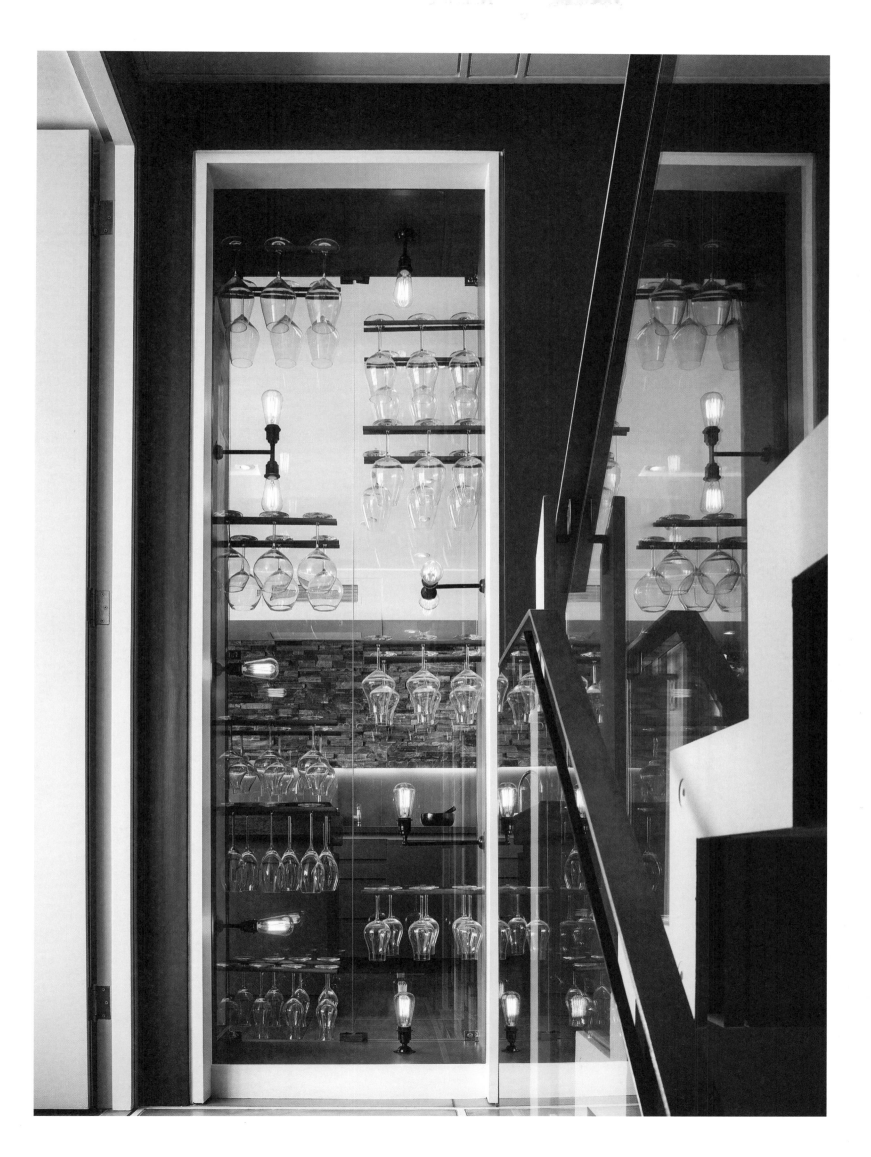

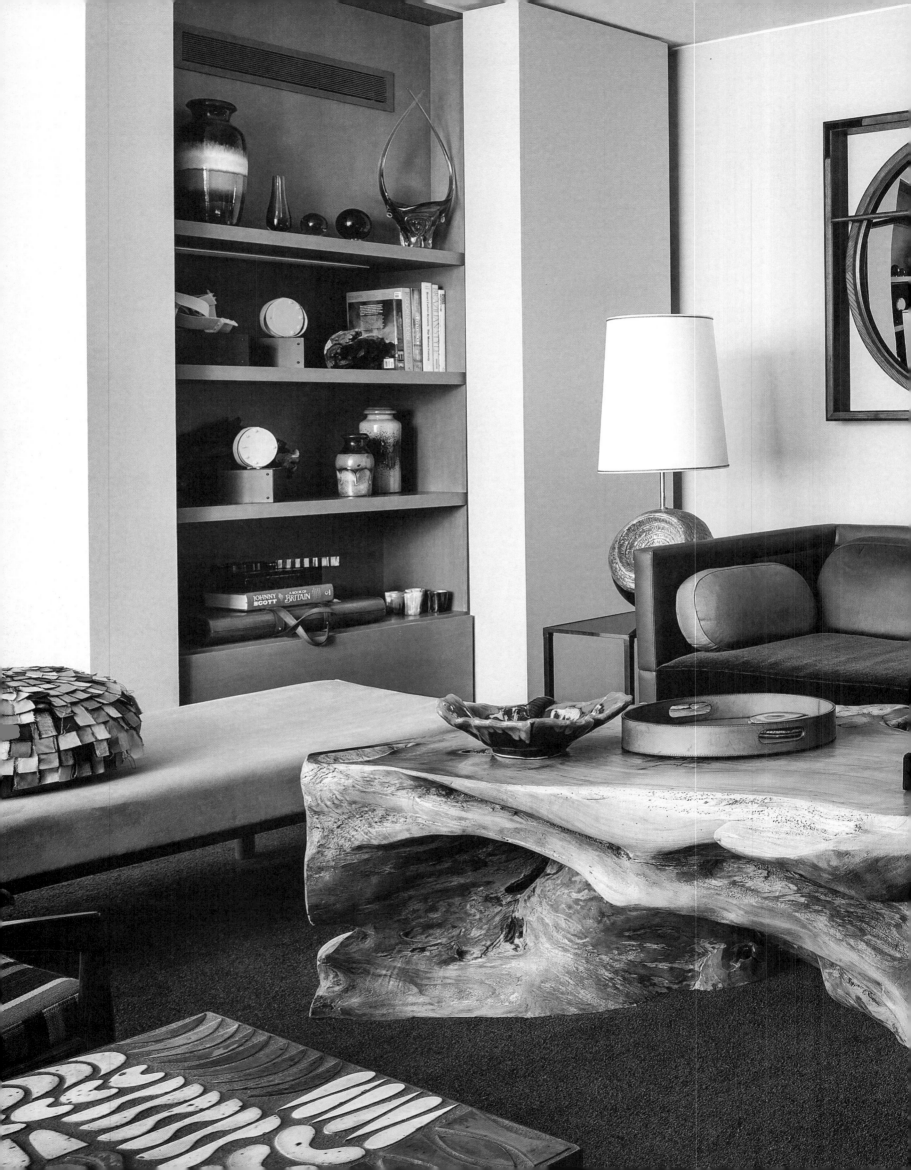

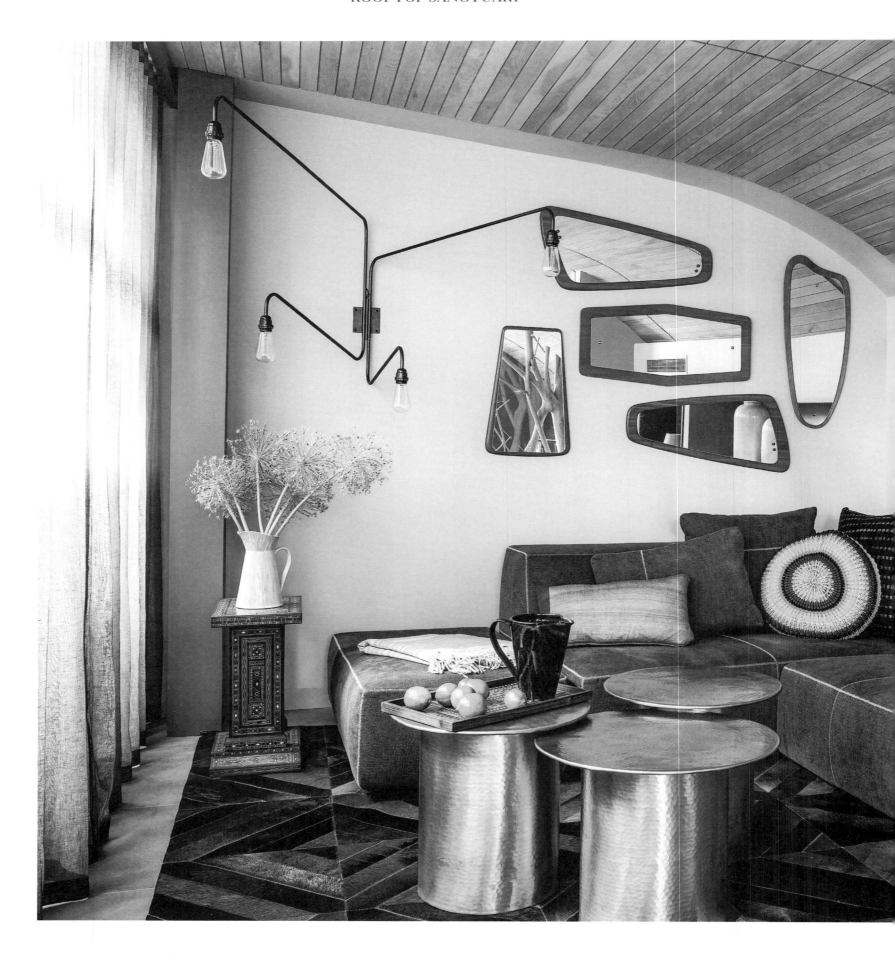

ON THE TOP floor, adjacent to the rooftop terrace, the lounge room with its rounded wooden ceiling and selection of unique vintage pieces, mirrors and ceramics functions as a comfortable hideaway.

DAS IN DER oberen Etage, neben der Dachterrasse gelegene Wohnzimmer mit seiner abgerundeten Holzdecke und den erlesenen, einzigartigen Vintage-Objekten, Spiegeln und der Keramik dient als gemütlicher Zufluchtsort.

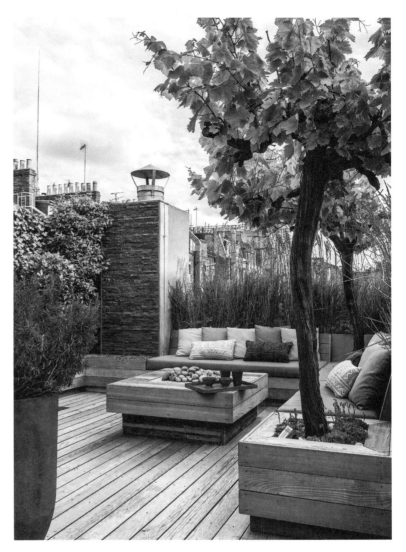

AVEC SON PLAFOND de bois voûté, ses objets rétro singuliers, ses miroirs et ses céramiques, ce salon constitue un confortable refuge niché au dernier étage et jouxtant le toit-terrasse.

EARTHY & ELEGANT

Kensington

This triplex apartment occupying the basement, ground and first floor of a small mansion block in a Kensington square is a perfect example of London's global design melting pot. The owner has maintained her strong bond to her Turkish roots whilst collecting a highly individual mix of items from her new hometown's countless art galleries and antique shops. The result is a truly personal home with a strong combination of contemporary art, styles, periods and natural materials, dramatic and elegant in warm and earthy tones. When moving from Istanbul with her husband, the passionate art lover left her own financial career and became an interior designer. She works with a great amount of patience believing that furnishing a home is a gradual process. When the family grew from three to five, radical alterations to the layout of the home were needed. With the help of interior designer Carina Carson and architectural designer Peter Jones from the leading architect studio Jones Lambell, they opened up a covered vault creating underground storage and moved the kitchen to the garden level for more practical access to the garden. Halfway through the project, the couple purchased the neighbouring apartment and incorporated that space into the stylish and fun home.

Diese Wohnung, die sich über Untergeschoss, Erdgeschoss und erste Etage eines kleinen Herrenhauses erstreckt, das an einem Platz in Kensington liegt, ist ein Musterbeispiel für Londons globalen Designschmelztiegel. Die Eigentümerin pflegt weiterhin ihre starke Verbundenheit zu ihren türkischen Wurzeln, hat aber ebenfalls sehr verschiedenartige Objekte aus den zahlreichen Kunstgalerien und Antiquitätengeschäften ihrer neuen Heimatstadt zusammengetragen. Das Ergebnis ist ein wahrhaft persönliches Heim, in dem sowohl zeitgenössische Kunst und Stile als auch natürliche Materialien, dramatisch und elegant in warmen erdigen Tönen in Szene gesetzt, eine kontrastreiche Mischung bilden. Als die begeisterte Kunstliebhaberin mit ihrem Mann von Istanbul nach London zog, gab sie ihren Beruf im Finanzbereich auf und wurde Innenarchitektin. Sie arbeitet mit großer Geduld und hält das Einrichten eines Hauses für einen schrittweisen Prozess. Die Familie vergrößerte sich von drei auf fünf Personen, sodass radikale Änderungen in der Raumaufteilung notwendig wurden. Mithilfe der Innenarchitektin Carina Carson und des Architekten Peter Jones, Mitbegründer des führenden Architekturbüros Jones Lambell, erschloss sie ein Kellergewölbe, schuf unterirdischen Speicherraum und verlagerte die Küche in das Gartengeschoss, um von dort direkt nach draußen zu gelangen. Die Umbaumaßnahmen waren mitten im Gang, als das Ehepaar die benachbarte Wohnung kaufte und diese in ihr stilvolles, fröhliches Heim integrierte.

8

Occupant le sous-sol, le rez-de-chaussée et le premier étage d'un petit immeuble ancien donnant sur une place du quartier de Kensington, ce triplex constitue un parfait exemple du design international issu du creuset multiculturel londonien. Sa propriétaire y met passionnément en valeur ses racines turques qu'elle associe de façon extrêmement personnelle à des objets dénichés chez les antiquaires ou dans les nombreuses galeries d'art de sa ville d'adoption. L'ensemble aboutit à une maison véritablement unique où les oeuvres d'art contemporain, les styles, les époques et les matériaux naturels, aux chaleureux tons de terre, se combinent avec une remarquable élégance. Lorsqu'elle quitte Istanbul avec son mari, cette amatrice d'art renonce à sa carrière dans le monde de la finance pour se consacrer à l'architecture d'intérieur. Convaincue que l'agencement d'une maison constitue un lent processus, elle oeuvre avec une infinie patience. Et quand la famille s'agrandit, passant de trois à cinq membres, de radicales modifications structurelles s'imposent. Avec l'aide de l'architecte d'intérieur Carina Carson, et de l'architecte-designer Peter Jones, de l'éminent studio Jones Lambell, le couple fait mettre à nu une voûte, ouvrant ainsi un espace de rangement au sous-sol, et déplace la cuisine au niveau du jardin, de sorte à pouvoir à accéder plus aisément à l'extérieur. Au cours des travaux, les propriétaires acquièrent l'appartement voisin qu'ils intègrent alors à cette demeure aussi stylée que surprenante.

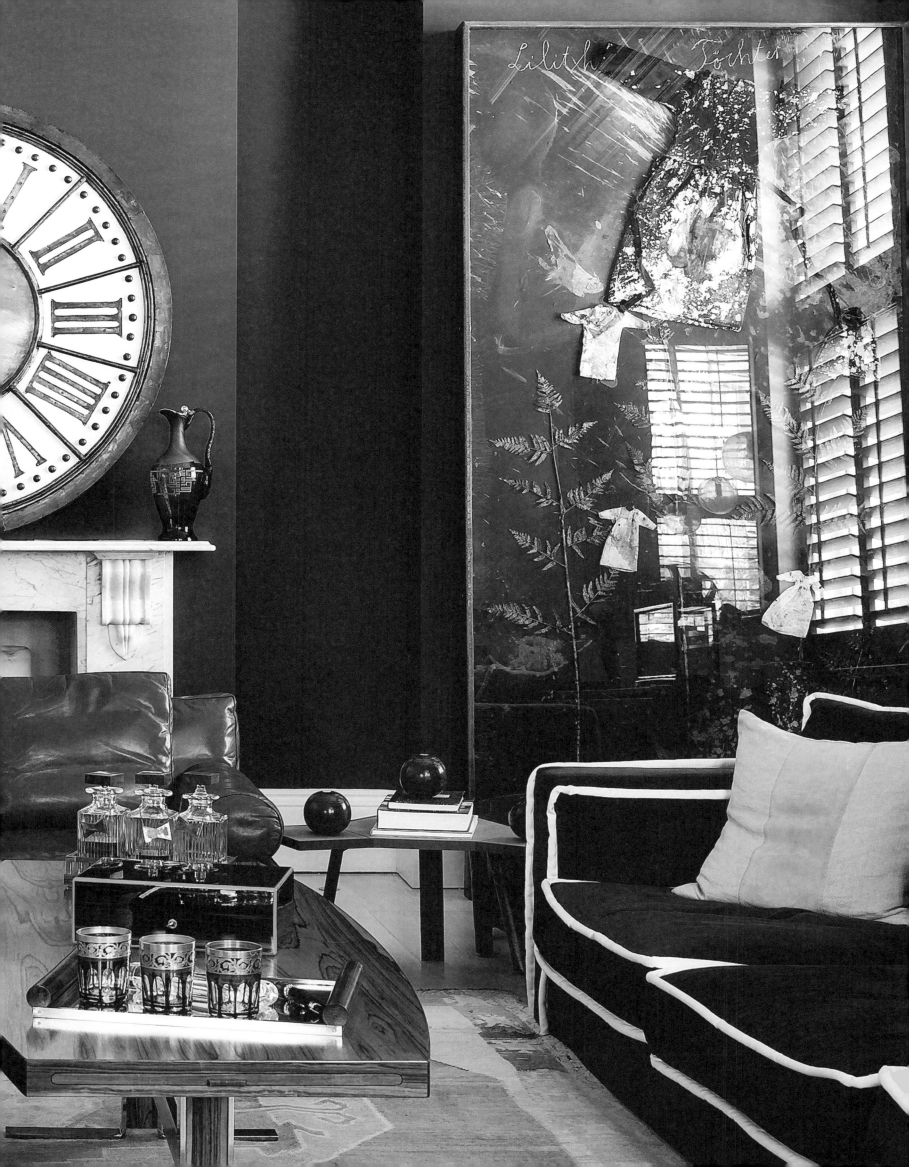

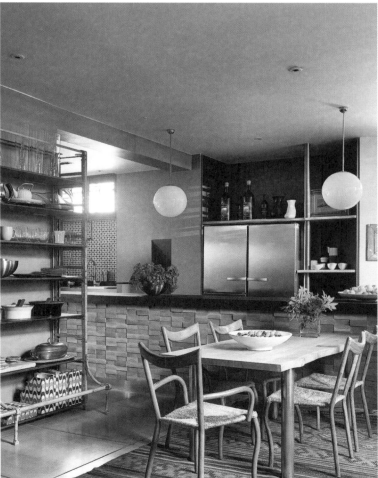

BULTHAUP UNITS WERE chosen for the kitchen, which is centered upon a 4.8-metre island unit with a bush-hammered granite work surface. Jones Lambell devised the fascia using oak of varying depths, which is acoustically efficient as well as adding warmth and character to the room.

EINBAUSCHRÄNKE VON BULTHAUP wurden für die Küche ausgewählt, in deren Mitte sich eine 4,80 m lange Kücheninsel mit scharrierter Granitarbeitsplatte befindet. Die Verblendung entwarf Jones Lambell und verwendete dafür unterschiedlich dickes Eichenholz, das akustisch wirksam ist und dem Raum Wärme und Charakter hinzufügt.

ORGANISÉE AUTOUR D'UN îlot central de 4,8 m pourvu d'une surface de travail en granit bouchardé, la cuisine est équipée d'éléments de rangement Bulthaup. Jones Lambell en a imaginé le parement à partir de pièces de chêne de différentes profondeurs qui, non seulement, sont efficaces du point de vue acoustique, mais encore, donne du charme et du caractère à la pièce.

EAST MEETS WEST

Chelsea

For those dreaming of a big, bold and beautiful house, this must be the one. Externally, the newly-built house in Chelsea has a Victorian stucco appearance in keeping with the style of the neighbourhood. Inside, a master class in bespoke, modern British craftsmanship awaits. The spectacular architectural style featuring Eastern inspired walnut shutters and floors, joinery paying tribute to Frank Lloyd Wright, furniture inspired by George Nakashima, large windows and vast proportioned fireplaces is reminiscent of a luxurious hotel. The décor is equally elegant with beautiful details such as walls covered in pale blue Donghia linen in the drawing room and celadon polished plaster in the dining area. Playing with contrasts and scales, Louise Jones Interiors has maintained a timeless and welcoming feel. The spacious rooms demanded not only large, made-to-measure sofas and chairs, but also an interesting and unusual mix of rich, natural and reflective textures and materials. Considering the palatial 16,500 square feet, the creation of a distinct homely feel was an achievement by the London-based design practice, which perfectly interpreted the owner's quest for a private home with a restful colour palette mainly of celadon, grey, and off-white tones in varied intensities.

Für diejenigen, die von einem großen, kühnen, herrlichen Haus träumen, muss das hier wohl das Richtige sein. Das äußere Erscheinungsbild des in Chelsea entstandenen Neubaus präsentiert sich viktorianisch und ist mit Stuck verziert, um den Stil der Umgebung zu wahren. Innen erwartet den Besucher meisterliche, maßgefertigte, moderne, britische Handwerkskunst. Der spektakuläre Architekturstil, der östlich inspirierte Fensterläden und Böden aus Walnussholz aufweist, Tischlerarbeiten, die Frank Lloyd Wright huldigen, Möbel, die von George Nakashama inspiriert sind, sowie große Fenster und gewaltige Kamine, erinnert an ein Luxushotel. Das Dekor ist ebenso elegant und besticht durch blassblaue Tapeten von Donghia in Leinenoptik im Wohnzimmer und glatten, seladon-grünen Putz im Essbereich. Louise Jones Interiors hat durch das Spiel mit Kontrasten und unterschiedlichen Größenordnungen eine zeitlose und wohnliche Atmosphäre geschaffen. Die geräumigen Zimmer machten nicht nur große, maßgefertigte Sofas und Sessel

erforderlich, sondern auch eine interessante und ungewöhnliche Mischung aus reichhaltigen, natürlichen sowie reflektierenden Stoffen und Materialien. Das Herbeiführen eines gemütlichen und individuellen Ambientes in einem Gebäude, das durch seine palastartige Größe von 600 Quadratmetern hervorsticht, war das Werk des in London beheimateten Innenarchitekturbüros. Es setzte die Bitte des Eigentümers nach einem Privathaus mit einer ruhigen, hauptsächlich aus unterschiedlich intensiven seladon-grünen, grauen und cremefarbenen Tönen bestehenden Farbpalette perfekt um.

Pour ceux qui rêvent d'une demeure aussi vaste et belle qu'audacieuse, alors, celle-ci les enchantera. A l'extérieur, quoique récemment construite à Chelsea, elle présente une façade en stuc de style victorien qui l'harmonise avec les maisons voisines. A l'intérieur, c'est tout le savoir-faire britannique moderne du sur-mesure dont elle est l'incarnation qui nous attend. Composé de volets et de parquets en noyer d'inspiration orientale, d'une menuiserie qui rend hommage à Frank Lloyd Wright, de mobilier évoquant George Nakashima, de larges fenêtres et de cheminées aux vastes proportions, son style architectural spectaculaire n'est pas sans rappeler celui d'un hôtel de luxe. Tout aussi raffinée est la décoration avec ses détails splendides – ainsi des murs tendus de lin bleu clair de chez Donghia dans le salon, ou du stuc vénitien céladon dans la salle à manger. Louis Jones Interiors a su créer un sentiment d'intemporalité et d'hospitalité en jouant sur les contrastes et les dimensions. Spacieuses, les pièces appelaient non seulement, de vastes canapés ou des sièges réalisés sur-mesure, mais encore, une singulière et intéressante association de textures et matériaux aussi opulents que naturels et lumineux. En dépit des imposants 1 500 mètres carré de la propriété, le studio de design basé à Londres est parvenu à instaurer une indéniable sensation de confort en interprétant à la perfection la quête d'intimité du propriétaire, au travers d'une reposante palette de couleurs essentiellement composée de céladon, de gris et de blancs cassés, déclinée en différentes nuances.

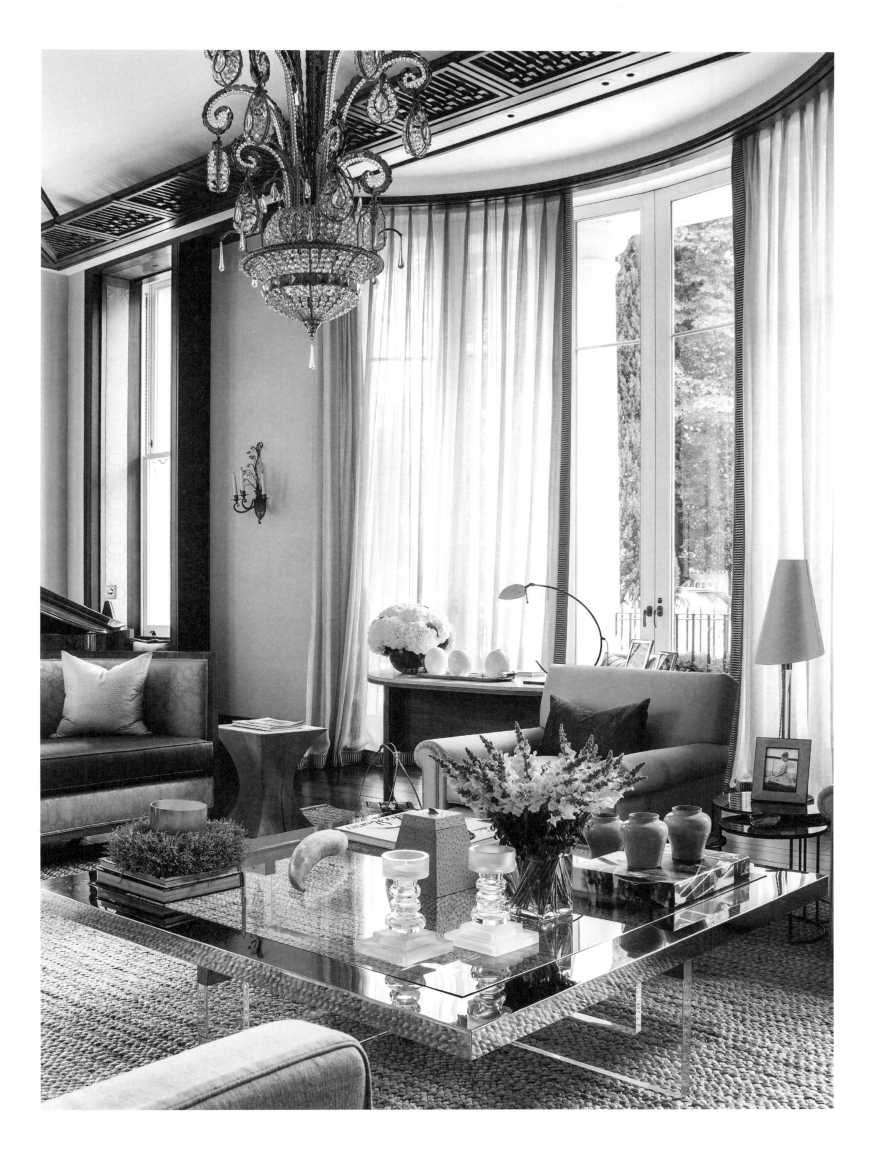

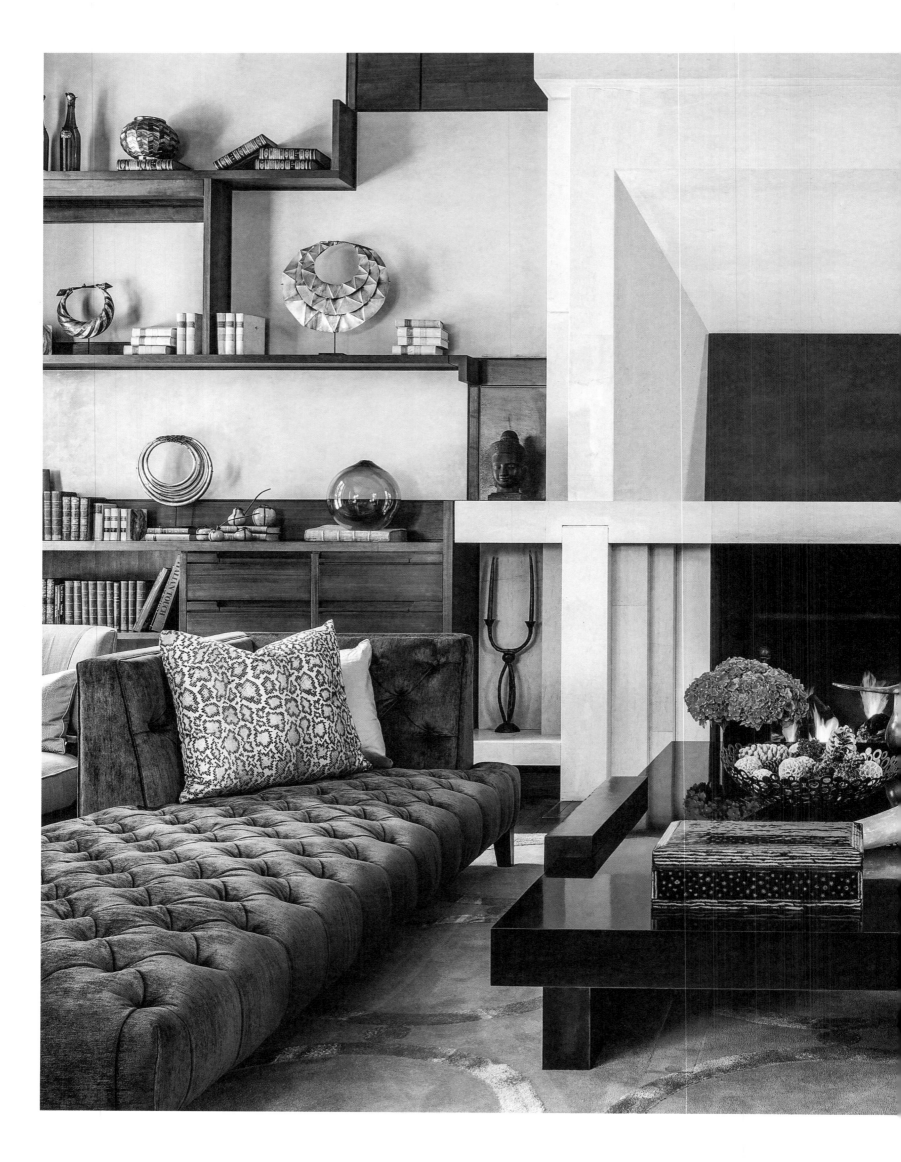

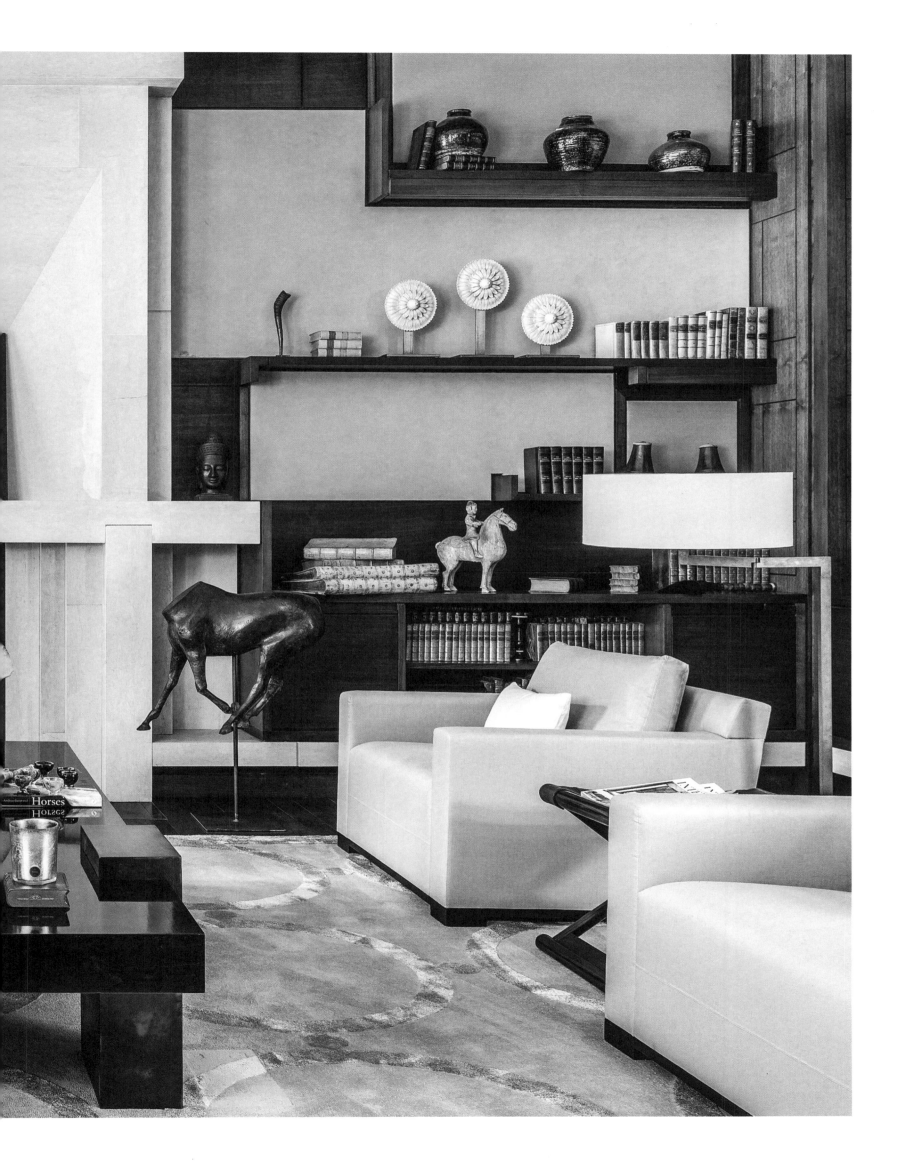

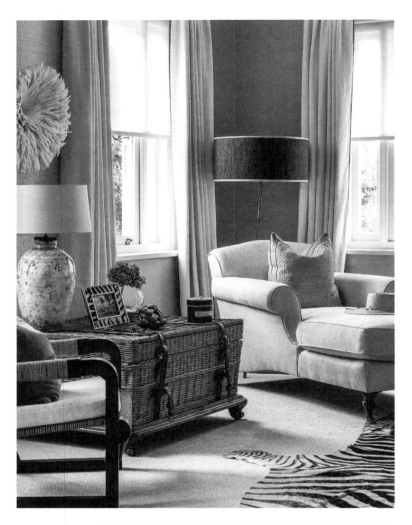

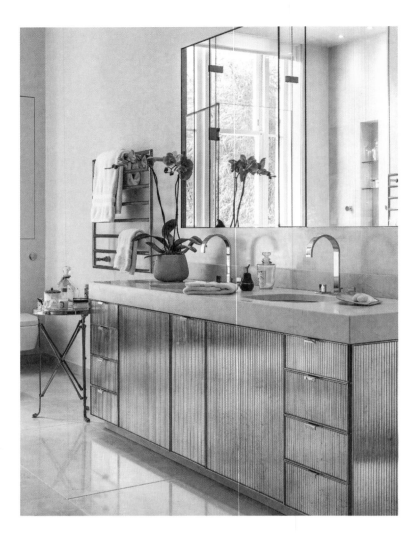

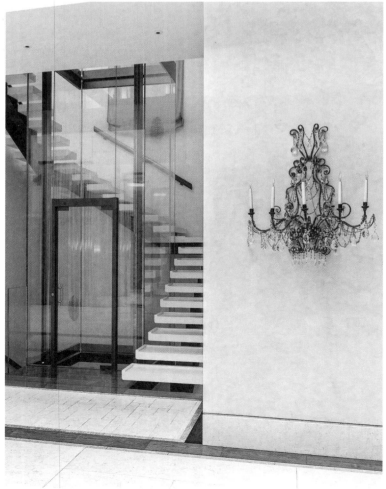

IN THE LIVING room, the large bespoke chairs, mixed with a delicate velvet chaise longue and fragile turquoise glass sculptures set on the shelves, are perfect examples of the blend of textures and materials. The guest bedroom exudes contemporary safari flair, and the master bathroom has a 1930s feel, with a specialist mirror used on the doors of the vanity unit.

DIE GROSSEN, MASSGEFERTIGTEN Sessel, kombiniert mit einer zarten, samtbezogenen Chaiselongue und zerbrechlichen, in den Regalen arrangierten, türkisfarbenen Glasskulpturen, sind Musterbeispiele für das Mischen von Stoffen und Materialien. Das Gästeschlafzimmer strahlt modernes Safari-Flair aus, während der Stil des Badezimmers an die 1930er-Jahre erinnert. Die Türen des Waschtischs sind mit einer besonderen, verspiegelten Oberfläche versehen.

DANS LE SALON, les vastes sièges réalisés sur mesure, à l'exemple de la délicate méridienne en velours, mais aussi, les fragiles sculptures en verre de couleur turquoise disposées sur les étagères, sont une parfaite illustration du mélange de textures et de matériaux. La chambre d'invité offre une ambiance safari contemporaine, tandis que la chambre principale évoque les années 1900 avec son meuble lavabo dont les portes sont pourvues d'un miroir taillé sur mesure.

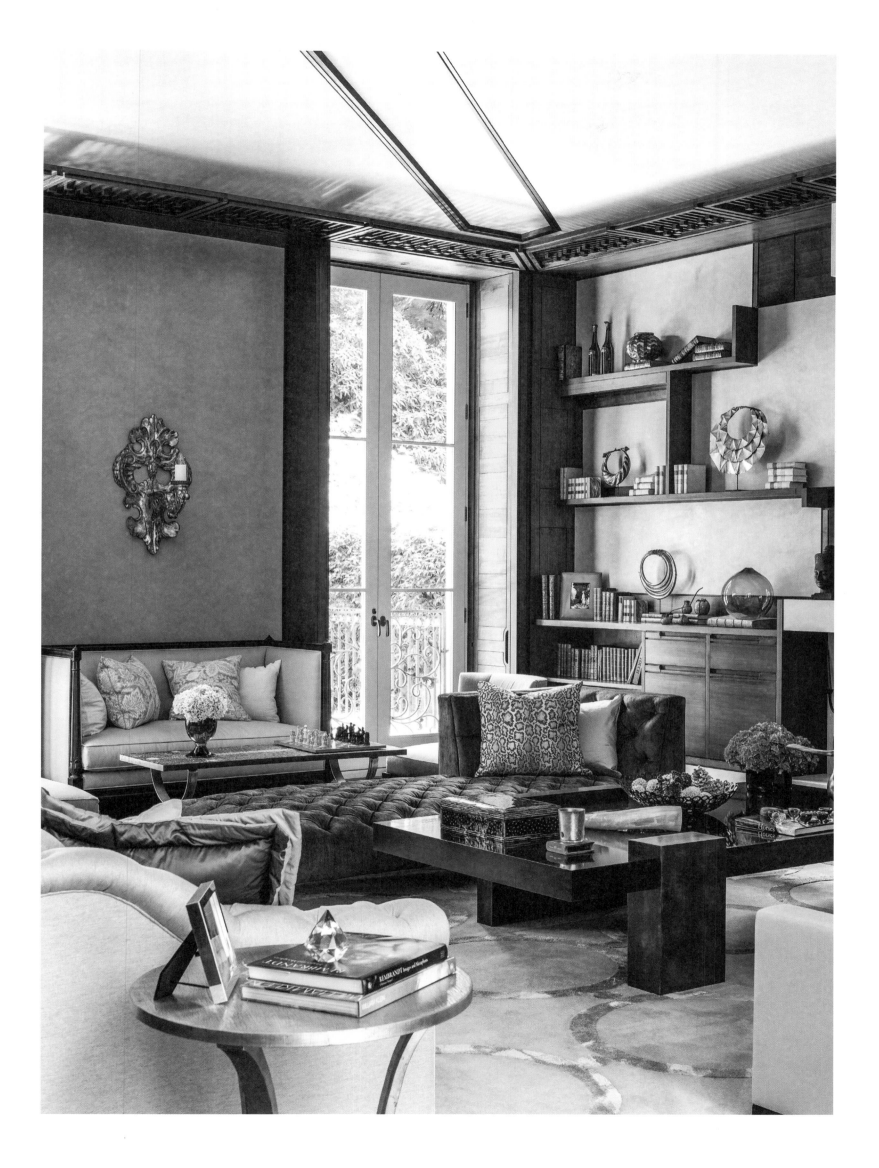

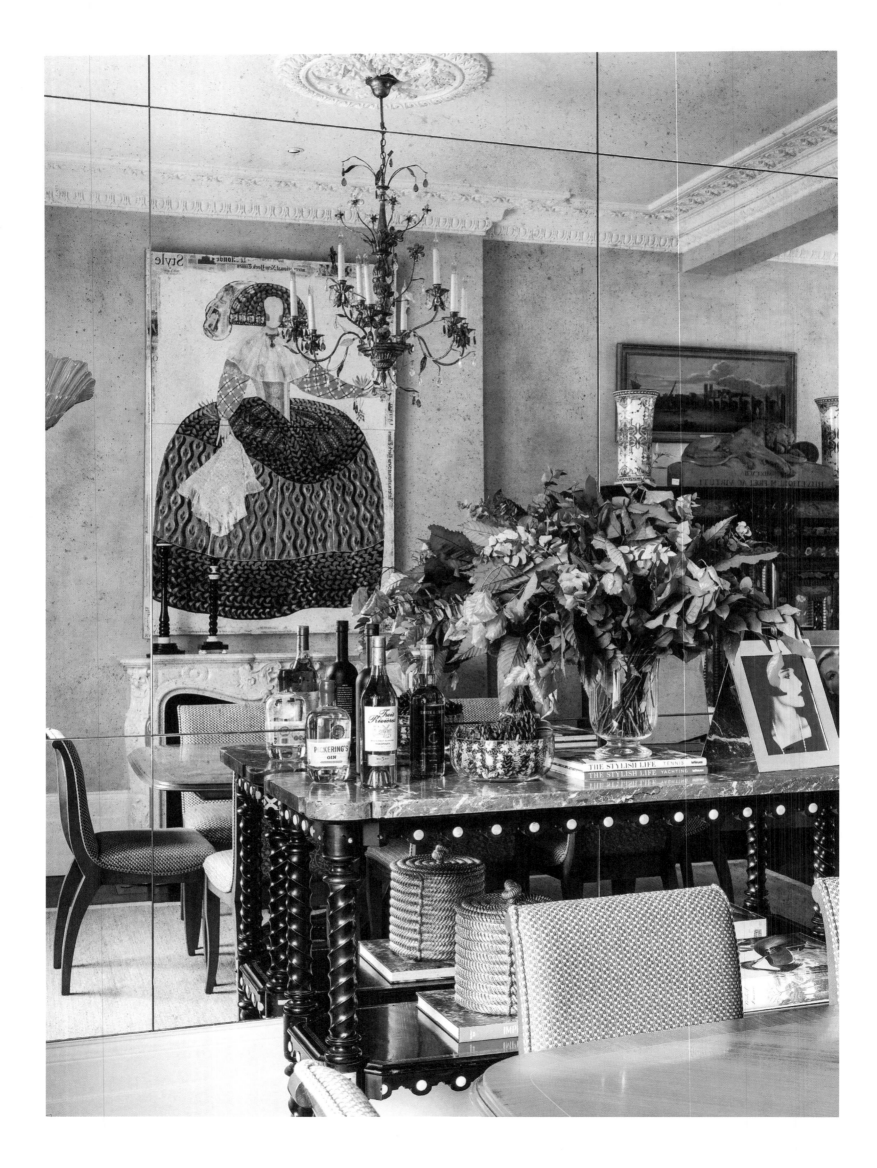

WHIMSICAL ELEGANCE

Knightsbridge

An elegant London Crescent requires no special adherence to cultural tradition. The owners have converted this Knightsbridge property with triple basement to make an eclectic home blending classical, contemporary and ethnic influences for whimsical elegance. Instead of the contemporary trend for grey and beige interiors, they have chosen an updated elegant country house feel with additions of colour, willow pattern and floral modern touches. The walls in the family room are lined in green silk and softly accentuate the ebony bookcases, lacquered Chinese coffee table and Syrian inlay table. An old film poster set against pale blue walls adds a timeless feel to the living room, while a vase with autumn leaves amplifies the dining rooms and their unique colour scheme from poetic pastels to rich lacquered wood. The dining area features ceiling-to-floor antique mirrors with a contemporary painting from the Stephanie Hoppen Gallery, which accentuates the mantelpiece. Period and modern décor throughout meet this varied mix of objects and furnishings, acquired at auctions and from all corners of the world. In collaboration with Louise Jones Interiors, the owners have invested patience in creating the perfect balance between grandeur and a charming ambience.

Ein stilvoller Londoner Crescent muss keine besondere Tradition wahren. Die Besitzer dieser Immobilie in Knightsbridge, die über ein dreifaches Untergeschoss verfügt, machten ein vielseitiges Heim daraus, in dem klassische, zeitgenössische und folkloristische Einflüsse sich zu eigenwilliger Eleganz vereinen. Statt dem heutigen Trend zu grauer und beiger Innenausstattung zu folgen, entschieden sie sich für einen modernen, anmutigen Landhausstil, dem sie unterschiedliche Farben, Muster und florale Elemente hinzufügten. Die mit grüner Seide bespannten Wände des Kaminzimmers heben die Bücherregale aus Ebenholz, den gelackten chinesischen Couchtisch und den syrischen, mit Intarsien versehenen Tisch leise hervor. Ein altes Filmplakat auf blassblauer Wand verleiht dem Wohnzimmer eine zeitlose Note, während eine Vase mit Herbstblättern im Esszimmer das Zusammenspiel zwischen einzigartiger, aus poetischen Pastelltönen bestehender Farbgebung und prächtigen, glänzenden Holzmöbeln verstärkt. Der Essbereich zeichnet sich durch raumhohe

10

Spiegel und ein zeitgenössisches Gemälde der Stephanie Hoppen Gallery aus, das den Kaminsims betont. Altes und modernes Dekor trifft auf verschiedenartige Objekte und Möbelstücke, die aus sämtlichen Ecken der Welt stammend, auf Auktionen erworben wurden. Die Eigentümer haben mit Beharrlichkeit und in Zusammenarbeit mit Louise Jones Interiors das perfekte Gleichgewicht zwischen Pracht und charmantem Ambiente geschaffen.

Habiter sur Egerton Crescent, à Londres, ne requiert nulle adhésion particulière à la tradition culturelle. Les propriétaires ont transformé cette demeure du quartier de Knightsbridge, avec triple sous-sol, en un espace éclectique dont l'élégance pleine de fantaisie mêle classicisme, contemporain et influences ethniques. Au goût actuel pour les intérieurs gris et beige, ces derniers ont préféré l'atmosphère raffinée d'un manoir, que complètent un jeu de couleurs, des motifs chinois, ou encore, de modernes touches florales. Les murs de la pièce de vie familiale sont tendus d'une soie verte qui met discrètement en valeur les étagères en ébène, la table basse en laque chinoise et la table syrienne en marqueterie. Dans le salon, l'affiche de film ancienne accrochée sur les murs d'un bleu pâle crée un sentiment d'intemporalité, cependant qu'un vase agrémenté de feuilles d'automne enjolive la salle à manger et sa singulière palette de couleurs qui associe la poésie des pastels à l'intensité des bois laqués. Courant du sol au plafond, des miroirs anciens y voisinent avec un tableau contemporain provenant de la Stephanie Hoppen Gallery, qui souligne le manteau de la cheminée. Cette combinaison d'objets ou de meubles acquis lors de ventes aux enchères et provenant du monde entier, s'accorde à une décoration qui mêle, dans chaque pièce, ancien et moderne. Avec la collaboration de Louise Jones Interiors, les propriétaires ont su patiemment créer un équilibre parfait entre splendeur et charme.

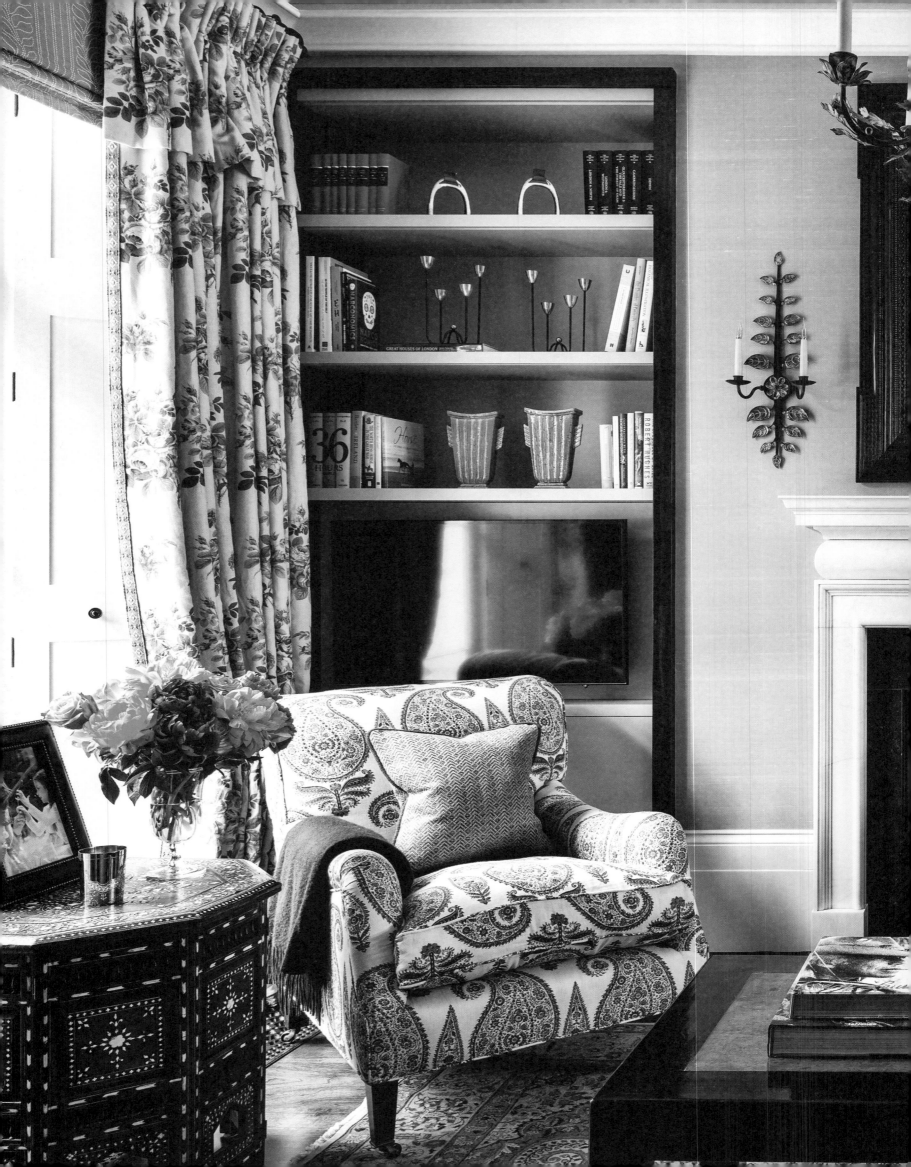

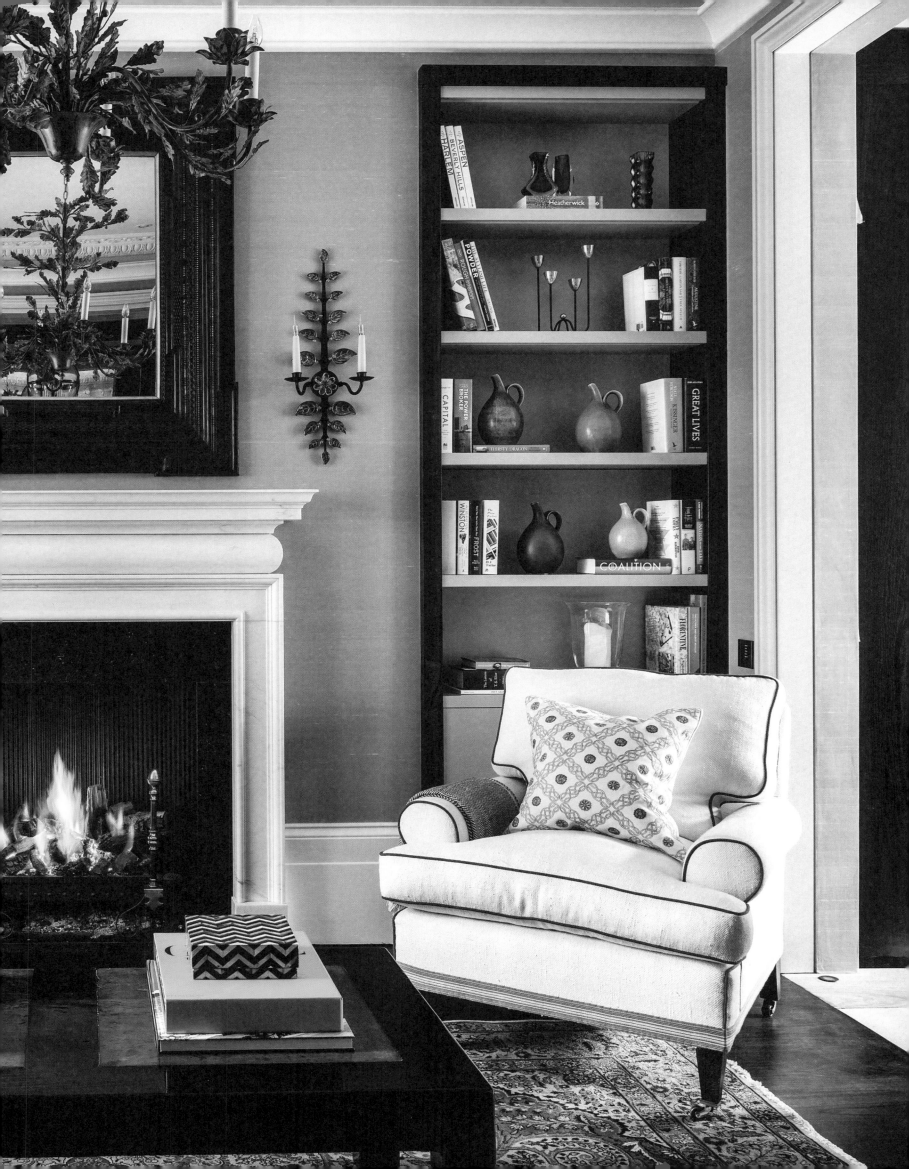

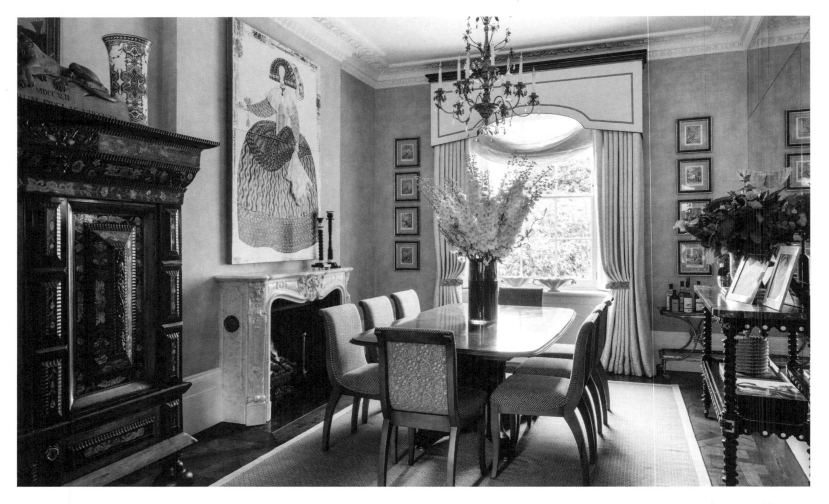

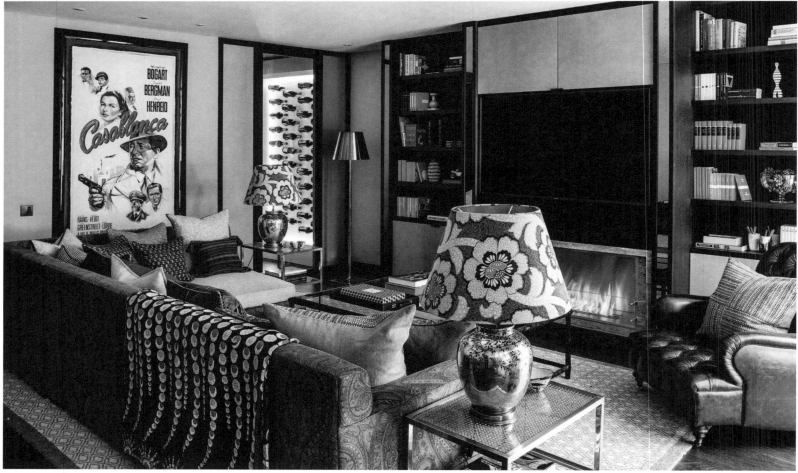

IN KEEPING WITH this elegantly styled space with beautiful design features, like the modern spiral staircase, the décor is a unique selection of modern design combined with period furniture, such as the Dutch marquetry cabinet in the dining area, where the walls have been painted with a special finish to replicate linen fabric.

UM DAS ELEGANTE Erscheinungsbild des Innenraums mit seinen wundervollen Designelementen wie der Wendeltreppe zu wahren, sind die Räume mit einer einzigartigen Sammlung moderner Elemente ausgestattet. Sie werden kombiniert mit antiken Möbeln, darunter dem holländischen Intarsien-Schrank im Essbereich, wo die Wände mit einer Spezialfarbe gestrichen wurden, um eine Leinenstruktur nachzubilden.

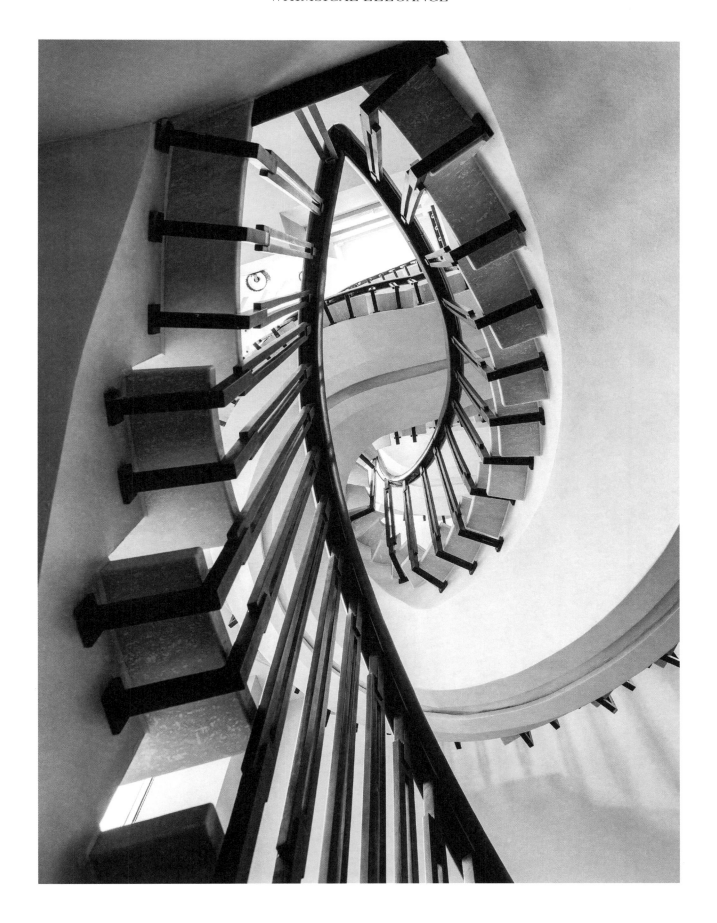

S'HARMONISANT AVEC L'ÉLÉGANCE raffinée des lieux et leurs particularités architecturales, à l'exemple de cet escalier en spirale contemporain, la décoration associe de façon originale les pièces design aux meubles d'époque, telle cette armoire hollandaise en marqueterie disposée dans la salle à manger dont les murs ont été recouverts d'un enduit spécifique évoquant la texture du lin.

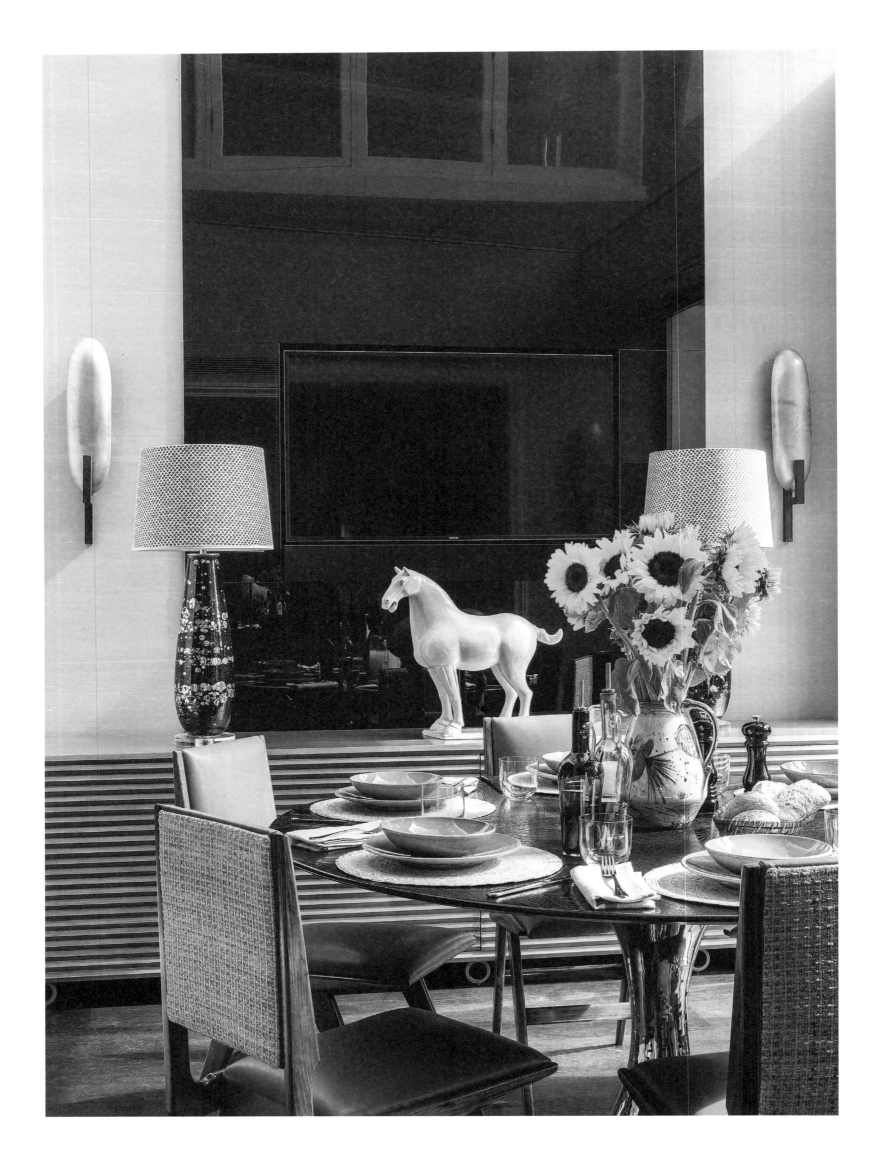

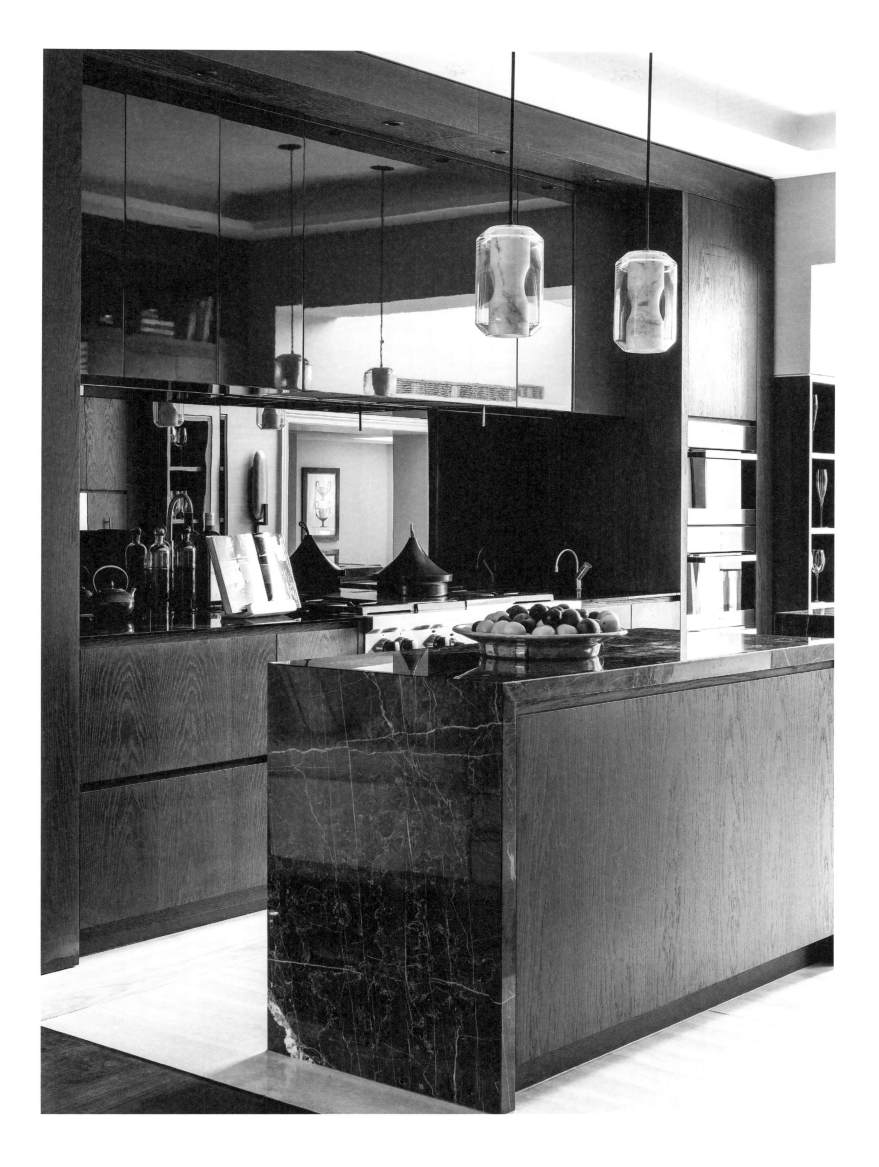

DAZZLING DRAMATIC

Chelsea

Behind the façade of this classic Grade II-listed terrace town house in Chelsea unfolds a unique, sassy and eccentric world. There is no need to try to make sense of its interior style; this home defies all conventions. Instead, each room, filled with an abundance of weird and wonderful objects, should simply be admired. In the hallway, a life-size elephant by Marc Quinn greets visitors, and the black and white striped dining room is contrasted with a pink ceiling. Black plastic upholstered armchairs are teamed with lots of contemporary art, such as a big Marilyn Monroe picture by Russel Young. Mirror-covered walls, shiny sculptures, dining chairs with wings, a seashell-shaped bed and many other opulent, dazzling and dramatic pieces of furniture and objects decorate the house. The home is a perfect reflection of its owner Amanda Eliasch: a creative mastermind and art lover, who with the assistance of interior designer Nicholas Haslam has created one of the most unusual homes in London, located in an area traditionally attracting rich, famous and colourful personalities. Whilst the duo has most certainly not been afraid to break the rules of upper-class elegant décor, the entire space is still quintessentially British. What it lacks in "stiff upper lip", it more than makes up for in wit and quirkiness.

Hinter der Fassade dieses klassischen, denkmalgeschützten Reihenhauses in Chelsea offenbart sich eine einzigartige, schicke und exzentrische Welt. Man muss den Einrichtungsstil nicht verstehen; dieses Heim trotzt allen Konventionen. Stattdessen sollte man jeden einzelnen Raum, der sich durch eine Fülle eigenwilliger und wunderschöner Objekte auszeichnet, einfach nur bewundern. In der Diele begrüßt ein lebensgroßer Elefant von Marc Quinn den Besucher, während eine rosafarbene Decke im Esszimmer einen Kontrast zu dem übrigen, schwarz-weiß gestreiften Ambiente bildet. Schwarze, gepolsterte Plastiksessel werden mit zeitgenössischer Kunst kombiniert, darunter ein großes Marilyn-Monroe-Bild von Russel Young. Verspiegelte Wände, glänzende Skulpturen, Esszimmerstühle mit Flügeln, ein muschelschalenförmiges Bett und zahlreiche andere opulente und spektakuläre Möbelstücke und Gegenstände schmücken das Interieur. Das Innenleben des Hauses spiegelt seine

Besitzerin perfekt wider: Amanda Eliasch, ein führender kreativer Kopf und eine große Kunstliebhaberin, die mithilfe von Innenarchitekt Nicholas Haslam eines der ungewöhnlichsten Heime in London schuf, das in einer Gegend liegt, die traditionell reiche, berühmte und schillernde Persönlichkeiten anzieht.

Derrière la façade de cette classique maison de ville inscrite au patrimoine (Grade II), c'est un univers unique, impertinent et excentrique qui se révèle. Inutile de chercher à donner un sens à la décoration intérieure : cette demeure défie toutes les conventions. Abondamment pourvue d'objets étranges et merveilleux, chaque pièce requiert simplement d'être admirée. Dans le couloir, un éléphant grandeur nature signé Marc Quinn accueille les visiteurs. Dans la salle à manger, le plafond rose contraste avec des rayures noires et blanches. Recouverts de plastique, des fauteuils noirs accompagnent les multiples oeuvres d'art contemporain, à l'exemple du vaste tableau de Russel Young représentant Marilyn Monroe. Murs recouverts de miroirs, sculptures brillantes, chaises pourvues d'ailes dans la salle à manger, lit en forme de coquillage, objets ou meubles somptueux, aussi éblouissants que spectaculaires, forment le décor de cette propriété. Située dans un quartier traditionnellement prisé des personnalités riches, célèbres ou originales, la demeure est le parfait reflet de son propriétaire, Amanda Eliasch, créatrice de génie et amatrice d'art qui, avec l'aide du décorateur Nicholas Haslam, a imaginé l'un des intérieurs les plus insolites de Londres. Si le duo n'a certes pas craint de briser les règles de la grande élégance bourgeoise, l'ensemble est cependant fondamentalement anglais. Et si le flegme en est absent, l'humour et l'extravagance compensent très largement.

11

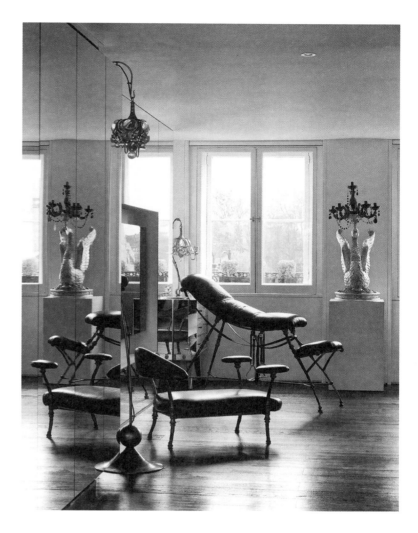

THE DÉCOR IS stylish and rebellious: lots of stunning statement pieces and eye-catching art are combined in a bold and beautiful mix, avoiding blank spaces or bland, minimalistic rooms.

DIE AUSSTATTUNG IST stilvoll und rebellisch: Viele beeindruckende Statement-Pieces werden in einer kühnen, wunderschönen Mischung mit Kunstwerken kombiniert, die ins Auge springen. Leere Flächen oder nichtssagende, minimalistische Räume werden so vermieden.

UNE DÉCORATION AUSSI frondeuse que raffinée, comme en témoigne le superbe et audacieux mélange de pièces maîtresse exceptionnelles et d'oeuvres d'art remarquables, bien loin des espaces vides et neutres du minimalisme.

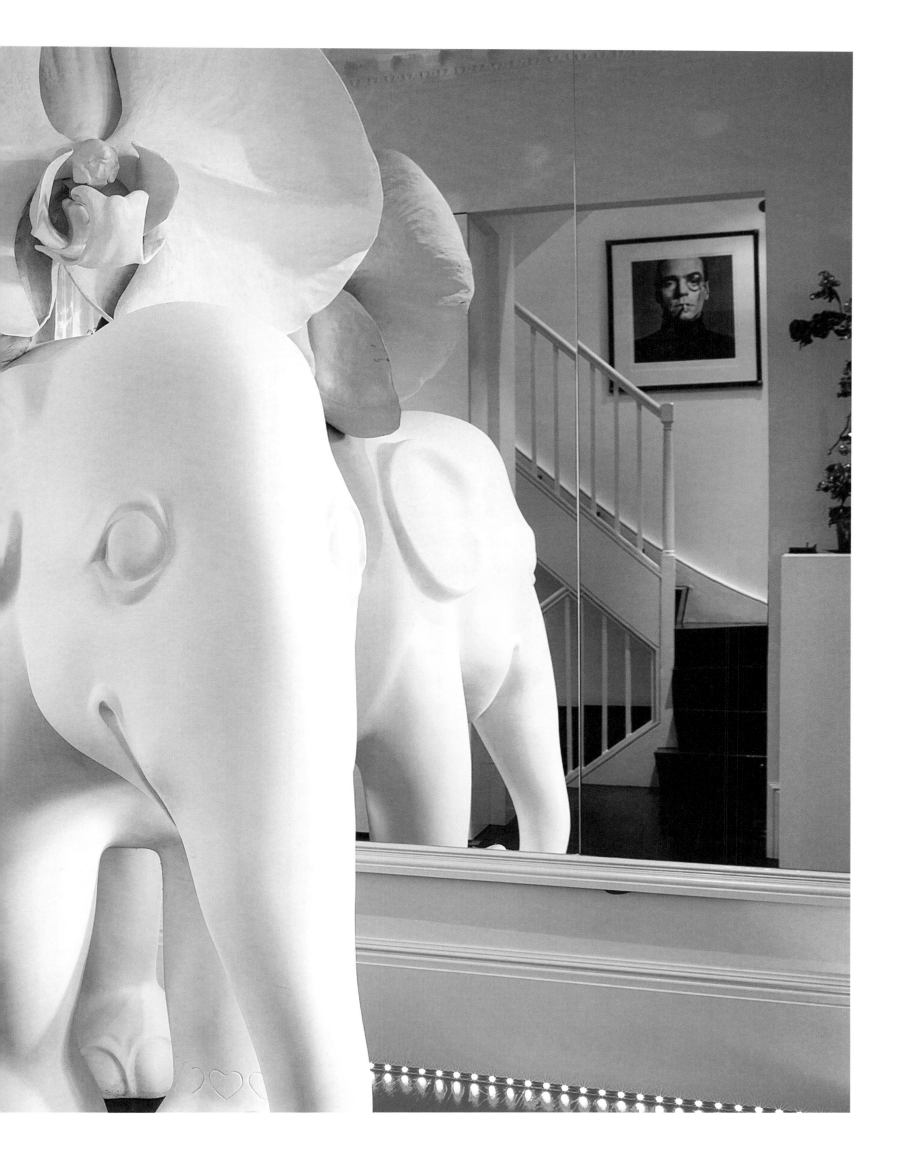

A BESPOKE HAVEN

Belgravia

It's hard to imagine that this beautiful and sophisticated family residence nestled in a quiet mews in Belgravia has been converted from a former pub. The building was demolished, and from scratch the owners built a home with an open-plan first floor dedicated to the formal reception rooms, with a bar and separate study. The house also has six bedrooms, a swimming pool and gym, a cinema room, a wine cellar, a garage and a private roof terrace. A beautiful helical staircase running through four floors of the house is just one of countless eye-catching features. In the living room, the Noir St. Laurent marble fireplace, with bronze-clad wall and shelves with golden lights is a perfect example of the use of bronze, alabaster, dimmed gold and glistening chrome throughout the house. Seamless elegance and the finest quality radiate from every inch of this home and most of the interior features are bespoke, with hand-sourced marble and made-to-measure furniture designed by Finchatton. All textures are handpicked according to the same high standards: silk, cashmere, wool and leather add opulence without indulgence. The ultimately timeless and unique design merges classic and contemporary elements and will look fresh and relevant for years to come.

Es ist schwer, sich vorzustellen, dass dieser wunderschöne und raffinierte Wohnsitz, in einer ruhigen Straße in Belgravia gelegen, in der sich früher die Stallungen der Herrenhäuser befanden, aus einem ehemaligen Pub entstanden ist. Das Gebäude wurde abgerissen, und der Besitzer baute anschließend neu. Er versah das erste Stockwerk, in dem sich die offiziellen Empfangsräume sowie eine Bar und ein separates Büro befinden, mit einem offenen Raumkonzept. Das Haus verfügt darüber hinaus über sechs Schlafzimmer, einen Swimmingpool, einen Fitnessraum, ein Kino, einen Weinkeller, eine Garage und eine nicht einsehbare Dachterrasse. Eine prachtvolle, spiralförmige Treppe, die vier Etagen des Hauses miteinander verbindet, stellt nur einen der zahlreichen Blickfänge dar. Der aus Noir St. Laurent Marmor gefertigte Kamin im Wohnzimmer mit seiner bronzeverkleideten Wand und den mit goldenem Licht ausgestatteten Regalen ist ein Musterbeispiel für die im Haus verwendeten Materialien Bronze, Alabaster, abgedunkeltes Gold und funkelndes Chrom. Jeder

12

Winkel dieses Hauses strahlt nahtlose Eleganz und allerhöchste Qualität aus. Der größte Teil der Innenausstattung beruht auf individuellen Wünschen und besticht durch persönlich ausgesuchten Marmor und maßgefertigte, vom Designbüro Finchatton entworfene Möbel. Entsprechend sind die Stoffe ebenfalls alle von bester Qualität und handverlesen: Seide, Kaschmir, Wolle und Leder fügen dem Interieur Opulenz hinzu, ohne dabei übertrieben zu wirken. Das letztlich zeitlose und einzigartige Design verbindet klassische und moderne Elemente, sodass es noch über viele Jahre hinweg frisch und zeitgemäß erscheinen wird.

Difficile d'imaginer que cette élégante et superbe demeure familiale, nichée dans un « mews » paisible de Belgravia, ait été conçue à partir d'un ancien pub. Repartant de zéro après avoir détruit le bâtiment d'origine, les propriétaires édifient une maison dont le premier étage offre un espace ouvert accueillant les salles de réception officielles, ainsi qu'un bar et un bureau. La résidence comporte également six chambres, une piscine, une salle de gymnastique, une salle de projection, une cave à vins, un garage et un toit-terrasse privé. Le magnifique escalier hélicoïdal qui relie les étages n'est que l'un des nombreux éléments qui attirent ici le regard. Témoignage parfait de l'usage du bronze, de l'albâtre, de l'or tamisé ou du chrome brillant à travers toute la demeure, le salon présente une cheminée en marbre noir Saint Laurent, un mur recouvert de bronze et des étagères aux lumières dorées. Une élégance fluide et une qualité extrême imprègnent chaque recoin de cette résidence. La plupart des éléments de la décoration ont été spécifiquement conçus, que ce soit avec le marbre choisi localement ou les meubles réalisés sur mesure par Finchatton. Conformément à ces rigoureux critères, les textures ont été triées sur le volet : la soie, le cachemire, la laine et le cuir évoquent une opulence sans complaisance. Mêlant classique et contemporain, la décoration au final intemporelle et singulière paraîtra longtemps originale et pertinente.

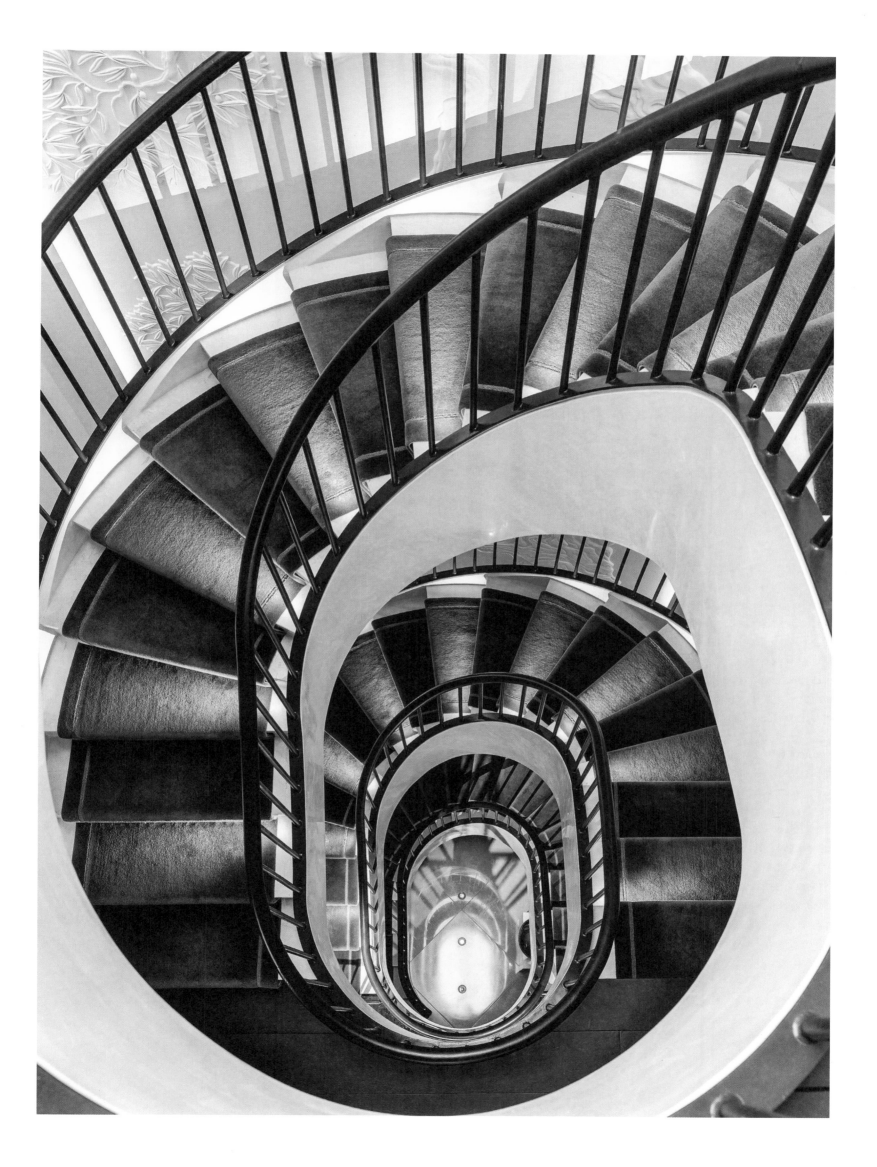

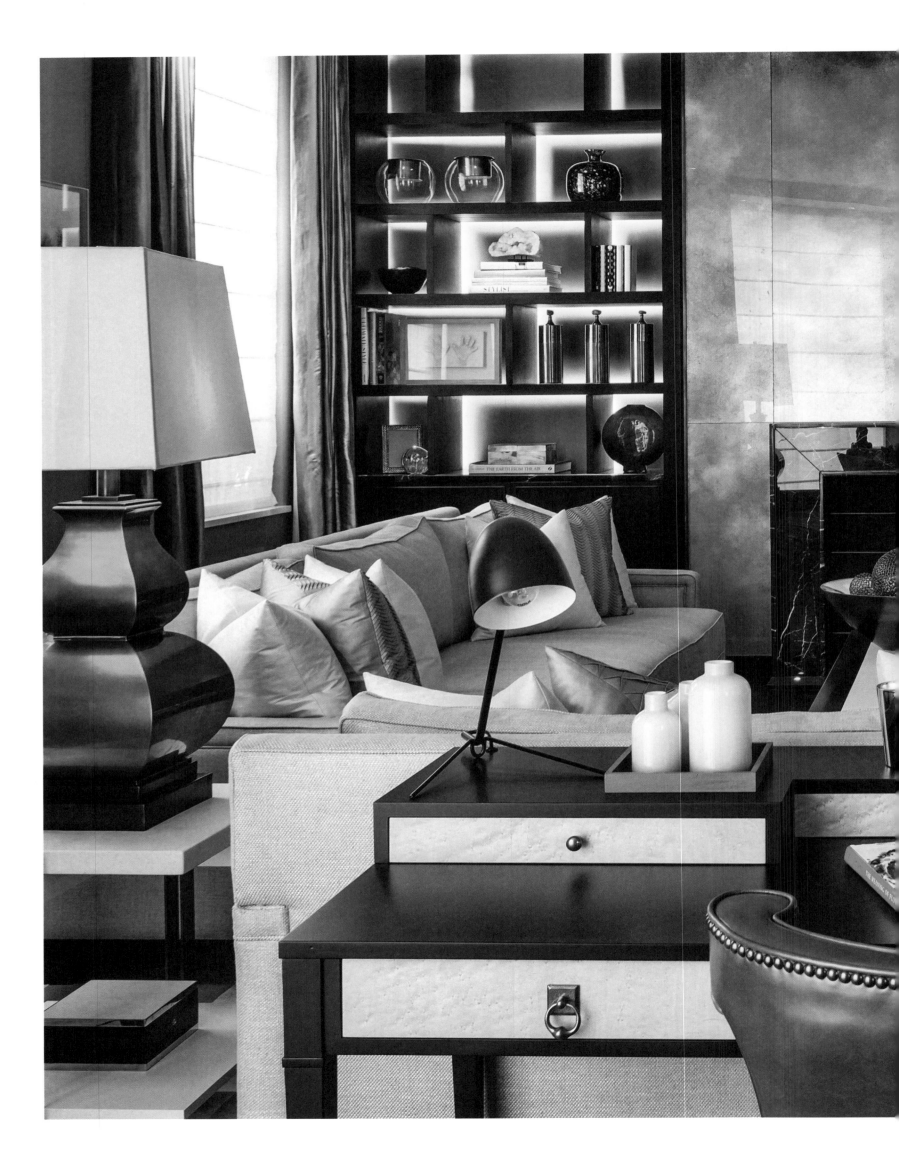

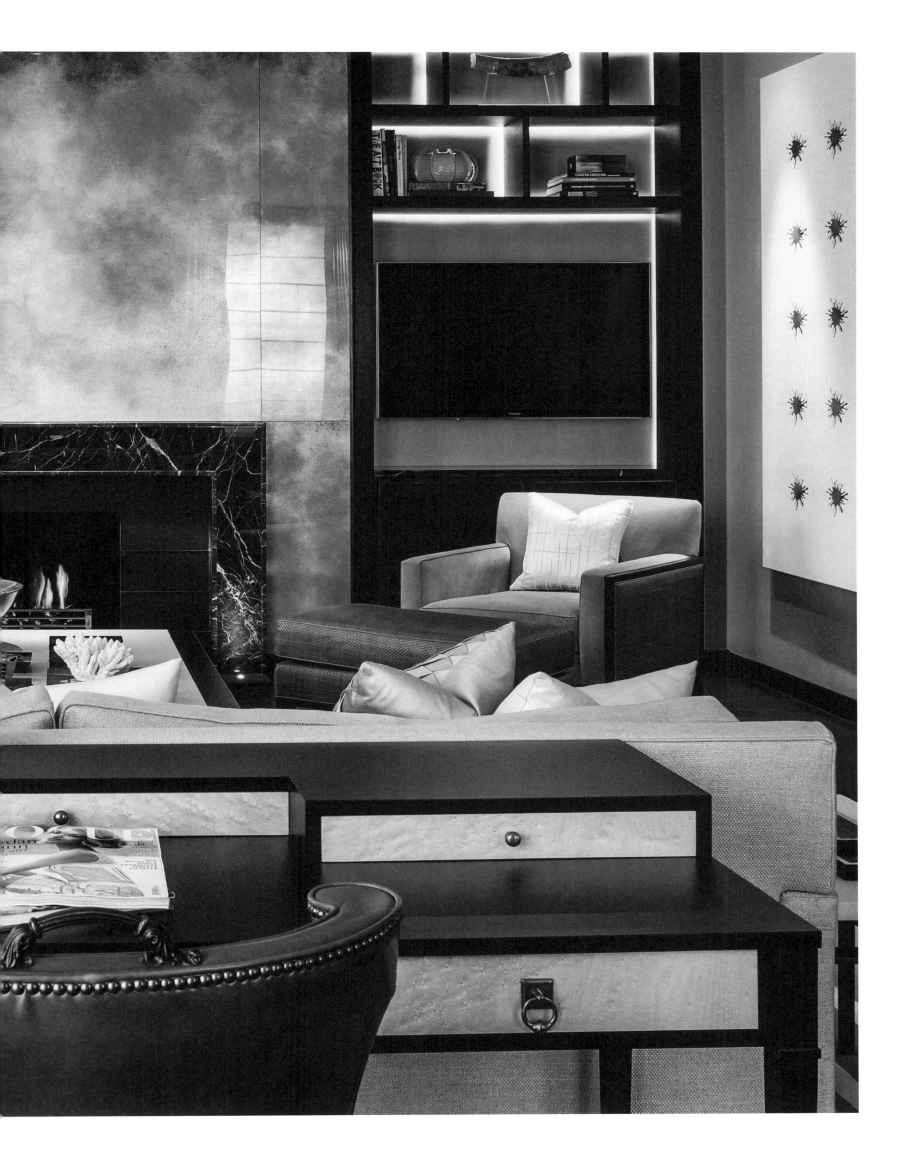

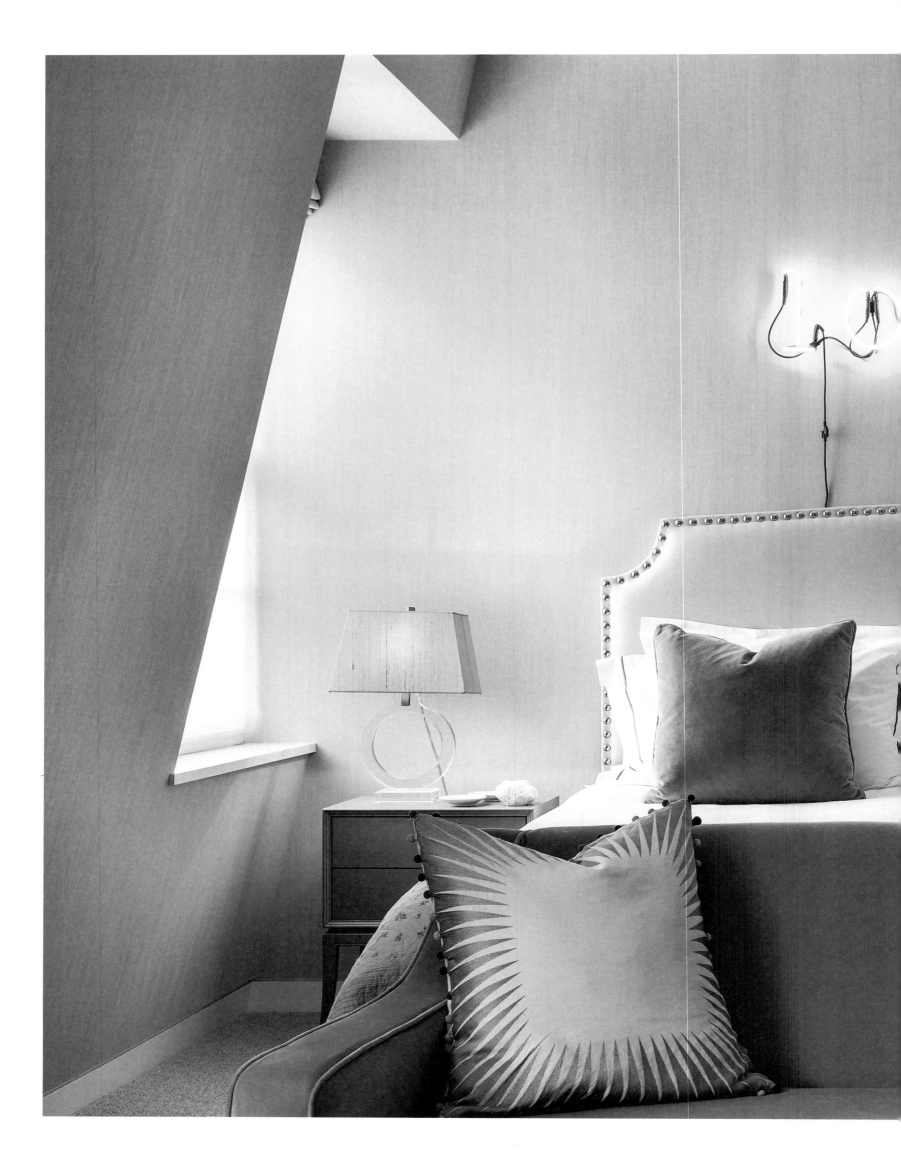

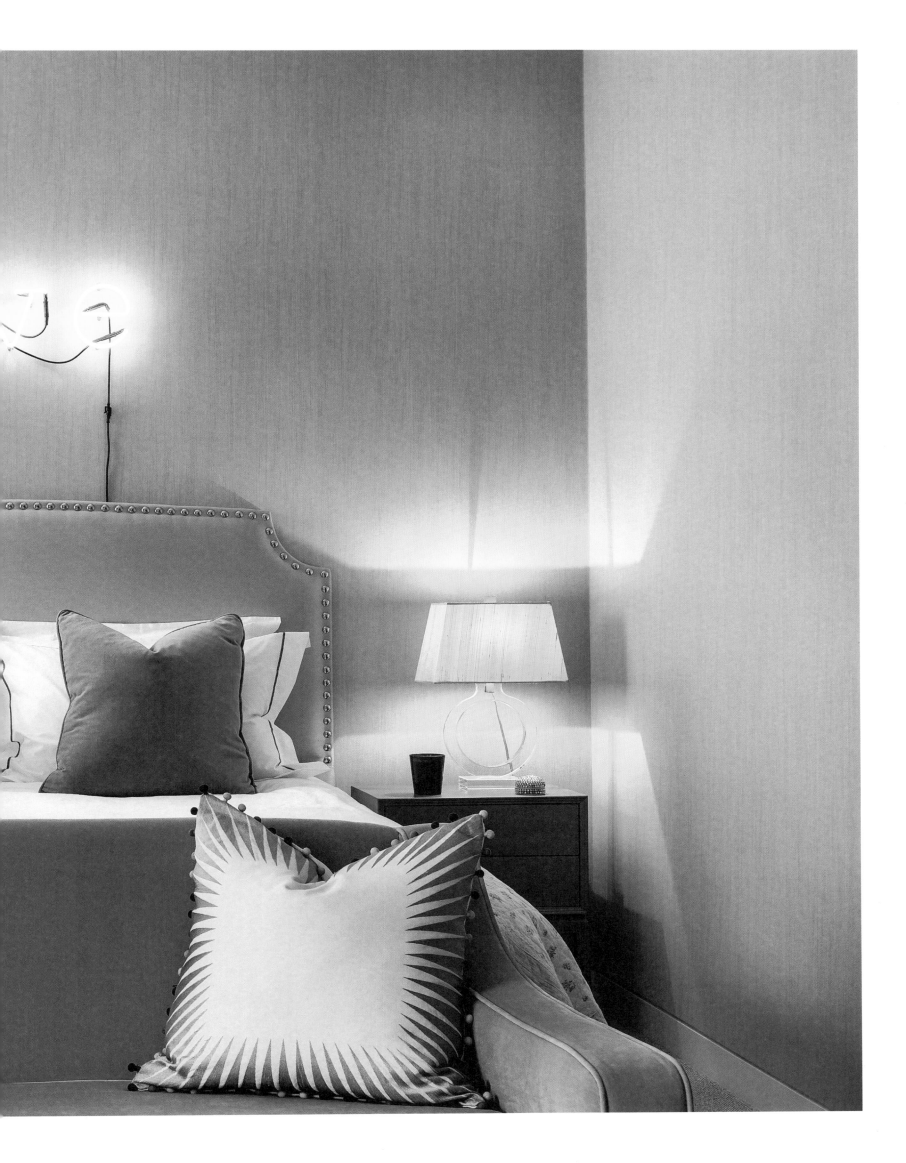

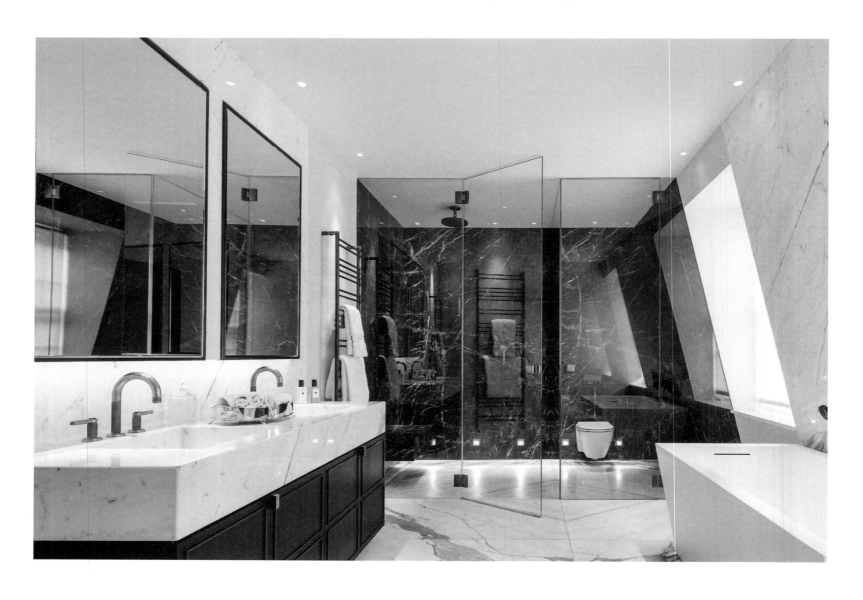

THE MASTER BATHROOM is one of the most carefully designed rooms, and is a repository of luxury. It is also a reminder that bathrooms can be as spectacular a space in the home as other rooms. The size of the bathroom is strikingly large and features book-matched statuary and Grigio Carnico marbles, and Kallista tapware.

DAS BADEZIMMER IST einer der am sorgfältigsten gestalteten Räume und präsentiert sich als wahrer Ort des Luxus. Ein Beweis dafür, dass Bäder genauso atemberaubend sein können wie jeder andere Wohnbereich eines Zuhauses. Dieses Bad ist von beeindruckender Größe und weist spiegelsymmetrischen, weißen Marmor aus Carrara, Grigio Carnico-Marmor sowie Armaturen von Kallista auf.

ECRIN DE LUXE, la salle de bain parentale est l'une des pièces les plus minutieusement conçues, prouvant par là que cet espace peut être tout aussi spectaculaire que les autres pièces. Remarquablement vaste, elle se compose de marbres statuaire et Grigio Carnico disposés de sorte à créer un effet miroir, ainsi que d'une robinetterie Kallista.

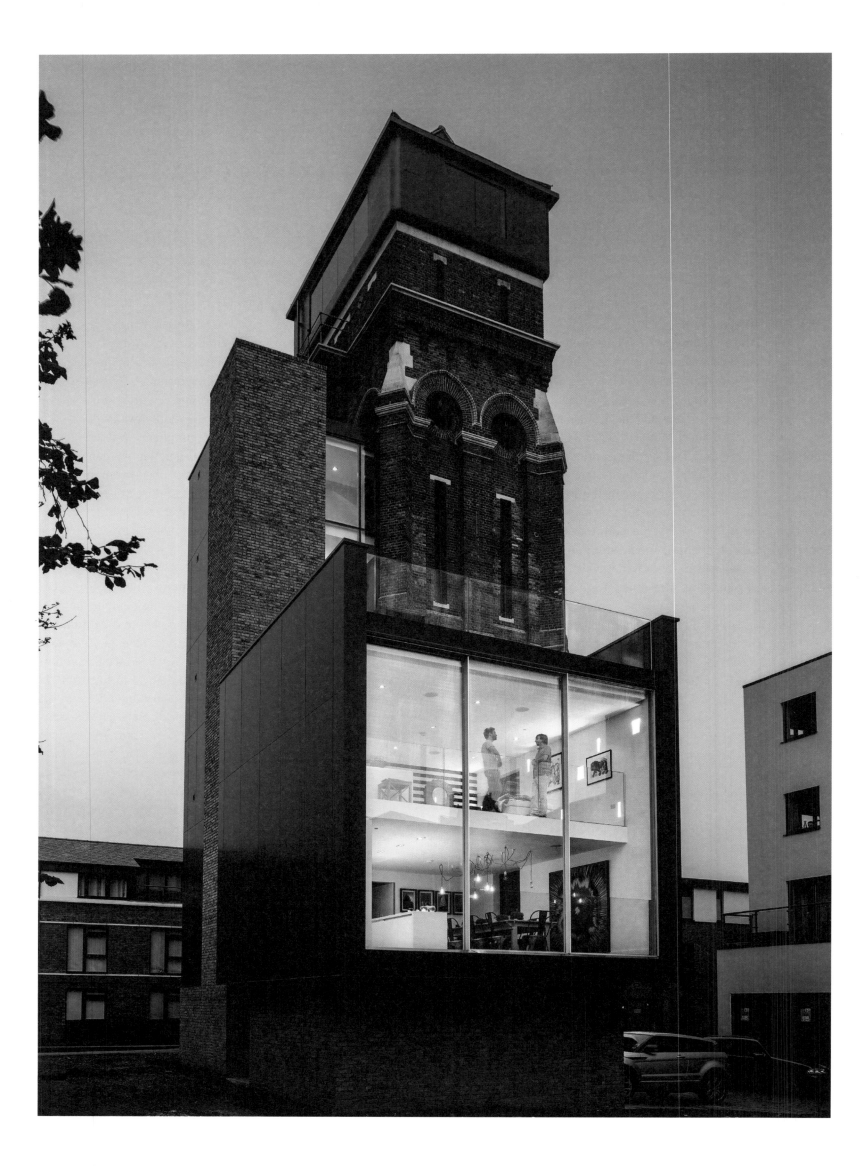

THE TOWER HOUSE

Kennington

When this couple discovered that a magnificent 100-foot, Italianate Victorian water tower in Kennington, South London, was for sale, they became curious. They were obsessed with the idea of living in such an unusual location. They decided to take on the massive task of transforming the tower, which was at serious risk of collapse. Today it is a truly unique living space with 'wow' factor. Upon completion, the work had blown the budget many times. Architect Mike Collier of ACR brought brilliant solutions to structural and aesthetic problems, and they brought in their friend, the designer Sue Timney, who amongst other work in the tower, was responsible for the blue colour schemes and the strong, crisp, 'no flower' masculine design. Four bedrooms, a dressing room, study and a gym were created within the original walls. The living spaces, one above the other, were made with the addition of a new 3-storey 'cube' structure providing a ground-level garage, kitchen-dining room, living room and a terrace on the top. A glass-walled link was made between the new cube and the old structure and connects to the lift tower, which was built on an exterior wall. Amazingly the original water tank was saved, much of it cut away and made into the 'prospect room', with huge custom windows providing possibly the best views of any private home in London.

Als dieses Londoner Paar herausfand, dass ein prächtiger, 30 Meter hoher viktorianischer Wasserturm im Italianate-Stil in Kennington, Südlondon, zum Verkauf stand, war seine Neugierde geweckt. Die Vorstellung, in einem so ungewöhnlichen Gebäude zu wohnen, ließ beide nicht mehr los. Sie beschlossen, die Mammutaufgabe anzunehmen und den einsturzgefährdeten Turm umzuwandeln. Heute bildet er den Rahmen eines wahrlich einzigartigen Wohnraums mit „Wow"-Faktor. Das Budget wurde um ein Vielfaches gesprengt, wie sich nach Abschluss der Umbauarbeiten herausstellte. Mike Collier, Architekt des Büros ACR, brachte geniale Vorschläge ein, um die baulichen und ästhetischen Probleme zu lösen. Zusätzlich zeichnete die befreundete Innenarchitektin Sue Timney neben anderen Dingen für die blaue Farbgestaltung und das kräftige, frische, „unblumige" maskuline Design verantwortlich. Im ursprünglichen Gemäuer wurden vier Schlafzimmer, ein Ankleidezimmer, ein Arbeitszimmer und ein Fitnessraum untergebracht. Ein dreigeschossiger Anbau in Form eines Kubus wurde geschaffen, in dem sich die Wohnräume befinden: eine Garage im Erdgeschoss, Küche und Essbereich im ersten Stock, darüber das Wohnzimmer und ganz oben eine Terrasse. Zwischen dem neuen Kubus und dem alten Gebäude wurde ein verglaster Gang gebaut, der zu dem an einer Außenwand des Turms errichteten Aufzug führt. Der ursprüngliche Wasserspeicher, der erstaunlicherweise gerettet werden konnte, wurde zum größten Teil abgetragen und zum „Aussichtszimmer" umgestaltet. Mit seinen maßgefertigten Fenstern bietet es wohl einen der besten Panoramablicke eines Privathauses auf die Stadt.

Lorsqu'il découvre qu'un splendide château d'eau de près de 30 mètres de hauteur, de style victorien italianisant, est à vendre à Kennington, dans le sud de Londres, le couple, séduit à l'idée de vivre dans un lieu aussi inhabituel, s'y intéresse. Il décide d'entreprendre les gigantesques travaux de transformation de la tour qui risque alors sérieusement de s'effondrer, et parvient à créer ce qui est aujourd'hui un lieu de vie absolument unique et saisissant. A l'achèvement du chantier, le budget a été maintes fois dépassé. Aux problèmes structurels et esthétiques, l'architecte Mike Collier, d'ACR, a su apporter de magistrales réponses, cependant que la designer et amie du couple, Sue Timney a conçu la palette de bleus qui accompagne le décor masculin, net et affirmé, dépourvu de toutes « fioritures ». A l'intérieur des murs d'origine, quatre chambres, un dressing, un bureau et une salle de sport ont été créés. Une structure de trois étages en forme de cube a été ajoutée, offrant des espaces de vie superposés qui incluent un garage en rez-de-chaussée, une cuisine-salle à manger, ainsi qu'un salon, et enfin, une terrasse au sommet. Reliée à la cage de l'ascenseur construit le long d'un mur extérieur, une paroi de verre unit le cube à l'ancienne structure. Etonnament, le bassin d'eau originel a été conservé, son espace épuré et pourvu de vastes fenêtres faites sur mesure, ce qui en fait une « salle d'observation » d'où le point de vue sur la ville est assurément le plus remarquable que puisse offrir une demeure privée londonienne.

13

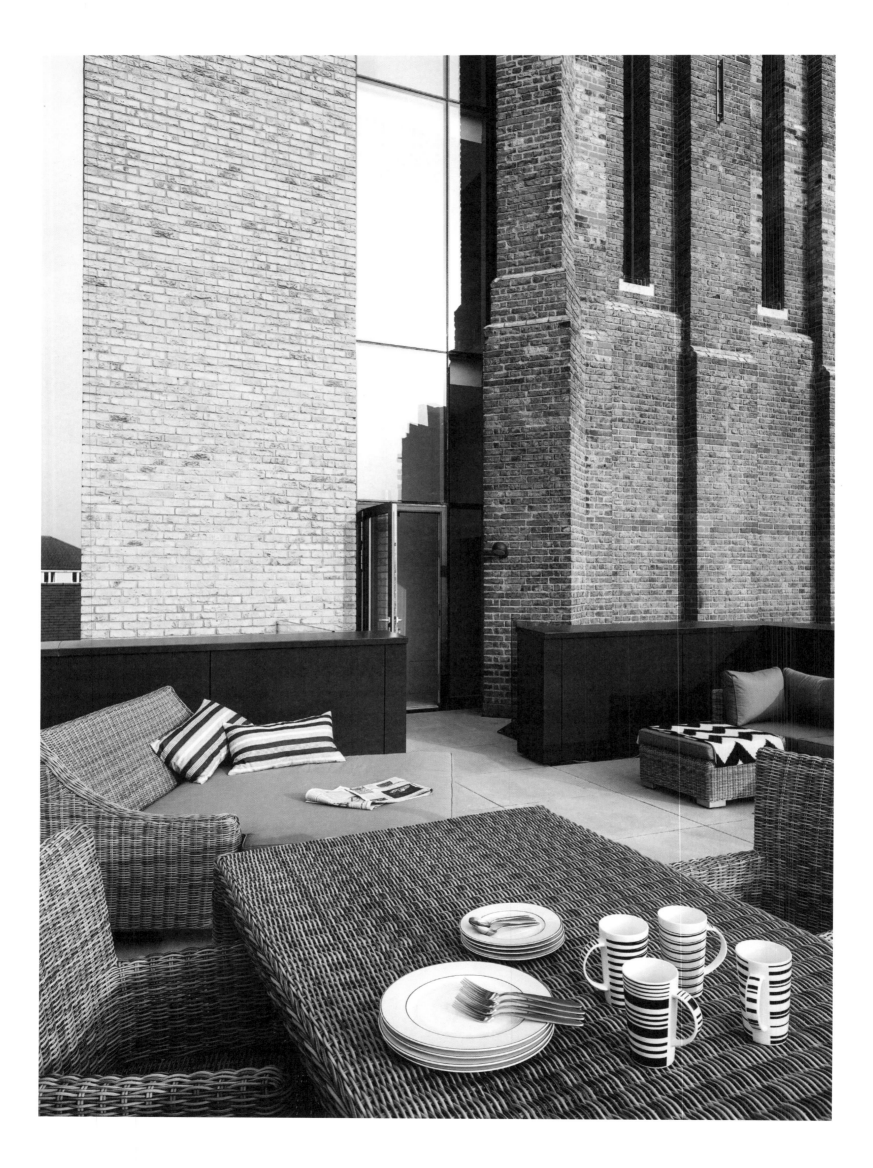

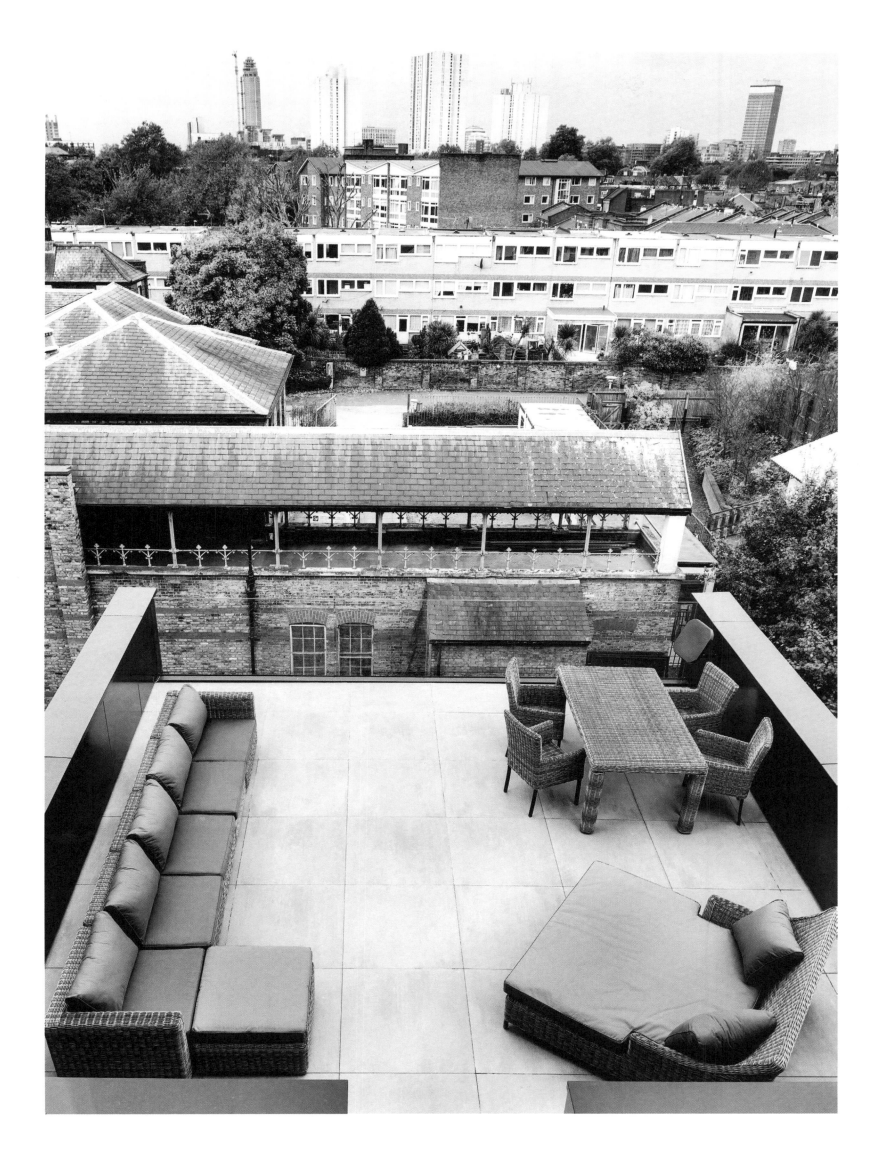

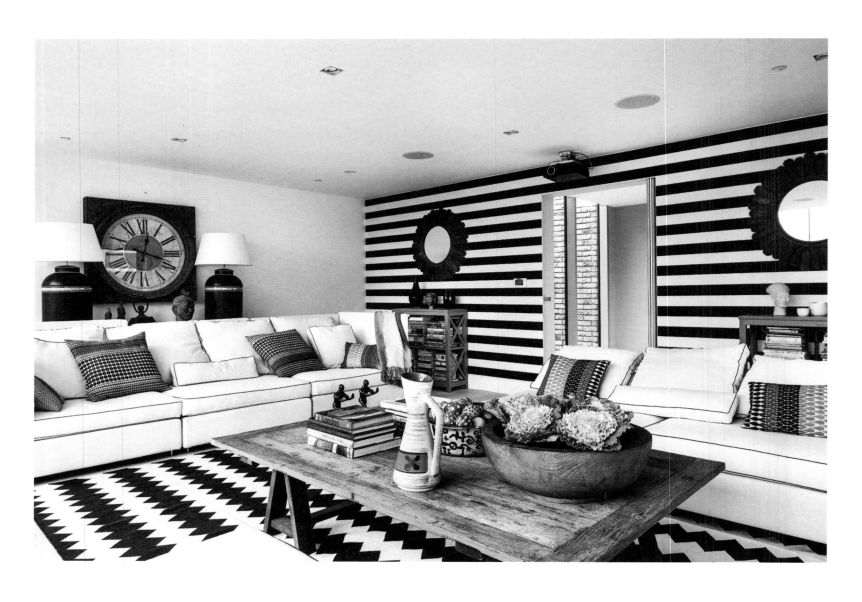

THE FIRST-FLOOR LIVING room with a five-piece Brooklyn sofa set and Tribal coffee table features a striking black and white scheme by Sue Timney, using bold striped wallpaper and a chevron-patterned rug. The stripes enhance the feeling of space in the low-ceilinged room.

DAS WOHNZIMMER IM ersten Stock, eingerichtet mit einer fünfteiligen Brooklyn-Sofagarnitur und einem Couchtisch von Tribal, besticht durch sein von Sue Timney konzipiertes schwarz-weißes Erscheinungsbild, das sich in einer breit gestreiften Tapete und einem Teppich mit Fischgrätmuster äußert. Die Streifen verbessern das Raumgefühl in diesem Zimmer, das über eine niedrige Decke verfügt.

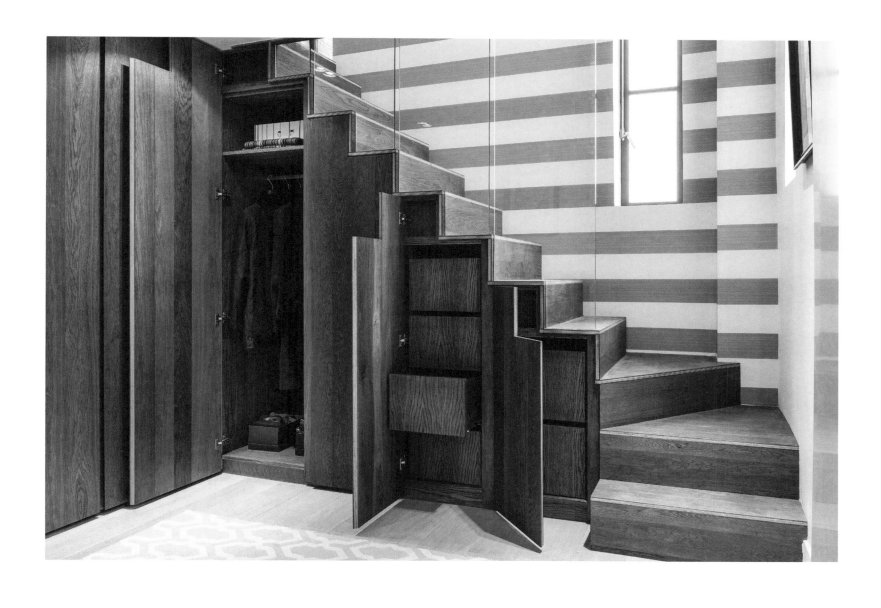

MEUBLÉ D'UN CANAPÉ Brooklyn composé de cinq éléments, ainsi que d'une table basse Tribal, le salon du premier étage offre un saisissant motif en noir et blanc que Sue Timney décline au travers d'un tapis à chevrons et d'un papier peint à larges rayures. Celles-ci renforcent la sensation d'espace dans cette pièce au plafond bas.

GLAMOROUS & GREGARIOUS

KENSINGTON

Don't judge a book by its cover – perhaps the same can be said about buildings, it's certainly true in the case of this mid-terrace house built in a pseudo Georgian style in the 1970s. It is located in the heart of the historic Arts and Crafts area of Holland Park. Although undistinguished externally, the house hides a surprising interior with a touch of old-school glamour and French rococo. An entry hall with a three-storey staircase is the impressive heart of the home and also doubles as a party space. The revamp of the house, carried out by Studio Indigo, has resulted in an elegant and timeless decor with exquisite antiques and art designed to reflect the owner's gregarious and glamorous lifestyle. On the ground floor a large, lateral drawing room stretches across the rear of the house overlooking the landscaped garden. On the first floor a new master bedroom with an ensuite bathroom and dressing room have been created, with further guest bedrooms on the floor above. A four-poster bed with padded headboards and an old travel trunk at the end are a nod to a bygone era. The lower ground floor is the family space, which opens onto the garden, and a large swimming pool on two levels is flooded with light from the skylights.

Beurteile ein Buch nicht nach seinem Einband – vielleicht gilt dies ebenfalls für Gebäude. Auf jeden Fall trifft es für dieses Reihenmittelhaus zu, erbaut im pseudogeorgianischen Stil in den 1970er-Jahren. Es befindet sich inmitten des historischen Arts-and-Crafts-Bezirks von Holland Park. Auch wenn das Gebäude von außen unauffällig wirkt, verbirgt es ein überraschendes Innenleben, das eine Spur altehrwürdigen Glamours und französischen Rokokos aufweist. Eine Eingangshalle mit dreistöckigem Treppenhaus bildet das eindrucksvolle Herzstück dieses Hauses und dient ebenfalls als Raum, um Feste zu feiern. Die Umgestaltung des Gebäudes, realisiert von Studio Indigo, führte zu einem eleganten, zeitlosen Dekor, das sich durch auserlesene Antiquitäten und Kunst auszeichnet, die den geselligen und glamourösen Lebensstil der Besitzer widerspiegeln. Im Erdgeschoss erstreckt sich über die Rückseite des Hauses ein großes Wohnzimmer mit Blick zu dem Landschaftsgarten. Ein neues Elternschlafzimmer mit angeschlossenem Bad und Ankleidezimmer wurde im ersten Stock geschaffen. In der Etage darüber befinden sich weitere Gästezimmer. Ein Himmelbett mit gepolstertem Kopfende und ein alter Überseekoffer verweisen still auf eine längst vergangene Ära. Das zum Garten liegende Untergeschoss dient der Familie als gemeinsamer Raum, und ein großer, über zwei Ebenen verlaufender Pool, erscheint durch die Dachfenster in hellem Licht.

14

L'habit ne fait pas le moine, dit-on – maxime sans doute applicable aux édifices et assurément vraie pour cette maison mitoyenne de style pseudo-georgien, bâtie à la fin des années 1970 dans le quartier historique – « Arts & Crafts » – de Holland Park. Si rien ne la distingue extérieurement, la demeure n'en abrite pas moins un intérieur étonnant, entre glamour à l'ancienne et rococo à la française. Avec son escalier courant sur trois étages, l'impressionnant hall d'entrée constitue le coeur de la maison et sert également d'espace de réception. Entreprise par le Studio Indigo, la rénovation a donné lieu à une décoration élégante et intemporelle où les meubles anciens et les objets d'art raffinés reflètent le sens de la convivialité du propriétaire, aussi bien que son goût pour le glamour. Au rezde-chaussée, un vaste salon latéral s'étend jusqu'à l'arrière de la maison et donne sur le jardin à l'anglaise. Au premier étage, une suite parentale avec salle de bain et dressing a été créée, cependant que des chambres d'invités ont été installées à l'étage supérieur. Le lit à baldaquin, avec son chevet capitonné, et la vieille malle de voyage sont autant de clins d'oeil à une époque révolue. Constituant l'espace familial, le rez-de-chaussée inférieur donne sur le jardin. Déployée sur deux niveaux, la piscine est éclairée par des fenêtres de toit.

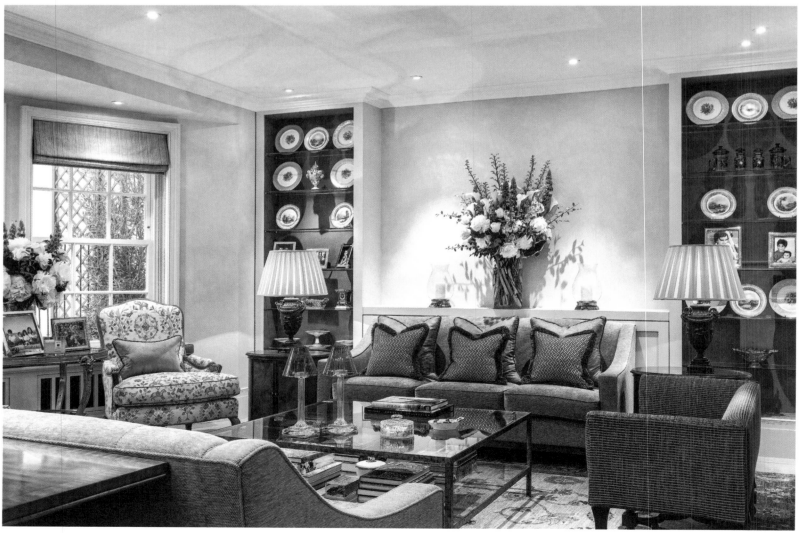

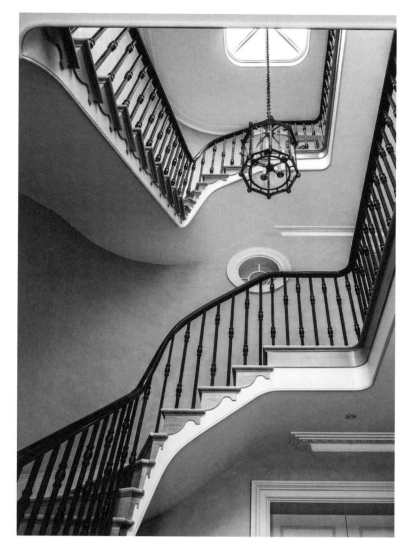

THE QUALITY OF design, the materials and the glamorous touches are impeccable. Lots of flowers, warm pink tones of velvet and faded satin on French rococo chairs make this a warm and welcoming space.

DER ENTWURF, DIE Materialien und glamouröse Details bestechen durch makellose Qualität. Durch die zahlreichen Blumengestecke und warmen Rosatöne der mit Samt und blassem Satin bezogenen französischen Rokoko-stühle wirkt dieser Raum behaglich und einladend.

LE DESIGN ET les matériaux, aussi bien que les touches de glamour sont impeccables. Les nombreuses fleurs, les teintes roses chaleureuses des velours et des satins passés qui recouvrent les chaises rococo à la française, font de cette demeure un espace particulièrement accueillant.

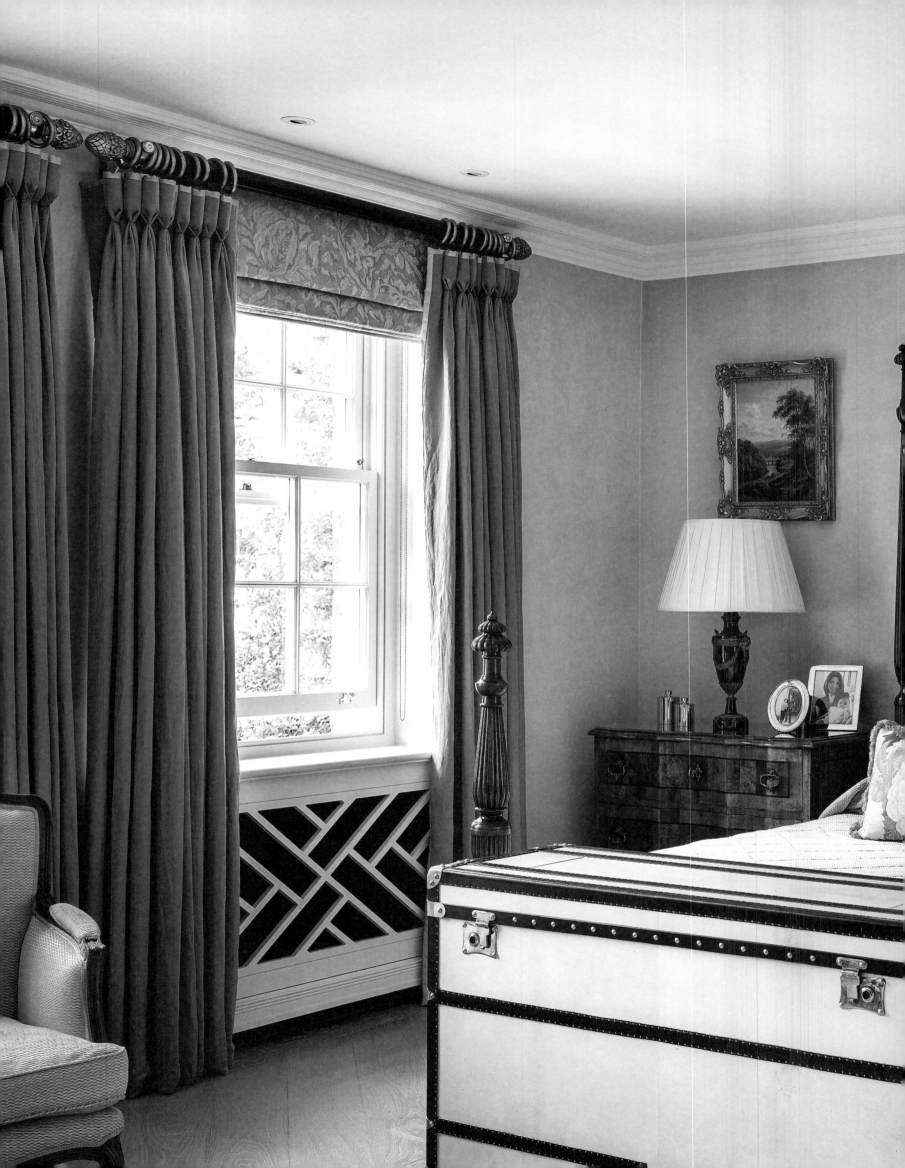

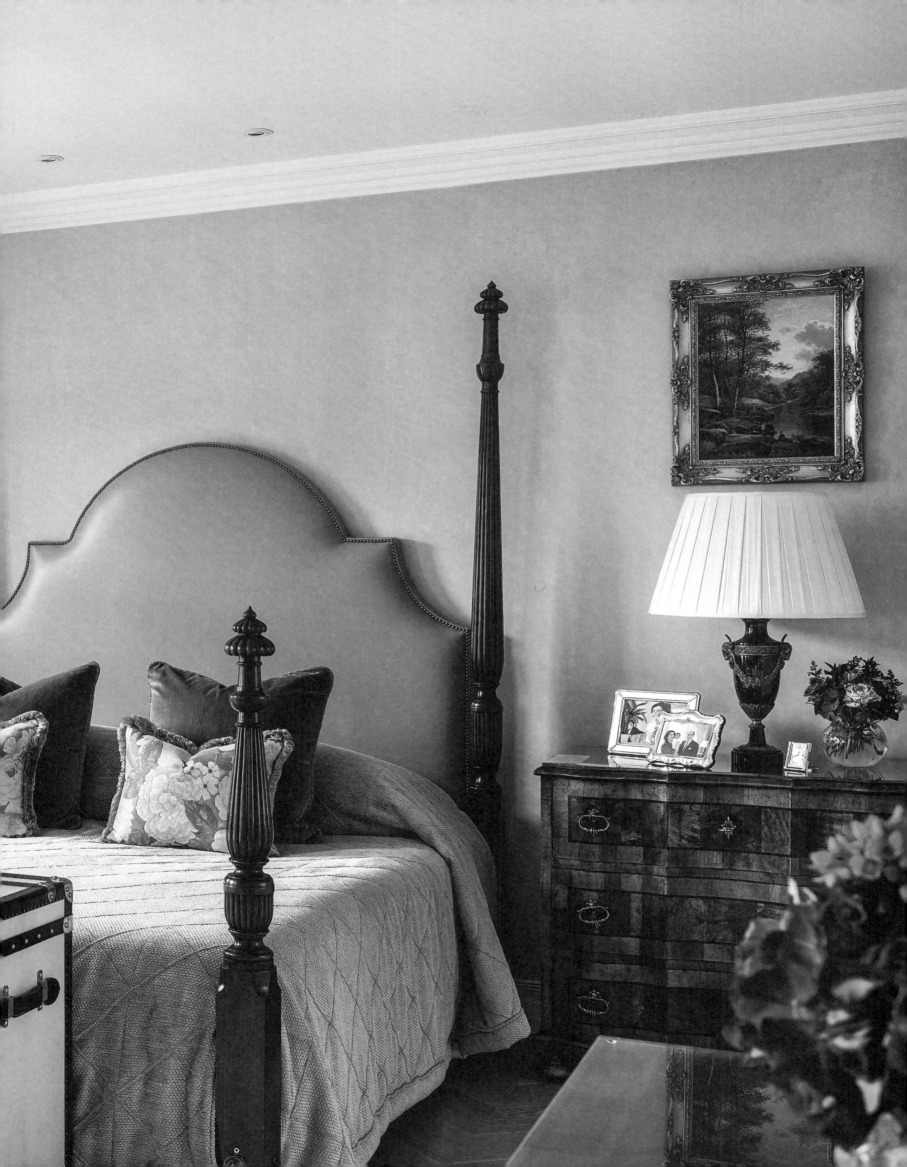

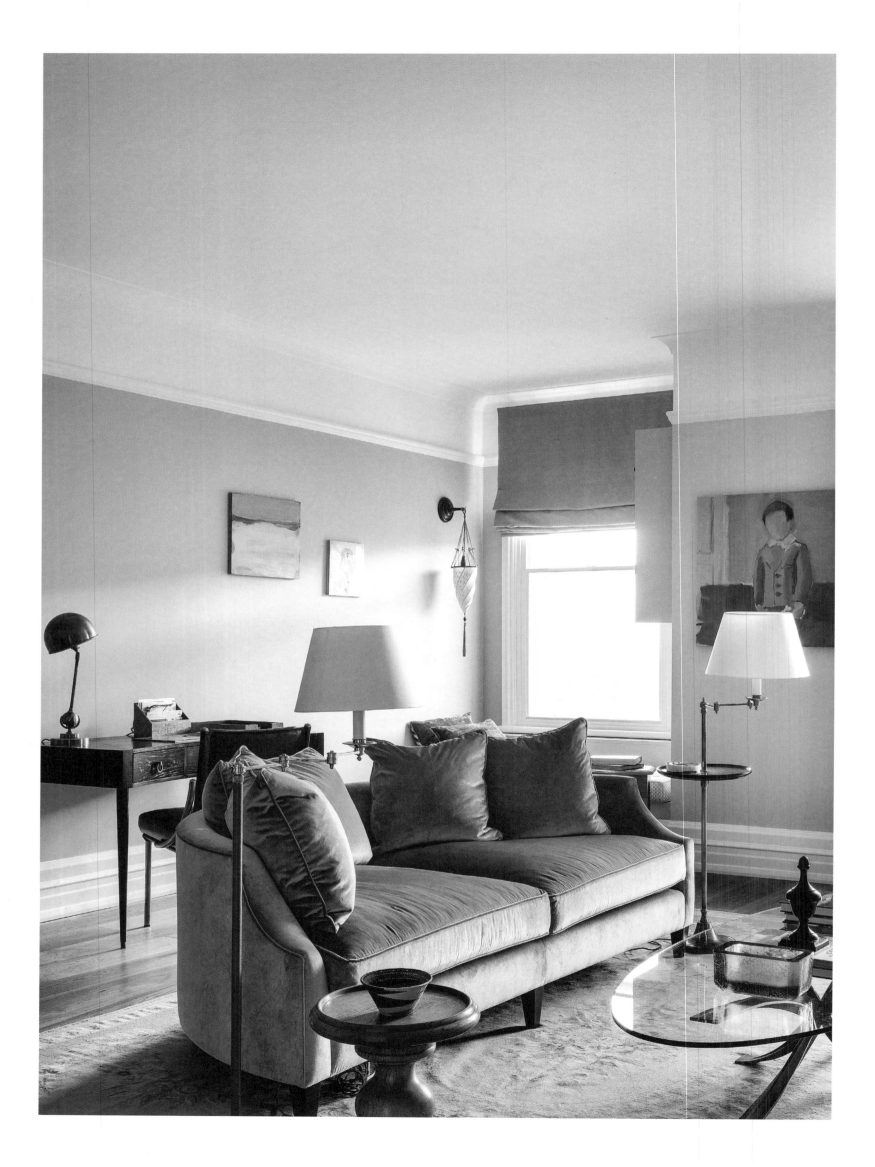

URBAN HIDEAWAY

Hampstead

In a busy, international city like London, many people divide their time between several countries, and properties are often second homes to jet-setters and global business people. In this case, the owner has created a timeless urban refuge in green Hampstead to accommodate her scattered family at any time whenever they visit London. The interior designer Ulrich Tredup has given this apartment in a Victorian style building a modern direction with a rich mix of traditional materials and contemporary influences. The floor plan was optimised, the master bathroom enlarged and four bathrooms reduced to three. Three bedrooms, two reception rooms, a kitchen and two balconies provide ample space for any visitors. An interesting and pretty colour scheme of greenish greys, dusky pinks and golden tones brings a poetic softness and edge to the interior. Oak wood floors are combined with silk rugs in all the rooms, and the aesthetic balances between traditional and cosy versus modern clean lines. Gorgeous chandeliers, antique pieces and striking art works are placed as interesting focal points in each room. The velvet mustard coloured Fox Linton sofa in the living room, Fornasetti plates on the wall in the bathroom, a fine Edwardian mahogany vitrine, and an exquisite hand-painted de Gournay wallpaper in the bedroom are some of the standout features.

In einer geschäftigen Metropole wie London gibt es viele Menschen, die ihre Zeit zwischen mehreren Ländern aufteilen. Immobilien sind häufig Zweitwohnsitze für Jetsetter und weltweit agierende Geschäftsleute. Bei diesem Haus hier hat die Eigentümerin einen urbanen Zufluchtsort im grünen Hampstead geschaffen, um ihre verstreut lebende Familie zu beherbergen, wann immer diese in London zu Besuch ist. Der Innenarchitekt Ulrich Tredup hat diesem Apartment, das sich in einem Gebäude im viktorianischen Stil befindet, einen modernen Anstrich verliehen, was sich in einer prächtigen Mischung aus traditionellen Materialien und zeitgenössischen Einflüssen äußert. Der Grundriss wurde optimiert, das Hauptbadezimmer vergrößert und die Anzahl der Gästebadezimmer von vier auf drei reduziert. Drei Schlafzimmer, zwei Wohnzimmer, eine Küche und zwei Balkone bieten viel Platz für Besucher. Die aus grünlichem Grau, dunklem Rosa und verschiedenen Goldtönen bestehende interessante und bezaubernde Farbgestaltung verleiht dem Innenbereich Struktur und eine poetische Sanftheit. In sämtlichen Räumen wurden

15

Eichenholzböden verlegt und mit Seidenteppichen kombiniert. Das Erscheinungsbild hält auf ästhetische Weise das Gleichgewicht zwischen Tradition, Gemütlichkeit und modernen, klaren Linien. Prächtige Kronleuchter, antikes Mobiliar und eindrucksvolle Kunstgegenstände wurden als interessante Blickfänge in den einzelnen Räumen platziert. Das senffarbene, samtbezogene Sofa von Fox Linton im Wohnzimmer, die Fornasetti-Teller an der Wand im Badezimmer, eine edle, edwardianische Vitrine aus Mahagoniholz und eine auserlesene, handbemalte de-Gournay-Tapete im Schlafzimmer stellen einige der herausragenden Objekte dar.

Dans cette ville internationale et active qu'est Londres, nombreux sont ceux qui partagent leur temps entre plusieurs pays. Pour ces hommes ou femmes d'affaires, ces jet-setteurs qui travaillent dans le monde entier, la maison devient alors souvent un second foyer. Ici, la propriétaire a créé un refuge urbain intemporel, au coeur du verdoyant quartier de Hampstead, afin d'y accueillir, chaque fois qu'ils se rendent dans la capitale anglaise, les membres disséminés de sa famille. Imprimant une orientation moderne à cet appartement situé dans un immeuble de style victorien, l'architecte d'intérieur Ulrich Tredup associe avec générosité matériaux traditionnels et influences contemporaines. Le plan au sol a été optimisé, la chambre principale agrandie et les quatre salles de bain réduites à trois. Les trois chambres, les deux salles de réception, la cuisine et les deux balcons offrent un bel espace aux visiteurs. L'intéressante palette de gris tirant sur le vert, de roses sombres ou de touches dorées introduit une dimension poétique d'une agréable douceur. Dans tout l'appartement, les parquets en chêne se combinent à des tapis en soie, cependant que les choix esthétiques s'inscrivent entre tradition, confort et lignes nettes et modernes. De superbes lustres, des objets ou meubles anciens, de singulières oeuvres d'art sont disposés dans chaque pièce de sorte à former un attrayant point de mire. Le canapé Fox Linton en velours jaune moutarde dans le salon, les assiettes Fornasetti accrochées sur le mur de la salle de bain, une délicieuse vitrine en acajou de style édouardien, ou encore, un délicat papier peint à la main signé de Gournay dans la chambre constituent quelques-uns de ces remarquables éléments.

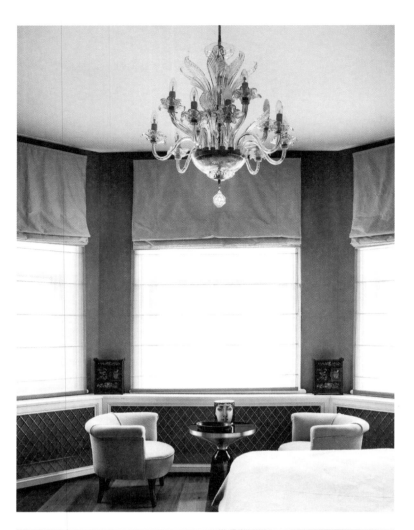

ON A UNIFIED backdrop of muted and pale colours, interesting art, sculptures or a striking, dark red velvet chair by Corrado Corradi Dell'Acqua pop out and give each room a very distinct character. Most of the furniture and decorative objects are hand-selected antique and vintage pieces as well as vintage reproductions, ranging from a Saarinen table in the kitchen to an Fornasetti ashtray.

INTERESSANTE KUNST, SKULPTUREN oder ein auffälliger, mit dunkelrotem Samt bezogener Stuhl von Corrado Corradi Dell'Acqua bestechen vor einem einheitlichen Hintergrund und verleihen jedem Raum einen eigenen Charakter. Ein Großteil des Mobiliars und der dekorativen Gegenstände besteht aus handverlesenen Vintage-Stücken, Vintage-Reproduktionen oder Antiquitäten und bildet von einem Saarinen-Tisch in der Küche bis hin zu einem Fornasetti-Aschenbecher ein breites Spektrum.

MIS EN VALEUR par un fond harmonieux de teintes douces et claires, les étonnantes oeuvres d'art et sculptures, ou encore, le remarquable fauteuil en velours rouge foncé de Corrado Corradi Dell'Acqua, donnent à chaque pièce un caractère particulier. Qu'ils soient anciens ou rétro, ou qu'il s'agisse de reproductions vintage, la plupart des meubles ou objets décoratifs ont été soigneusement choisis – depuis la table Saarinen de la cuisine jusqu'au vieux cendrier Fornasetti.

EXQUISITE VIEW

Central London

It's understandable if dinner guests get distracted when gathering around the elegant dining table of this stylish riverside apartment in Central London. The panorama is absolutely spectacular, offering an uninterrupted view of the River Thames and some of London's most iconic buildings, including the Houses of Parliament, Big Ben and the London Eye. When the architects of Oro Bianco planned the design of this modern apartment, the entire floor plan was laid out to make the most of this view. The dining room and living room are both facing the river. These rooms are partly divided by a decorative wall creating two distinct areas. At the end of the half wall, the two rooms open up to one big kitchen space, which overlooks both areas and once more highlights the breathtaking London scenery. The apartment itself is equally stunning, incorporating all the latest smart home gadgets. Luxurious materials, such as the crystal and brass pendants above the marble breakfast bar in the kitchen, give the home an incredible sharp and classic finish with a touch of a timeless gentleman's club. Walls are dedicated to an extensive collection of art, books, and photos, while carefully selected decorative objects are displayed in elegant built-in shelves.

Es ist verständlich, dass Gäste abgelenkt werden, wenn sie an dem eleganten Esstisch dieses stilvollen, an der Themse gelegenen Apartments in Central London sitzen. Die Aussicht ist absolut atemberaubend und bietet einen freien Blick auf den Fluss sowie auf einige der symbolträchtigsten Gebäude Londons, darunter das Parlament, Big Ben und London Eye. Als die Architekten von Oro Bianco die Wohnung entwarfen, legten sie den gesamten Grundriss so aus, dass der Ausblick bestmöglich ausgenutzt wurde. Ess- und Wohnraum sind zum Fluss gerichtet und bilden durch eine Trennwand eigene Bereiche. Die Räume münden am Ende dieser Wand in eine große offene Küche, die beides überblickt. Das fulminante Stadtbild Londons wird erneut hervorgehoben. Das Apartment selbst, mit den modernsten Smart-Home-Geräten ausgestattet, ist gleichermaßen fantastisch. Luxuriöse Materialien wie das Kristall und das Messing der Hängelampen über der marmornen Küchentheke verleihen dem Heim eine äußerst stilvolle, klassische Note, über der der Hauch eines zeitlosen Herrenklubs schwebt. Die Wände nehmen die umfangreiche Sammlung von Kunst, Büchern und Fotos auf. Elegante, eingebaute Regale präsentieren sorgsam ausgewählte Dekorationsgegenstände.

Comment ne pas comprendre que les invités se détournent de la table raffinée de cet élégant appartement, pour contempler le panorama aussi vaste que spectaculaire qui s'offre sur la Tamise et certains des édifices les plus symboliques de Londres – le Palais de Westminster (Chambres du Parlement), Big Ben ou encore, le London Eye (Roue du Millénaire) ? Lorsqu'ils se penchent sur le design de cet appartement moderne, les architectes d'Oro Bianco conçoivent l'ensemble du plan au sol de sorte à exploiter la vue au maximum. Disposés face au fleuve, la salle à manger et le salon sont séparés par une demi-cloison décorative qui instaure deux zones distinctes, donnant l'une et l'autre sur la spacieuse cuisine qui les borde et met également en valeur le saisissant décor londonien. Intégrant les tous derniers équipement de la domotique intelligente, l'appartement est lui-même tout aussi remarquable. Les matériaux de luxe, à l'exemple du cristal et du laiton des lampes suspendues au-dessus du comptoir en marbre de la cuisine, introduisent un élément de raffinement d'un classicisme incroyablement net, auquel s'ajoute une touche très gentleman's club. Les murs accueillent une importante collection d'oeuvres d'art, de livres et de photographies, cependant que des objets décoratifs sont soigneusement disposés sur les élégantes étagères encastrées.

16

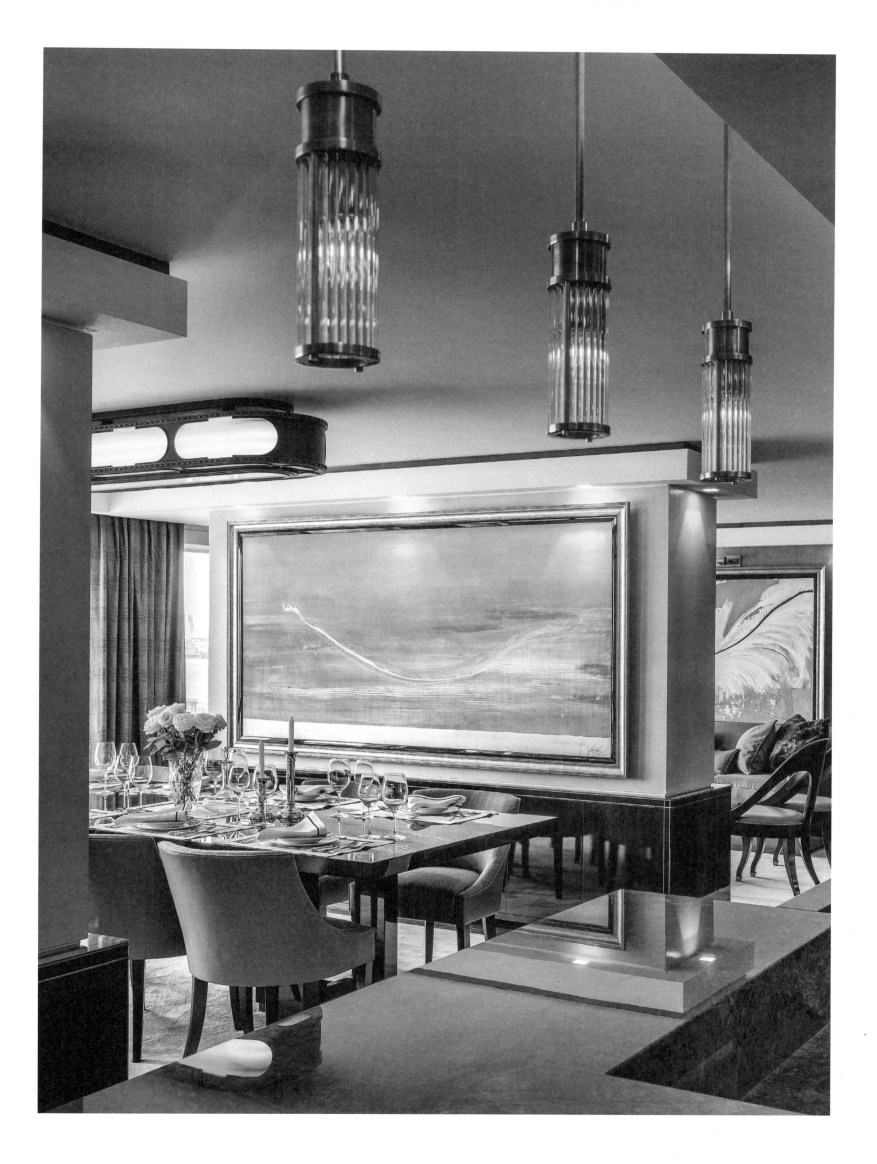

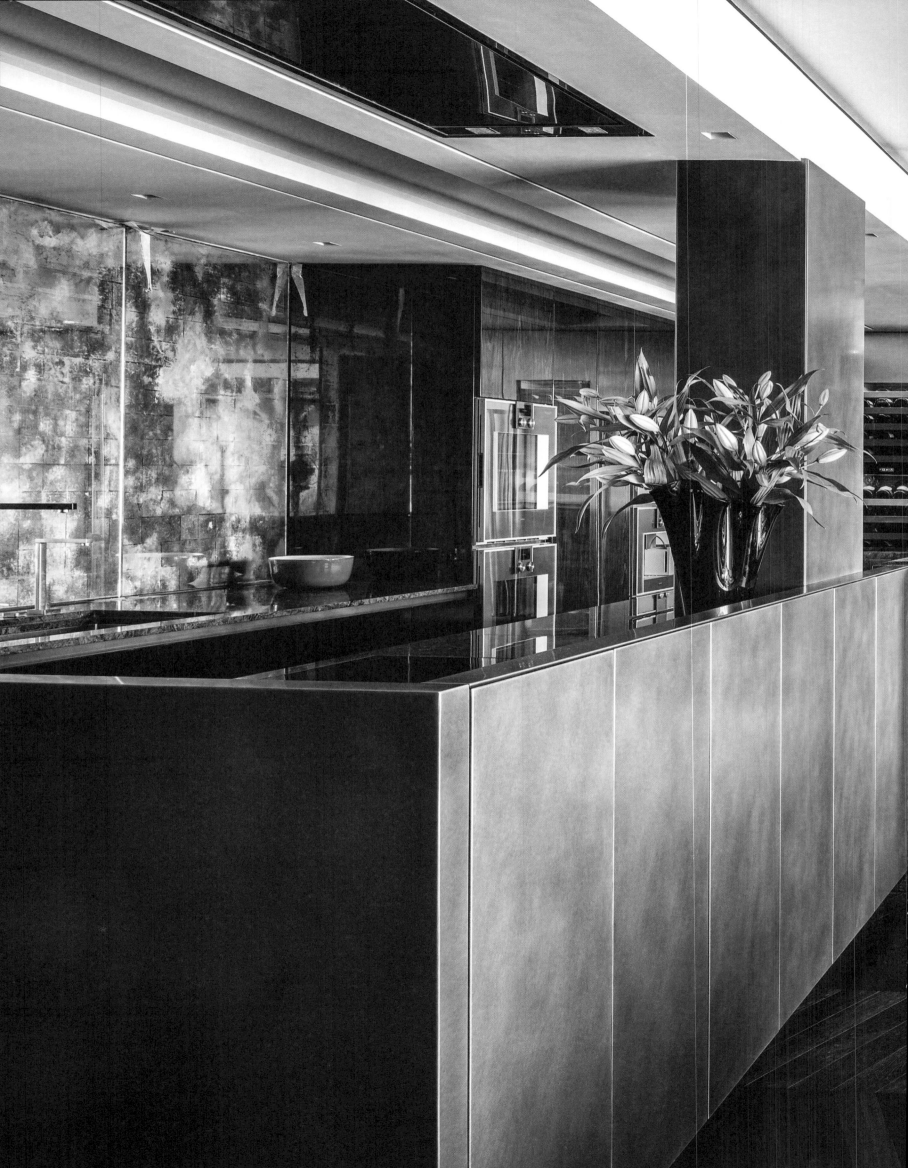

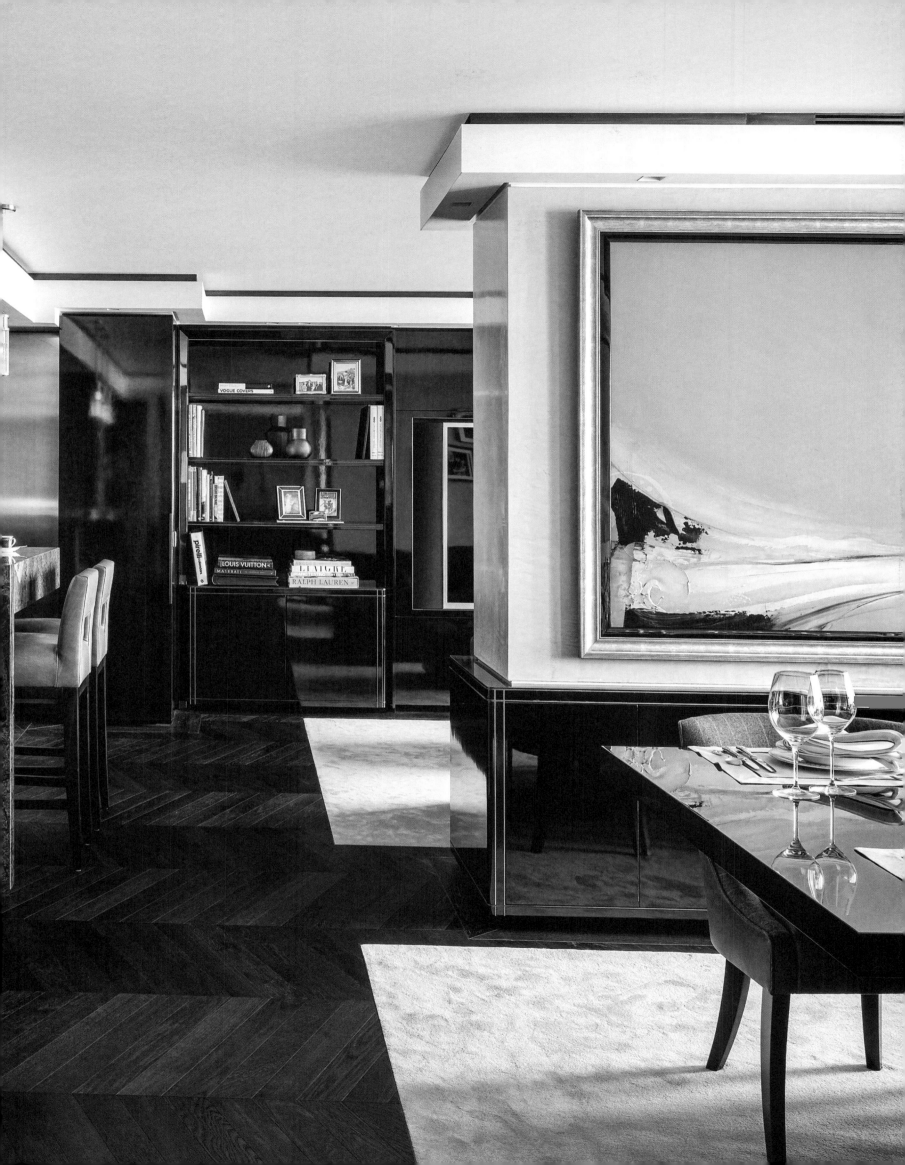

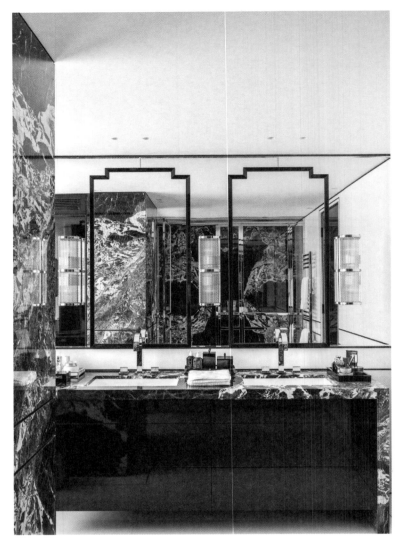

HIGH-QUALITY MATERIALS, DARK herringbone floors, glossy wood, emerald green fabrics and marble are used throughout this sophisticated home to keep the decor sleek and elegant.

HOCHWERTIGE MATERIALIEN, DUNKLES Fischgrätparkett, glänzendes Holz, smaragdgrüne Stoffe und Marmor durchziehen dieses geschmackvolle Heim und wahren so das elegante Dekor.

LES MATÉRIAUX DE grande qualité, les parquets à chevrons de teinte sombre, le bois verni, les tissus vert émeraude ou encore, le marbre participent de la décoration épurée et élégante de cette demeure sophistiquée.

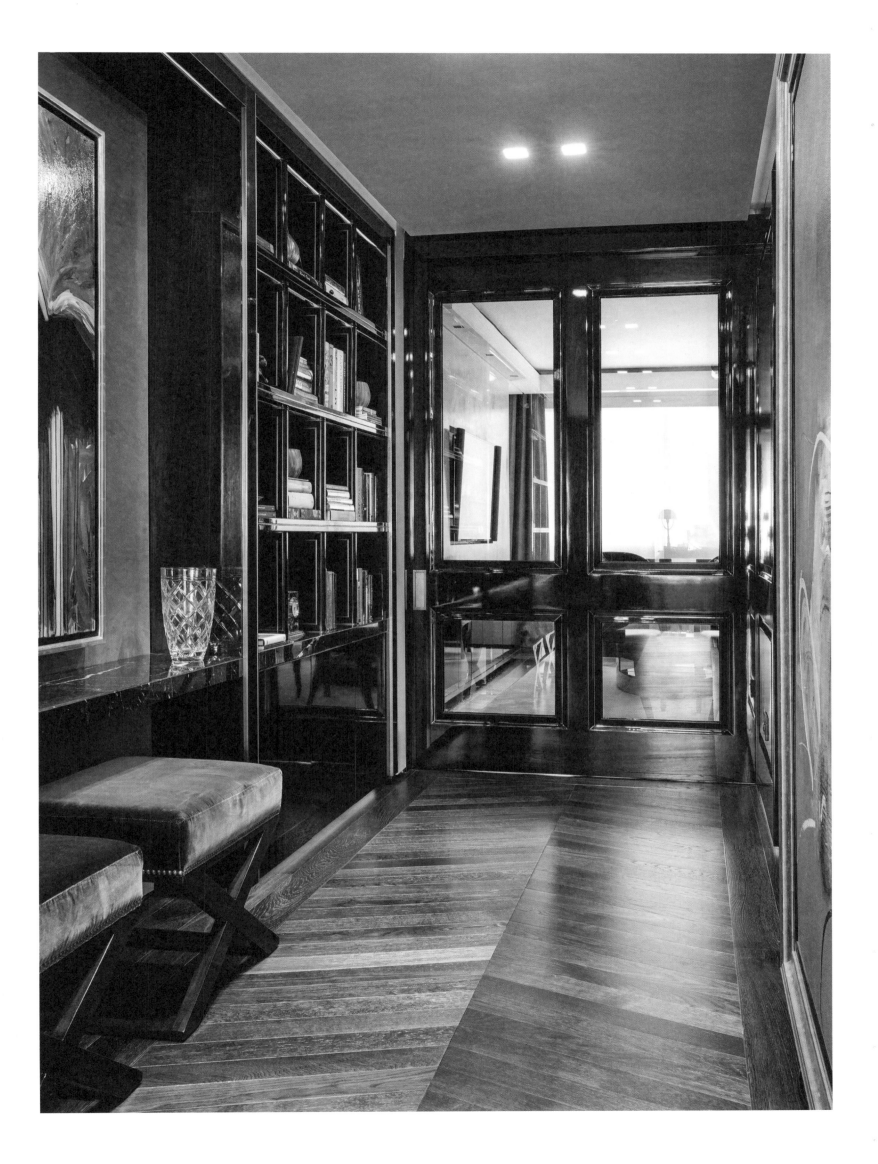

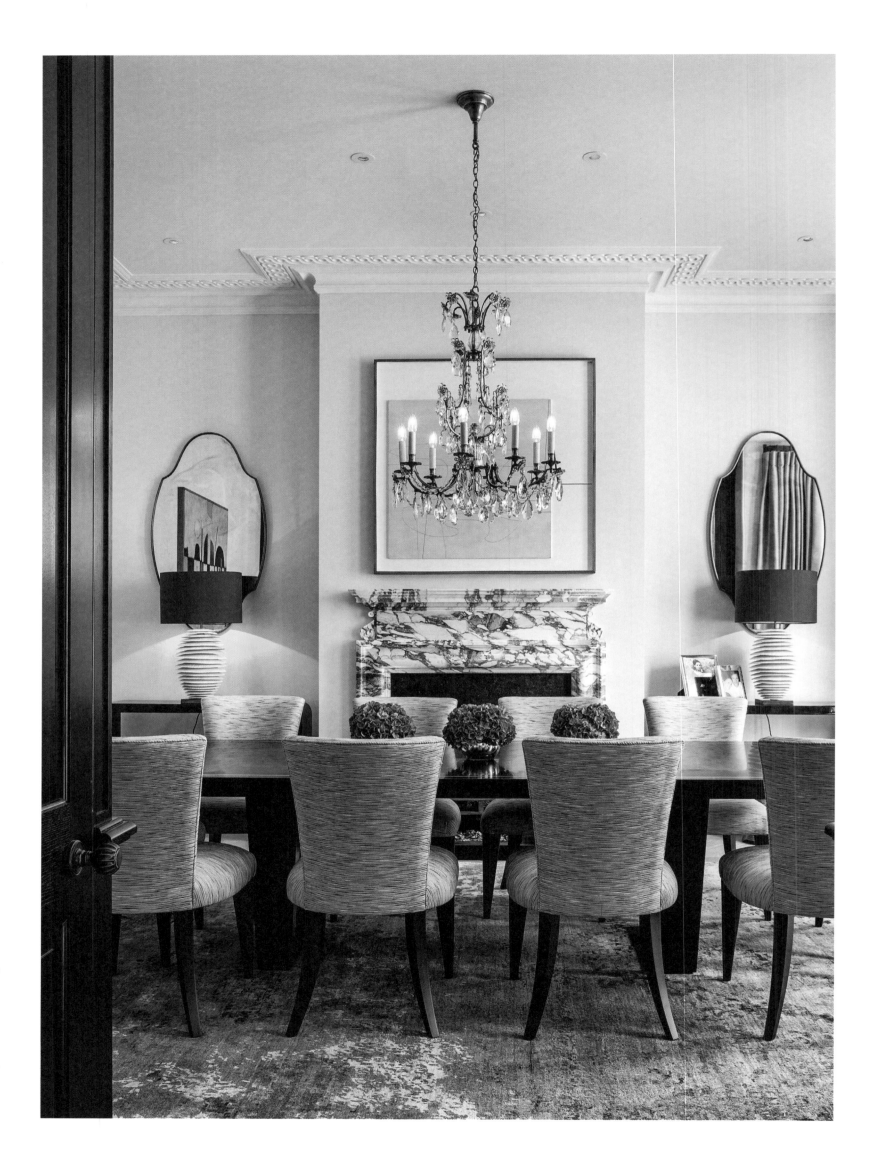

PARK VIEW GEM

Kensington

London has many beautiful residential buildings tucked away from view and the Phillimore Estate just north of Kensington High Street is a very stunning and sought-after property. No wonder the owners were pleased when they found this house overlooking one of the most special green spaces, Holland Park. Getting hands on this property was a unique chance to create the home of their dreams. It had been untouched for many decades and needed updating. Its most distinguished feature internally was the magnificent cantilevered stone staircase that leads from the entrance hall but then just stopped. Studio Indigo replanned the entire house, and the main living spaces were reoriented to overlook the west-facing garden and Holland Park. Planning permission was given for a new rear extension and basement leisure complex under the footprint of the main house. When it came to the architectural finishes the heavily eroded and damaged stucco details were restored to their former glory. In some places details were recreated to reflect the original building. The new house incorporates all the latest technology and was updated by Todhunter Earle Interiors to reflect the needs of a modern large family while remaining true to the original Victoria Italianate-style villa typical of this part of Kensington. The classic proportions are decorated with a gracious interior, and mirrors and lamps are stately and symmetrically displayed, adding an elegant Mediterranean twist.

In London gibt es viele wunderschöne Wohngebäude, die im Verborgenen liegen. Dieses Anwesen nördlich der Kensington High Street ist eine äußerst imposante und begehrte Immobilie. Daher ist es nicht verwunderlich, dass die Besitzer sich freuen, als sie auf dieses Haus stießen, das an einer der beeindruckendsten Grünanlagen liegt, dem Holland Park. Durch den Erwerb des Anwesens erhielten sie die einmalige Chance, ihr Traumhaus zu schaffen. Das Gebäude war über mehrere Jahrzehnte unangetastet geblieben und bedurfte einer Modernisierung. Sein hervorragendstes innenarchitektonisches Merkmal war die prächtige, von der Eingangshalle abgehende frei schwebende Steintreppe, die aber dann einfach endete. Studio Indigo plante das gesamte Haus neu. Die Lage der Hauptwohnräume wurde neu ausgerichtet, sodass sie jetzt auf den nach Westen gerichteten Garten und den Holland Park blicken. Eine Baugenehmigung wurde erteilt für eine neue, rückwärtige Erweiterung sowie einen Fitnessbereich im Untergeschoss unterhalb der Grundfläche des Haupthauses. Der stark erodierte und beschädigte Stuck an Wänden

17

und Decken wurde beim Innenausbau restauriert und erstrahlt in altem Glanz. An manchen Stellen wurden Details nachgebildet, um das Erscheinungsbild des ursprünglichen Gebäudes wiederzugeben. Das neue Haus verfügt über modernste Technik und wurde von Todhunter Earle Interiors auf den neuesten Stand gebracht, um den Bedürfnissen einer großen Familie der heutigen Zeit gerecht zu werden. Der ursprüngliche Italianate-Stil der viktorianischen Villa, der für diesen Teil von Kensington typisch ist, wurde dabei beibehalten. Eine vornehme Einrichtung schmückt die klassischen Proportionen. Stattliche Spiegel und Lampen sind symmetrisch angeordnet und verleihen dem Innenbereich eine zusätzliche elegante, mediterrane Note.

Londres recèle nombre de propriétés splendides qui sont dissimulées aux regards. Situé juste au nord de Kensington High Street, Phillimore Estate est un quartier résidentiel aussi somptueux que convoité. Rien d'étonnant donc à ce que les propriétaires aient été séduits lorsqu'ils ont découvert cette demeure qui donnait sur l'un des espaces verts les plus singuliers qui soient, Holland Park. Acquérir cette propriété leur offrait la possibilité unique de créer la maison de leurs rêves. Demeurée en l'état plusieurs décennies durant, elle avait besoin d'être rénovée. A l'intérieur, le splendide escalier de pierre à console murale qui partait du hall d'entrée avant de s'arrêter subitement, en constitue son élément architectural le plus remarquable Le Studio Indigo a entièrement redessiné la maison dont les principaux espaces de vie ont été ré-orientés afin de donner sur le jardin, situé à l'ouest, et sur Holland Park. Une autorisation a été accordée pour la construction d'une extension à l'arrière, ainsi que d'équipements de loisirs en sous-sol, sous l'emplacement de la bâtisse principale. Restaurés au moment des finitions architecturales, les stucs, particulièrement érodés et très endommagés, ont retrouvé leur splendeur ancienne. Par endroits, des détails ont été recréés en harmonie avec l'édifice d'origine. Intégrant la technologie la plus récente, la nouvelle demeure a été mise au goût du jour par Todhunter Earle Interiors afin de répondre aux attentes d'une grande famille d'aujourd'hui, tout en conservant l'esprit de cette villa de style victorien italianisant, typique du quartier de Kensington. De dimension classique, l'intérieur est décoré avec grâce. Majestueux et symétriquement disposés, les miroirs et les lampes introduisent une élégante touche méditerranéenne.

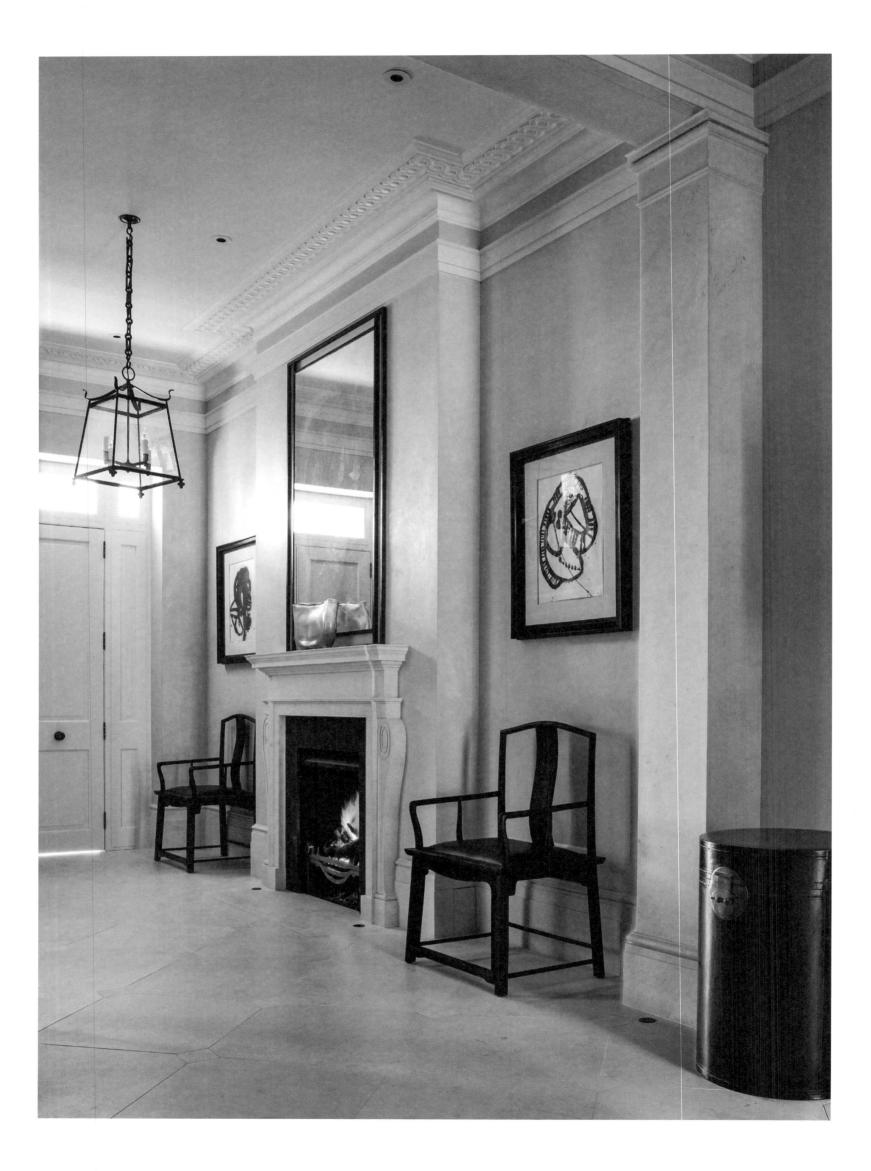

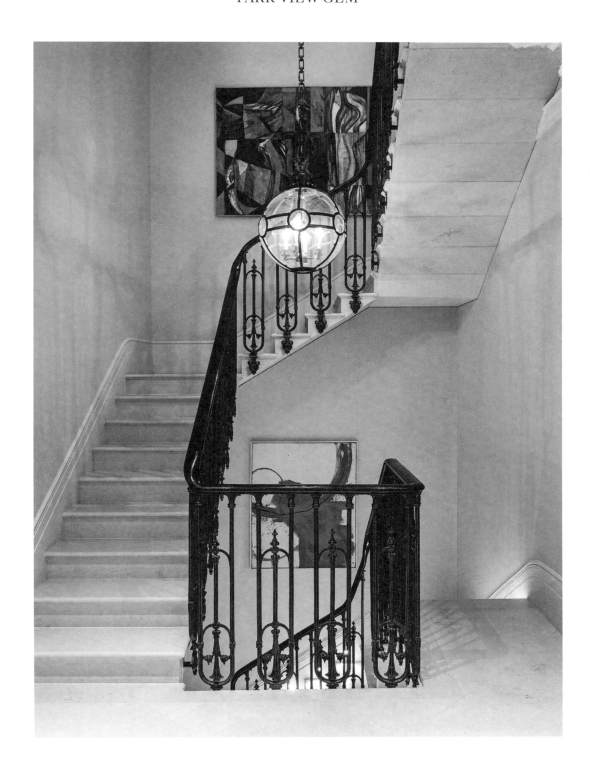

A SERENE AND glamorous hallway with marble, original stucco details and the stunning staircase gives a stately welcome to the house. The soft cream colour scheme layered with warm earthy tones is continued in the rest of the house.

DER RUHIGE UND glanzvolle marmorne Eingang, die Stuckverzierungen und die beeindruckende Treppe tragen in dem Haus zu einem stattlichen Empfangsbereich bei. Die weiche, helle Farbgebung, durchzogen mit warmen, erdigen Tönen, setzt sich im Rest des Hauses fort.

C'EST UN ACCUEIL imposant qu'offre l'entrée, sereine et chic avec son marbre, ses stucs d'origine et son remarquable escalier. Omniprésente dans la maison, la palette de tons crème se superpose à des bruns chaleureux.

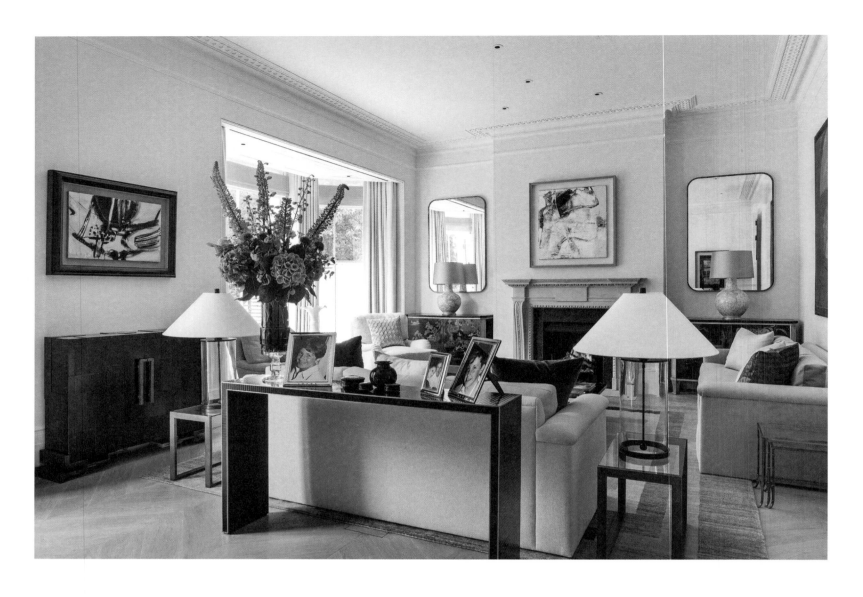

NATURAL DAYLIGHT FLOODS the rooms and plays an essential part in the ambience in the living spaces. Green trees in the park outside decorate the windows like natural art and work as an atmospheric, organic contrast to the creamy white tones and contemporary furniture.

DAS VIELE NATÜRLICHE Licht, das in die Zimmer dringt, spielt eine wesentliche Rolle bei den Wohnräumen. Die grünen Bäume des draußen gelegenen Parks schmücken die Fenster und bilden einen atmosphärischen, organischen Gegensatz zu den cremefarbenen Tönen und der modernen Einrichtung.

LA LUMIÈRE NATURELLE qui les éclaire joue un rôle essentiel dans l'atmosphère des pièces de vie. Les arbres verdoyants du parc s'affichent aux fenêtres à l'égal d'une oeuvre d'art végétale, offrant un contraste poétique et naturel avec les teintes crème et le mobilier contemporain.

A DREAMY OASIS

Chelsea

With an understated, classical look and a year-round green garden, this Chelsea house is like a dreamy oasis in a quiet cul de sac off the Fulham Road in West London. A bland post-war house with no architectural significance was demolished and together with Adrian Lees of architects Powell Tuck Associates the owner created a new, contemporary, four-bedroom terrace house. The new façade is a more modern and simplified version of the traditional 19th century terraced properties on either side. The black-framed windows echo the proportions of the older neighbouring buildings. Once inside the front door, contemporary style has taken over – from the bigger living space to the emphasis on views of the garden maximizing the sense of light and space on both floors. Glass features prominently; from the hall, there is an uninterrupted view of the garden through the floor-to-ceiling sliding glass door which leads into the living room. In the living room itself, a floor-to-ceiling door and a sizeable window create the illusion that the house and lush garden are virtually one. The architecture and the neutral palette provided a good backdrop for interior designer Christa Luntzel's understated style – a mix of classic and contemporary with shots of quirky colour and art, which add special character.

Dieses Haus in Chelsea, mit seinem unaufdringlichen, klassischen Erscheinungsbild und seinem ganzjährig grünen Garten, wirkt wie eine verträumte Oase in einer ruhigen Stichstraße abseits der Fulham Road in West London. Ein schmuckloses Nachkriegshaus ohne architektonische Bedeutung wurde abgerissen, und der Besitzer schuf zusammen mit dem Architekten Adrian Lees von Powell Tuck Associates ein zeitgemäßes Reihenhaus mit vier Schlafzimmern. Die neue Fassade präsentiert sich als moderne und vereinfachtere Variante der Fassaden der angrenzenden, traditionellen Reihenhäuser aus dem 19. Jahrhundert. Die Größe der schwarz gerahmten Fenster steht im Einklang mit der der älteren, benachbarten Gebäude. Betritt man das Haus, zeigt es sich in einem zeitgenössischen Stil – vom größeren Wohnbereich bis hin zur Hervorhebung des Blicks auf den Garten, wodurch die Wahrnehmung von Licht und Raum in beiden Stockwerken maximiert wird. Glas kommt an markanten

18

Stellen zum Einsatz; durch die raumhohe Glasschiebetür, die in das Wohnzimmer führt, bietet sich vom Eingangsbereich ein freier Blick auf den Garten. Eine raumhohe Tür und ein stattliches Fenster im Wohnzimmer selbst erwecken die Illusion, dass das Haus und der üppige Garten nahezu eins sind. Die Bauweise und neutrale Farbpalette lieferten den passenden Hintergrund für den dezenten Stil der Innenarchitektin Christa Luntzel – sie kombiniert klassische und moderne Elemente mit eigenwilligen Farbklecksen und Kunst, die den Räumen einen besonderen Charakter verleihen.

Discrète et classique, ceinte d'un jardin vert toute l'année, cette maison de Chelsea qui donne sur une paisible impasse à l'écart de Fulham Road, dans le West London, se présente comme une oasis de rêve. Datant de l'après-guerre et dépourvu de toute particularité architecturale, l'édifice qui s'élevait à cet emplacement, a été détruit, permettant au propriétaire de concevoir avec l'architecte Adrian Lee, de Powell Tuck Associates, une maison mitoyenne contemporaine pourvue de quatre chambres. La façade s'offre comme la version moderne et épurée des propriétés traditionnelles du XIXème siècle auxquelles elle est accolée, de part et d'autre. Les nouvelles fenêtres à encadrement noir s'harmonisent avec les proportions des édifices du voisinage, plus anciens. Une fois la porte d'entrée franchie, le style contemporain l'emporte – depuis le vaste salon jusqu'aux perspectives sur l'extérieur, mises en valeur de sorte à accentuer la sensation de lumière et d'espace qui caractérise les deux étages. Le verre est prédominant ; dès le hall, le regard glisse sans discontinuer jusqu'au jardin, grâce à la porte coulissante entièrement vitrée qui ouvre sur le salon, cependant que dans le salon lui-même, une porte également vitrée et une vaste fenêtre donnent l'illusion d'une unité entre la maison et le luxuriant espace vert. L'architecture, tout comme les couleurs neutres, mettent en valeur le style sobre de la décoratrice Christa Luntzel – mélange de classique et de contemporain, auquel d'excentriques touches de couleurs ou objets d'art impriment un caractère singulier.

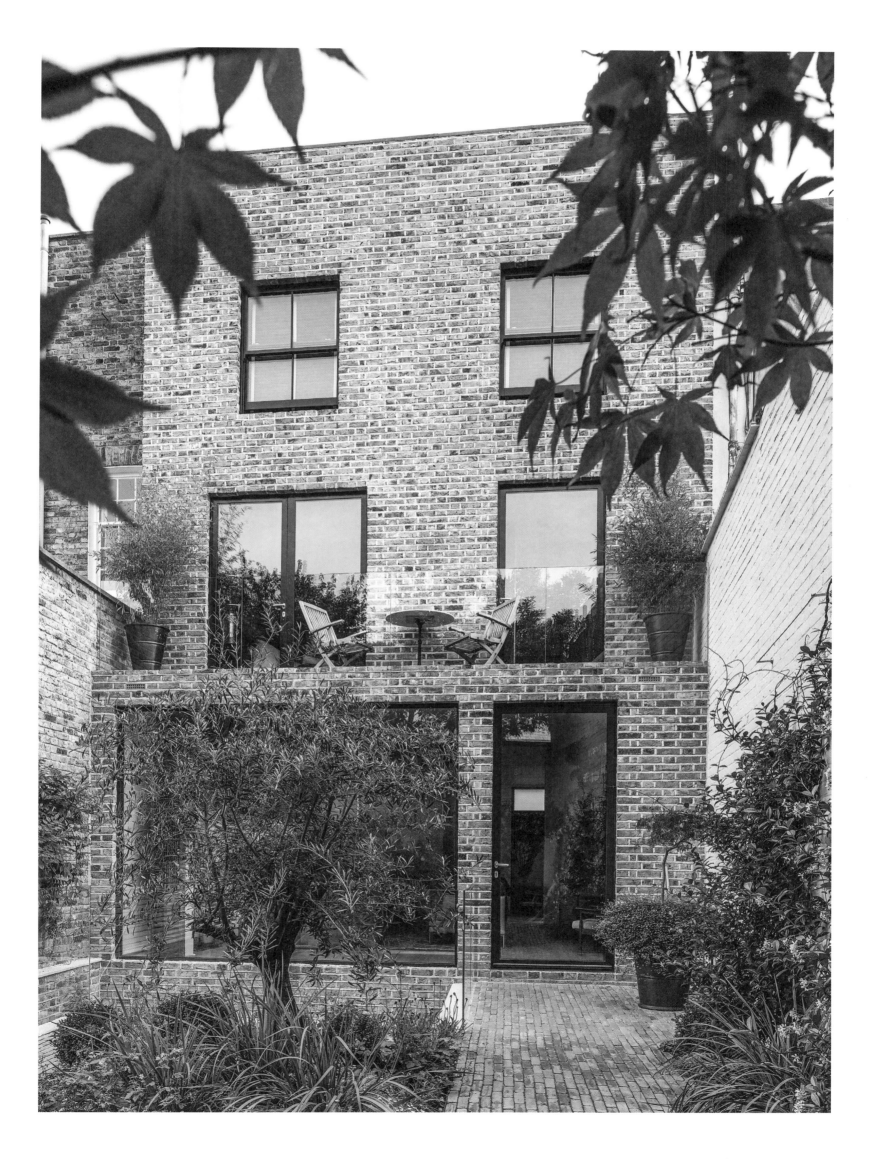

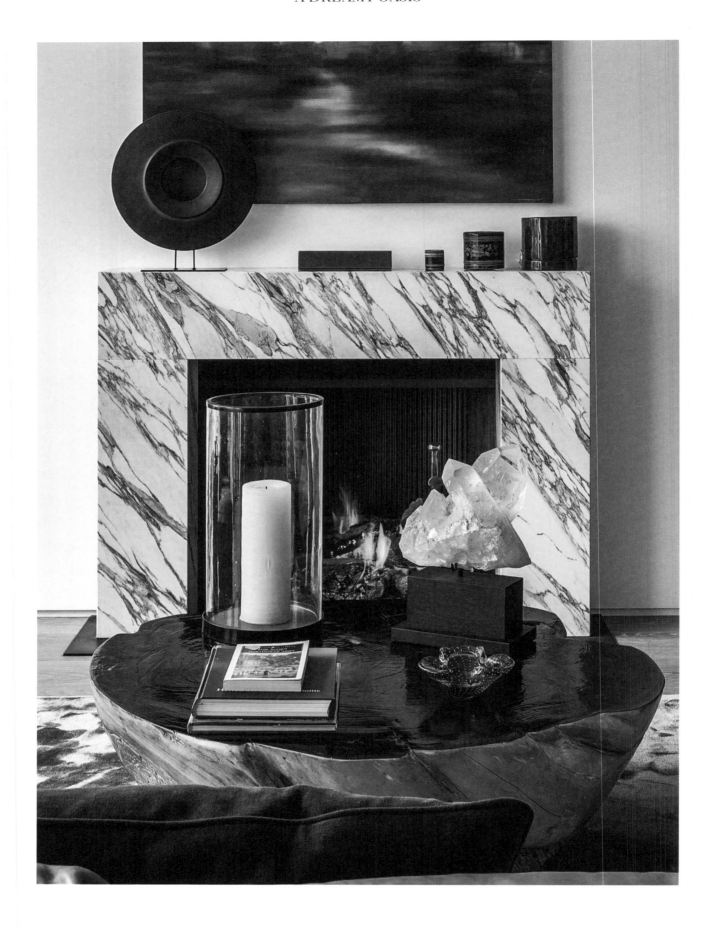

NEUTRAL TONES AND natural textures add to the sense of light and space in the living room, where a sculptural fireplace in strongly figured Arabascato marble is the interesting focal point. The coffee table with lacquered top is based on tree roots, and this interesting botanical touch can also be found in the kitchen, where the dining table has intertwined tree roots as its base.

NEUTRALE FARBTÖNE UND natürliche Texturen tragen zu dem hellen, geräumigen Gefühl im Wohnzimmer bei, dessen interessanter Mittelpunkt ein skulptural wirkender Kamin aus kräftig gemustertem Arabascato-Marmor ist. Der Couchtisch mit seiner lackierten Tischplatte ruht auf Baumwurzeln. Diese ausgefallene botanische Note findet sich ebenfalls in der Küche wieder, wo ineinander verschlungene Baumwurzeln den Fuß des Esstisches bilden.

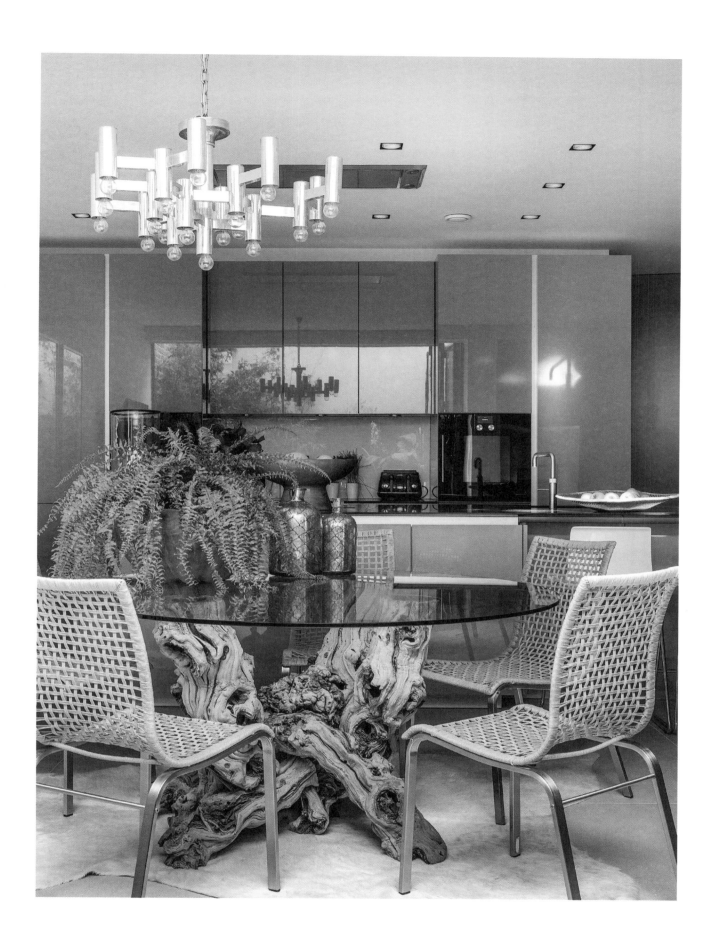

LES TEINTES NEUTRES et les textures naturelles ajoutent à la sensation de lumière et d'espace dans le salon où une sculpturale cheminée en marbre Arabascato au veinage prononcé crée un intéressant point focal. La table basse est formée de racines d'arbre dont le dessus a été laqué. Touche végétale que l'on retrouve dans la cuisine dont la table repose sur un pied également composé de racines, cette fois entrelacées.

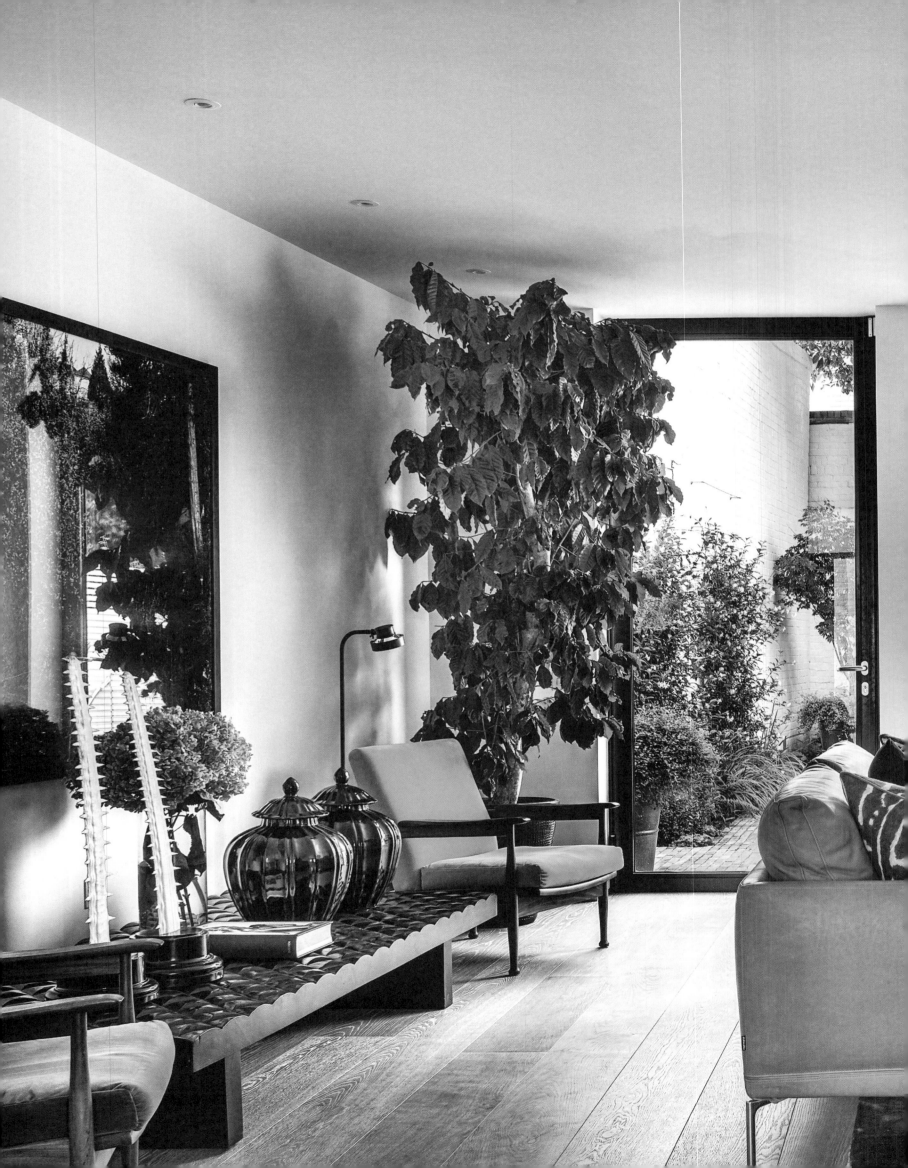

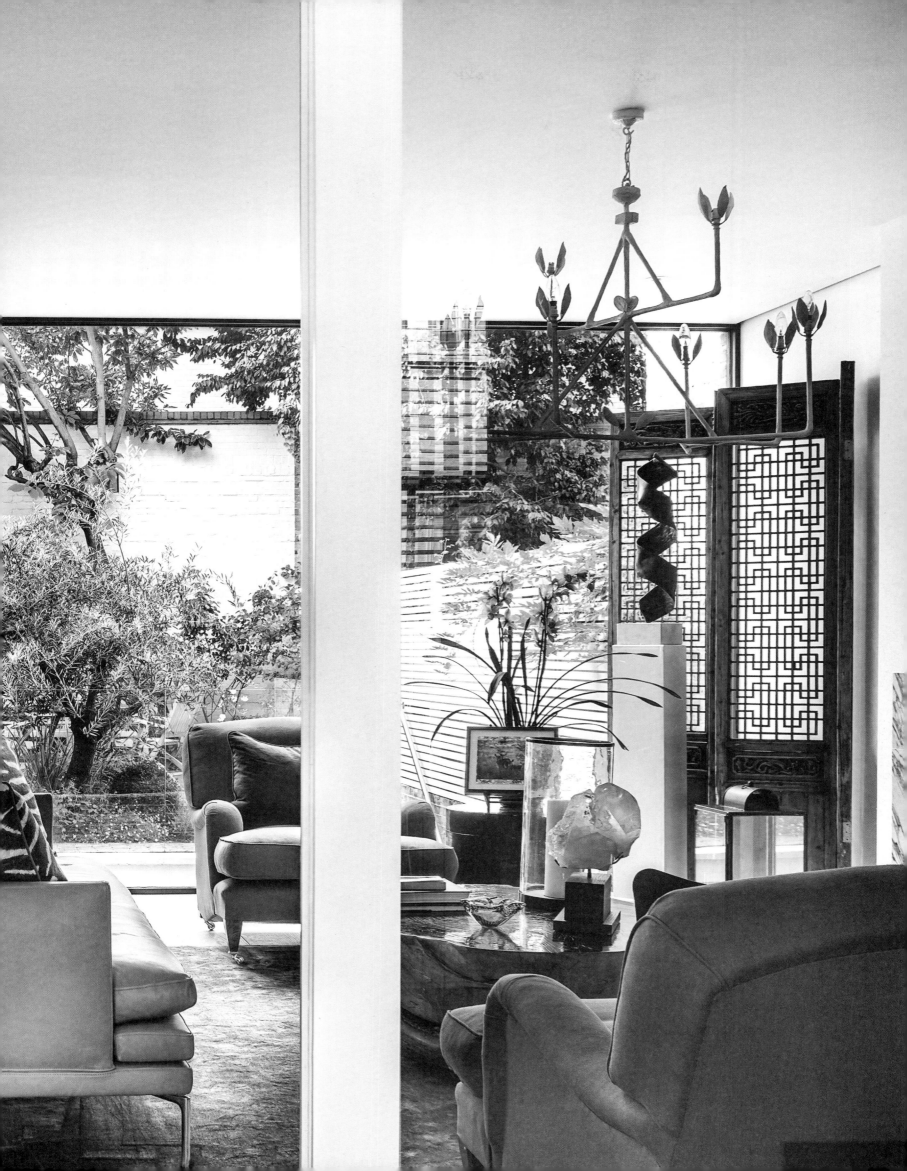

COSY AND CREATIVE

Islington

A home with character and personality is always desirable, and this house has lots of heart and soul. Charming features such as rustic wooden floors, an old Victorian radiator, rounded windows and a fireplace set the tone of customary British cosiness, whilst a huge, extended kitchen leading to a nice garden brings a modern touch. The house used to belong to a chef, hence the big kitchen and a pizza oven in a covered seating area in the garden. Today it's a personal family home with a perfect flow of practical rooms like walk-in pantry, utility room and music room. The interior is clearly influenced by a highly creative family, lots of travels and the owner's degree in Russian. Pieces designed by the owner's sister, interior designer Selina van der Geest, are mixed effortlessly with heirlooms, vintage pieces like a Victorian parlour chair, 17th century Italian chairs, Russian prints, a large 1960s school map and several beautiful chandeliers. A very welcoming and creative ambience rules within these panelled walls. The space is relaxed and playful, and choices like chic Cotswold green-toned limestone on the kitchen floor, a light grey painted floor, and original 19th century shutters instead of curtains instil a modern and clean feel.

Ein Haus mit Charakter und Persönlichkeit ist stets wünschenswert, und dieses hier zeichnet sich durch viel Herz und Seele aus. Charmante Eigenschaften wie rustikale Holzböden, ein alter, viktorianischer Heizkörper, runde Fenster und ein Kamin bilden den Rahmen für traditionelle, britische Gemütlichkeit, während eine riesige, zu einem netten Garten gelegene, geräumige Küche dem Raum eine moderne Note verleiht. Das Haus gehörte einmal einem Koch, daher die große Küche und der Pizzaofen in einem überdachten Sitzbereich im Garten. Heute präsentiert sich das Gebäude als behagliches und persönliches Familienheim, in dem sich praktische Räume, wie eine begehbare Speisekammer, ein Hauswirtschaftsraum und ein Musikzimmer, perfekt aneinanderfügen. Aus der Inneneinrichtung sprechen klar und deutlich eine äußerst kreative Familie, zahlreiche Reisen und der akademische Abschluss, den die Besitzerin in der russischen Sprache erworben hat. Objekte, von der Schwester der Eigentümerin – Innenarchitektin Selina van der Geest – entworfen, werden spielend mit Familienerbstücken, Vintage-Gegenständen, wie einem viktorianischen Wohnzimmerstuhl, italienischen

19

Sesseln aus dem 17. Jahrhundert, russischen Druckgrafiken, einer großen Schullandkarte aus den 1960er-Jahren sowie mehreren wunderschönen Kronleuchtern kombiniert. Es herrscht ein sehr einladendes und kreatives Ambiente innerhalb dieser getäfelten Wände. Die Räumlichkeiten wirken entspannt und ausgelassen, und durch die Wahl des grünlichen Kalksteinbodens aus den Cotswolds in der Küche, hellgrau gestrichener Böden und Originalfensterläden aus dem 19. Jahrhundert statt Vorhängen, wird ihnen eine moderne, frische Atmosphäre zuteil.

Qui ne rêve de posséder une maison avec du caractère et de la personnalité ? Celle-ci ne manque assurément pas d'âme. Des parquets rustiques, un vieux radiateur datant de l'ère victorienne, des fenêtres arrondies, une cheminée – autant d'éléments qui soulignent avec charme une conception traditionnelle du confort à l'anglaise. Indéniablement moderne en revanche est la spacieuse cuisine, tout en longueur, qui donne sur le jardin – héritage de l'ancien propriétaire, chef cuisinier, qui a également conçu le four à pizza installé à l'extérieur, sous une véranda. Aussi cosy qu'originale, c'est aujourd'hui une demeure familiale où se succèdent à la perfection différentes pièces à usage pratique, telles que la buanderie, l'office ou la salle de musique. A l'évidence, l'esprit créatif de la famille, mais aussi les voyages ou les études russes de la propriétaire ont imprimé leur marque sur la décoration. Les objets créés par Selina van der Geest, architecte d'intérieur et soeur de la propriétaire, voisinent librement avec des meubles de famille ou des pièces de collection – que ce soit une chaise de salon de style victorien, un siège italien du XVIIème siècle, des gravures russes, une grande carte géographique scolaire des années 1960, ou encore, de nombreux et splendides lustres. Entre ces murs lambrissés règne une atmosphère particulièrement hospitalière et imaginative. A l'intérieur de cet espace paisible et ludique, le choix d'une élégante pierre calcaire verte de Cotswold pour le sol de la cuisine, et d'un parquet peint en gris clair, mais aussi, les volets d'origine datant du XIXème siècle qui remplacent les rideaux, instillent un rigoureux sentiment de modernité.

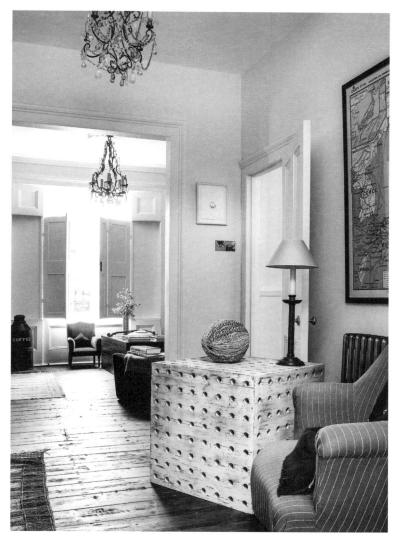

DIE RÄUME SIND allesamt sehr persönlich gestaltet und verblüffen häufig mit einer skurrilen Wendung, wie zum Beispiel der rote, großformatige Buchstabe „S" im Kamin. Die bemalte, als Couchtisch dienende Holzkiste stammt von der Designerin Selina van der Geest. Die dunkel akzentuierte Thematik setzt sich mit alten, gerahmten Buslinennummern und einem dunkelgrauen Sofa fort.

DES TOUCHES PERSONNELLES, souvent excentriques, caractérisent chaque pièce, telle cette lettre industrielle rouge en forme de S, placée à l'intérieur de la cheminée, ou, dans le salon, la table basse en bois dessinée par Selina van der Geest. Les anciens panneaux de signalisation pour bus, ou le canapé gris anthracite, s'inscrivent dans la tonalité sombre choisie comme fil conducteur.

EACH ROOM HAS lots of personal touches, often with a quirky twist, such as the red industrial letter "S" inside the fireplace. In the living room, the painted wooden box coffee table came from designer Selina van der Geest. The dark accent theme continues with old framed bus signs and a charcoal grey sofa.

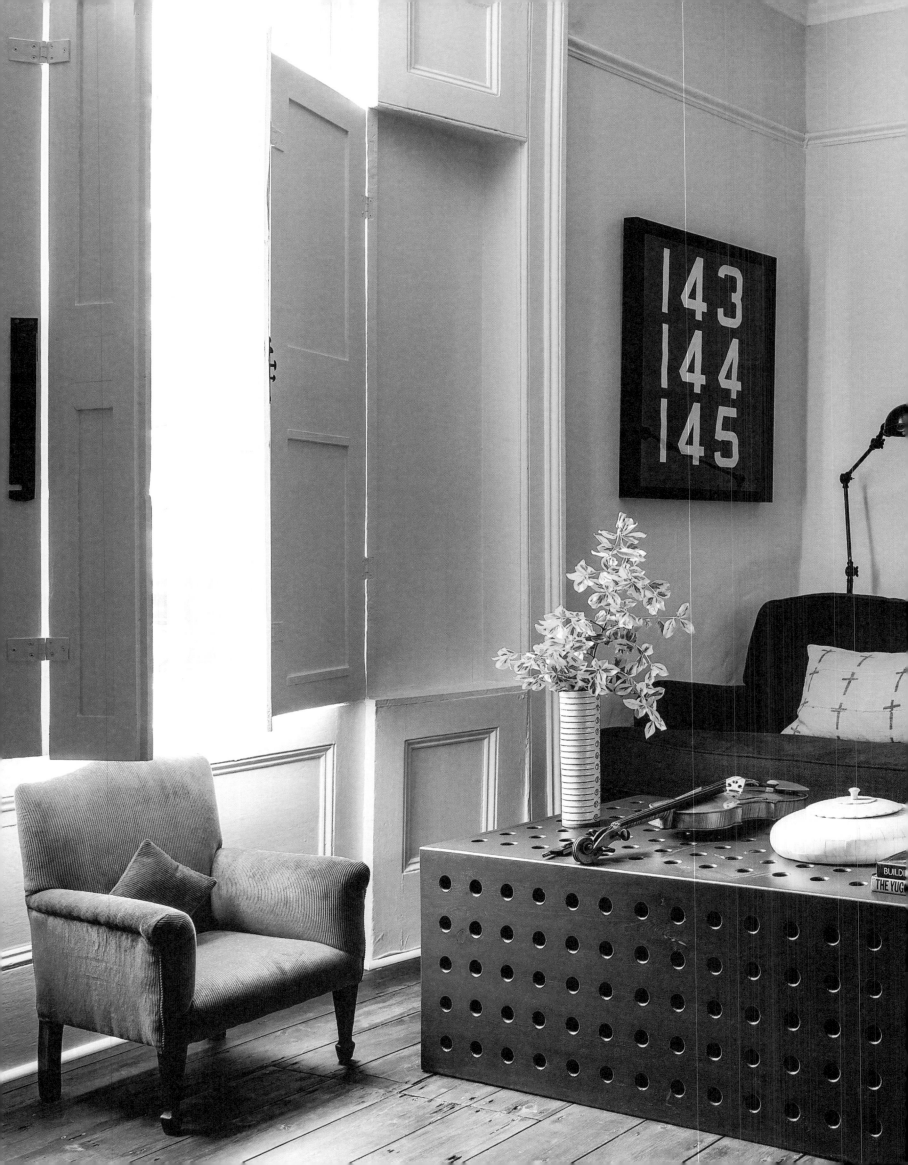

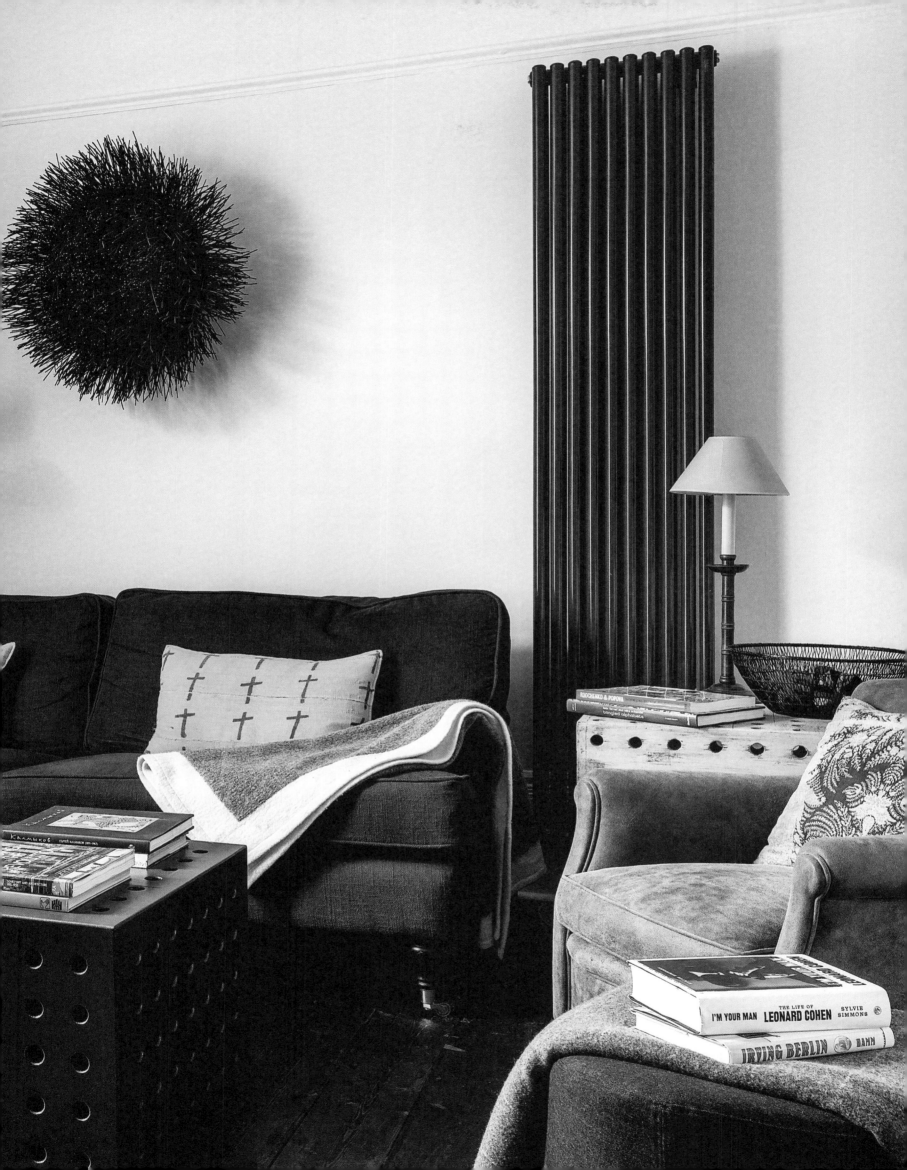

EXCLUSIVE MAGIC

Kensington

20

The line between inside and outside blurs as the pool area merges with a terrace furnished with brightly coloured chairs, then continuing to a lush, enchanting garden. Several surprising 'wow' factors define this property – from the giant decorative lizards climbing the walls by the swimming pool to a stunning sculptural staircase inside. When the owner asked Studio Indigo to redesign this building, everything looked different. Architecturally, it was uninspiring and poorly laid out with three staircases and a maze of rooms. Technically, several problems had to be addressed, including damp. It took only seven months to rebuild the house from start to finish – an amazing achievement for a property measuring 7,000 square feet. The internal spaces were reconfigured: three staircases were rationalised into one masterpiece, helping to integrate all four floors. Each individual room was designed to give a distinct character and identity. The most important are the large living room with conservatory roof with skylights and the master bedroom with its amazing vellum-lined, 1930s inspired dressing room. The interior design blends an elegant cosy style with an exclusive look. By the fireplace in the living room the owners can curl up on a sofa amongst interesting art and antique mahogany pieces.

Die Grenze zwischen innen und außen verschwimmt, während der Poolbereich in eine Terrasse mündet, die mit farbenprächtigen Sesseln ausgestattet ist und an die sich ein üppiger, bezaubernder Garten anschließt. Mehrere überraschende Elemente mit „Wow"-Faktor bestimmen dieses Anwesen – von den riesigen Ziereidechsen, die an der Wand des Pools entlangklettern, bis hin zu der beeindruckenden, skulpturalen Treppe im Innern des Hauses. Als der Besitzer Studio Indigo bat, dieses moderne Gebäude umzugestalten, sah es völlig anders aus. Der Baustil war langweilig, und der Grundriss aufgrund von drei Treppen und einem Gewirr von Räumen unzulänglich. Verschiedene technische Probleme mussten gelöst werden, eines davon war Feuchtigkeit. Die Sanierung dauerte insgesamt nur sieben Monate – eine erstaunliche Leistung für eine Immobilie von 650 Quadratmetern. Auch die Innenräume wurden neu geordnet: Die drei vorhandenen Treppen wurden entfernt und durch ein Prachtstück ersetzt, das alle vier Stockwerke miteinander verbindet. Die einzelnen Räume wurden so gestaltet, dass sie einen eigenen Charakter und eine eigene Identität erhielten. Das große Wohnzimmer mit Gewächshausdach und eingelassenem Dachfenster sowie das Elternschlafzimmer mit Ankleideraum im Stil der 1930er-Jahre stellten die wichtigsten Arbeiten dar. Die Innenausstattung vereint einen eleganten, behaglichen Stil mit einem exklusiven Look. Im Wohnzimmer können sich die Besitzer, umgeben von interessanter Kunst und antiken Mahagonimöbeln, auf ein Sofa zurückziehen.

Brouillant la frontière entre intérieur et extérieur, l'espace dédié à la piscine se prolonge par une terrasse meublée de chaises aux couleurs vives, laquelle donne à son tour sur un jardin aussi luxuriant qu'enchanteur. Nombreuses sont les surprises qui provoquent l'admiration dans cette propriété – depuis les immenses lézards qui ornent le mur de la piscine jusqu'à l'étonnant escalier sculptural qui se déploie à l'intérieur. Lorsque le propriétaire des lieux demande au Studio Indigo de repenser le design de cet immeuble d'époque récente, tout est alors différent. Du point de vue architectural, l'agencement, terne et maladroit, se compose de trois escaliers et d'un labyrinthe de pièces. Du point de vue technique, un certain nombre de problèmes doivent être pris en compte, dont celui de l'humidité. Le réaménagement de la demeure ne prendra que sept mois – une prouesse au regard des 650 mètres carrés de la propriété. L'intérieur est reconfiguré : les trois escaliers sont rationalisés de sorte à constituer un chef-d'oeuvre singulier qui permet d'intégrer les quatre étages. Chaque pièce est pensée avec un caractère et une identité spécifiques. Le vaste salon avec sa verrière, et la chambre principale avec son surprenant dressing tendu de papier velin inspiré des années 1930, sont parmi les plus marquantes. La décoration intérieure associe élégance et confort pour un résultat unique en son genre. Dans le salon, les propriétaires peuvent se lover sur le canapé situé près de la cheminée, parmi d'attrayants objets d'art ou meubles anciens en acajou.

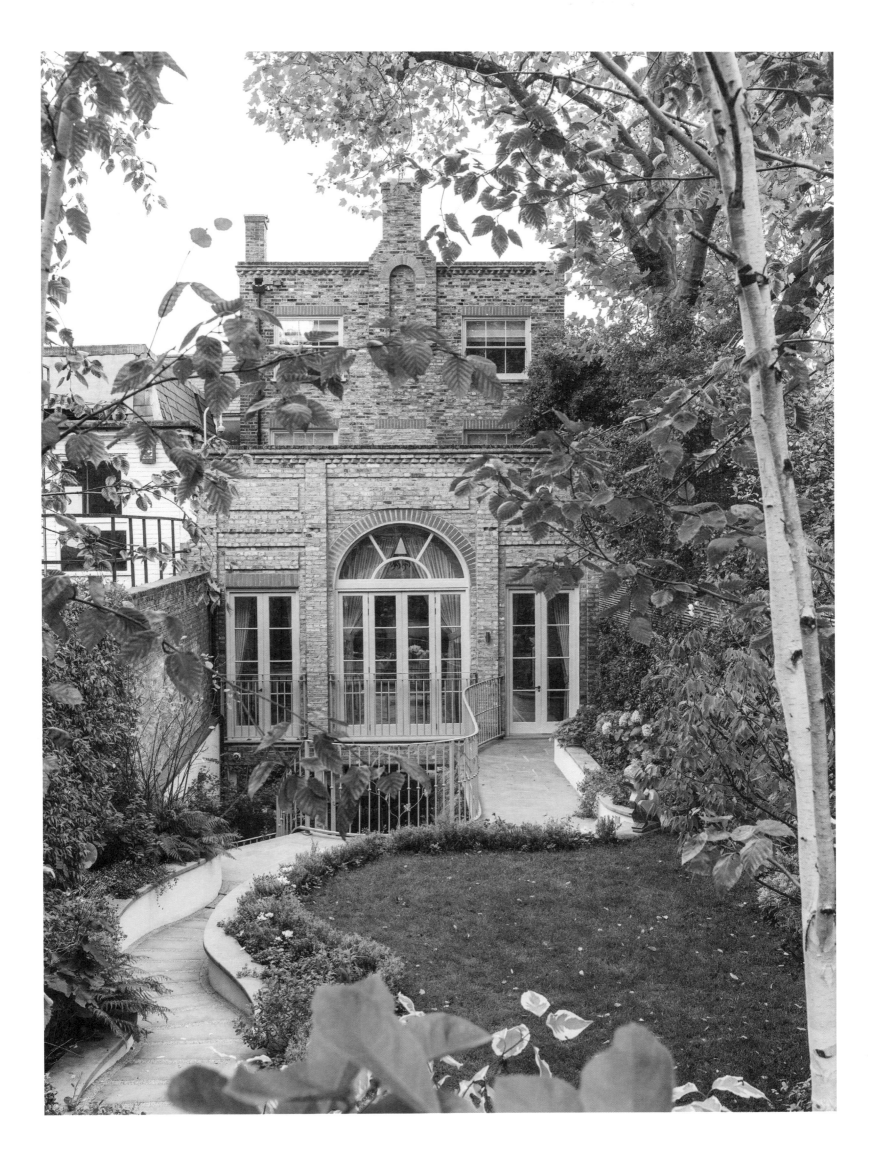

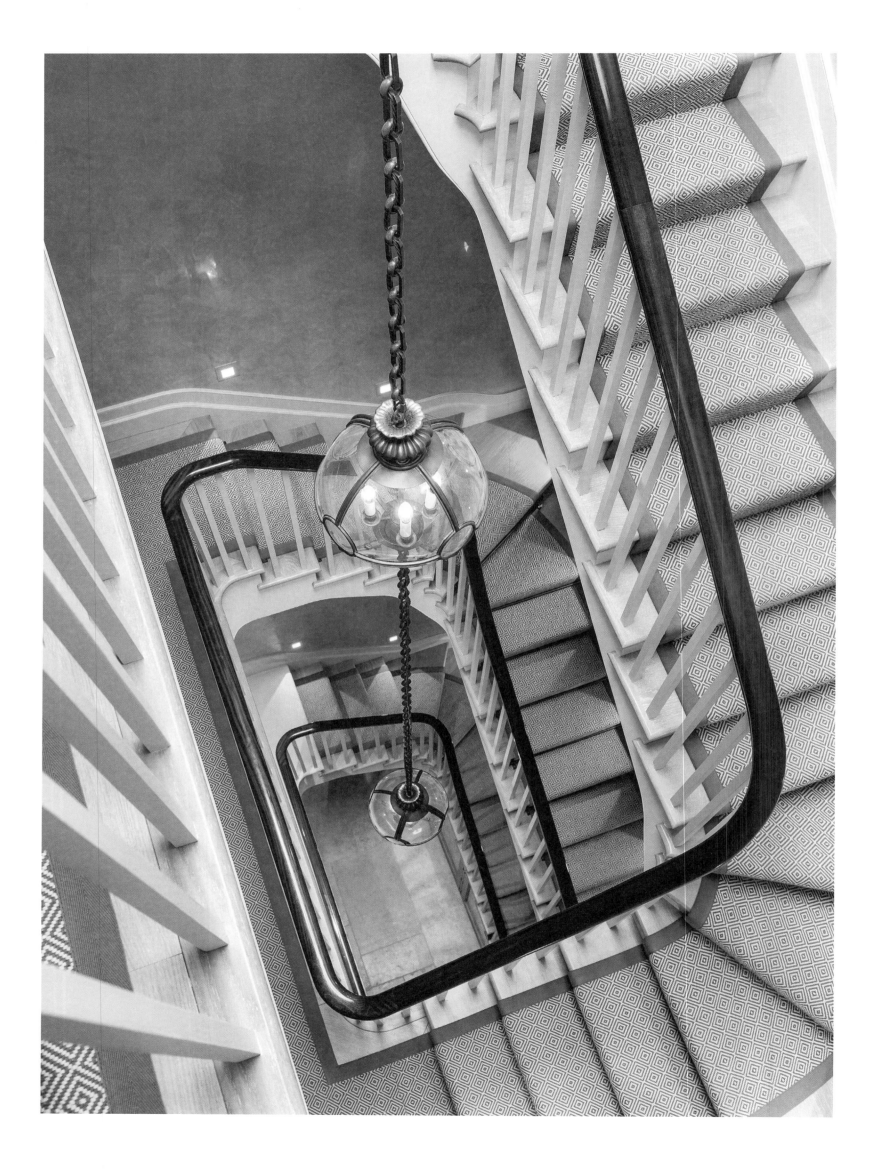

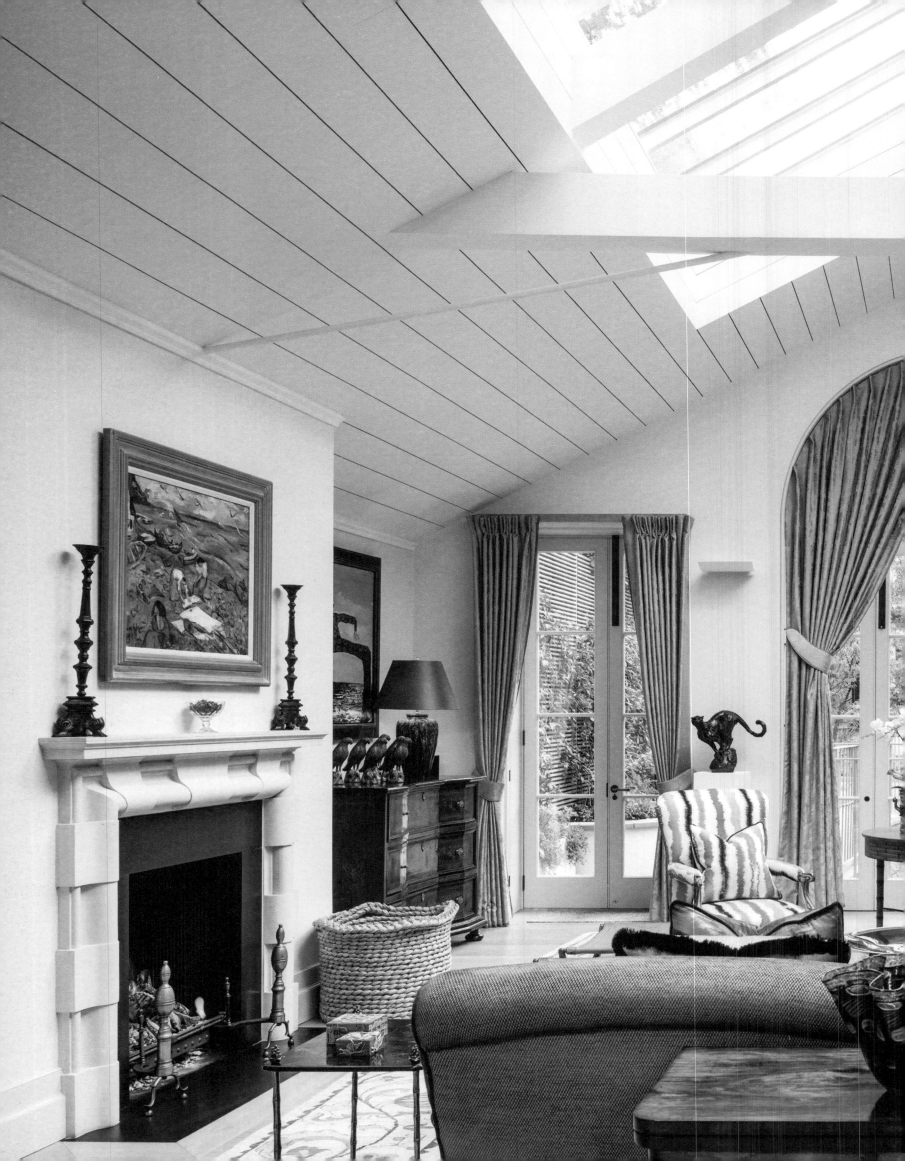

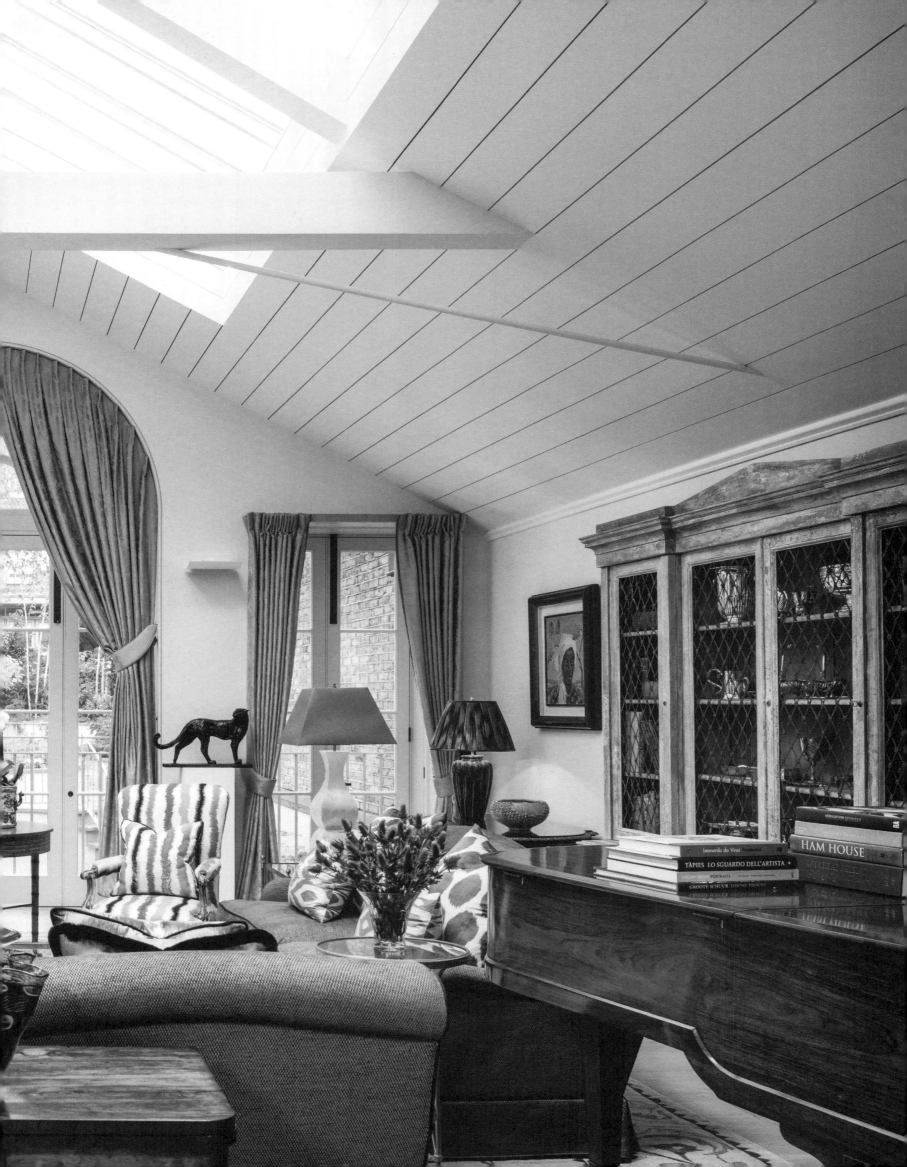

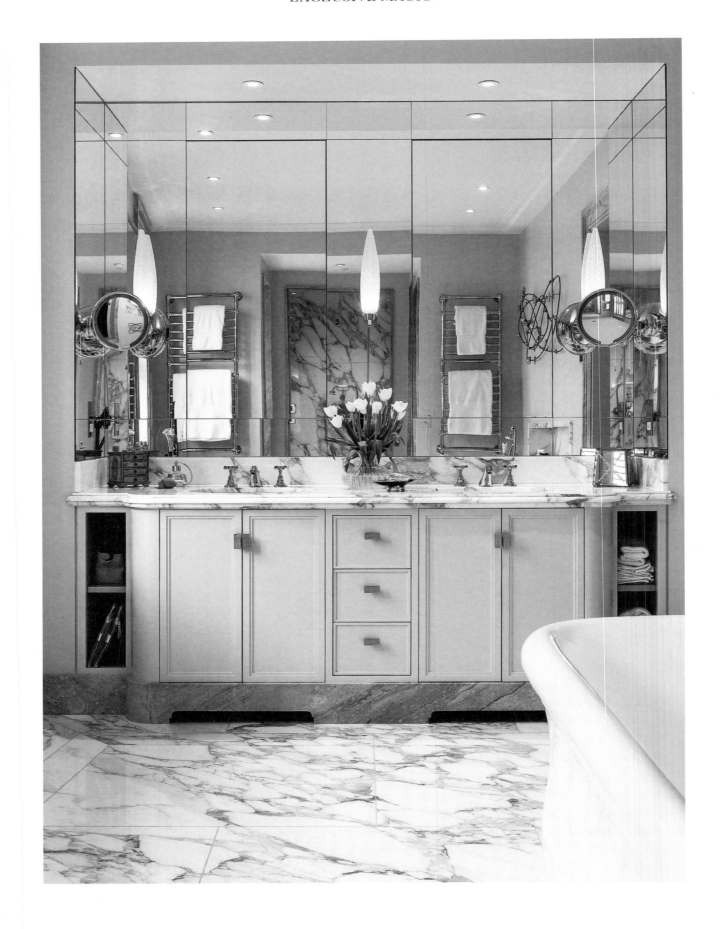

ELEGANCE RULES IN the bathroom with marble floors, and the bedroom draped in beautiful, pale fabrics has an ornate upholstered bedhead with curtains as a focal point.

DAS BADEZIMMER STRAHLT durch den Marmorboden Eleganz aus. Das Bett in dem mit hellen, wunderschönen Stoffen dekorierten Schlafzimmer verfügt über ein verziertes, gepolstertes Kopfteil, das von Vorhängen eingerahmt wird, die einen Blickfang bilden.

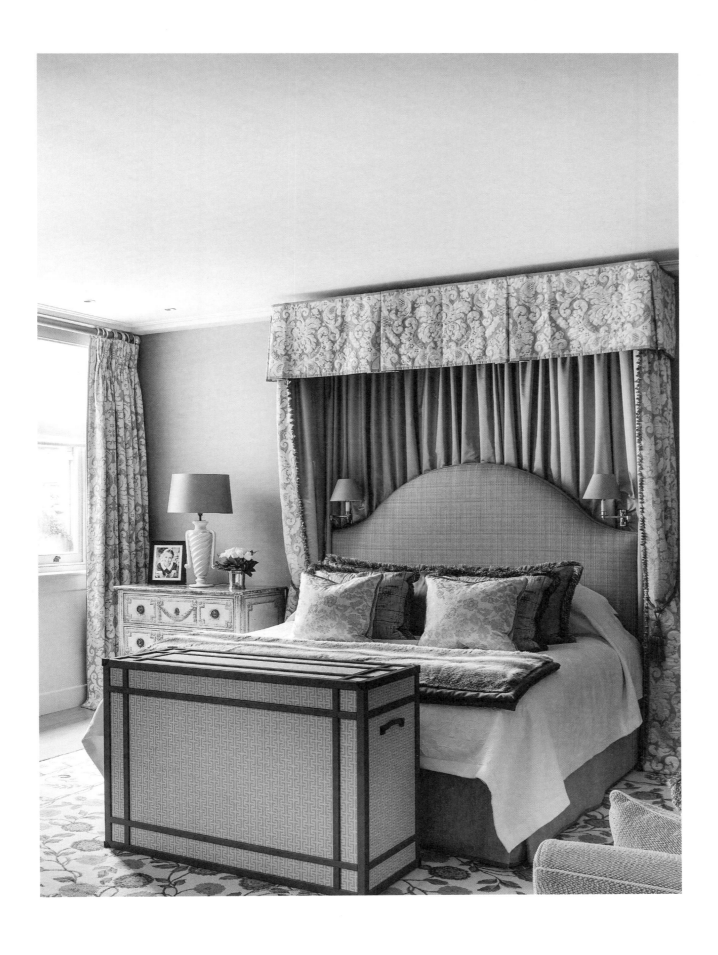

LE SOL EN marbre souligne le raffinement de la salle de bain, cependant que la chambre à coucher est habillée de magnifiques tissus aux teintes claires, depuis l'élégante tête de lit capitonnée jusqu'aux rideaux qui attirent le regard.

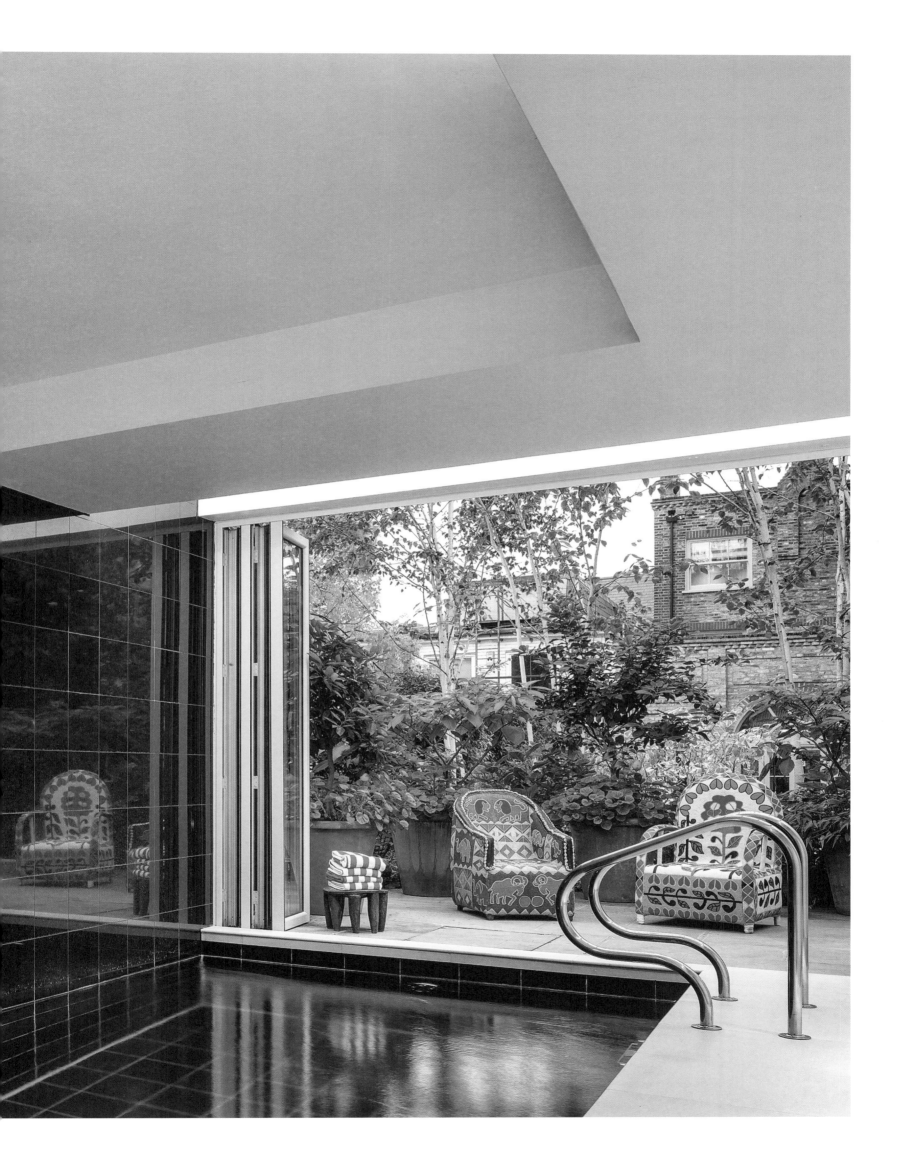

GOLDEN NATURE

Regent's Park

Natural greens, reds, ochres and browns live in perfect symbiosis with sparkles of pale gold silk, antique Chinese furniture and bronze lamps in this central London apartment. Originally two individual flats, the conversion into a single home required clever planning; the main challenge being a narrow corridor only 80 cm wide between the two spaces. The opening was improved by lining the walls in a faceted, tinted mirror, which created depth of space and plenty of interest. Many large windows facing Regent's Park provide a colourful backdrop and wonderful views. Louise Jones Interiors used the lush surroundings as a source of inspiration. Autumnal colours led the way when choosing the fabrics, while artwork has influenced the accent colours. Everything is underlined with subtle beauty, and the style is like an ancient Chinese fairy tale with a modern twist. The drawing room walls are lined in a rough silk with a pale gold colour, the coffee table is an antique Chinese piece, and the bookcases are made of warm walnut. The dining room has an interesting mid-century vellum and metal cabinet; the bronze lamps and embossed gilded wallpaper were sourced in Paris. Hand-embroidered silk wallpaper by Fromental continues the sense of luxury in the daughter's bedroom.

In dieser in Londons Innenstadt gelegenen Wohnung bilden natürliche Grün-, Rot-, Ocker- und Brauntöne eine perfekte Symbiose mit blassgoldenem Glitzer, antiken chinesischen Möbeln und Bronzelampen. Kluge Planung war notwendig, um das aus ursprünglich zwei Wohneinheiten bestehende Apartment in ein einzelnes Heim zu verwandeln; die größte Herausforderung war ein schmaler Flur von nur 80 cm Breite zwischen beiden Wohnbereichen. Der Durchgang wurde optimiert, indem die Wand mit einem getönten Facettenspiegel versehen wurde, wodurch die Raumtiefe optisch vergrößert wurde und ein spannungsreiches Gesamtbild entstand. Viele große, zum Regent's Park gewandte Fenster liefern einen farbenprächtigen Hintergrund und wunderschöne Ausblicke. Louise Jones Interiors nutzte die üppige Umgebung als Inspirationsquelle. Herbstliche Nuancen waren tonangebend bei der Auswahl der Stoffe, während Kunstwerke die akzentsetzenden Farben beeinflusst haben. Über allem schwebt eine dezente Schönheit. Der Stil ist wie ein altes, chinesisches Märchen mit einer modernen Wendung. Die Wände des Wohnzimmers sind mit blassgoldener, schimmernder Rohseide verkleidet, der Couchtisch ist ein antikes chinesisches Stück, und die Bücherregale sind aus warmem Walnussholz gefertigt. Eine interessante Anrichte aus Pergament und Metall, die aus der Mitte des 20. Jahrhunderts stammt, schmückt das Esszimmer. Die Bronzeleuchten und die vergoldete Prägetapete stammen aus Paris. Eine handgestickte Seidentapete von Fromental setzt das luxuriöse Ambiente im Schlafzimmer der Tochter fort.

Les verts, les rouges, les ocres ou les bruns naturels de cet appartement du centre de Londres s'harmonisent à la perfection avec l'or pâle des soies disposées çà et là, les meubles chinois anciens ou les lampes en bronze. Convertir deux appartements distincts un une demeure unique requérait un planning intelligemment pensé dont le principal défi était l'étroit couloir de 80 cm de large qui séparait les deux espaces. L'ouverture ainsi créée a été amplifiée grâce à un miroir teinté à facettes qui, non seulement, introduit une profondeur de champ, mais encore, se révèle particulièrement attrayant. Les vastes fenêtres qui donnent sur Regent's Park offrent à la fois un arrière-plan multicolore et une vue splendide. S'inspirant de ce verdoyant environnement, Louise Jones Interior a opté, dans le choix des tissus, pour des teintes automnales, tandis ques les oeuvres d'art ont influencé les touches de couleur. Soulignée par une beauté subtile, la décoration évoque un vieux conte de fée chinois revisité par un regard moderne. Dans le salon, les murs sont tendus de soie brute dans des tons d'or pâle, la table basse ancienne provient de Chine, les bibliothèques sont en noyer chaleureux. La salle à manger recèle une remarquable vitrine datant du milieu du siècle, faite de vélin et de métal, cependant que les lampes en bronze et le papier peint à gaufrure dorée ont été dénichés à Paris. Dans la chambre de la fille des propriétaires, le papier peint en soie brodée main de chez Fromental participe de la sensation de luxe.

21

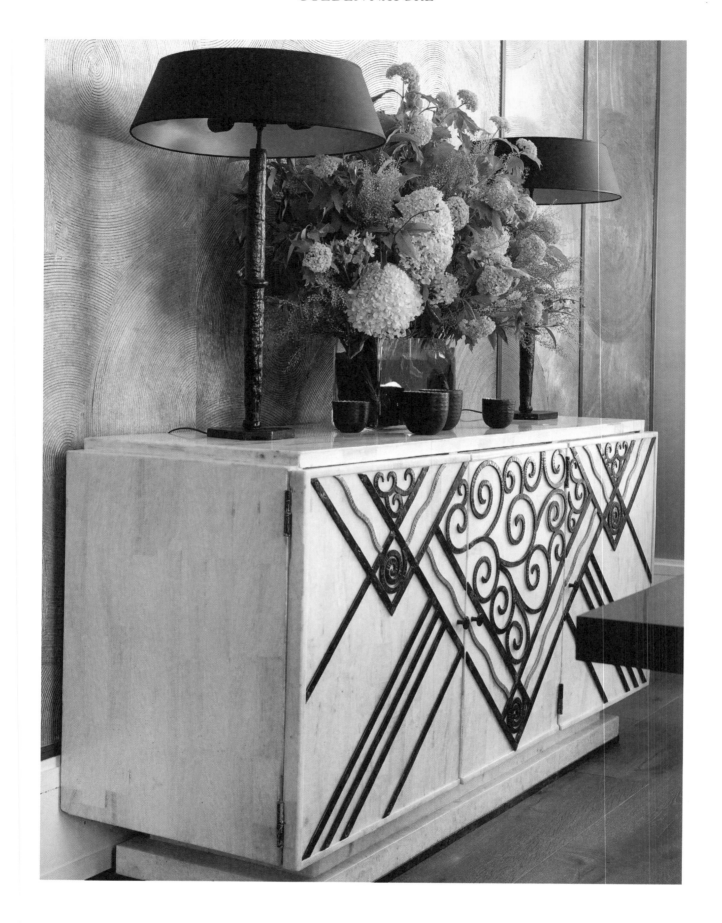

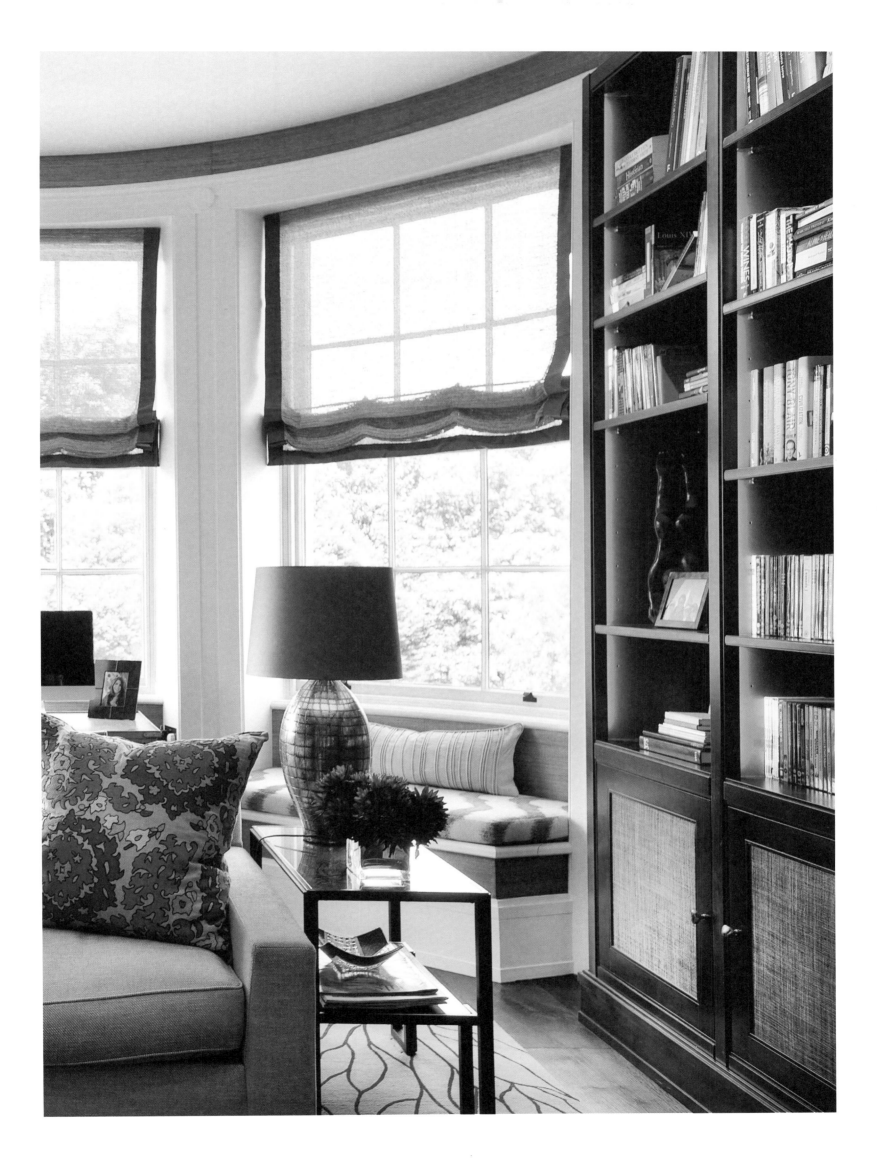

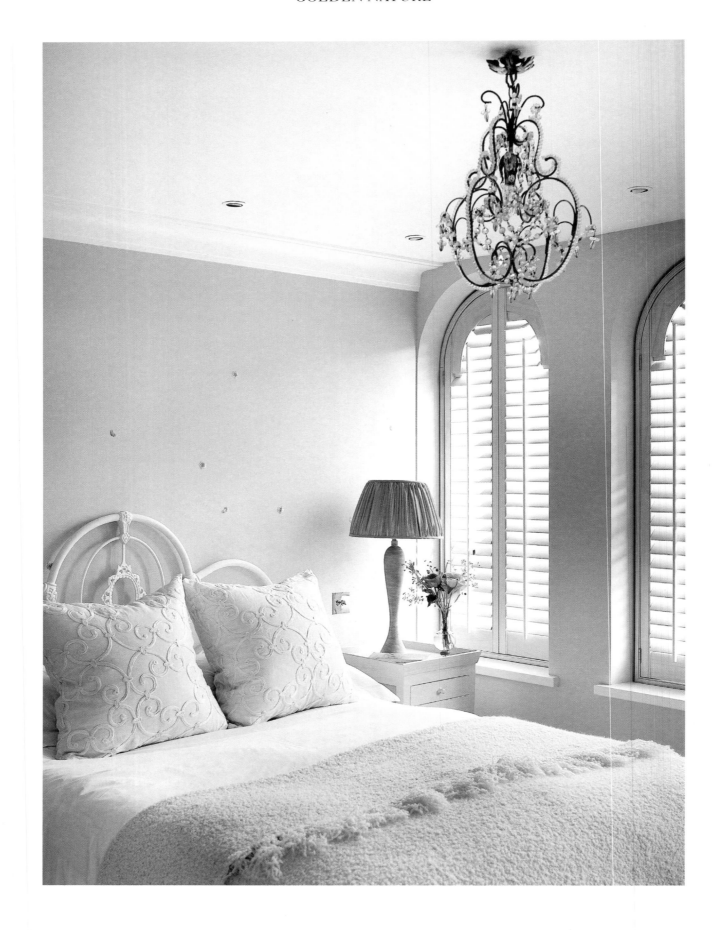

AN ALMOST ENTIRELY off-white palette sets the tone of the subtle, natural and calming bedroom and bathroom. Different textures and a classical chandelier bring a touch of romance and richness.

EINE FARBPALETTE, DIE fast gänzlich aus Cremetönen besteht, bestimmt das dezente, natürliche und beruhigende Schlaf- und Badezimmer. Unterschiedliche Texturen und ein klassischer Kronleuchter verleihen einen Hauch von Romantik und Opulenz.

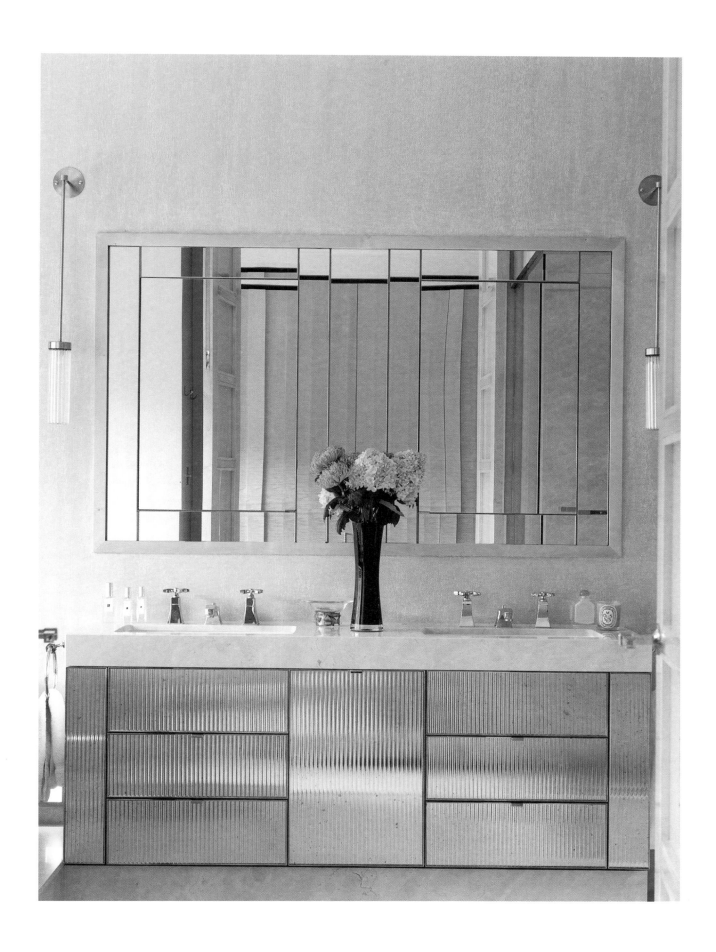

RAFFINÉE, NATURELLE ET apaisante, la palette de couleurs presque entière-
ment composée de blancs cassés donne le ton de la chambre et de la salle bain.
Le jeu de textures et le lustre classique introduisent une note à la fois opulente
et romantique.

FLORAL BEAUTY

Chelsea

When a self-taught florist with a creative streak and an eye for beauty takes over a former butcher's shop, the outcome couldn't be more joyful. Whilst maintaining the charm of its heritage, the owner's sister, who is well versed in architectural restoration, has modernized this four-storey town house, located in a historic street in old Chelsea. Focusing on the redesign of the kitchen and dining space, the former hall wall was replaced with a partial wall open at both ends, an ideal spot for displaying art. The living room was transformed into a stylish niche for book lovers, decorated with seasonal flowers, a wall full of books, a warm and vibrant mix of soft textiles and splashes of magenta and mustard yellow. A contemporary interpretation of a traditional British sitting room, this space full of comfortable upholstered chairs and inviting sofas is the beating heart of a home that is warm and personal in every detail. The especially large windows make the space wonderfully light and airy and provide a lesson in how to live with countless books and seating, yet without a sense of clutter.

Wenn eine autodidaktische Floristin mir kreativer Ader und einem Auge für Schönheit ein Haus kauft, in dem früher eine Metzgerei untergebracht war, könnte das Ergebnis nicht erfreulicher sein. Die Schwester der Besitzerin, die im Restaurieren von Gebäuden versiert ist, hat dieses vierstöckige Stadthaus, in einer historischen Straße im alten Teil von Chelsea gelegen, modernisiert und dabei den Charme seines Erbes bewahrt. Im Mittelpunkt stand die Umgestaltung der Küche und des Essbereichs. Der ehemalige Flur wurde durch eine an beiden Seiten offene Trennwand ersetzt, die sich ideal als Präsentationsort für Kunst eignet. Das Wohnzimmer wurde in eine elegante Nische für Buchliebhaber verwandelt, versehen mit Blumen der Saison, einer Wand voller Bücher, einer warmen, lebendigen Mischung weicher Stoffe und Farbtupfern aus Magenta und Senfgelb. Der Raum, eine moderne Interpretation eines traditionellen britischen Wohnzimmers, ist mit seinen bequemen Sesseln und den einladenden Sofas das pulsierende Herz eines Heims, das mit jedem Detail Wärme und Persönlichkeit ausstrahlt. Durch die

besonders großen Fenster, die einen lehren, dass man durchaus mit zahllosen Büchern und üppigen Sitzgelegenheiten leben kann, ohne ein unordentliches Erscheinungsbild zu riskieren, ist das Zimmer wunderbar hell und luftig.

Lorsqu'une fleuriste autodidacte aimant la créativité et sachant repérer la beauté s'intéresse à une ancienne boucherie, le résultat est incroyablement joyeux. Particulièrement versée dans la rénovation architecturale, la soeur de la propriétaire a su moderniser cette maison de quatre étages, située dans une rue historique de Chelsea, tout en en préservant le charme, hérité de son passé. Dans la cuisine et la salle à manger, au coeur du projet de réagencement, le mur de l'ancienne entrée a été remplacé par une demi-cloison ouverte à chaque extrémité qui constitue un espace d'exposition idéal pour les oeuvres d'art. Transformé en un lieu protégé dédié aux amoureux des livres, avec son mur rempli d'ouvrages, le salon est orné de fleurs de saison, ainsi que d'un chaleureux et vibrant mélange de tissus doux, avec çà et là des pointes de magenta et de jaune moutarde. Version contemporaine du « sitting room » à l'anglaise, cet espace pourvu de confortables fauteuils tapissés et de canapés accueillants, constitue le coeur névralgique d'une demeure hospitalière et singulière jusque dans ses moindres détails. Particulièrement vastes, les fenêtres illuminent et agrandissent merveilleusement la pièce, prouvant qu'il est possible de vivre entouré de livres et de sièges sans pour autant donner une sensation d'amoncellement.

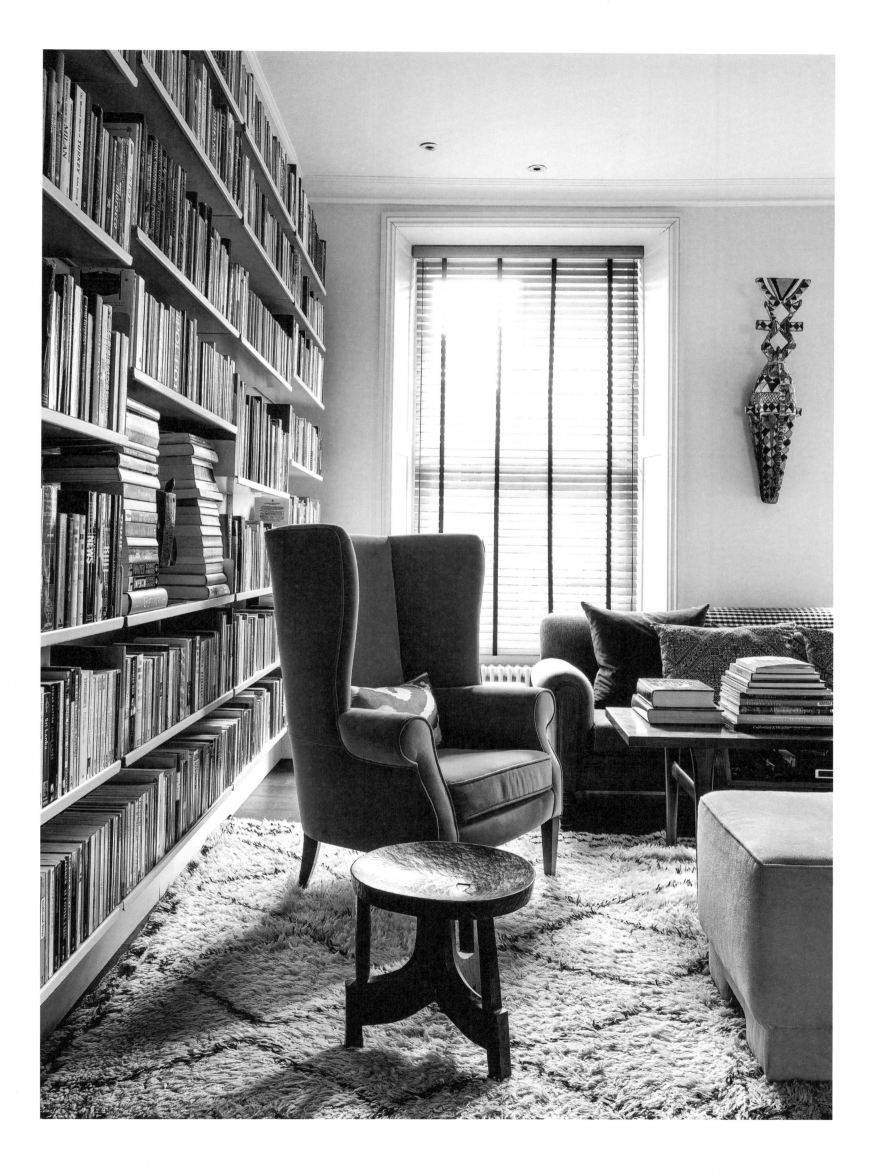

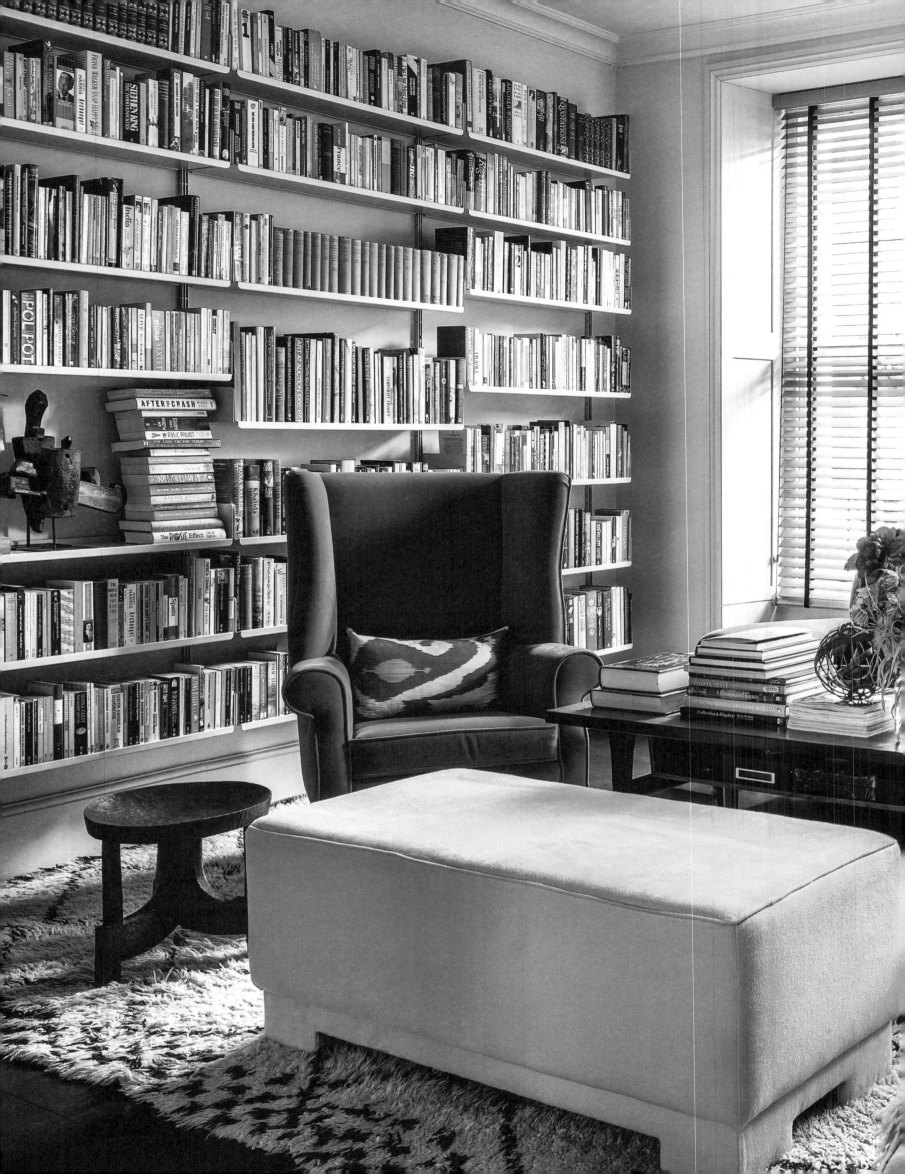

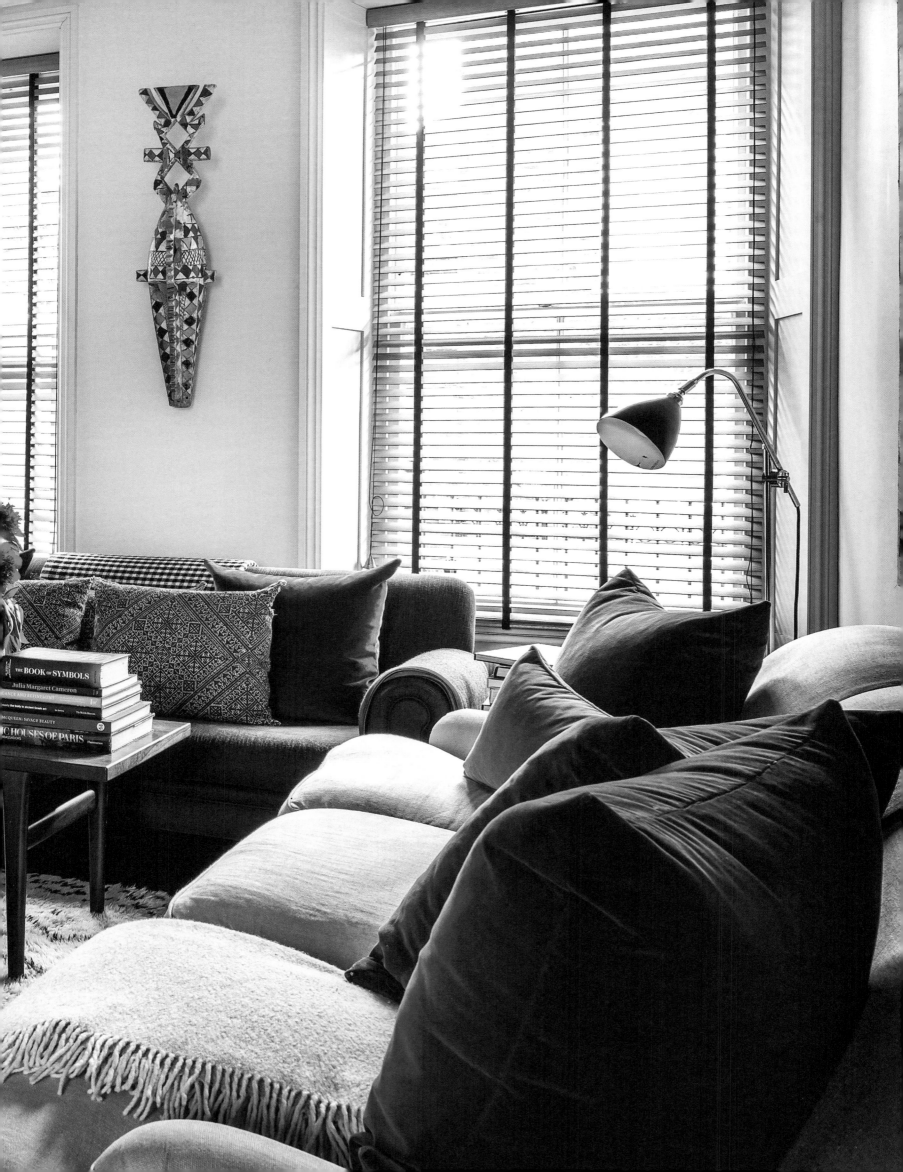

On the books, partial titles visible:

THE **BOOK** OF SYMBOLS

Julia Margaret Cameron

GANCE AND REFINEMENT

the body in ancient Greek art

McQUEEN: SAVAGE BEAUTY

C HOUSES OF PARIS

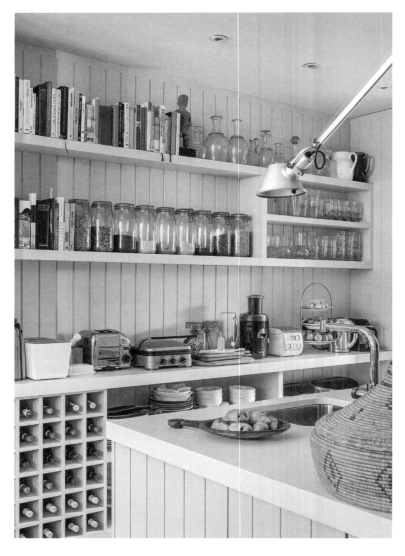

INSPIRED BY HER father, a well-known art collector, the house is decorated with numerous books, carefully arranged on Vitsoe shelves, as well as textiles, antiques, artefacts, bohemian-inspired rugs and bold colours.

INSPIRIERT VON IHREM Vater, einem bekannten Kunstsammler, ist das Haus der kreativen Londonerin mit zahlreichen, in Vitsoe-Regalen verstauten Büchern, Textilien, Antiquitäten, Artefakten, Teppichen im Ethno-Stil und kräftigen Farben ausgestattet.

INSPIRÉE PAR LE père de la propriétaire, célèbre collectionneur d'art, la décoration se compose de livres nombreux, soigneusement disposés sur des étagères Vitsoe, de tissus, de meubles anciens, d'artefacts, de tapis d'inspiration bohémienne et de couleurs audacieuses.

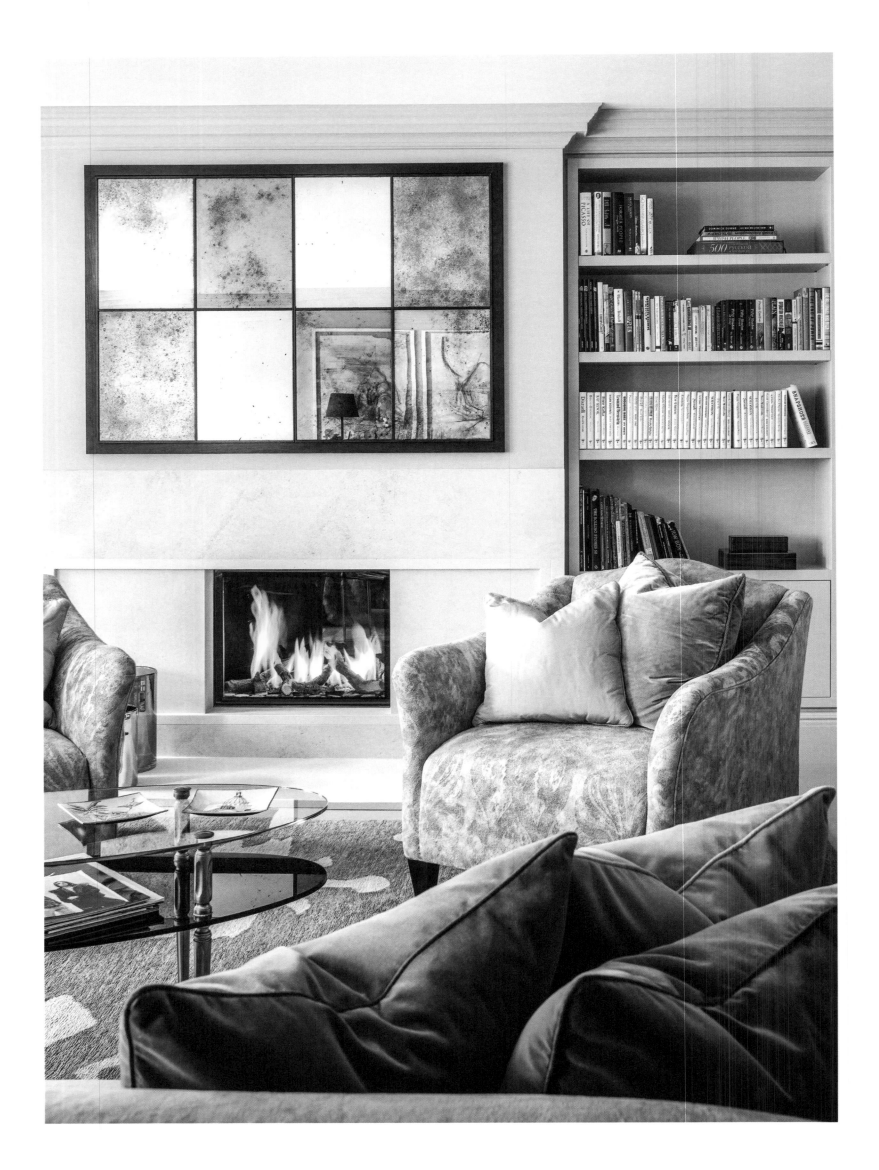

SENSUAL NEST

Belgravia

Partridge birdcages turned into three sizes of lights above the dining table are a perfect example of British eccentricity. Given the location in one of the most prestigious areas in Belgravia, it comes as no surprise that this apartment has been styled in a feminine and elegant way. However, it is the deliberate use of unusual objects and materials which makes the place feel more intimate. The entire design concept was inspired by a stunning 'mother of pearl', tribal, decorative breast piece from Polynesia, found on Portobello Market, and now a sculptural decoration in the dining room. This room is the heart of the home with a rustic table flanked by Eames chairs and a bench with bright blue cushions, the only vibrant colour splash. A well-placed wall-to-wall mirror with patina finish brings a sense of depth to the space and draws attention to the curated collection of 19th century butterfly and plant prints on the opposite wall. The slightly industrial looking metal windows and doors have been scraped and varnished for a softer and more casual look. The hallway has been panelled with special Perspex sheets in different colours, bringing intensity and visual impact to the entrance. Details like these are essential for the ambience. Without a doubt this home is intended to make the owner feel relaxed or ensconced in a sensual nest.

Drei unterschiedlich große, zu Lampen umfunktionierte Rebhuhnkäfige über dem Esstisch sind ein Musterbeispiel für britische Exzentrik. Angesichts der Lage des Apartments in einer der prestigeträchtigsten Gegenden in Belgravia überrascht es nicht, dass der Einrichtungsstil feminin und elegant ist. Der bewusste Einsatz ungewöhnlicher Gegenstände und Materialien lässt dieses Heim jedoch intimer wirken. Das gesamte Designkonzept wurde von einem beeindruckenden, aus Polynesien stammenden und auf dem Portobello Market erstandenen Perlmutt-Stammes-Brustschmuck inspiriert, der jetzt als Dekorationselement im Esszimmer fungiert. Dieser Raum mit seinem rustikalen Tisch, eingerahmt von Eames-Stühlen und einer Bank mit leuchtend blauen Kissen, die den einzigen kräftigen Farbklecks darstellen, bildet das Herz des Hauses. Eine wohl platzierte, mit Patina überzogene Spiegelfläche, die die gesamte Wand einnimmt, verleiht dem Raum Tiefe und lenkt die Aufmerksamkeit

23

auf die gegenüberliegende kuratierte Sammlung von Schmetterlings- und Pflanzendrucken aus dem 19. Jahrhundert. Die dem Industrie-Look ähnelnden Metallfenster und -türen wurden aufgeraut und lackiert, um weicher und lässiger zu wirken. Die Diele wurde mit besonderen, unterschiedlich farbigen Perspex-Platten vertäfelt, wodurch der Eingang ein markantes, leuchtendes Erscheinungsbild erhält. Details wie diese sind für die Atmosphäre unerlässlich. Dieses Heim ist eindeutig dazu bestimmt, ein Gefühl der Entspanntheit bei seiner Bewohnerin hervorzurufen oder sich wie in einem sinnlichen Nest zu fühlen.

Les cages à perdrix transformées en lampes de trois tailles différentes qui éclairent la table de la salle à manger, sont un parfait exemple de l'excentricité anglaise. Si l'on considère l'emplacement de cet appartement, situé dans l'un des quartiers les plus prestigieux de Belgravia, il n'est guère étonnant que sa décoration affiche une féminine élégance. Ce qui, toutefois, lui donne toute sa personnalité, c'est l'usage délibéré d'objets et de matériaux insolites. Le design a été entièrement inspiré par un étonnant plastron ornemental en nacre ayant appartenu à une tribu de Polynésie. Déniché sur le Portobello Market, il est devenu une décoration sculpturale, placée dans la salle à manger. Avec sa table rustique flanquée de chaises Eames et son banc garni de coussins bleu vif qui forment l'unique tache de couleur éclatante du lieu, cette pièce constitue le coeur de la maison. Vieilli et judicieusement placé, le miroir qui recouvre le mur crée une sensation de profondeur et met en valeur la remarquable sélection de gravures du XIXème siècle représentant des papillons et des plantes, disposée sur la cloison opposée. Non dépourvues d'un caractère industriel, les fenêtres et les portes en métal ont été poncées et vernies afin de leur donner un aspect plus doux et informel. Le couloir a été tapissé de plaques Perspex adaptées dont les différentes couleurs créent dans l'entrée un intense impact visuel. Ce type de détails participe de façon déterminante à l'atmosphère des lieux. Sans doute aucun, cette demeure a été conçue pour que ses habitants s'y sentent à l'aise, confortablement installés dans un nid voluptueux.

SUBTLE 'MOTHER OF pearl' shades inspired by the pearl, tribal, decorative piece from Polynesia in the dining room have been repeated in the colour palette and materials used not only in the living room but also for other spaces, including a customized hand-knotted silk carpet in the bedroom.

INSPIRIERT VON DEM aus Polynesien stammenden Brustschmuck im Esszimmer wiederholen sich dezente Perlmutt-Töne in der Farbpalette und in den Materialien. Sie wurden jedoch nicht nur im Wohnzimmer eingesetzt, sondern auch in anderen Räumen, darunter im Schlafzimmer, wo ein maßgefertigter, handgeknüpfter Seidenteppich liegt.

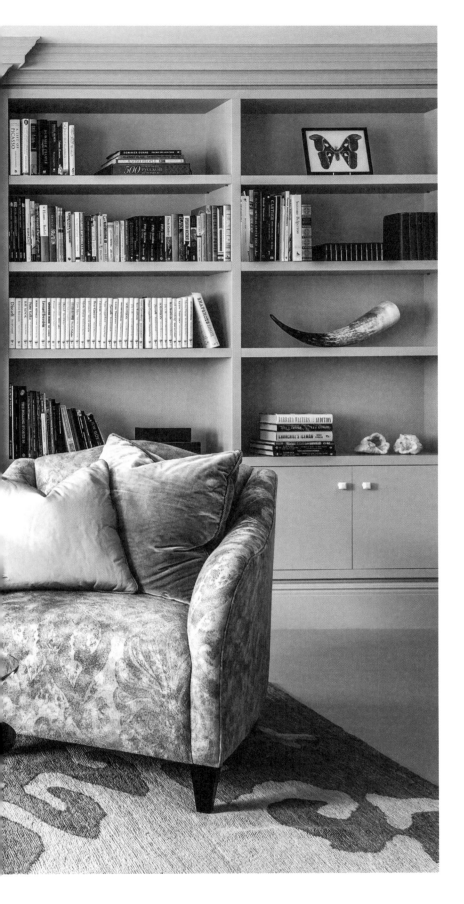

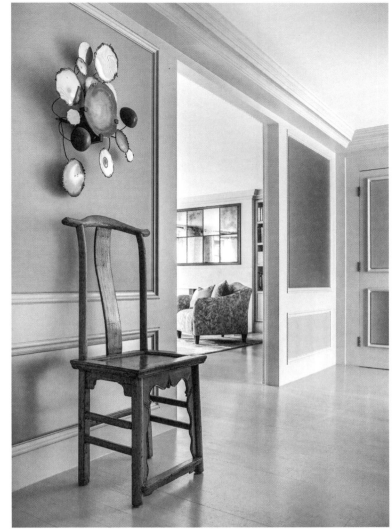

LES SUBTILES NUANCES nacrées des perles de la pièce ornementale polyné-sienne de la salle à manger ont été reprises dans la palette de couleurs et les matériaux utilisés non seulement dans la salle à manger, mais également dans les autres espaces, à l'exemple du tapis en soie noué à la main et fait sur mesure de la chambre à coucher.

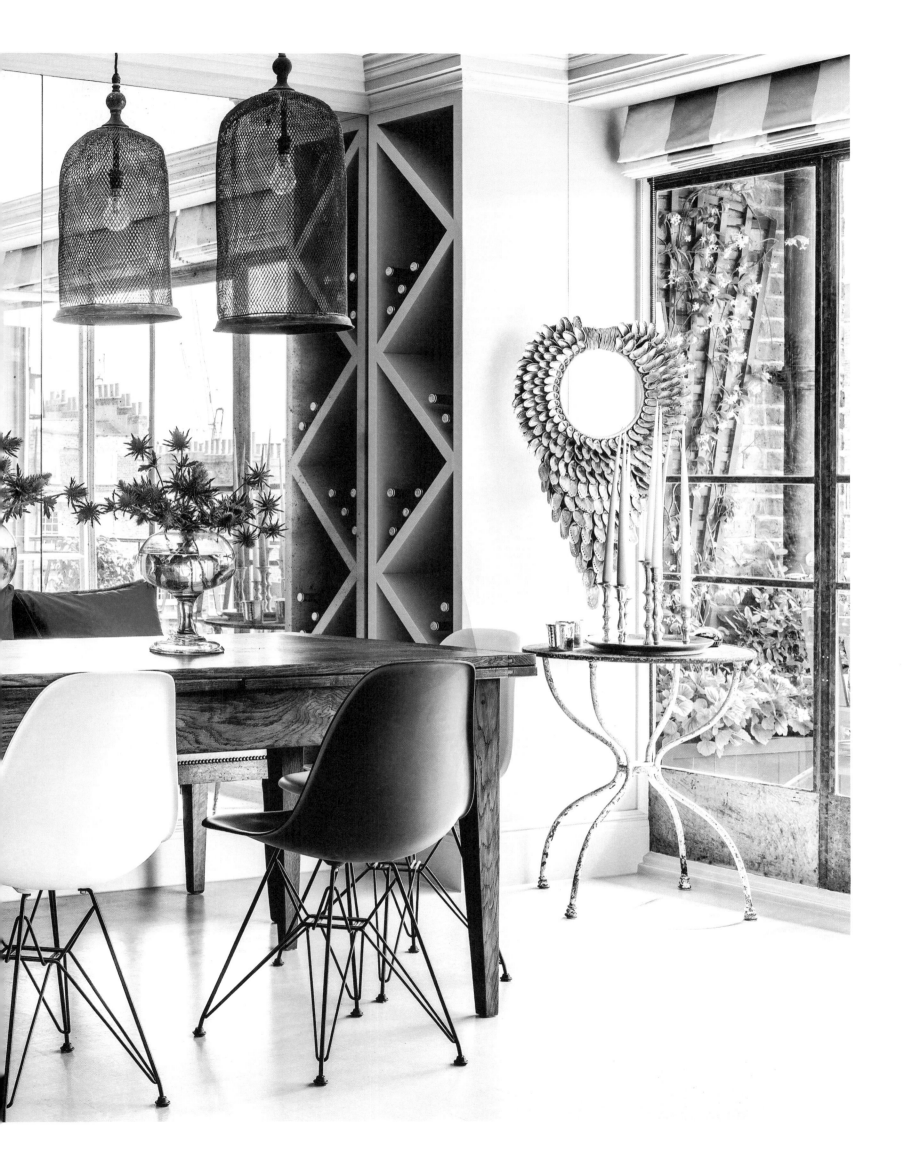

ECLECTIC FORMAL
Belgravia

Living in one of the most iconic and elegant streets in London might entail some responsibility for a certain mode of living. The architectural style and finesse of this family dwelling certainly matches the surroundings of affluent Belgravia. The building remained unrestored for 30 years and has now been completely refurbished to provide a stunningly beautiful, formal residence. With three young boys and a full social entertaining calendar, the house had to feel like a home and provide elegant, refined dining and reception spaces for guests. Using an eclectic mix of antique furniture, artwork from a Syrian artist reflecting the owners' Syrian background and a soft and natural colour range, Louise Jones Interiors managed to achieve a fine balance between the different elements. A smooth contemporary style unifies the look throughout the rooms, with interesting modern pieces and antiques, unusual twists and a few vibrant red or warm colour splashes. Each room has its own standout flourish or object d'art. The family room features a large B&B Italia L-shaped sofa and a lacquer coffee table from Ruggiano. In the dining room, a modern glass chandelier from Roll&Hill contrasts with the straight lines, and a gorgeous Jules Leleu cabinet gives the drawing room a timeless and edgy quality.

In einer der prestigeträchtigsten und elegantesten Straßen Londons zu wohnen, kann eine gewisse Verantwortung für eine bestimmte Lebensweise in sich bergen. Der Baustil und die Raffinesse dieses Hauses passen auf jeden Fall in die Umgebung des wohlhabenden Belgravia. Das Gebäude wurde zuvor 30 Jahre lang nicht renoviert und erfuhr daher eine vollständige Sanierung, um als wunderschöner, repräsentativer Wohnsitz zu dienen. Mit drei heranwachsenden Söhnen und einem Kalender voller gesellschaftlicher Termine, benötigten die Eigentümer ein Haus, dass nicht nur über elegante, stilvolle Ess- und Empfangsräume verfügt, um Gäste zu bewirten, sondern auch die Funktion eines familientauglichen Heims erfüllt. Durch die vielfältige Mischung aus antiken Möbeln, Kunstwerken eines syrischen Künstlers – eine Hommage an die syrische Herkunft der Besitzer – und die sanfte, natürliche Farbpalette gelang es Louise Jones Interiors, ein wunderbares Gleichgewicht zwischen den

verschiedenen Elementen herzustellen. Ein weicher, zeitgenössischer Stil mit interessanten, modernen Stücken und Antiquitäten, ungewöhnlichen Wendungen und einigen leuchtend roten oder warmen Farbtupfern durchzieht die Räume und verbindet sie optisch miteinander. Jedes Zimmer verfügt über ein eigenes, herausragendes Dekorationselement oder einen Kunstgegenstand. Das Wohnzimmer besticht durch ein großes L-förmiges Sofa von B&B Italia und einen Lacktisch von Ruggiano. Im Esszimmer bildet ein moderner Kronleuchter aus Glas einen Kontrast zu den geraden Linien, während ein prachtvoller Schrank von Jules Leleu das Wohnzimmer zeitlos und ausgefallen erscheinen lässt.

24

Résider dans l'une des rues les plus chics et symboliques de Londres n'est pas sans impliquer quelque responsabilité dans le choix du mode de vie. Assurément, le style architectural et le raffinement de cette demeure familiale s'accordent à l'environnement aisé du quartier de Belgravia. Resté en l'état durant trente ans, l'édifice a fait l'objet d'une rénovation totale dont le résultat est d'une beauté incroyablement élégante. Accueillant trois jeunes garçons et un nombre conséquent d'événements sociaux, la maison devait à la fois donner le sentiment d'être un foyer et offrir aux invités des espaces de réception chics et raffinés. Associant de façon éclectique meubles anciens et oeuvres d'art réalisées par un artiste dont l'origine syrienne est liée à l'histoire des propriétaires, et recourant à une palette de couleurs douces et naturelles, Louise Jones Interior est parvenu à instaurer un remarquable équilibre entre ces divers éléments. Composé d'objets modernes ou anciens singuliers, de touches inattendues, de pointes de couleur chaudes ou rouges, un style contemporain fluide unifie les pièces dont chacune possède un élément décoratif ou une oeuvre d'art d'exception. L'espace de vie familial présente ainsi un vaste canapé en forme de L de chez B&B Italia, ainsi qu'une table basse laquée de chez Ruggiano. Dans la salle à manger, le moderne lustre en verre de chez Roll&Hill contraste avec les lignes droites, cependant qu'une délicieuse vitrine Jules Leleu diffuse dans le salon une atmosphère intemporelle et avant-gardiste.

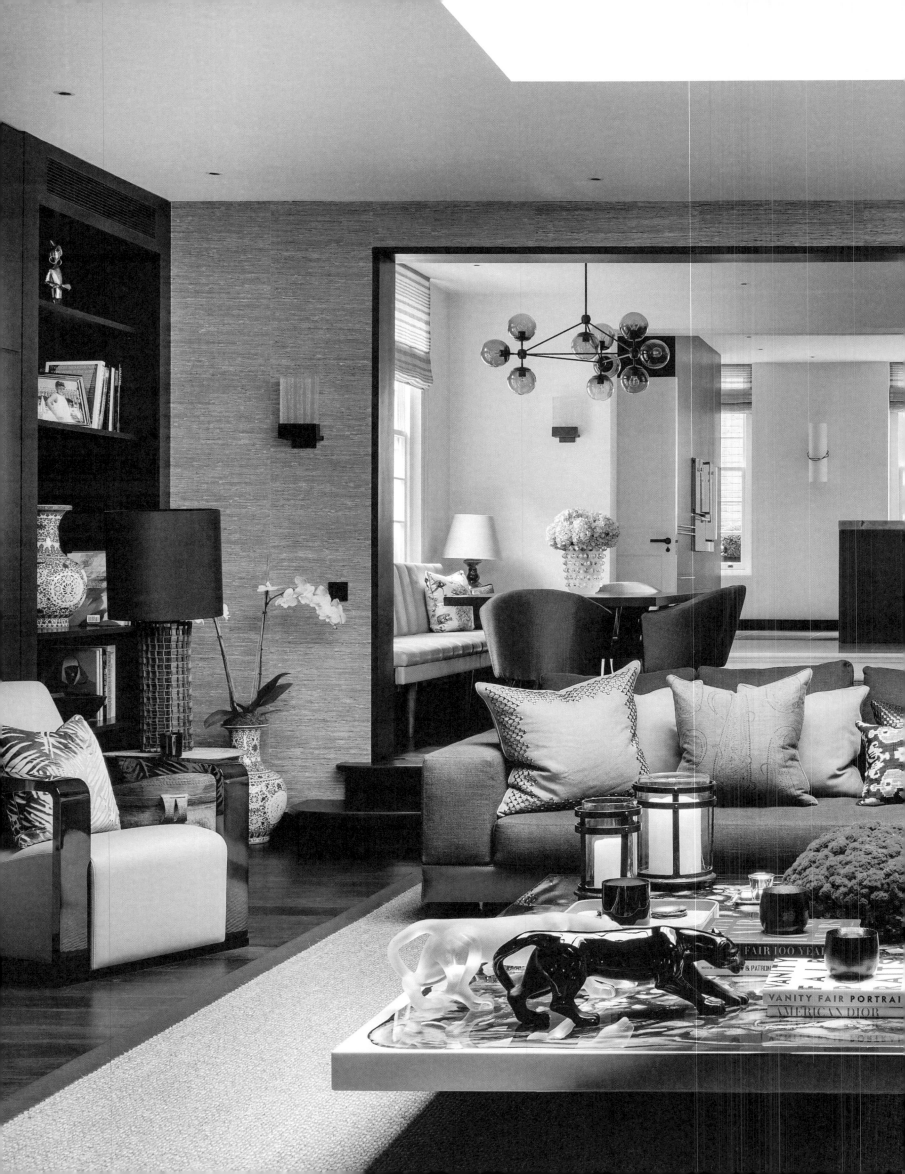

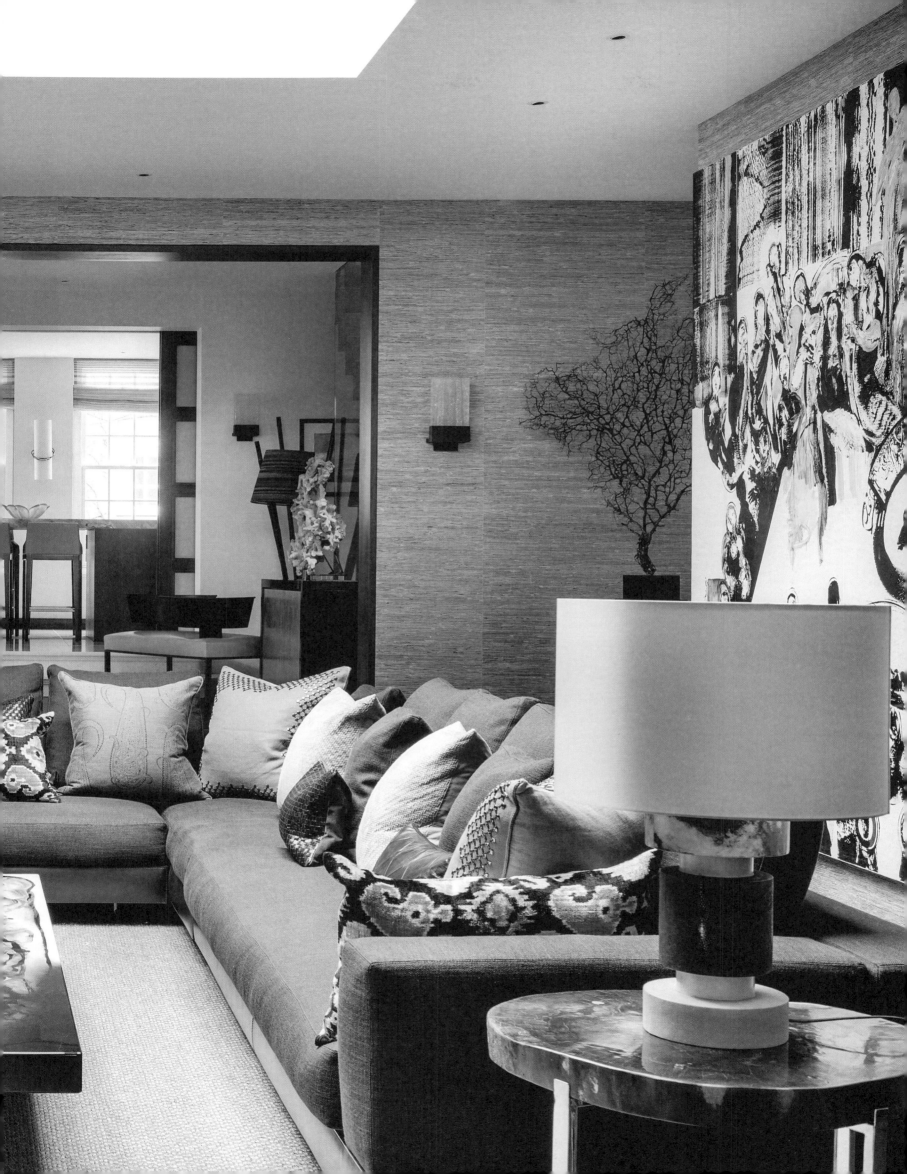

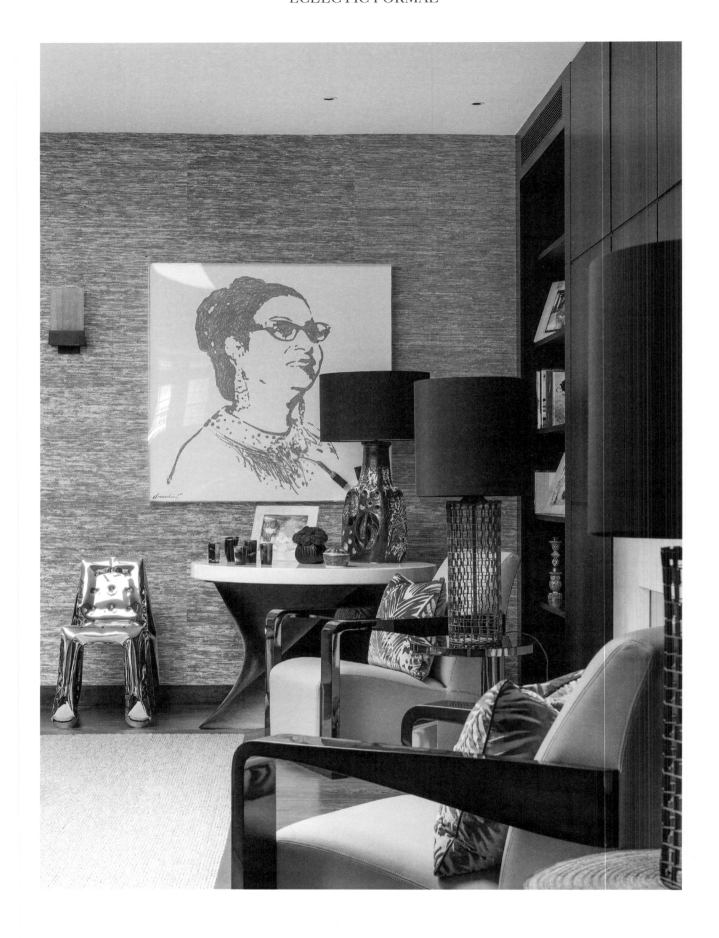

THE NUMEROUS UNIQUE pieces in the home have been purchased at Christie's and other antique auctions and are interspersed with eye-catching art by a Syrian artist. In the dining room, the walls are covered in a Fortuny fabric, which creates a warm, dramatic backdrop for the mix of furniture from various decades.

DIE ZAHLREICHEN UNIKATE in diesem Haus, bei Christie's und anderen Auktionshäusern erstanden, werden mit Werken eines syrischen Künstlers kombiniert, die ins Auge fallen. Die Wände im Esszimmer sind mit einem Fortuny-Stoff überzogen, der einen warmen, effektvollen Hintergrund bildet für die aus unterschiedlichen Jahrzehnten stammenden verschiedenartigen Möbel.

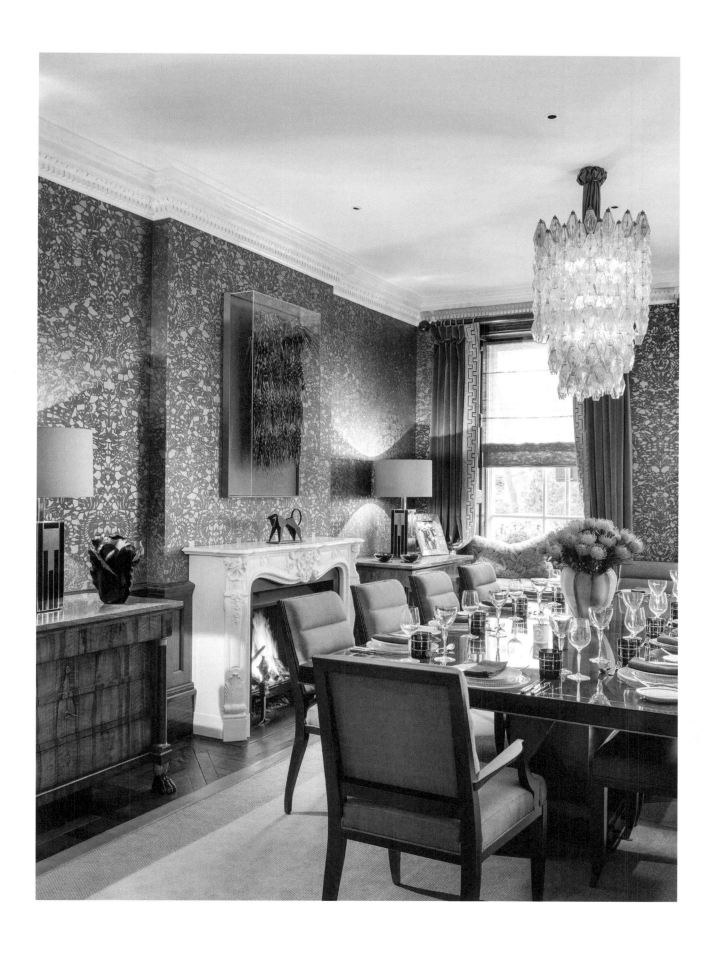

ACQUISES CHEZ CHRISTIE'S ou dans d'autres salles des ventes, les nombreuses pièces uniques que recèle cette maison alternent avec les toiles saisissantes signées par un artiste syrien. Les murs de la salle à manger sont tendus d'un tissu Fortuny qui offre un arrière-plan chaleureux et spectaculaire aux meubles qui datent de différentes époques.

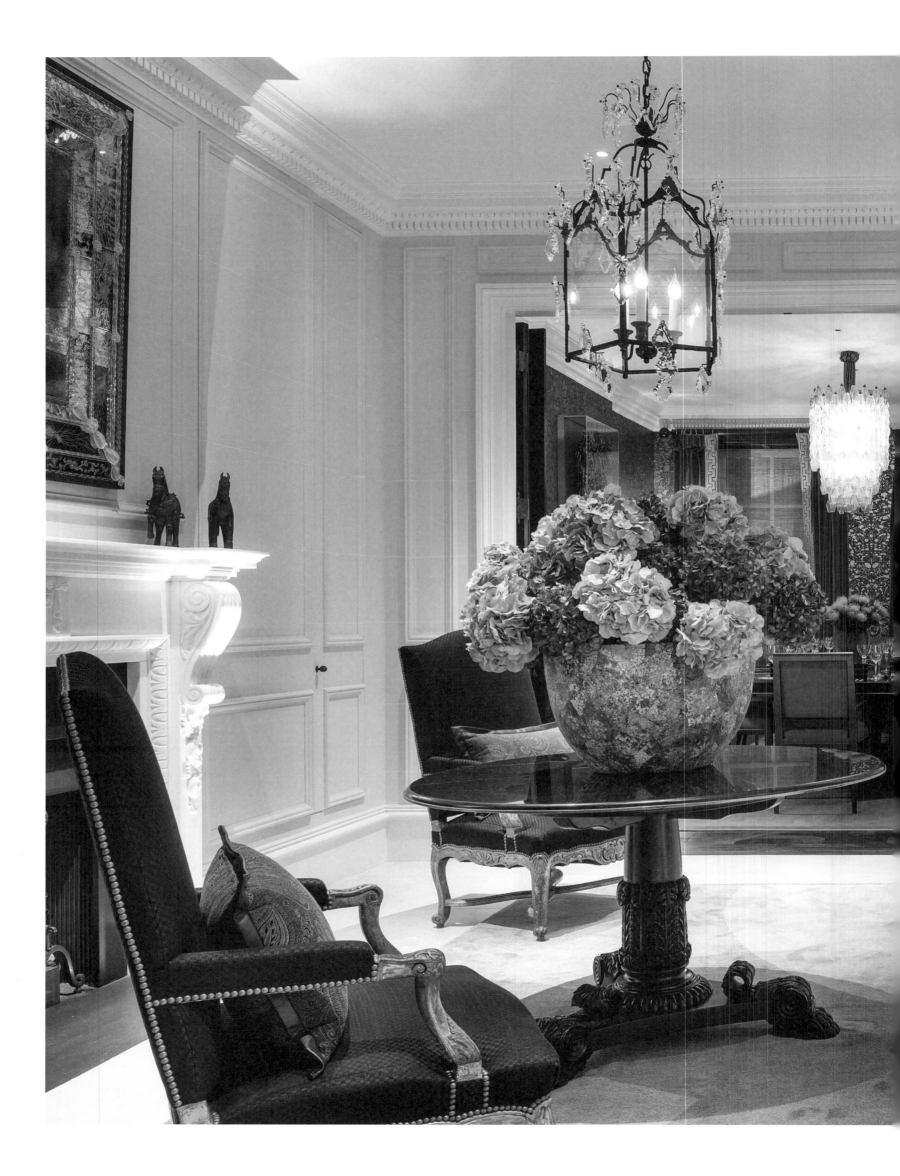

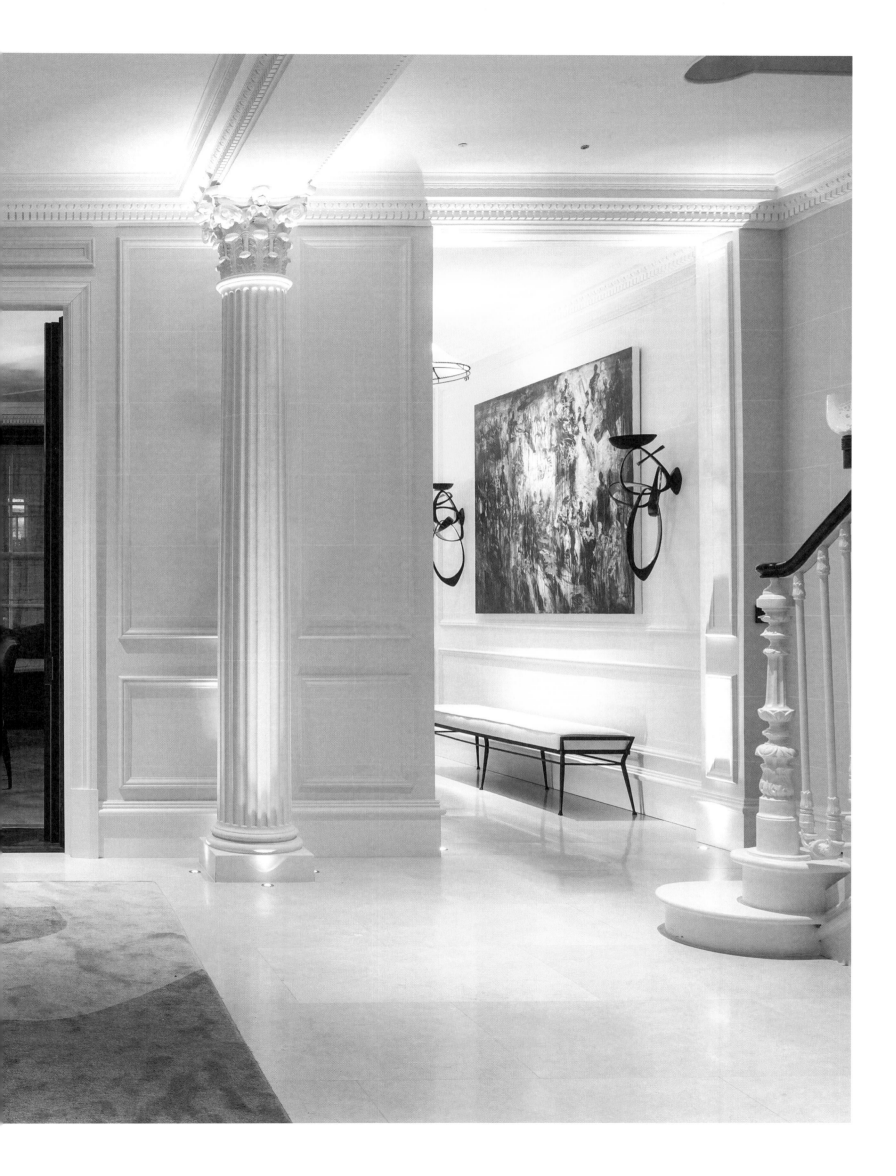

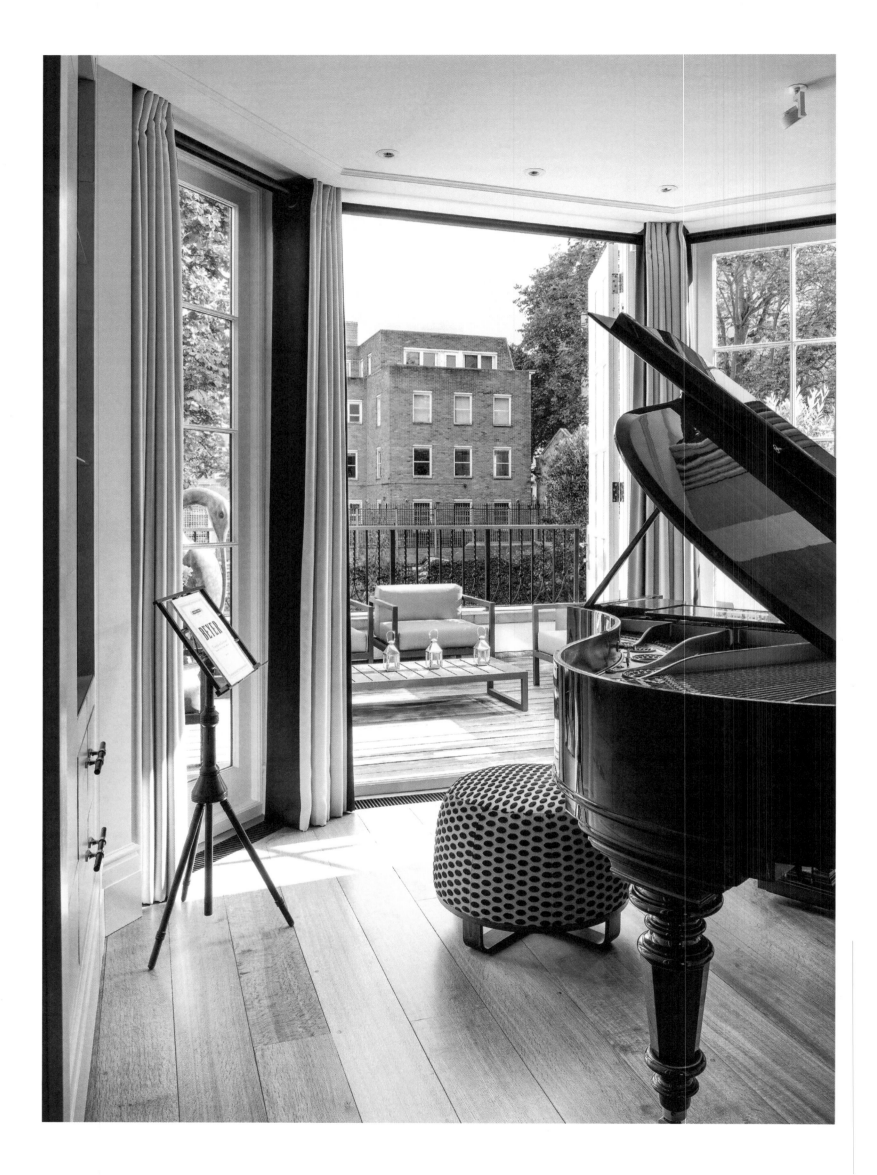

CALM AND VIBRANT

Belgravia

When choosing their forever dream house, the owners placed a lot of importance on light and location. In a very ambitious refurbishment project, they transformed the Georgian Grade II-listed terraced house into a vibrant and calming home. The central location in affluent Belgravia and the bright, well-proportioned rooms provided a blank canvas, allowing architects Jones Lambell and Pero Designs to create beautifully airy and sculptural spaces for a young family to enjoy. A large subterranean basement was created which provides the generous open space often lacking in a typical Georgian townhouse. The rear elevation of the house was re-modelled to extend the master bedroom suite, to add a first-floor music room and provide a sunny, south-facing first-floor terrace. Throughout this elegant and uncompromising home several surprising elements make an appearance. Above the family room is a glass-bottomed garden pond, and a skylight above the master shower adds a certain playfulness. In order to enhance the different areas, such as the basement, mirrors are used extensively, making the house feel even more spacious. In fact, everything has been customized to the owners' taste and the end result feels like a beautifully tailored suit of the finest quality.

Als die Besitzer dieser Immobilie ihr absolutes Traumhaus wählten, legten sie viel Wert auf Licht und Lage. Alles andere veränderten und fügten sie einfach in einer sehr ehrgeizigen Modernisierungsmaßnahme später hinzu und verwandelten das denkmalgeschützte, georgianische Reihenhaus in ein strahlendes, beruhigendes Heim. Die zentrale Lage im wohlhabenden Belgravia und die hellen, ansehnlichen Zimmer lieferten den Architekten von Jones Lambell und Pero Designs eine leere Leinwand, wodurch sie wunderbar luftige, skulpturale Räume schaffen konnten, in denen sich eine junge Familie wohlfühlt. Ein großes Kellergeschoss mit einem weiten, offenen Raum entstand – etwas, woran es einem typischen georgianischen Stadthaus häufig mangelt. Die Rückansicht des Hauses wurde umgestaltet, sodass das Elternschlafzimmer vergrößert und im ersten Stock ein Musikzimmer mitsamt sonniger, nach Süden gerichteter Dachterrasse hinzugefügt werden konnte. In diesem durchweg

25

eleganten und beispiellosen Heim treten einige überraschende Elemente in Erscheinung: Oberhalb des Wohnzimmers befindet sich ein Gartenteich mit Glasboden, und über der Dusche ist eine Dachluke eingelassen, die dem Bad eine gewisse Verspieltheit verleiht. Um die verschiedenen Bereiche wie zum Beispiel das Untergeschoss aufzuwerten, wurden zahlreiche Spiegel angebracht, sodass das Haus noch geräumiger wirkt. Die gesamte Innenausstattung wurde nach dem Geschmack des Besitzers gefertigt, und so fühlt sich das Endergebnis an wie ein wunderschöner, maßgeschneiderter Anzug höchster Qualität.

Au moment de choisir la maison dont ils avaient toujours rêvé, les propriétaires ont d'abord tenu compte de la lumière et de l'emplacement. Ensuite seulement sont venus les changements et les ajouts, au cours d'un projet de rénovation particulièrement ambitieux qui a vu la transformation de cette maison de ville de style georgien et classée (Grade II) en un foyer tout à la fois vivant et serein. La situation centrale de la propriété, dans le quartier aisé de Belgravia, les pièces lumineuses et parfaitement proportionnées, offraient aux cabinets d'architecture et de décoration intérieure, Jones Lambell et Pero Designs, un espace vierge à partir duquel imaginer des pièces extraordinairement aérées et sculpturales pouvant accueillir une jeune famille. L'ouverture d'un vaste sous-sol a permis de créer ce généreux espace ouvert dont sont si souvent dépourvues les demeures georgiennes typiques. La façade arrière a été reconstruite de sorte à agrandir la suite parentale et installer au premier étage une salle de musique, ainsi qu'une terrasse ensoleillée et orientée au sud. Nombreux sont les éléments de surprise dans cette demeure à l'exigeante élégance. Ainsi du bassin d'agrément à fond vitré situé au-dessus de la pièce de vie familiale, ou encore, du vélux qui introduit une dimension ludique dans la douche parentale. Le recours à de multiples miroirs a permis non seulement, de mettre en valeur les différentes zones de la maison, dont le sous-sol, mais encore d'accroître la sensation d'espace. De fait, l'architecture a été entièrement pensée en fonction du goût des propriétaires et au final, l'ensemble évoque un costume de la meilleure qualité magnifiquement taillé sur-mesure.

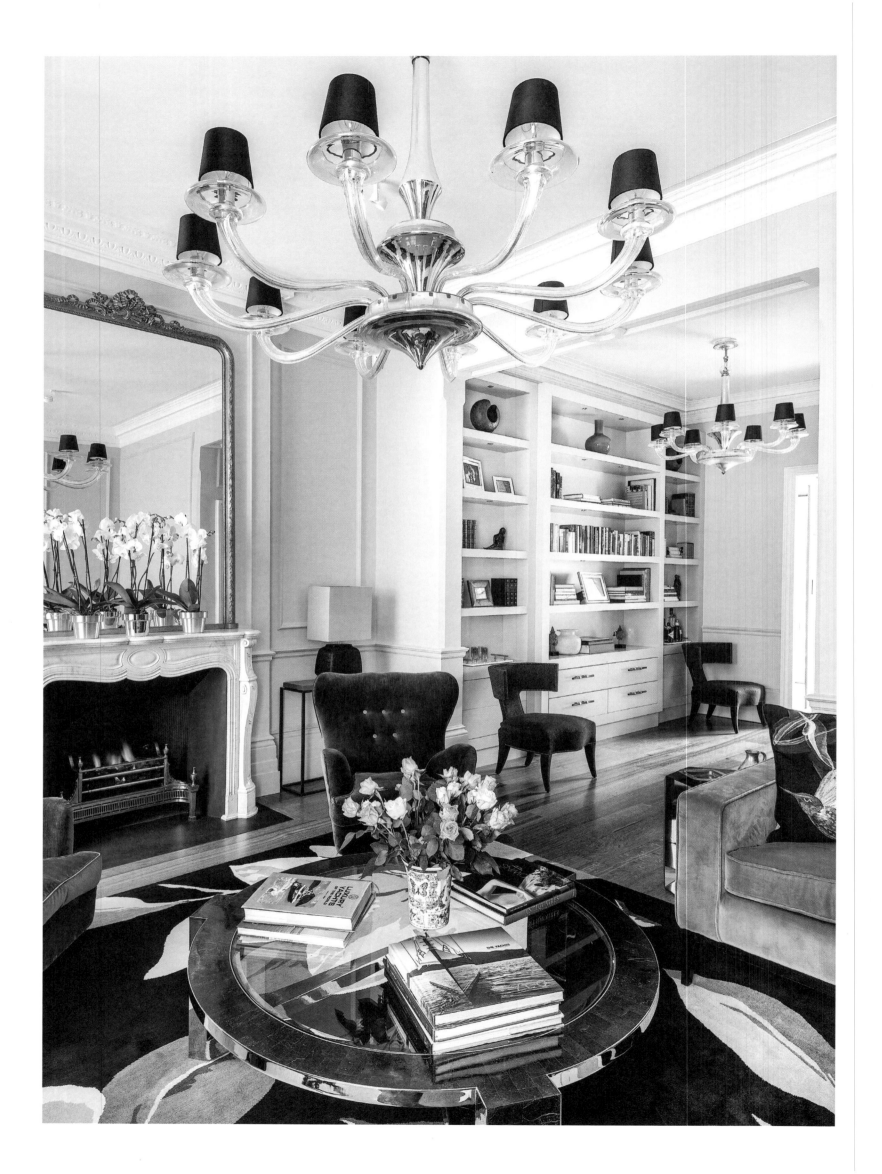

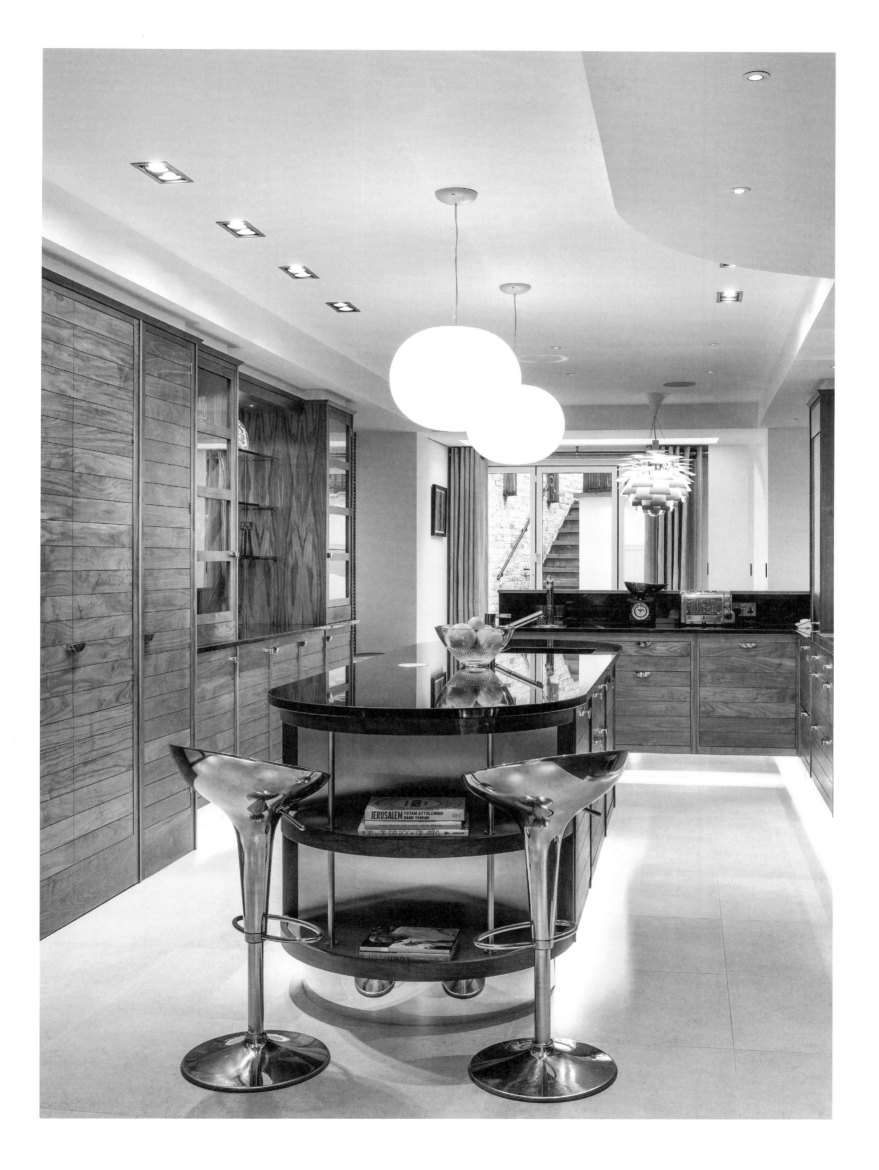

IN THE GORGEOUS master dressing room, the built-in wardrobes have mirrored sliding doors and a polished nickel trim that contrasts with the rich walnut colour of the wood.

DIE EINBAUSCHRÄNKE IN dem prächtigen Ankleidezimmer sind mit verspiegelten Schiebetüren und glänzenden Zierleisten aus Nickel versehen, die einen Kontrast zu dem kräftigen, walnussfarbenen Holz bilden.

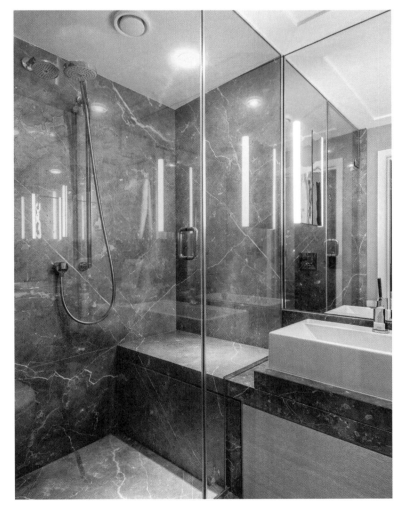

LES PENDERIES ENCASTRÉES du splendide dressing de la suite parentale, présentent des portes coulissantes pourvues de miroir, cependant que leurs bordures en nickel poli contrastent avec la chaude couleur du noyer utilisé.

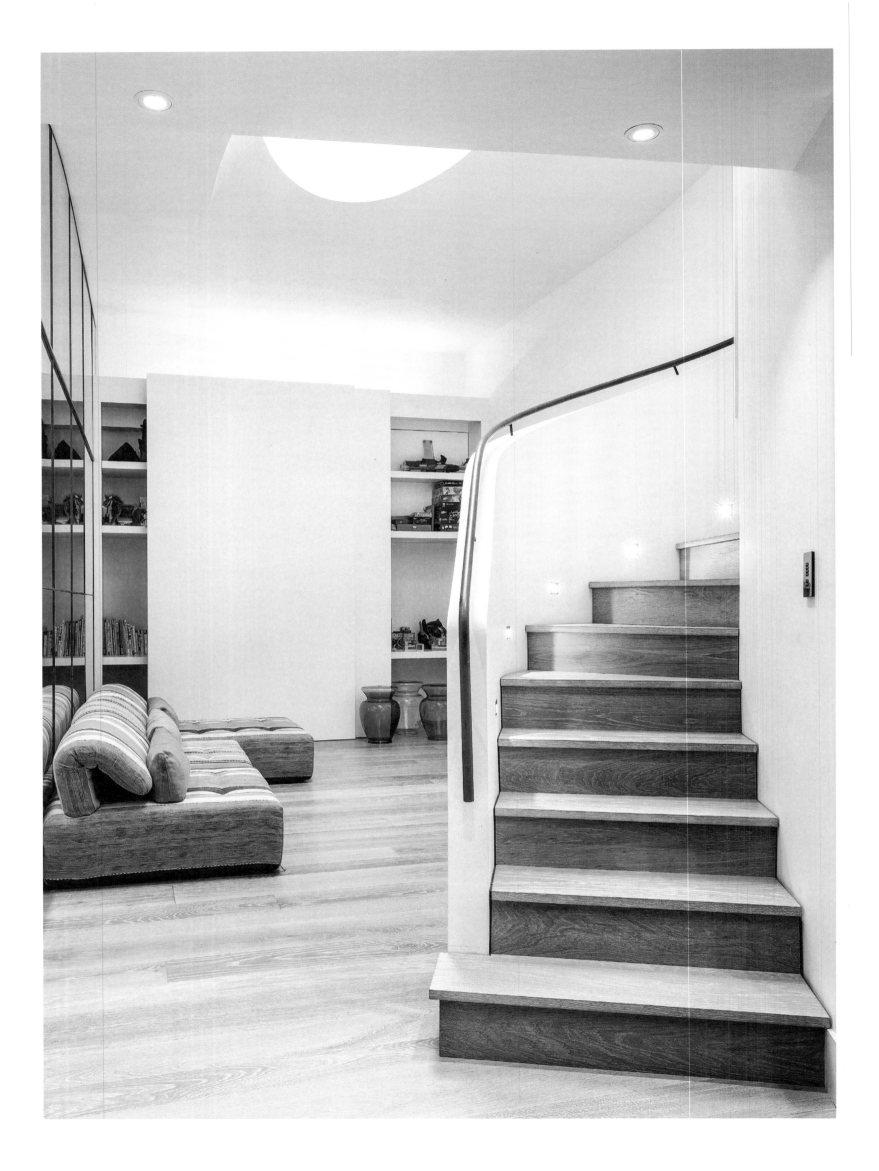

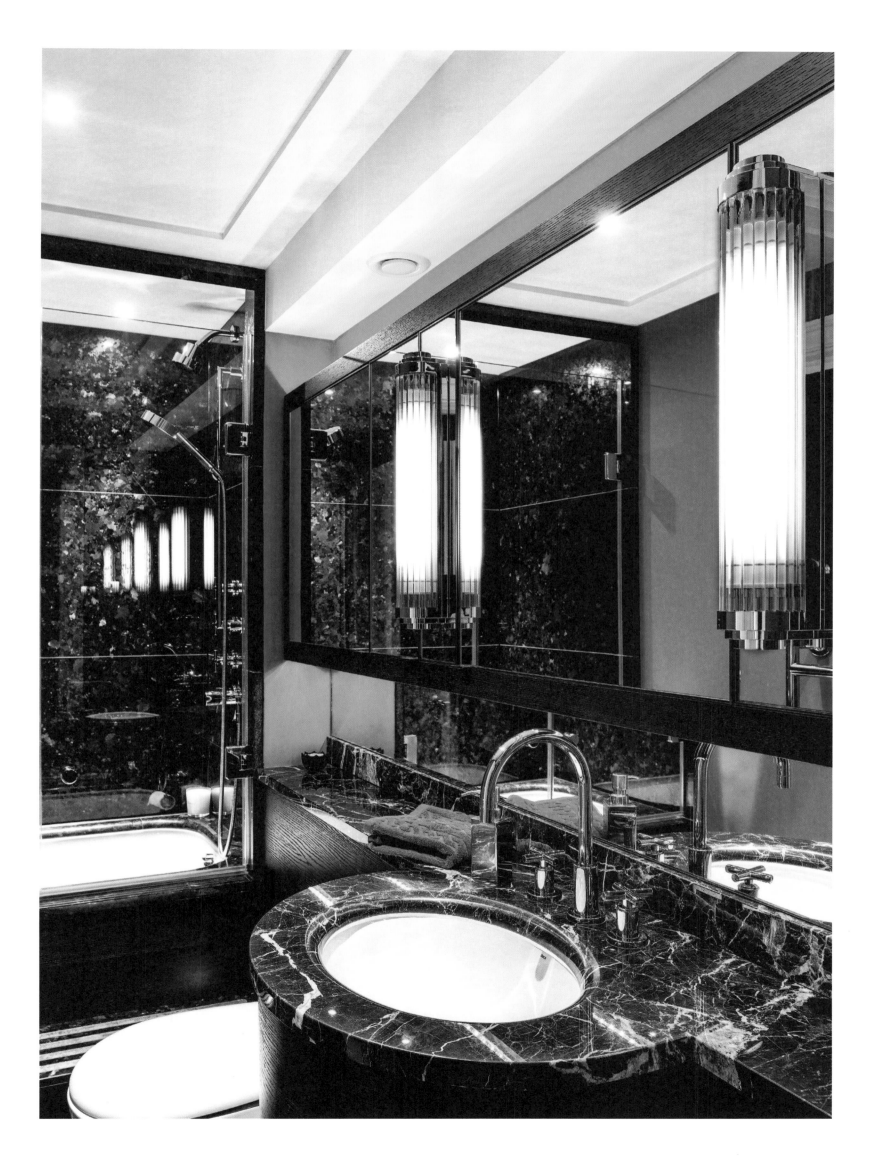

FLAMBOYANT ELEGANCE

Soho

The eclectic aesthetic of the neon-lit streets outside underpins the owners' more elegant and restrained restoration of this Soho home. The vibrant charm of the neighbourhood reminded them of New York's West Village and they loved the idea of living in a building with a tumultuous past. The creative duo previously owned an architectural practice themselves and instead of just getting the one-bedroom apartment they had initially looked at, they bought the entire building and turned it into a home spreading over three floors. Being in a conservation area they had to do everything in keeping with the façade. Poky bedsits and dingy offices have given way to generous rooms full of light and with a feeling akin to a New York loft. Oak flooring throughout gives a sense of calm uniformity and flow as the stairs lead to the other floors ending with the couple's bedroom and bathroom with roof terrace and balcony. The neutral palette throughout provides a restful backdrop for their flamboyant flourishes, manifested in their art collection, decoration and favourite pieces of furniture, sourced from round the world. The residents wanted the renovation to reflect their international lifestyle, as well as bringing the old building back to life.

Das mannigfaltige Erscheinungsbild der neonbeleuchteten Straßen untermauert die eher elegante und dezente Sanierung dieses Hauses in Soho, die die Besitzer vornahmen. Der lebendige Charme des Viertels erinnerte das Paar an das West Village in New York, und die Idee, in einem Gebäude zu leben, das auf eine stürmische Vergangenheit zurückblickt, gefiel ihnen. Das kreative Zweiergespann besaß früher selbst ein Architekturbüro und statt sich nur ein Apartment mit einem Schlafzimmer zu kaufen, wonach sie ursprünglich suchten, erwarben sie das gesamte Gebäude und verwandelten es in ein Heim, das sich über drei Stockwerke erstreckt. Da das Haus in einem denkmalgeschützten Quartier liegt, musste alles getan werden, um die Fassade zu erhalten. Ehemals winzige Einzimmerwohnungen und schäbige Büros wichen großzügigen, lichtdurchfluteten Räumen, die an ein New Yorker Loft erinnern. Die im gesamten Haus verlegten Eichenholzböden versprühen Ruhe und eine fließende Einheitlichkeit. Die Treppe führt zum Schlafzimmer des Paars sowie zum Badezimmer, zur Dachterrasse und zum Balkon. Die neutrale Farbpalette liefert einen ruhigen Hintergrund für die prächtige Ausgestaltung, die sich in der Kunstsammlung, der Dekoration und den aus der gesamten Welt stammenden Lieblingsmöbelstücken der beiden äußert. Die Besitzer wollten durch die Renovierung einerseits den Geist des alten Gebäudes wiedererwecken, aber andererseits auch ihren internationalen Lebensstil darin zum Ausdruck bringen.

26

L'éclectique esthétique de la rue éclairée par des néons met en valeur la sobre élégance de cette demeure rénovée de Soho. Pour ses propriétaires, le charme dynamique du quartier rappelle celui du West Village à New York. L'idée de vivre dans un édifice au tumultueux passé les séduit. Avant de fonder « Snog », chaîne de yaourts surgelés, ce duo de créateurs possédait un cabinet d'architecture. Renonçant au deux-pièces qu'ils recherchaient à l'origine, ils acquièrent la totalité du bâtiment qu'ils transforment en une demeure répartie sur trois étages. L'édifice se trouvant dans une zone classée au patrimoine, il leur faut absolument conserver la façade. Les studios exigus et les bureaux défraîchis laissent alors place à des pièces généreuses et lumineuses qui ne sont pas sans évoquer un loft new yorkais. Par son omniprésence, le parquet en chêne crée une paisible sensation d'uniformité et de continuité, à mesure que les escaliers s'élèvent d'un étage à l'autre, jusqu'à la chambre avec salle de bain du couple, laquelle donne sur un toit-terrasse et un balcon. Déclinée dans chaque pièce, la palette de tons neutres offre un arrière-plan reposant au flamboyant décor que les propriétaires ont constitué à partir de leur collection artistique, leurs objets décoratifs ou meubles favoris, provenant du monde entier. Ces derniers souhaitaient que la rénovation entreprise reflète le style de vie international qui étaient le leur, tout en insufflant une vie nouvelle à l'ancien édifice.

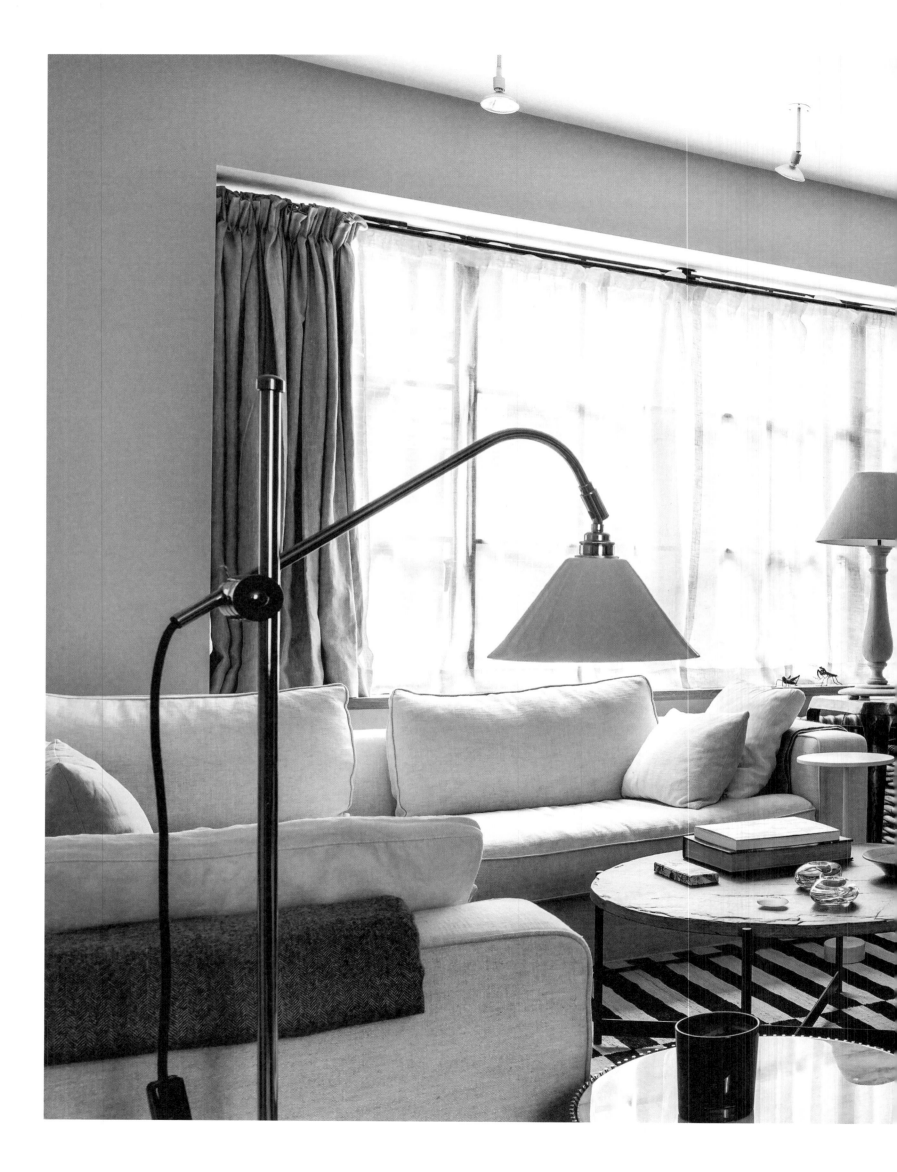

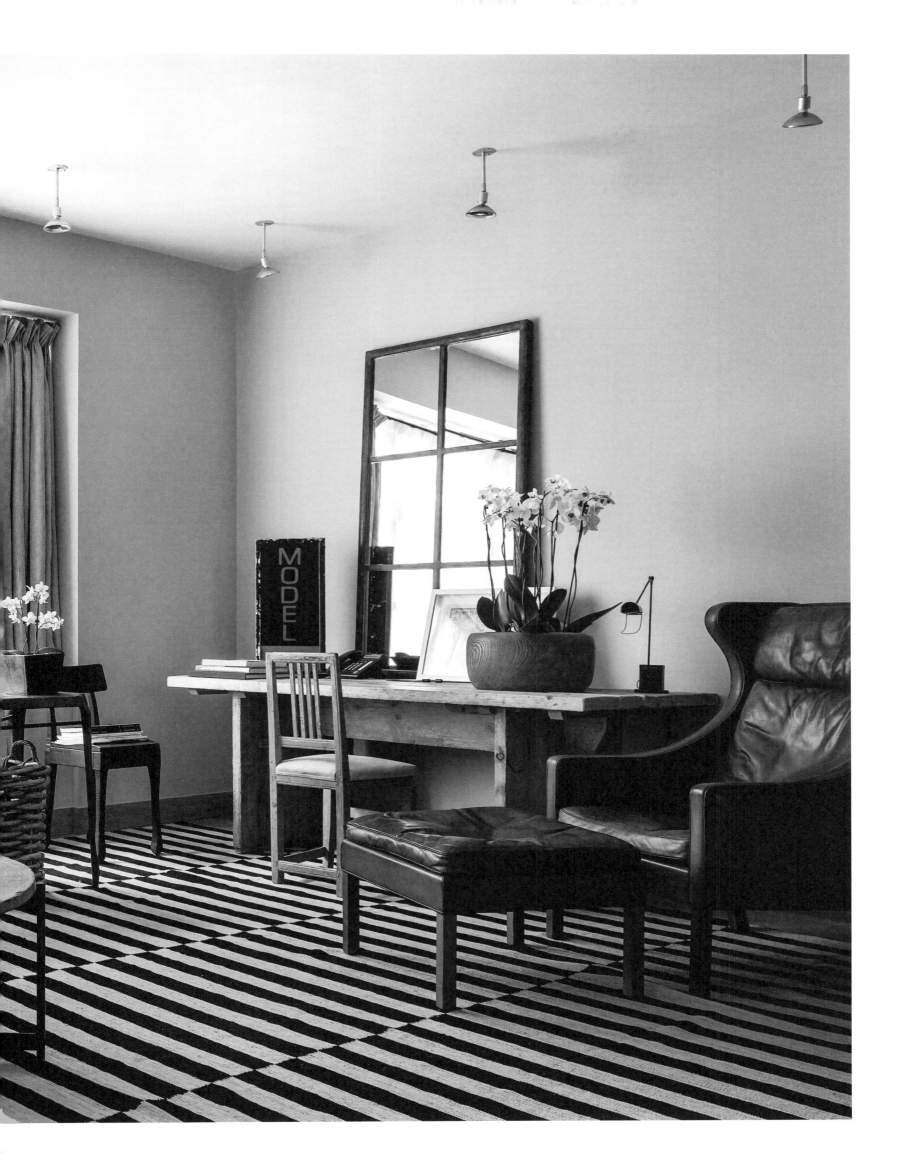

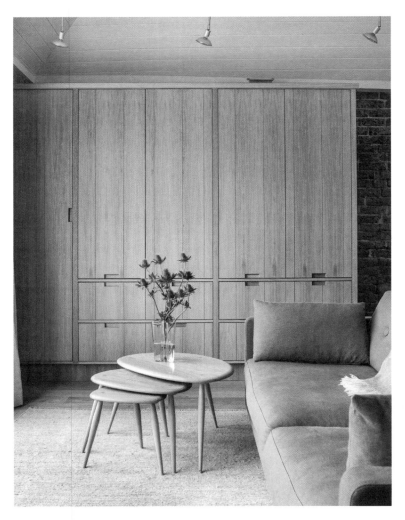

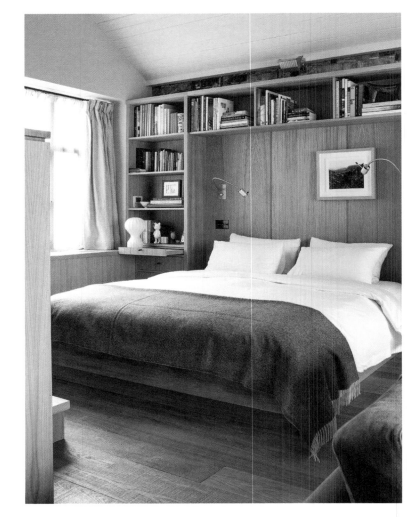

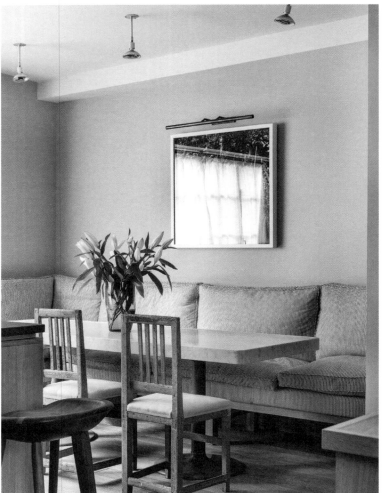

THE NEUTRAL PALETTE throughout provides a restful backdrop for the interesting collection of furniture, sourced from around the world. The grey of the Erik Jørgensen sofa underlines the Scandinavian simplicity, and the colour scheme is continued in the bedspread in the bedroom. In the bathroom, they have used subway tiling and basins from Laufen.

DIE DURCHWEG NEUTRALE Farbpalette liefert einen ruhigen Hintergrund für die interessante, aus der gesamten Welt stammende Sammlung von Möbeln. Das Grau des Sofas von Erik Jørgensen unterstreicht die skandinavische Schlichtheit. Das Farbschema setzt sich im Schlafzimmer in der Überdecke des Betts fort. Im Badezimmer wurden Metrofliesen und Waschbecken von Laufen verwendet.

OMNIPRÉSENTE, LA PALETTE de tons neutres offre un écrin reposant à l'attrayante collection de meubles dénichés dans le monde entier. Le canapé gris Erik Jørgensen met en valeur une simplicité toute scandinave, cependant que le couvre-lit de la chambre prolonge la thématique colorée. Un carrelage métro et des vasques Laufen ont été utilisés dans la salle de bain.

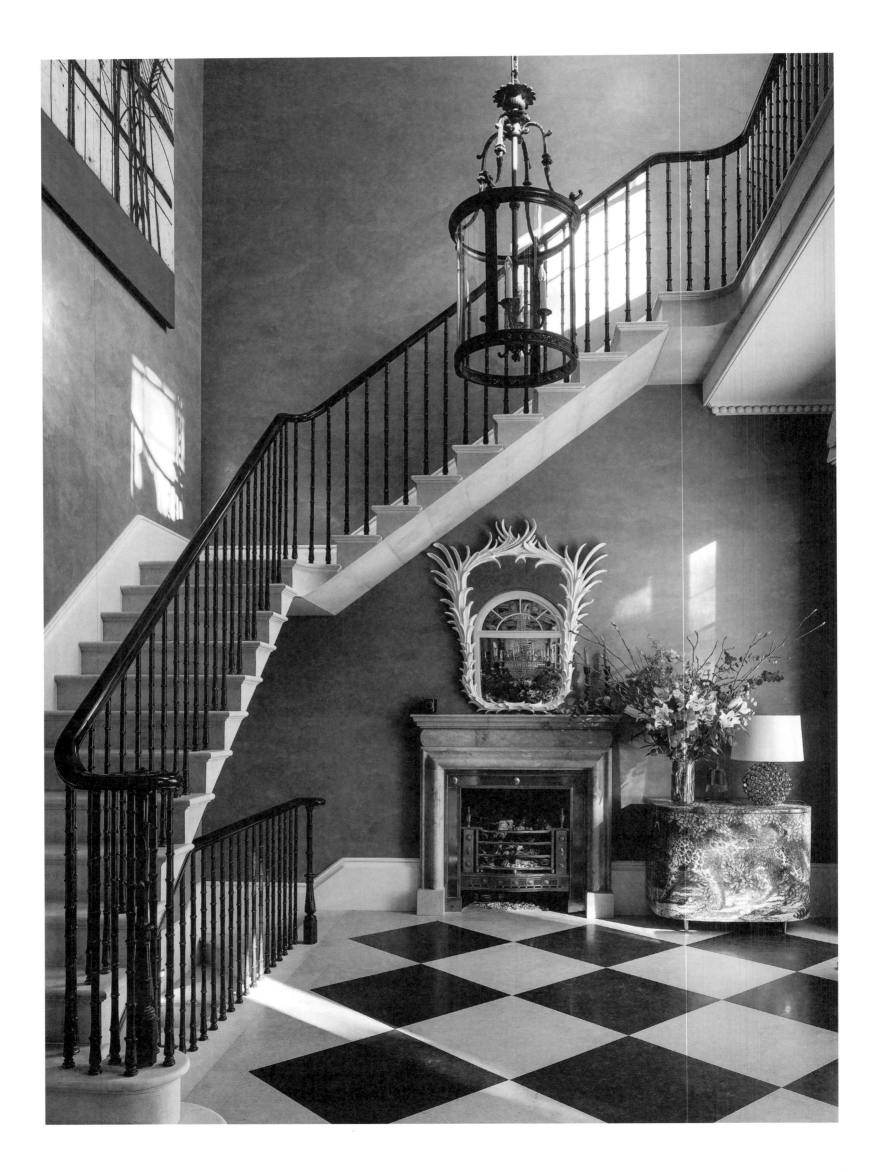

UNDERSTATED SOPHISTICATION

Notting Hill

With crisp white facades, covered entrances with pillars and black iron gates, the properties in the affluent part of Notting Hill are stunningly beautiful. This wonderful double-fronted, stuccoed house is certainly no exception. Nevertheless, the interior needed tender love and care, when Studio Indigo took on the challenging restoration. Typical of this type of house, the layout was formed with a central staircase flanked by two long and narrow rooms. The interior was disappointing, lifeless and particularly dark on the garden side, where a dominating, top-lit artist's studio had been constructed in the late 19th century and overshadowed and blocked most of the garden. Removing the studio and reintroducing the garden space was the first step to bring glory and life into the property, which now offers everything a family could ever dream of, including an unusual mezzanine play area and a swimming pool. Newly created spaces take advantage of the light and views. Each part of the house has its own character and identity, from the vaulted games room to the grand and imposing seven-and-a-half-metre high entrance hall. This majestic welcome sets the tone for the rest of the house, which oozes sophistication in a smooth grey, soft and dusty colour palette. Everything is luxurious and grand, yet discreet and understated.

Die im wohlhabenden Teil von Notting Hill gelegenen Anwesen sind mit ihren frischen, weißen Fassaden, den überdachten, pfeilergestützten Eingängen und den schwarzen Eisentoren atemberaubend schön. Auch dieses wundervolle, stuckverzierte Haus, dessen Eingangstür mittig angeordnet ist, bildet daher überhaupt keine Ausnahme. Als sich jedoch Studio Indigo der herausfordernden Sanierung annahm, bedurfte der Innenbereich liebevoller Aufmerksamkeit. Der für diese Art von Haus typische Grundriss beinhaltete eine zentrale Treppe und zwei lange, schmale angrenzende Zimmer. Die Raumaufteilung war enttäuschend, leblos und besonders zur Gartenseite hin dunkel: Ende des 19. Jahrhunderts war dort ein von oben beleuchtetes Künstleratelier errichtet worden, das nicht nur diesen Teil des Hauses beherrschte und ihn verdüsterte, sondern auch noch den Blick zum Garten größtenteils versperrte. Der Rückbau des Ateliers und die Einbindung des Gartenbereichs stellten den ersten Schritt dar, um dem Anwesen neuen Glanz zu verleihen und es

27

wieder zum Leben zu erwecken. Heute bietet das Haus alles, was eine Familie sich erträumen kann, darunter ein ungewöhnliches Zwischengeschoss mit Spielecke und ein Schwimmbad. Neu geschaffene Räume nutzen Licht und Ausblicke optimal aus. Die verschiedenen Bereiche des Hauses zeichnen sich durch ihren ganz eigenen Charakter aus; vom gewölbten Spielzimmer bis hin zum prachtvollen, imposanten, siebeneinhalb Meter hohen Eingangsbereich. Dieser majestätische Empfang ist tonangebend für den Rest des Hauses, der in eine Farbpalette aus sanftgrauen und weichen, gedämpften Tönen gehüllt, Raffinesse versprüht. Ein Interieur, das luxuriös und beeindruckend, aber dennoch diskret und unaufdringlich wirkt.

Avec leur façade en stuc d'un blanc immaculé, leur porche soutenu par des piliers et leur porte métallique noire, les propriétés de ce quartier aisé de Notting Hill sont d'une exceptionnelle beauté. Cette splendide maison, pourvue de larges fenêtres de part et d'autre de la porte d'entrée, n'y fait assurément pas exception. Pourtant, lorsque le Studio Indigo relève le défi de la rénovation, l'intérieur requiert d'être traité avec amour et tendresse. Typiquement structuré autour d'un escalier central flanqué de deux longues pièces étroites, il est aussi morne que décevant. Du côté du jardin, un imposant atelier d'artiste pourvu d'une verrière et construit à la fin du XIXème siècle, lui fait de l'ombre. Ôter cet atelier et réaménager le jardin dont il occupe la majeure partie, constituent donc la première étape du processus visant à redonner gloire et vie à une demeure qui aujourd'hui, offre tout ce dont une famille peut rêver, y compris une étonnante salle de jeux installée sur une mezzanine et une piscine. La lumière et les perspectives ainsi créées profitent aux nouveaux espaces. Les différentes parties de la maison bénéficient chacune, d'un caractère et d'une identité propres – depuis les salle de jeux voûtée jusqu'au majestueux hall d'entrée qui impose ses sept mètres et demi de hauteur. Cet accueil grandiose donne d'emblée la mesure d'un intérieur dont les gris lisses, doux et poudreux soulignent le raffinement. Tout est luxueux et magistral, et cependant, discret et subtil.

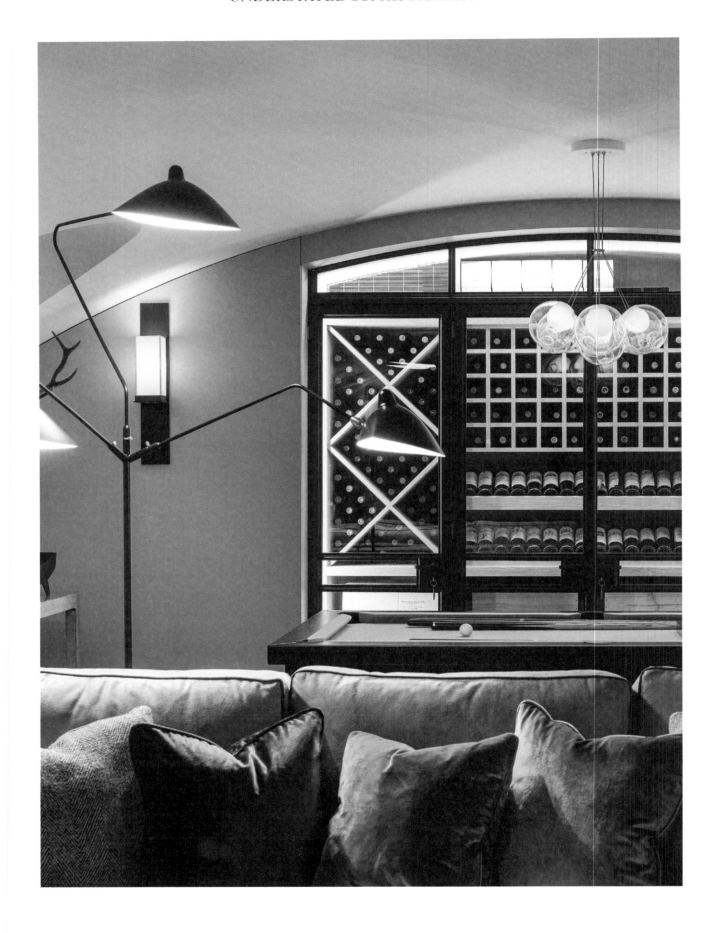

DARK WOODEN FLOORS, crisp white walls and fabric in muted colours give the spaces a soft and clean ambience. All rooms have natural light, and stylish and beautiful designer lamps and chandeliers in different styles amplify the atmospheric feel.

DUNKLE HOLZBÖDEN, FRISCHE, weiße Wände und Stoffe in gedeckten Farben verleihen den Räumen ein sanftes und cleanes Ambiente. In sämtliche Zimmer dringt viel natürliches Licht, elegante, wunderschöne Designerlampen und unterschiedlich gestaltete Kronleuchter verstärken die wohnliche Atmosphäre zusätzlich.

214

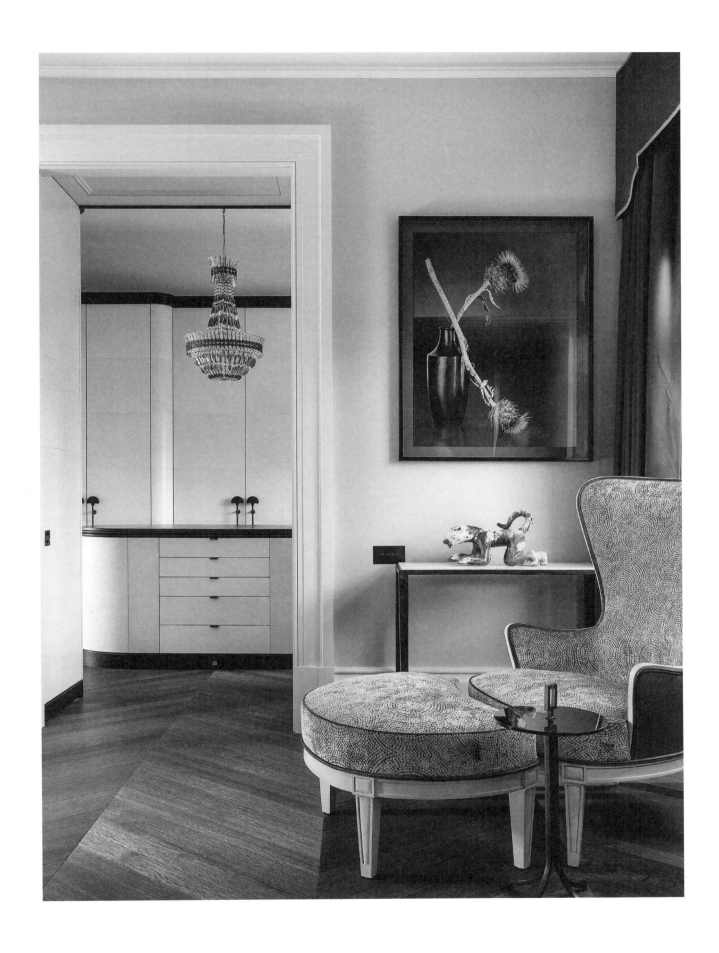

LES PARQUETS SOMBRES, les murs d'un blanc immaculé, les tissus aux teintes sourdes imprègnent chaque espace d'une ambiance douce et nette. Toutes les pièces bénéficient de lumière naturelle, cependant que les lampes de designer et les lustres à la superbe élégance renforcent l'atmosphère des lieux.

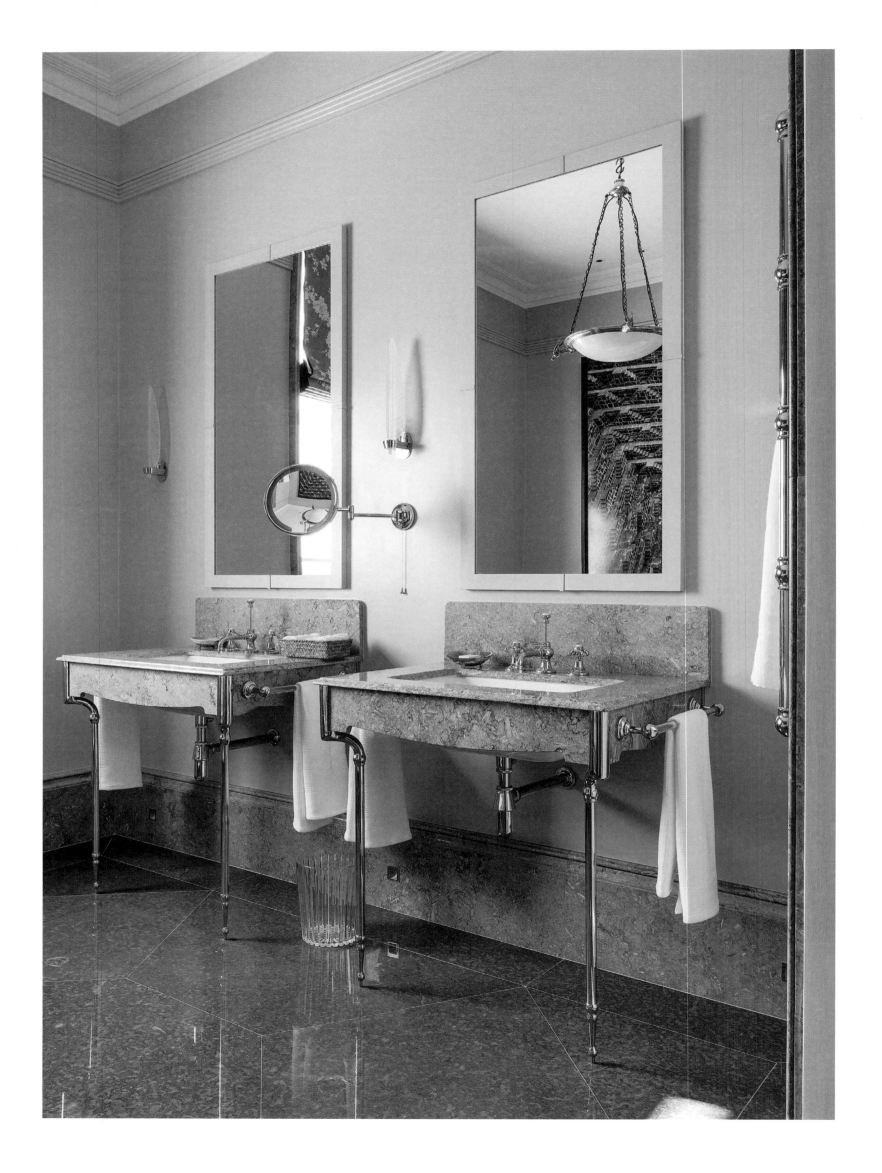

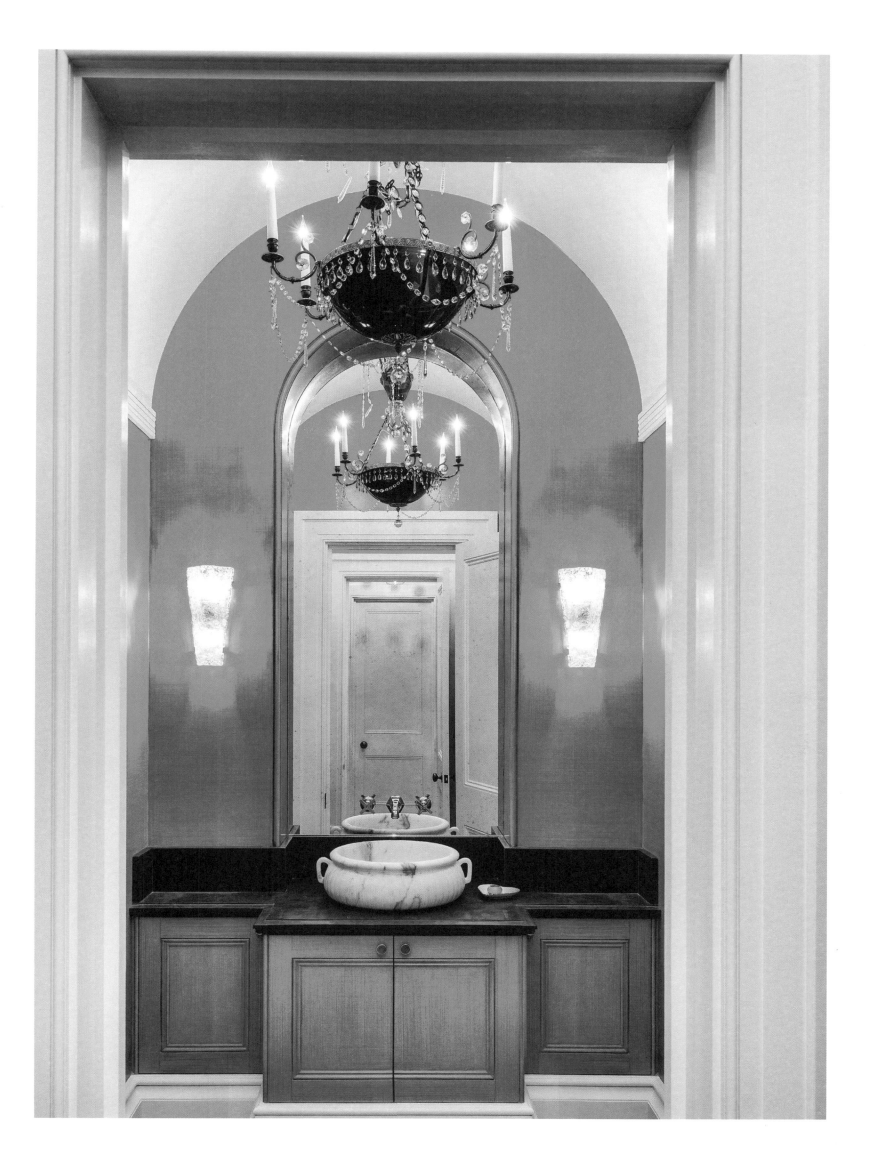

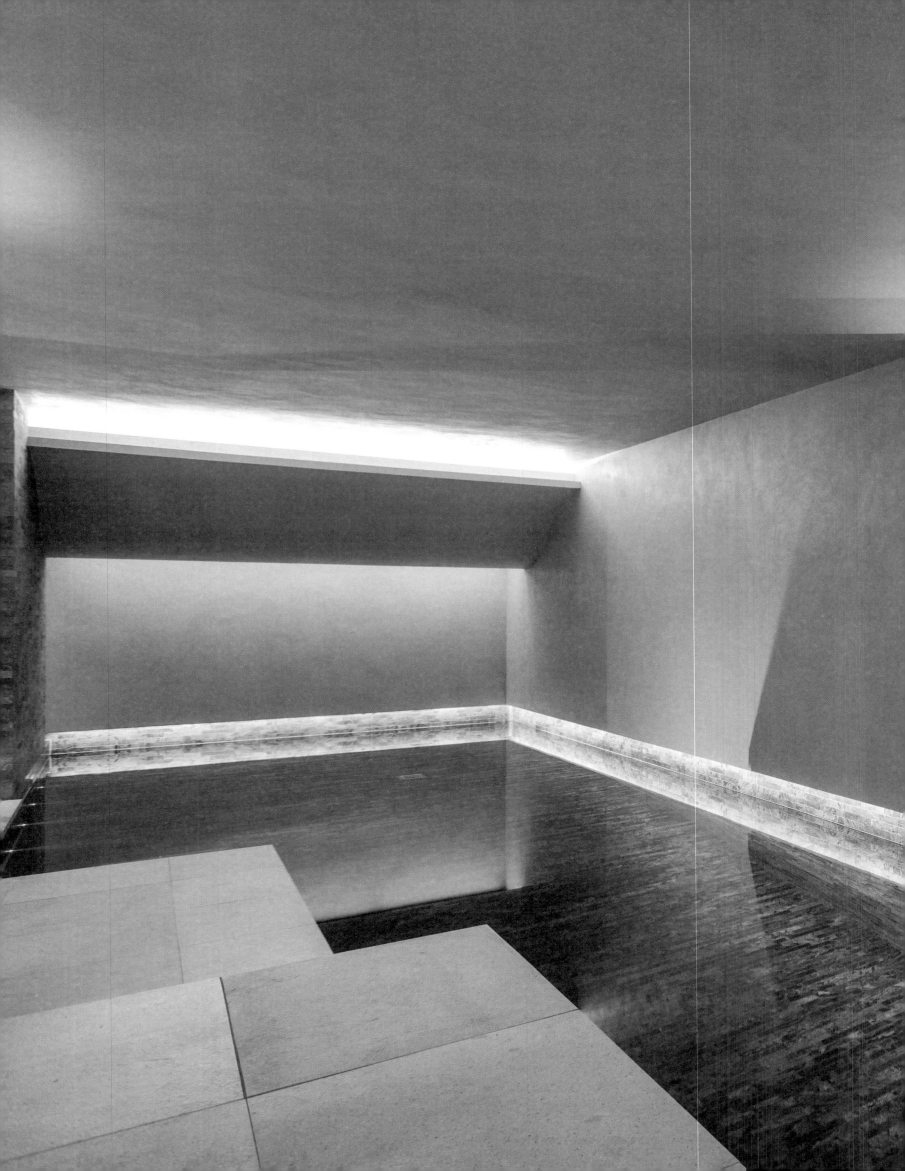

KARIN GRÅBÆK HELLEDIE | Author

She is a Danish-born journalist and author (*Living in Style Scandinavia*) living in London with her husband and two daughters. For more than 20 years, she has written about trends, design, travel, and celebrities for Danish media, and writes and translates interior design articles for international magazines. She feels very lucky to have a job involving travel and exploring big cities – testing a new yoga class in London, finding a great coffee shop in Paris, or spending hours walking the streets of New York. She has published two personal guidebooks, *London My Love and I Love New York* (Gyldendal, Denmark) and is part of the American company Good Life Designed, which has just published the book *Design Your Life* in the US.

ANDREAS VON EINSIEDEL | Photographer

London-based Andreas von Einsiedel is a German freelance photographer who has specialised in interiors and architecture for 25 years. Highly regarded by magazines and publishers for his use of natural light and sense of composition, Andreas von Einsiedel has photographed over 30 books featuring interiors, flower design, cookery, antiques, lifestyle, and architecture. He is a regular contributor to the world's most prestigious magazines, including *World of Interiors*, *House & Garden*, *Elle Decoration*, *Homes & Gardens*, *Vogue Living*, and *Architectural Digest*. He is frequently commissioned by (Britain's) National Trust to photograph the interiors of many of the country's greatest historic houses and their gardens.

Published in the same series

LIVING IN STYLE AMSTERDAM
ISBN 978-3-96171-007-2

LIVING IN STYLE PARIS
ISBN 978-3-96171-005-8

HOW WE LIVE
ISBN 978-3-96171-016-4

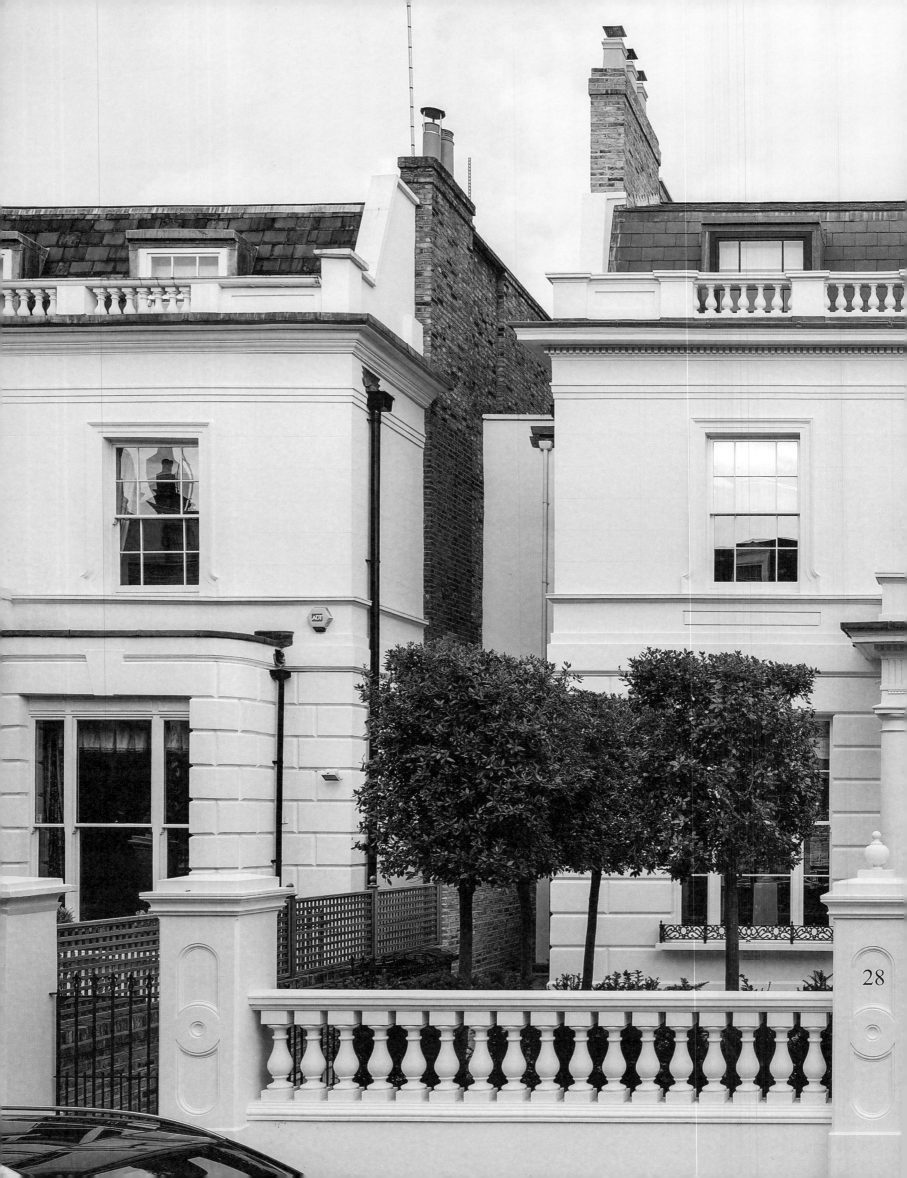

IMPRINT

© 2017 teNeues Media GmbH & Co. KG, Kempen
Photographs © 2017 Andreas von Einsiedel. All rights reserved.

Copy Writing: Karin Gråbæk Helledie
Translations: Alice Boucher (French),
Irene Eisenhut (English)
Copy Editing:
Suzanne Kirkbright, Paul Bendelow (English),
Christina Reuter, Sabine Egetemeir (German),
Alice Boucher (French)
Editorial Coordination: Christina Reuter
Creative Director: Martin Graf
Design & Layout: Robin John Berwing
Production: Nele Jansen
Colour separation: Jens Grundei

Published by teNeues Publishing Group

teNeues Media GmbH & Co. KG
Am Selder 37, 47906 Kempen, Germany
Phone: +49-(0)2152-916-0
Fax: +49-(0)2152-916-111
e-mail: books@teneues.com

teNeues Media GmbH & Co. KG
Munich Office
Pilotystraße 4, 80538 Munich, Germany
Phone: +49-(0)89-443-8889-62
e-mail: bkellner@teneues.com

Press department: Andrea Rehn
Phone: +49-(0)2152-916-202
e-mail: arehn@teneues.com

teNeues Publishing Company
7 West 18th Street, New York, NY 10011, USA
Phone: +1-212-627-9090
Fax: +1-212-627-9511

teNeues Publishing UK Ltd.
12 Ferndene Road, London SE24 0AQ, UK
Phone: +44-(0)20-3542-8997

teNeues France S.A.R.L.
39, rue des Billets, 18250 Henrichemont, France
Phone: +33-(0)2-4826-9348
Fax: +33-(0)1-7072-3482

www.teneues.com

ISBN 978-3-96171-006-5
Library of Congress Number: LoC 2017942015

Printed in Italy

Bibliographic information published by
the Deutsche Nationalbibliothek
The Deutsche Nationalbibliothek lists this publication in the
Deutsche Nationalbibliografie; detailed bibliographic data are
available on the Internet at http://dnb.dnb.de.

teNeues Publishing Group
Kempen
Berlin
London
Munich
New York
Paris

teNeues